MAKING
COMICS

STORYTELLING SECRETS OF COMICS, MANGA AND GRAPHIC NOVELS

HARPER

New York • London • Toronto • Sydney

FROM THE AUTHOR OF *UNDERSTANDING COMICS*

SCOTT McCLOUD

Written and Drawn by
Scott McCloud

Editors

Kate Travers
John Williams

Editorial Consultants

Kurt Busiek
Jenn Manley Lee
Neil Gaiman
Larry Marder
Ivy Ratafia

Comics Font designed by

John Roshell at Comicraft

comicbookfonts.com

HARPER

HarperCollins books may be purchased for educational, business, or sales promotional use. For information please write: Special Markets Department, HarperCollins Publishers, 10 East 53rd Street, New York, NY 10022.

Library of Congress Cataloging-in-Publication Data is available upon request.

ISBN-10: 0-06-078094-0
ISBN-13: 978-0-06-078094-4

11 12 13 14 15 ❖/RRD 15 14 13 12 11

Pre -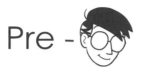

Visit any big bookstore and you'll find tons of how-to-draw books on the shelves aimed at comics artists. Flip through them and you'll see step-by-step instructions on drawing manga schoolgirl outfits, superhero muscles and strip gags. These are the books that tell you what they all assume you want to know—how to draw like your favorite artists—and they're pretty good at it. But there's something they're not telling you. In fact, there's a whole book's worth of secrets they're leaving out.

If you've ever felt there must be something more to making comics than just copying drawing styles, then this is the book for you.

In these pages, I've done my best to cover the storytelling secrets I don't see any other books talking about, the ideas every comics artist needs to tackle before they even pick up a pen, including:

- Choosing the right moments to make into panels—what to include, what to leave out.
- Framing actions and guiding the reader's eyes.
- Choosing words and images that communicate together.
- Creating varied and compelling characters with inner lives and unforgettable appearances.
- Mastering body language and facial expressions.
- Creating rich, believable worlds for your readers to explore.
- Picking the tools that are right for you, and understanding how those tools evolved.
- Navigating the vast world of comics styles and genres.

The comics industry is changing fast. Old formats die and new ones are born. Whole industries come and go. But these storytelling principles always apply. They mattered fifty years ago and they'll matter fifty years from now.

Whether you want to draw graphic novels, superheroes, manga-style, comic strips or webcomics, you're going to be putting one picture after another to tell a story.

Here's how.

Scott McCloud

CONTENTS

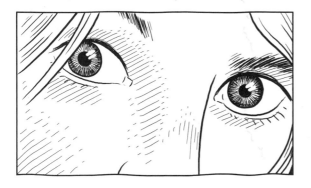

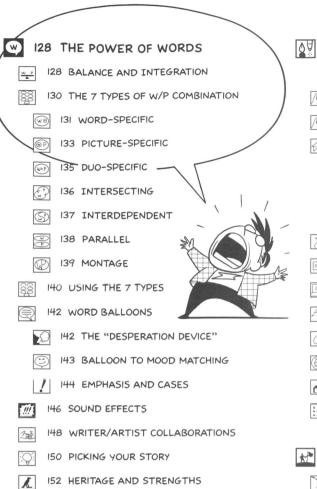
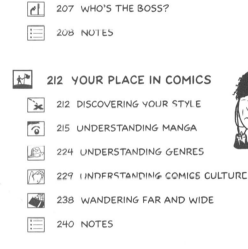

For
Will Eisner

Acknowledgments

Thank you to my editorial kibitzers, Kurt Busiek, Jenn Manley Lee, Neil Gaiman, Larry Marder and Ivy Ratafia for taking a close look at early drafts of this book. Kurt, as always, led the pack with his merciless critiques and helped chop out any number of embarrassing fumbling passages (any that remain you can blame on me). Thank you also to the comics pros who responded to my email tools survey (see the notes section of Chapter Five for the list). Special proofreading services provided by Carol Pond. Also helping out with information were Shaenon Garrity, Karl Kesel and the staff at Graphaids in Agoura Hills, CA, and thank you to all our friends and family who offered reference materials or posed for reference shots including: Ivy, Sky, Winter, Nat Gertler, Lauren Girard (that's Nat and Lauren in the goofy photo on page 94), Lori Matsumoto, John Wiseman, S. Krystal McCauley, Matt Miller and of course, The Mighty Paul Smith for posing, sketching and helping us move the fridge.

Thank you to Kelly Donovan for making Page 30, panel 6 possible.

Thank you to David, Kate, John, Lucy and everyone else at Harper for their advice and support.

Thank you to Judith Hansen for finding this book a great home and eternally watching out for us.

Thanks to Art Spiegelman for introducing me to the term "Picture Writing" which inspired the title of Chapter One, and for influencing my own ideas about comics over the years.

Thank you, with love, to the amazing Ivy for typing thousands of words into those balloons and into the index, and to the whole family for enduring my very long work days for a year and a half and for making it all worthwhile.

The comics world lost Will Eisner in January 2005, while this book was being written. He was 87, but very much in his prime. His book *Comics and Sequential Art* seriously examined the art of making comics way back in 1985 and he inspired us to treat comics with dignity and respect throughout his century-spanning career. He'll be terribly missed.

INTRODUCTION

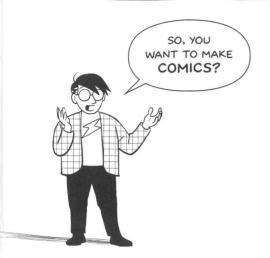

SO, YOU WANT TO MAKE **COMICS?**

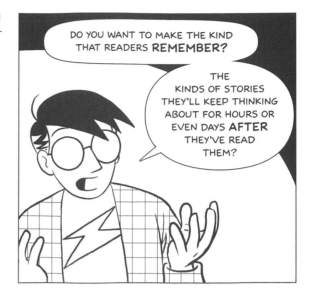

DO YOU WANT TO MAKE THE KIND THAT READERS **REMEMBER?**

THE KINDS OF STORIES THEY'LL KEEP THINKING ABOUT FOR HOURS OR EVEN DAYS **AFTER** THEY'VE READ THEM?

DO YOU WANT TO CREATE COMICS THAT PULL READERS INTO THE WORLD OF THE STORY?

A READING EXPERIENCE SO SEAMLESS THAT IT DOESN'T FEEL LIKE READING AT ALL BUT LIKE **BEING** THERE?

POPULATED BY CHARACTERS SO VIVID THEY SEEM AS **REAL** AS THE READER'S OWN FRIENDS AND FAMILY?

WELL, SO DO **I.**

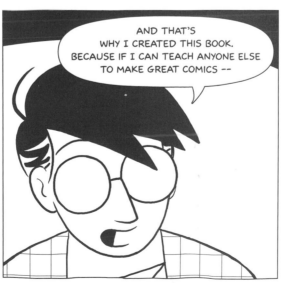

AND THAT'S WHY I CREATED THIS BOOK. BECAUSE IF I CAN TEACH ANYONE ELSE TO MAKE GREAT COMICS --

-- MAYBE I CAN TEACH **MYSELF** AS WELL.

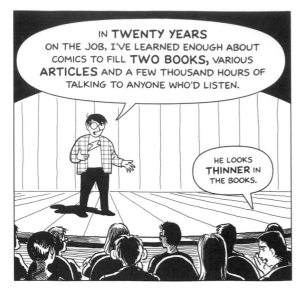

IN **TWENTY YEARS** ON THE JOB, I'VE LEARNED ENOUGH ABOUT COMICS TO FILL **TWO BOOKS,** VARIOUS **ARTICLES** AND A FEW THOUSAND HOURS OF TALKING TO ANYONE WHO'D LISTEN.

HE LOOKS **THINNER** IN THE BOOKS.

BUT **MY OWN** COMICS STORIES HAVE NEVER BEEN AS GOOD AS I KNOW THEY COULD BE.

I'M SURE I CAN DO A BETTER JOB AND I'M DETERMINED TO LEARN **HOW.**

SOME CHALLENGES, LIKE IMPROVING MY FIGURE DRAWING, CAN ONLY BE MET BY HARD WORK, OBSERVATION AND STUDY.

AND FORTUNATELY, THERE ARE PLENTY OF GOOD TEACHERS OUT THERE FOR THAT SORT OF THING.

BUT THERE'S **MUCH MORE** TO MAKING GREAT COMICS THAN DRAWING AND WRITING SKILLS.

COMICS IS A **SECRET LANGUAGE** ALL ITS OWN, AND **MASTERING** IT POSES CHALLENGES UNLIKE ANY FACED BY PROSE WRITERS, ILLUSTRATORS OR ANY OTHER CREATIVE PROFESSIONALS.

UNFORTUNATELY, APART FROM A FEW GREAT BOOKS ON THE SUBJECT* --

-- MOST OF THAT TERRITORY HAS REMAINED UNEXPLORED... UNTIL **NOW.**

WILL EISNER COMICS & SEQUENTIAL A

SO, FOR YOUR SAKE **AND** MINE, I'VE GONE "BACK TO THE DRAWING BOARD" ONCE MORE AND COLLECTED EVERYTHING I KNOW ABOUT THE ART OF TELLING STORIES WITH PICTURES --

-- THEN FIGURED OUT WHAT I **DIDN'T** KNOW, FILLED IN THOSE GAPS AND PUT IT ALL TOGETHER.

THESE ARE THE BEDROCK PRINCIPLES OF COMICS STORYTELLING...

CONCEPTS THAT GO FAR DEEPER THAN THE USUAL HOW-TO BOOKS.

THE PRINCIPLES OF **CLARITY** AND **COMMUNICATION**, FOR EXAMPLE, AND HOW THEY GOVERN THE WAYS OUR STORIES ARE **PACED** --

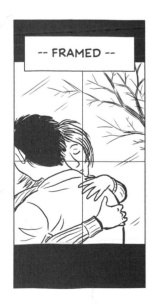

-- FRAMED --

-- AND **RENDERED.**

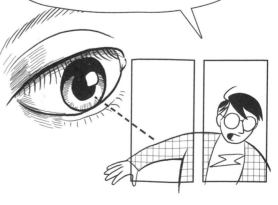

HOW THE READER'S EYE IS **GUIDED** FROM PANEL TO PANEL, AND HOW THE READER'S MIND IS PERSUADED TO **CARE** ABOUT WHAT IT SEES.

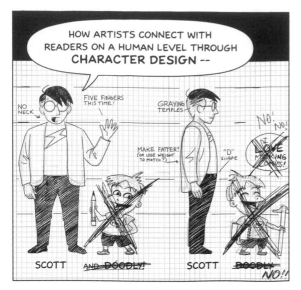

HOW ARTISTS CONNECT WITH READERS ON A HUMAN LEVEL THROUGH **CHARACTER DESIGN** --

NO NECK

FIVE FINGERS THIS TIME!

GRAYING TEMPLES

MAKE FATTER? (OR LOSE WEIGHT TO MATCH?)

NO! NO!

"D" SHAPE

SCOTT AND DOODLY!

SCOTT DOODLY

NO!!

-- **FACIAL EXPRESSIONS** --

-- AND **BODY LANGUAGE**.

HOW WHOLE **WORLDS** ARE CONSTRUCTED ON THE PAGE -- AND IN THE READER'S **IMAGINATION**.

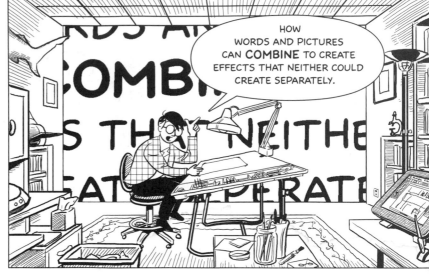

HOW WORDS AND PICTURES CAN **COMBINE** TO CREATE EFFECTS THAT NEITHER COULD CREATE SEPARATELY.

WHY PEOPLE CHOOSE THE **TOOLS** THEY DO TO **CREATE** THESE STORIES.

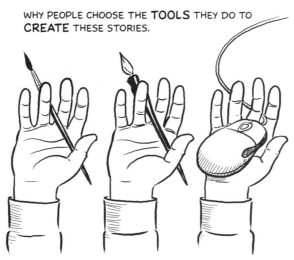

AND WHY THEY CHOOSE ONE **KIND** OF STORY OVER **ANOTHER**.

WHETHER YOU'RE DRAWN TO **COMIC STRIPS, COMIC BOOKS** OR **GRAPHIC NOVELS...** WHETHER YOU LIKE **JAPANESE, EUROPEAN, NORTH AMERICAN** OR ANY OTHER REGIONAL STYLES... WHETHER YOU WORK IN **PRINT, ONLINE** OR **BOTH** --

-- THESE ARE THE **ISSUES** YOU'LL HAVE TO **FACE.**

I WON'T TELL YOU THE "RIGHT" WAY TO WRITE OR DRAW BECAUSE THERE'S **NO SUCH THING.**

ANY STYLE, ANY APPROACH, ANY TOOL, CAN WORK IN COMICS IF IT'S RIGHT FOR **YOU.**

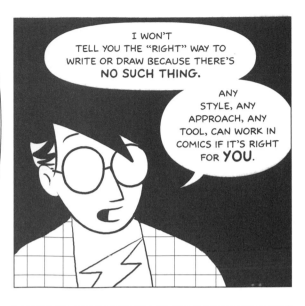

BUT, YOUR CHOICES **NARROW** WHEN YOU WANT YOUR COMICS TO PROVIDE A SPECIFIC **REACTION** IN READERS. THAT'S WHEN CERTAIN METHODS MIGHT DO THE JOB FOR YOU --

-- AND OTHERS **WON'T.**

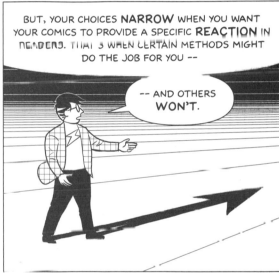

THERE ARE **NO LIMITS** TO WHAT YOU CAN FILL THAT **BLANK PAGE** WITH -- ONCE YOU UNDERSTAND THE **PRINCIPLES** THAT ALL COMICS STORYTELLING IS **BUILT** UPON.

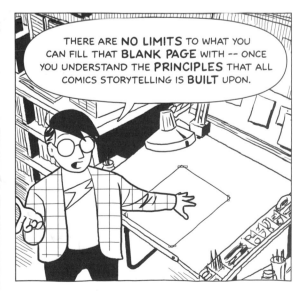

IN SHORT: **THERE ARE NO RULES.**

PANEL ONE: ART BY LYNN JOHNSTON, DAVID MAZZUCCHELLI, ART SPIEGELMAN, RUMIKO TAKAHASHI, DAVID B. AND DEMIAN 5 (SEE ART CREDITS, PAGE 258).

5

MAKING
COMICS

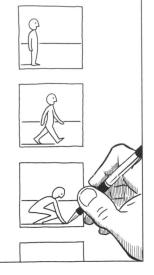

Chapter One

Writing with Pictures

Clarity, Persuasion and Intensity

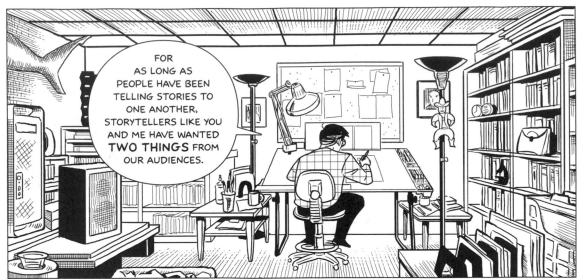

FOR AS LONG AS PEOPLE HAVE BEEN TELLING STORIES TO ONE ANOTHER, STORYTELLERS LIKE YOU AND ME HAVE WANTED **TWO THINGS** FROM OUR AUDIENCES.

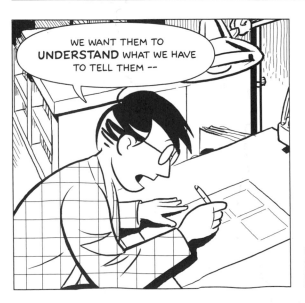

WE WANT THEM TO **UNDERSTAND** WHAT WE HAVE TO TELL THEM --

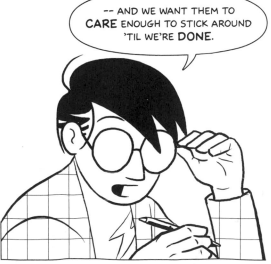

-- AND WE WANT THEM TO **CARE** ENOUGH TO STICK AROUND 'TIL WE'RE **DONE**.

TO ACHIEVE THAT FIRST GOAL, YOU'LL NEED TO LEARN THE PRINCIPLES OF COMMUNICATING WITH **CLARITY** --

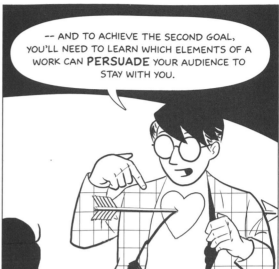

-- AND TO ACHIEVE THE SECOND GOAL, YOU'LL NEED TO LEARN WHICH ELEMENTS OF A WORK CAN **PERSUADE** YOUR AUDIENCE TO STAY WITH YOU.

IF THE STORY YOU HAVE IN MIND IS **COMPELLING**, IN AND OF ITSELF, THEN **TELLING IT STRAIGHT** WITH A MAXIMUM OF CLARITY MAY BE THE ONLY PERSUASION YOUR AUDIENCE WILL NEED.

It was a dark and stormy night...

tap tap tap

IN **COMICS**, THAT STORY WILL NEED TO TAKE THE FORM OF **IMAGES IN SEQUENCE**, PERHAPS WITH **WORDS** --

HMM... DARK NIGHT...

AND **STORMY** TOO.

YES... IT **IS**.

DARK **AND** STORMY. AND NIGHT

NOW, WHAT?

SHH! JUST KEEP STALLING. WE'RE ALMOST OUT OF ROOM HERE.

-- SO LET'S START BY EXAMINING HOW THAT CONVERSION IS DONE WHEN **CLARITY** AND **COMMUNICATION** ARE THE PRIMARY **GOALS**.

COMICS REQUIRES US TO MAKE A CONSTANT STREAM OF **CHOICES** REGARDING IMAGERY, PACING, DIALOGUE, COMPOSITION, GESTURE AND A TON OF OTHER OPTIONS --

-- AND THESE CHOICES BREAK DOWN INTO **FIVE BASIC TYPES**.

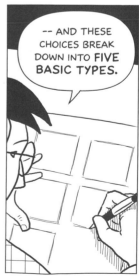

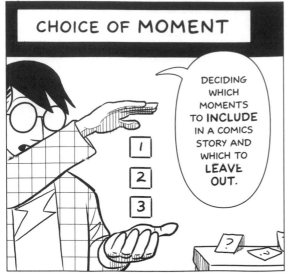

CHOICE OF MOMENT

DECIDING WHICH MOMENTS TO **INCLUDE** IN A COMICS STORY AND WHICH TO **LEAVE OUT.**

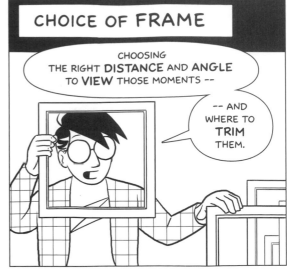

CHOICE OF FRAME

CHOOSING THE RIGHT **DISTANCE** AND **ANGLE** TO **VIEW** THOSE MOMENTS --

-- AND WHERE TO **TRIM** THEM.

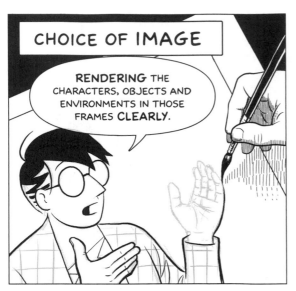

CHOICE OF IMAGE

RENDERING THE CHARACTERS, OBJECTS AND ENVIRONMENTS IN THOSE FRAMES **CLEARLY.**

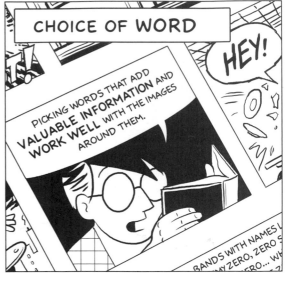

CHOICE OF WORD

PICKING WORDS THAT ADD **VALUABLE INFORMATION** AND **WORK WELL** WITH THE IMAGES AROUND THEM.

HEY!

BANDS WITH NAMES L...
MY ZERO, ZERO S...
...ERO... WH...

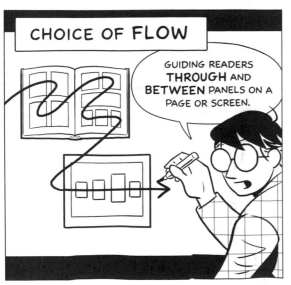

CHOICE OF FLOW

GUIDING READERS **THROUGH** AND **BETWEEN** PANELS ON A PAGE OR SCREEN.

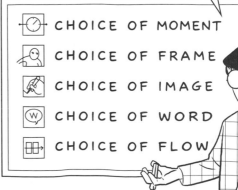

THESE ARE THE **FIVE ARENAS** WHERE YOUR CHOICES CAN MAKE THE DIFFERENCE BETWEEN **CLEAR, CONVINCING STORYTELLING** AND A **CONFUSING MESS.**

- CHOICE OF MOMENT
- CHOICE OF FRAME
- CHOICE OF IMAGE
- CHOICE OF WORD
- CHOICE OF FLOW

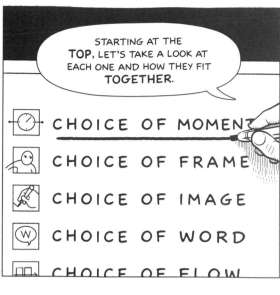

STARTING AT THE **TOP**, LET'S TAKE A LOOK AT EACH ONE AND HOW THEY FIT **TOGETHER**.

⊙ CHOICE OF MOMENT

👤 CHOICE OF FRAME

🖌 CHOICE OF IMAGE

Ⓦ CHOICE OF WORD

▭ CHOICE OF FLOW

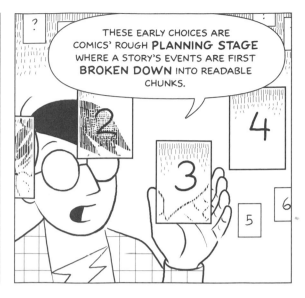

?

THESE EARLY CHOICES ARE COMICS' ROUGH **PLANNING STAGE** WHERE A STORY'S EVENTS ARE FIRST **BROKEN DOWN** INTO READABLE CHUNKS.

2 4 3 5 6

SUPPOSE, FOR EXAMPLE, THAT YOU WANTED TO SHOW A MAN **WALKING**...

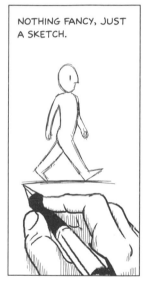

NOTHING FANCY, JUST A SKETCH.

THEN, LET'S SAY THE MAN FINDS A **KEY** ON THE GROUND, PICKS IT UP, TAKES IT WITH HIM AND COMES TO A **DOOR**.

SO, HE **UNLOCKS** THE DOOR AND THEN A... I DUNNO... A **HUNGRY LION** JUMPS OUT!

HERE'S HOW A SEQUENCE LIKE THAT MIGHT TAKE SHAPE IN **COMICS** FORM.

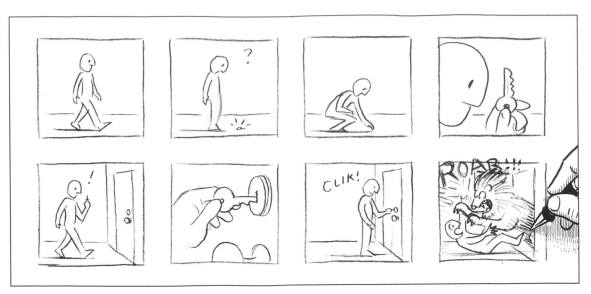

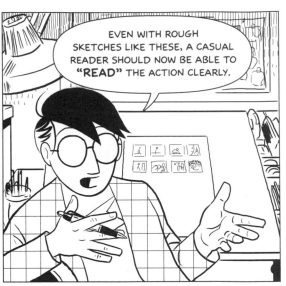

EVEN WITH ROUGH SKETCHES LIKE THESE, A CASUAL READER SHOULD NOW BE ABLE TO "READ" THE ACTION CLEARLY.

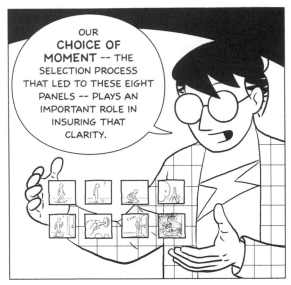

OUR **CHOICE OF MOMENT** -- THE SELECTION PROCESS THAT LED TO THESE EIGHT PANELS -- PLAYS AN IMPORTANT ROLE IN INSURING THAT CLARITY.

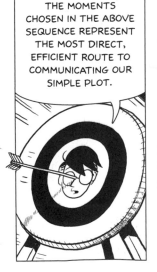

THE MOMENTS CHOSEN IN THE ABOVE SEQUENCE REPRESENT THE MOST DIRECT, EFFICIENT ROUTE TO COMMUNICATING OUR SIMPLE PLOT.

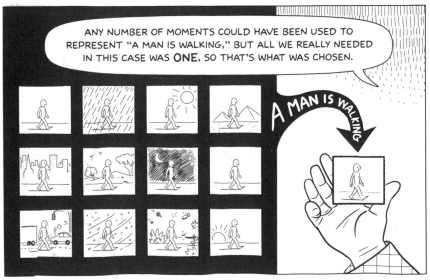

ANY NUMBER OF MOMENTS COULD HAVE BEEN USED TO REPRESENT "A MAN IS WALKING," BUT ALL WE REALLY NEEDED IN THIS CASE WAS **ONE**, SO THAT'S WHAT WAS CHOSEN.

A MAN IS WALKING

EACH PANEL FURTHERS THE "PLOT."

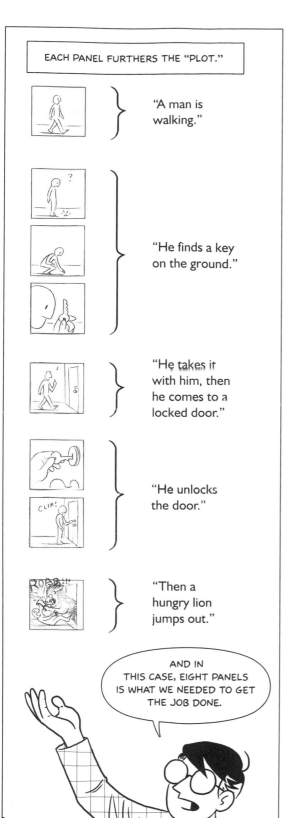

"A man is walking."

"He finds a key on the ground."

"He takes it with him, then he comes to a locked door."

"He unlocks the door."

"Then a hungry lion jumps out."

AND IN THIS CASE, EIGHT PANELS IS WHAT WE NEEDED TO GET THE JOB DONE.

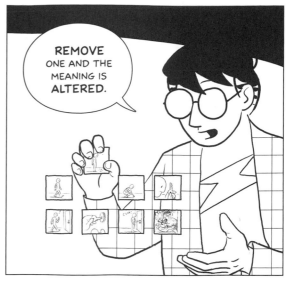

REMOVE ONE AND THE MEANING IS ALTERED.

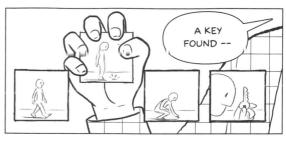

A KEY FOUND --

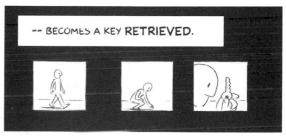

-- BECOMES A KEY RETRIEVED.

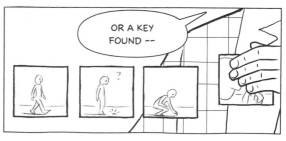

OR A KEY FOUND --

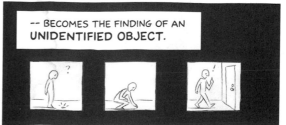

-- BECOMES THE FINDING OF AN UNIDENTIFIED OBJECT.

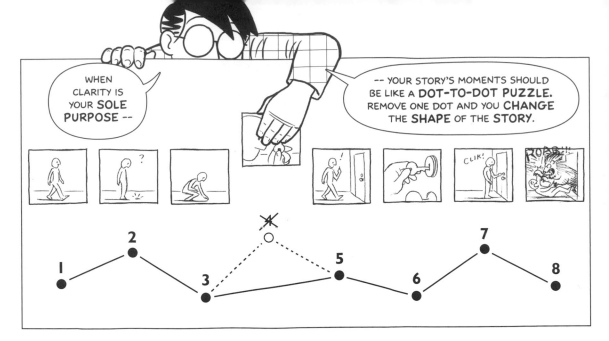

WHEN CLARITY IS YOUR **SOLE PURPOSE** --

-- YOUR STORY'S MOMENTS SHOULD BE LIKE A **DOT-TO-DOT** PUZZLE. REMOVE ONE DOT AND YOU **CHANGE** THE **SHAPE** OF THE **STORY**.

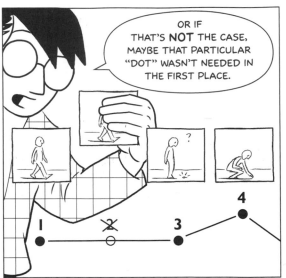

OR IF THAT'S **NOT** THE CASE, MAYBE THAT PARTICULAR "DOT" WASN'T NEEDED IN THE FIRST PLACE.

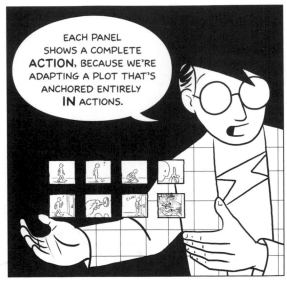

EACH PANEL SHOWS A COMPLETE **ACTION**, BECAUSE WE'RE ADAPTING A PLOT THAT'S ANCHORED ENTIRELY **IN** ACTIONS.

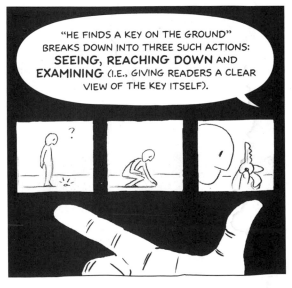

"HE FINDS A KEY ON THE GROUND" BREAKS DOWN INTO THREE SUCH ACTIONS: **SEEING, REACHING DOWN** AND **EXAMINING** (I.E., GIVING READERS A CLEAR VIEW OF THE KEY ITSELF).

IF THE PLOT CALLED FOR THE MAN TO **"SLOWLY"** REACH DOWN, A CERTAIN NUMBER OF **EXTRA** "DOTS" MIGHT HAVE BEEN NECESSARY TO SHOW THE FINDING OF THE KEY --

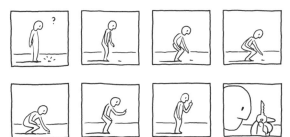

-- BUT BECAUSE WE'RE ILLUSTRATING THE **FACT** OF THESE ACTIONS, RATHER THAN THEIR **QUALITY**, ONE PANEL PER ACTION SEEMS TO BE ENOUGH.

CONSIDER WHAT YOU WANT FROM EACH PART OF YOUR STORY: DO YOU WANT TO JUMP AHEAD TO A **KEY EVENT?** DO YOU WANT TO PUT ON THE BRAKES AND FOCUS ON **SMALLER MOMENTS?** DO YOU WANT TO DRAW ATTENTION TO **CONVERSATIONS** AND **FACES?**

DEPENDING ON YOUR ANSWERS, YOU'LL FIND THAT CERTAIN TYPES OF TRANSITIONS **BETWEEN** PANELS MAY GET THE JOB DONE BETTER THAN OTHERS

THESE **PANEL TO PANEL TRANSITIONS** COME IN **SIX** VARIETIES*, INCLUDING:

 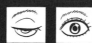

I. MOMENT TO MOMENT

A SINGLE ACTION PORTRAYED IN A SERIES OF MOMENTS.

2. ACTION TO ACTION

A SINGLE SUBJECT (PERSON, OBJECT, ETC...) IN A SERIES OF ACTIONS.

3. SUBJECT TO SUBJECT

A SERIES OF CHANGING SUBJECTS WITHIN A SINGLE SCENE.

4. SCENE TO SCENE

TRANSITIONS ACROSS SIGNIFICANT DISTANCES OF TIME AND/OR SPACE.

5. ASPECT TO ASPECT

TRANSITIONS FROM ONE ASPECT OF A PLACE, IDEA OR MOOD TO ANOTHER.

6. NON SEQUITUR

A SERIES OF SEEMINGLY NONSENSICAL, UNRELATED IMAGES AND/OR WORDS.

* SEE *UNDERSTANDING COMICS* PAGES 70-89 FOR MORE INFORMATION ABOUT THE SIX TRANSITIONS.

1

MOMENT TO MOMENT TRANSITIONS, FOR EXAMPLE, ARE USEFUL FOR SLOWING THE ACTION DOWN, INCREASING SUSPENSE, CATCHING SMALL CHANGES AND CREATING MOVIE-LIKE MOTION ON THE PAGE.

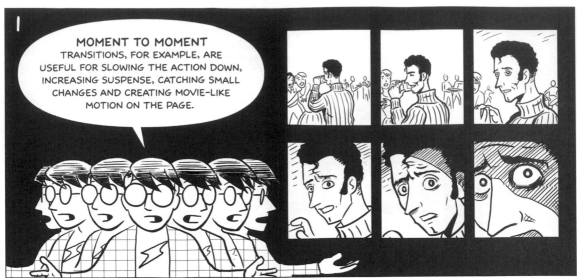

2

ACTION TO ACTION TYPES ARE KNOWN FOR THEIR **EFFICIENCY**. THE CARTOONIST ONLY PICKS ONE MOMENT PER ACTION, SO EACH PANEL HELPS FURTHER THE PLOT AND KEEP THE PACE BRISK.

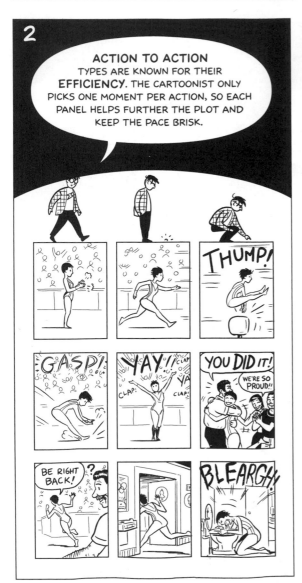

THUMP!

GASP!

YAY!!
CLAP!
YA
CLAP!
CLAP!

YOU DID IT!
WE'RE SO PROUD!!

BE RIGHT BACK! ?

BLEARGH!!

3

SUBJECT TO SUBJECT TRANSITIONS ARE EQUALLY EFFICIENT AT MOVING THE STORY FORWARD --

-- WHILE CHANGING ANGLES TO DIRECT READER ATTENTION AS NEEDED.*

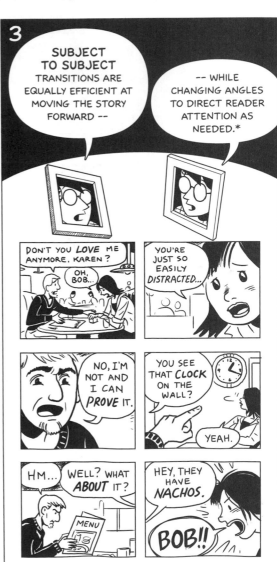

DON'T YOU *LOVE* ME ANYMORE, KAREN?
OH, BOB...

YOU'RE JUST SO EASILY DISTRACTED...

NO, I'M NOT AND I CAN *PROVE* IT.

YOU SEE THAT *CLOCK* ON THE WALL?
YEAH.

HM... WELL? WHAT *ABOUT* IT?
MENU

HEY, THEY HAVE *NACHOS.*
BOB!!

* ALTHOUGH THEY PRIMARILY RELATE TO CHOICE OF MOMENT, TRANSITIONS THREE AND FIVE ALSO TOUCH ON THE UPCOMING TOPIC CHOICE OF **FRAME**.

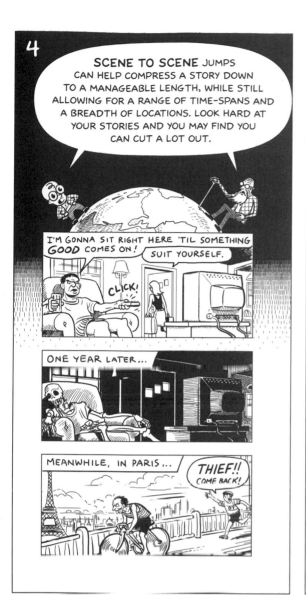

4 SCENE TO SCENE JUMPS CAN HELP COMPRESS A STORY DOWN TO A MANAGEABLE LENGTH, WHILE STILL ALLOWING FOR A RANGE OF TIME-SPANS AND A BREADTH OF LOCATIONS. LOOK HARD AT YOUR STORIES AND YOU MAY FIND YOU CAN CUT A LOT OUT.

I'M GONNA SIT RIGHT HERE 'TIL SOMETHING *GOOD* COMES ON!

SUIT YOURSELF.

CLICK!

ONE YEAR LATER...

MEANWHILE, IN PARIS...

THIEF!! COME BACK!

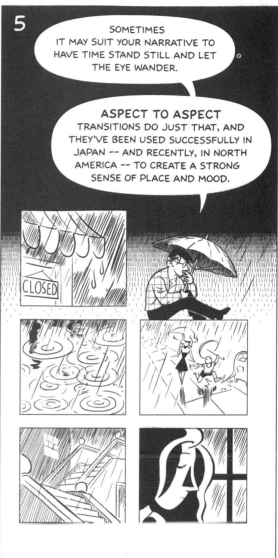

5 SOMETIMES IT MAY SUIT YOUR NARRATIVE TO HAVE TIME STAND STILL AND LET THE EYE WANDER.

ASPECT TO ASPECT TRANSITIONS DO JUST THAT, AND THEY'VE BEEN USED SUCCESSFULLY IN JAPAN -- AND RECENTLY, IN NORTH AMERICA -- TO CREATE A STRONG SENSE OF PLACE AND MOOD.

CLOSED

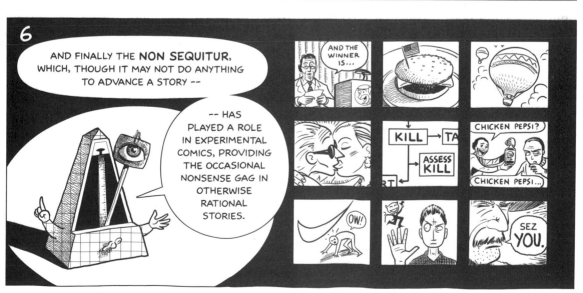

6 AND FINALLY THE NON SEQUITUR, WHICH, THOUGH IT MAY NOT DO ANYTHING TO ADVANCE A STORY --

-- HAS PLAYED A ROLE IN EXPERIMENTAL COMICS, PROVIDING THE OCCASIONAL NONSENSE GAG IN OTHERWISE RATIONAL STORIES.

AND THE WINNER IS...

KILL → TA

ASSESS KILL

RT

CHICKEN PEPSI?

CHICKEN PEPSI...

OW!

SEZ YOU.

IF YOU HAVE A STORY THAT'S VERY **PLOT-DRIVEN**, YOU MAY FIND THAT A LOT OF **ACTION TO ACTION** TRANSITIONS WITH A FEW **SUBJECT TO SUBJECTS** AND **SCENE TO SCENES** ARE ALL YOU NEED.

THESE TEND TO CLARIFY THE **FACTS** OF A SCENE: WHO DOES WHAT, WHERE IT'S DONE, HOW IT'S DONE AND SO FORTH.

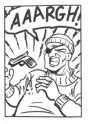

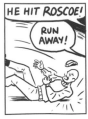

2. ACTION 3. SUBJECT 2. ACTION 4. SCENE

TRANSITIONS **ONE** AND **FIVE**, ON THE OTHER HAND, HELP CLARIFY THE **NATURE** OF AN ACTION, IDEA OR MOOD, AND WORK WELL IN MORE NUANCED OR EMOTIONALLY-DRIVEN STORES.

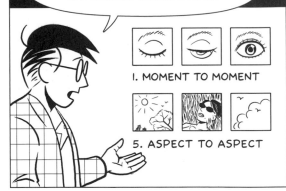

1. MOMENT TO MOMENT

5. ASPECT TO ASPECT

WHATEVER YOUR CHOICE OF MOMENT, THOUGH, CLARITY MEANS LETTING THESE TECHNIQUES OPERATE QUIETLY IN THE BACKGROUND AND LETTING THE **CONTENT** OF THE WORK SPEAK FOR ITSELF.

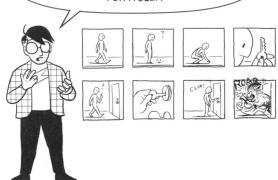

OF COURSE, CHOOSING THE RIGHT **MOMENT** IS ONLY THE BEGINNING.

ONCE YOU'VE PICKED THE RIGHT MOMENTS FOR THE JOB, YOU'LL NEED TO SHOW YOUR READERS WHERE THAT MOMENT'S **FOCUS** LIES.

AND THAT'S WHEN PICKING THE RIGHT **VIEW** OF THAT MOMENT CAN BE CRUCIAL.

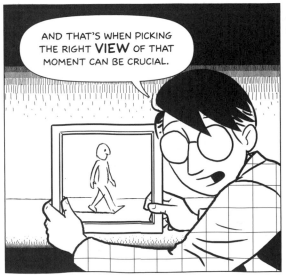

CHOICE OF FRAME IS THE STAGE WHERE YOU DECIDE HOW **CLOSELY** TO FRAME AN ACTION TO SHOW ALL THE PERTINENT DETAILS --

-- OR HOW FAR TO **PULL BACK** TO LET THE READER KNOW WHERE AN ACTION IS TAKING PLACE --

-- AND MAYBE GIVE A SENSE OF **BEING THERE** IN THE PROCESS.

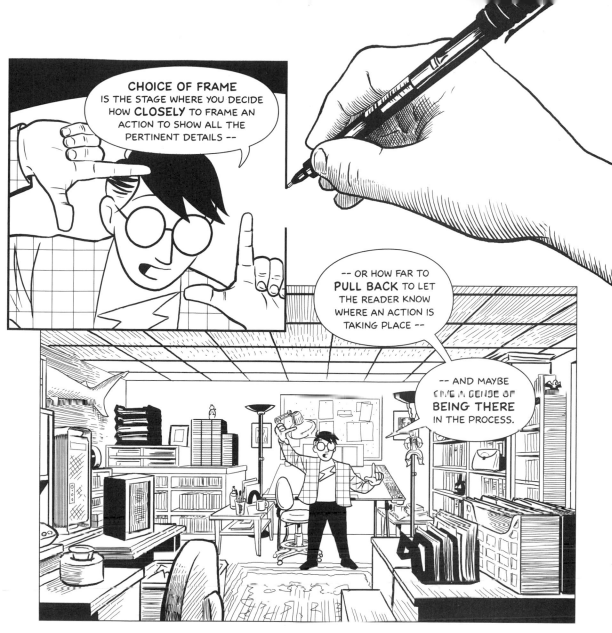

IT'S THE STAGE WHERE YOU DECIDE HOW COMPOSITIONAL FACTORS LIKE **CROPPING, BALANCE** AND **TILT** AFFECT YOUR READERS' IMPRESSIONS OF YOUR WORLD --

-- AND THEIR SENSE OF POSITION **WITHIN** THAT WORLD.

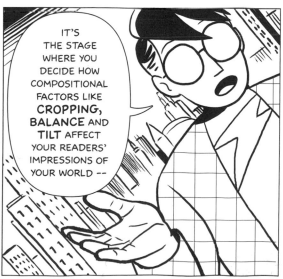

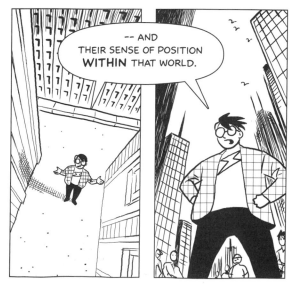

THE CHOICE OF MOMENT FOR OUR ORIGINAL EXAMPLE WAS PRETTY **SIMPLE** (JUST STRAIGHT ACTION TO ACTION) --

-- AND THE CHOICE OF **FRAME** FOR THOSE PANELS WAS TOO.

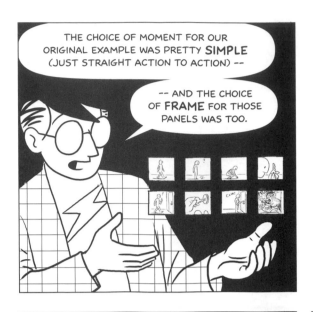

TWO OUT OF THE EIGHT PANELS FEATURED **CLOSE-UPS** TO SHOW A FEW IMPORTANT DETAILS --

-- BUT OTHERWISE, THE ACTION WAS SHOWN FROM A FIXED MIDDLE **DISTANCE** AND FIXED VIEWING **ANGLE.**

OUR TALE COULD HAVE BEEN SHOT FROM **MANY** ANGLES AND DISTANCES, BUT BY OFFERING A VIEW OF THE ACTION THAT BARELY CHANGES --

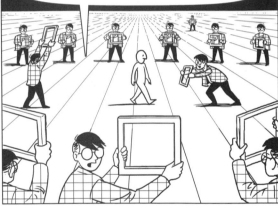

-- THE READER IS ENCOURAGED TO FOCUS ON WHAT **DOES** CHANGE, SUCH AS THE **POSITION** AND **ATTITUDE** OF THE CHARACTER, AS WELL AS HIS UNCHANGING FORWARD **STANCE** --

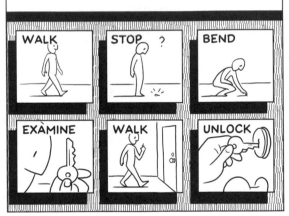

WALK STOP ? BEND

EXAMINE WALK UNLOCK

-- INSTEAD OF BEING **DISTRACTED** BY NEEDLESSLY VARYING SHOTS, IRRELEVANT TO THE NARRATIVE.

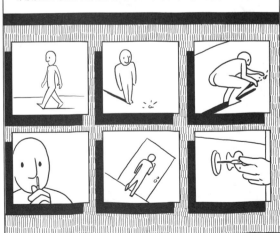

READERS **LIKE** CHANGE AND VARIETY, SO IT'S TEMPTING TO VARY ANGLES A LOT. JUST MAKE SURE THAT THE CHANGES IN YOUR **ARTWORK** --

-- AREN'T **DISTRACTING** READERS FROM MORE IMPORTANT CHANGES TAKING PLACE IN YOUR **STORY.**

THAT SAID, SOME SCENES REQUIRE FREQUENT **CHANGES** OF FRAME, SUCH AS THE FLIP-FLOPPING ANGLES OF SUBJECT TO SUBJECT TRANSITIONS USED TO CAPTURE THE RHYTHM OF TWO PEOPLE IN **CONVERSATION**.

WHY DO *I* HAVE TO GET MAULED BY THE HUNGRY LION *?!*

BECAUSE IT'S *FUNNY!*

TO *YOU*, MAYBE.

I'M *TIRED* OF BEING A THROW-AWAY CHARACTER.

BUT, LOOK AT ALL THE *PANELS* YOU'VE BEEN IN!

IT'S ONLY PAGE 21!

YOU MEAN I HAVE TO KEEP *DOING THIS?!*

HEY, AT LEAST YOU *GET* TO APPEAR AGAIN. THIS IS MY LAST PANEL *EVER!*

OH, DORIS...

=SNIFF=

AND THERE'S NO NEED TO KEEP EVERY PANEL AT **EYE LEVEL**.

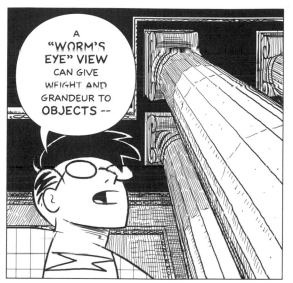

A "WORM'S EYE" VIEW CAN GIVE WEIGHT AND GRANDEUR TO **OBJECTS** --

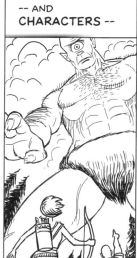

-- AND **CHARACTERS** --

-- WHILE GETTING **ABOVE** A SCENE CAN GIVE READERS ACCESS TO A WEALTH OF INFO ABOUT A SETTING --

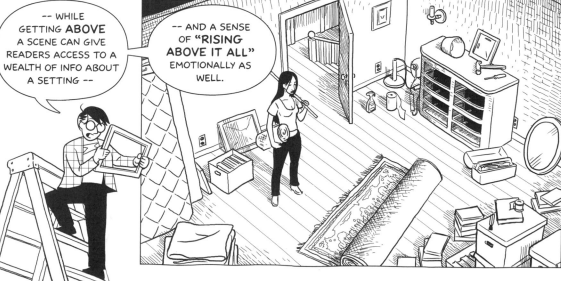

-- AND A SENSE OF **"RISING ABOVE IT ALL"** EMOTIONALLY AS WELL.

21

CONCEPTS LIKE "A MAN IS WALKING" DON'T REQUIRE PULLING BACK THE FRAME MUCH, BUT IF YOU WANT YOUR READERS TO KNOW **WHERE** THAT MAN IS WALKING --

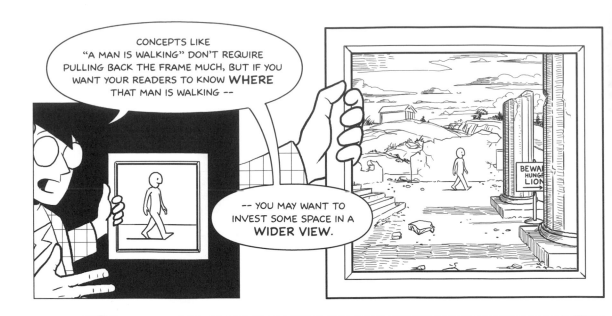

-- YOU MAY WANT TO INVEST SOME SPACE IN A **WIDER VIEW.**

READERS NEED THAT INFORMATION ESPECIALLY WHEN MOVING FROM **SCENE TO SCENE** --

-- HENCE THE TRADITION OF THE **ESTABLISHING SHOT**: A BIG LONG-SHOT PANEL OR TWO AT THE BEGINNING OF EACH NEW SCENE, USUALLY FOLLOWED BY SOME MIDDLE GROUND AND CLOSE-UP PANELS OF INDIVIDUAL CHARACTERS.

UH-OH. LOOK AT THE TIME!

ALMOST DAWN...I BETTER GET ON THE ROAD.

REMEMBER TO SAY *HI* FOR ME.

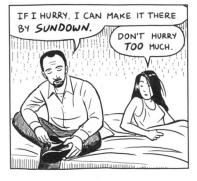

IF I HURRY, I CAN MAKE IT THERE BY *SUNDOWN.*

DON'T HURRY *TOO* MUCH.

DRIVE *SAFELY,* OKAY?

DON'T I *ALWAYS?*

ON THE OTHER HAND, BECAUSE READERS **WANT** AND **EXPECT** THAT SENSE OF PLACE, A CLEVER STORYTELLER CAN CHOOSE TO **DELAY** THE ESTABLISHING SHOT TO INCREASE **SUSPENSE** --

-- OR TO MIRROR THE THOUGHTS OF A CHARACTER WHO'S TEMPORARILY **UNAWARE** OF HIS OR HER SURROUNDINGS.

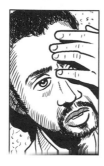
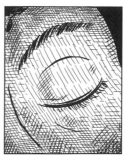

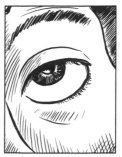

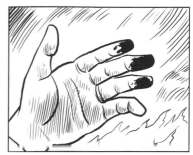
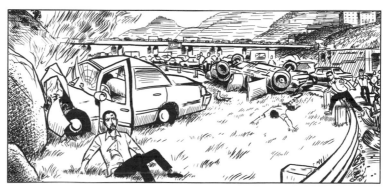

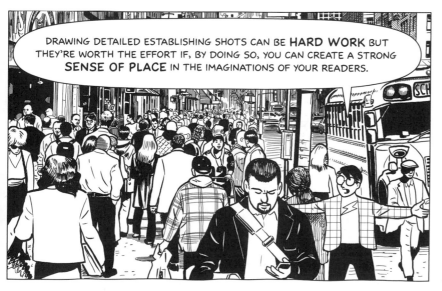

DRAWING DETAILED ESTABLISHING SHOTS CAN BE **HARD WORK** BUT THEY'RE WORTH THE EFFORT IF, BY DOING SO, YOU CAN CREATE A STRONG **SENSE OF PLACE** IN THE IMAGINATIONS OF YOUR READERS.

LOOK FOR MORE ON THIS TOPIC IN **CHAPTER FOUR.**

CHOOSING HOW TO **FRAME** MOMENTS IN COMICS IS LIKE CHOOSING **CAMERA ANGLES** IN PHOTOGRAPHY AND FILM.

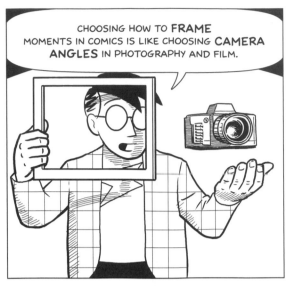

THERE ARE **DIFFERENCES** --

--SUCH AS THE ROLE THAT **SIZE, SHAPE** AND **POSITION** HAVE ON COMICS PANELS --

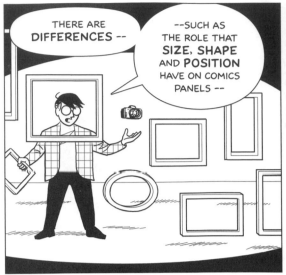

-- BUT TO THINK OF THAT FRAME AS **THE READER'S CAMERA** IS A USEFUL METAPHOR.

THIS IS THE DEVICE BY WHICH YOU CAN GRAB THE READER BY THE SHOULDER, GUIDE THEM TO THE RIGHT SPOT --

-- AND TELL THEM **"YOU ARE HERE..."**

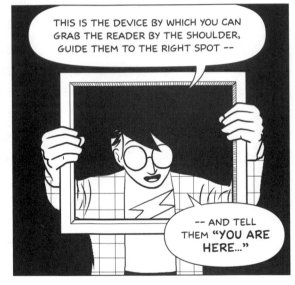

"NOW **LOOK**."

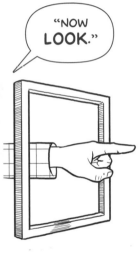

READERS WILL ASSIGN IMPORTANCE TO CHARACTERS AND OBJECTS PLACED IN THE **CENTER** --

YOU CAN'T KILL **ALL** OF US, FRANK.

NOT THAT HE'S **SUGGESTING** ANYTHING!

-- AND SOME COMICS ARTISTS OBLIGE BY PUTTING THEIR MOST IMPORTANT SUBJECTS THERE.

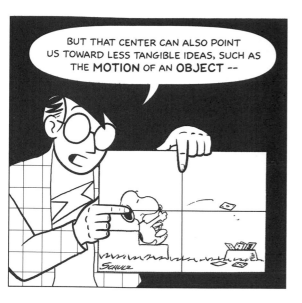

BUT THAT CENTER CAN ALSO POINT US TOWARD LESS TANGIBLE IDEAS, SUCH AS THE **MOTION** OF AN **OBJECT** --

SCHULZ

-- A MYSTERIOUS **ABSENCE** --

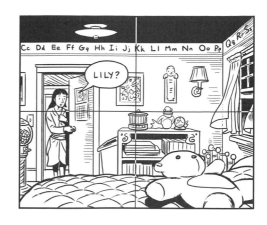

LILY?

-- A **DISTANCE** ABOUT TO BE **CROSSED** --

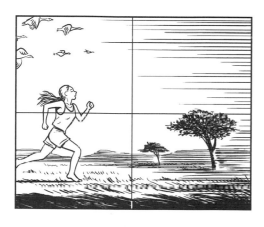

-- A DISTANCE CROSSED **ALREADY** --

OH, SPEEDY! WHERE HAVE YOU BEEN? EVERYBODY'S BEEN GOING CRAZY LOOKING FOR YOU! POOR LITOS. IT'S SO TERRIBLE, BUT HE'S GONNA BE OK...

I KNOW. I JUST HAD TO SEE YOU.

-- OR THE UNSEEN OBJECT OF A CHARACTER'S **ATTENTION**.

HERE IT COMES.

THOSE ARE JUST A **FEW** OF THE REASONS THAT AN ARTIST MIGHT CHOOSE A SEEMINGLY **OFF-CENTER** COMPOSITION. WE'LL CONSIDER OTHERS LATER.

PANEL ONE: ART BY CHARLES SCHULZ. PANEL FOUR: ART BY JAIME HERNANDEZ (SEE ART CREDITS, PAGE 258).

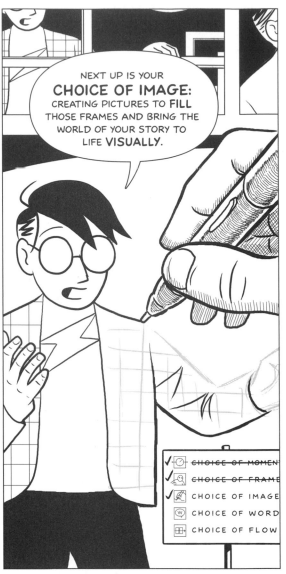

NEXT UP IS YOUR **CHOICE OF IMAGE:** CREATING PICTURES TO **FILL** THOSE FRAMES AND BRING THE WORLD OF YOUR STORY TO LIFE **VISUALLY.**

✓ ~~CHOICE OF MOMENT~~
✓ ~~CHOICE OF FRAME~~
✓ CHOICE OF IMAGE
☐ CHOICE OF WORD
☐ CHOICE OF FLOW

AFTER ALL THAT **PLANNING, CHOOSING, ARRANGING** AND **SKETCHING** THINGS OUT, HERE'S THE PART OF THE PROCESS WHERE YOU GET TO PICK UP YOUR PEN, BRUSH OR DIGITAL STYLUS AND FINALLY **DRAW** SOMETHING!

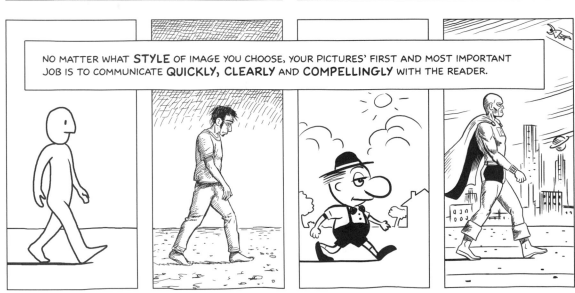

NO MATTER WHAT **STYLE** OF IMAGE YOU CHOOSE, YOUR PICTURES' FIRST AND MOST IMPORTANT JOB IS TO COMMUNICATE **QUICKLY, CLEARLY** AND **COMPELLINGLY** WITH THE READER.

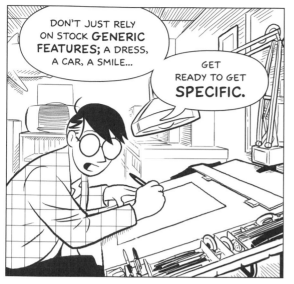

DON'T JUST RELY ON STOCK **GENERIC FEATURES;** A DRESS, A CAR, A SMILE...

GET READY TO GET **SPECIFIC.**

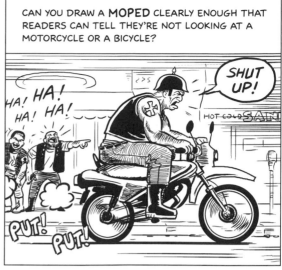

CAN YOU DRAW A **MOPED** CLEARLY ENOUGH THAT READERS CAN TELL THEY'RE NOT LOOKING AT A MOTORCYCLE OR A BICYCLE?

HA! HA! HA! HA!

SHUT UP!

PUT! PUT!

CAN YOU DRAW AN EXPRESSION OF **MOCK DISAPPROVAL** THAT WON'T BE MISTAKEN FOR THE **REAL THING?**

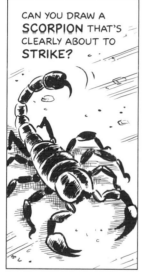

CAN YOU DRAW A **SCORPION** THAT'S CLEARLY ABOUT TO **STRIKE?**

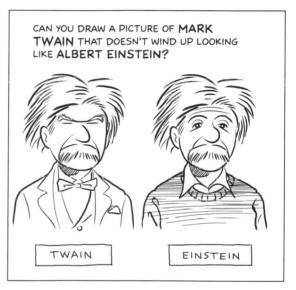

CAN YOU DRAW A PICTURE OF **MARK TWAIN** THAT DOESN'T WIND UP LOOKING LIKE **ALBERT EINSTEIN?**

TWAIN

EINSTEIN

EVEN WHEN WORKING IN A MINIMAL STYLE LIKE STICK FIGURE MASTER MATT FEAZELL, YOUR PICTURES CAN STILL INCORPORATE A WEALTH OF **REAL LIFE DETAILS.**

IF I ASKED YOU TO DRAW A CLOCK, A WATER BOTTLE OR A SHOE IN JUST A FEW LINES, HOW **SPECIFIC** COULD **YOU** GET?

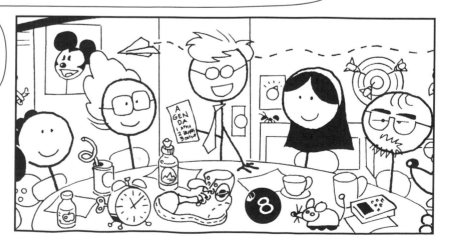

PANEL SIX: ART BY MATT FEAZELL (SEE ART CREDITS, PAGE 258)

CHOICE OF IMAGE IS WHERE ALL THOSE TRADITIONAL **HOW-TO-DRAW** BOOKS CAN BE HELPFUL --

-- AND **DRAWING FROM LIFE** EVEN **MORE** SO.

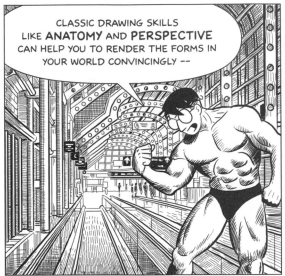

CLASSIC DRAWING SKILLS LIKE **ANATOMY** AND **PERSPECTIVE** CAN HELP YOU TO RENDER THE FORMS IN YOUR WORLD CONVINCINGLY --

-- BUT IN COMICS, THOSE CHARACTERS AND OBJECTS CAN BE FAR MORE THAN JUST PRETTY PICTURES.

HOW YOU DRAW THE INTERIOR OF AN APARTMENT, FOR EXAMPLE, CAN TELL YOUR READERS A LOT ABOUT THE CHARACTER WHO **LIVES** IN IT.

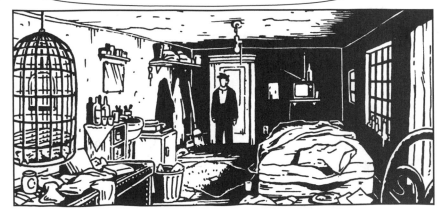

PANEL FOUR: ART BY JASON LUTES
(SEE ART CREDITS, PAGE 258).

THE **STANCES** AND **EXPRESSIONS** OF CHARACTERS -- EVEN WHEN SILENT AND IN THE BACKGROUND -- CAN GIVE READERS A WEALTH OF INFORMATION ABOUT THEIR **EMOTIONS** AND **ATTITUDES.**

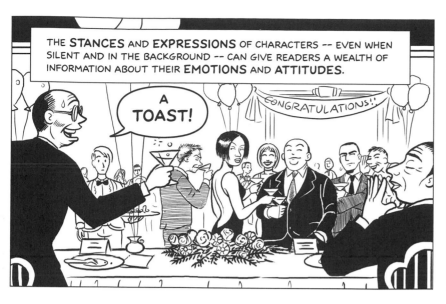

A **TOAST!**

CONGRATULATIONS!!

A MINOR DETAIL IN THE **ART** CAN FORESHADOW MAJOR DEVELOPMENTS IN A **STORY.**

AN **ABSTRACT, EXPRESSIONISTIC** OR **SYMBOLIC** IMAGE CAN STRENGTHEN THE RECOUNTING OF AN INTENSELY FELT **EMOTION.**

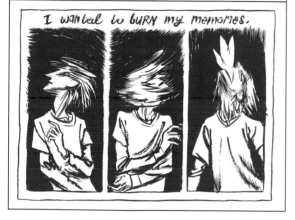

I wanted to burn my memories.

AN EXTREME **STYLISTIC** CHOICE CAN INVEST EVERY MOMENT OF A STORY WITH AN OVERRIDING **MOOD.**

THE ULTIMATE TEST OF CLARITY IN COMICS ARTWORK IS IN HOW WELL IT DELIVERS ON THE **BASIC INTENT** OF EACH PANEL.

YOU MIGHT ALREADY BE ABLE TO DRAW LIKE MICHELANGELO, BUT IF IT DOESN'T **COMMUNICATE,** IT'LL JUST DIE ON THE PAGE --

-- WHILE A CRUDER BUT **MORE** COMMUNICATIVE STYLE WILL WIN FANS BY THE HUNDREDS OF THOUSANDS.

QUESTION NUMBER ONE: WILL READERS **GET THE MESSAGE?**

PANEL THREE: ART BY CRAIG THOMPSON. PANEL FOUR: ART BY HO CHE ANDERSON AND FRANK MILLER (SEE ART CREDITS, PAGE 258).

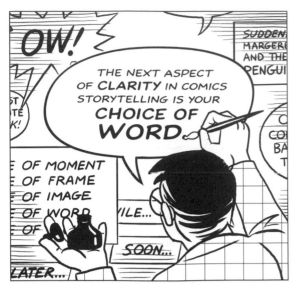

THE NEXT ASPECT OF **CLARITY** IN COMICS STORYTELLING IS YOUR **CHOICE OF WORD...**

WORDS CAN BE A **POWERFUL ALLY** IN THE STRUGGLE TO COMMUNICATE.

THEY BRING WITH THEM AN UNPARALLELED LEVEL OF **SPECIFICITY.**

THERE'S NO IMAGE SO **VAGUE** THAT WORDS CAN'T LOCK IT INTO A DESIRED **MEANING.**

"On the bright side, I got my caffeine. On the not-so-bright side, we got mugged on the way home."

AND SOME SPECIFIC CONCEPTS AND NAMES CAN **ONLY** BE CLEARLY EXPRESSED THROUGH WORDS.

OH HEY, **LOOK!** IT'S **KELLY DONOVAN,** TWIN BROTHER OF THE GUY WHO PLAYED **XANDER** ON *BUFFY THE VAMPIRE SLAYER,* PLUS **HUMPHREY BOGART** WEARING A **FREDDIE MERCURY MASK** AND A ROBOT DUPLICATE OF FORMER U.N. SECRETARY-GENERAL **BOUTROS BOUTROS-GHALI!**

TRY DOING **THAT** WITH **JUST PICTURES!**

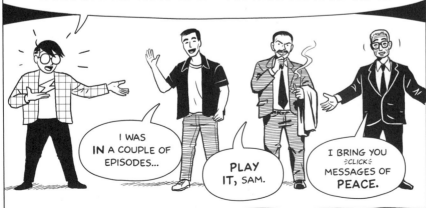

I WAS **IN** A COUPLE OF EPISODES...

PLAY IT, SAM.

I BRING YOU ⇒CLICK⇐ MESSAGES OF **PEACE.**

SPECIAL THANKS TO KELLY DONOVAN (SEE ART CREDITS, PAGE 258).

WORDS CAN BE USED TO **COMPRESS** A STORY, SUMMING UP VAST CHANGES IN A SINGLE CAPTION AS SEEN IN **SCENE-TO-SCENE** TRANSITIONS.

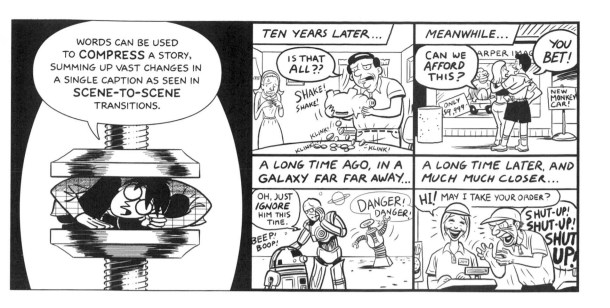

TEN YEARS LATER...

IS THAT ALL??

SHAKE! SHAKE!

KLINK! KLINK! KLINK!

MEANWHILE...

HARPER IMAG

CAN WE AFFORD THIS?

ONLY $9,999

YOU BET!

NEW MONKEY CAR!

A LONG TIME AGO, IN A GALAXY FAR FAR AWAY...

OH, JUST *IGNORE* HIM THIS TIME.

BEEP! BOOP!

DANGER! DANGER!

A LONG TIME LATER, AND MUCH MUCH CLOSER...

HI! MAY I TAKE YOUR ORDER?

JOY

SHUT-UP! SHUT-UP! SHUT UP!

AND OF COURSE, WORDS TAKE **CENTER STAGE** WHEN REPRODUCING THE FINE ART OF **CONVERSATION.**

Well, you know what they say, "The best things come to those who wait."

Makes me wonder if "they" work for DMV...

So who're you waiting for, anyhow?

Words alone have been telling stories clearly for millennia. They've done just fine without pictures...

BUT IN **COMICS,** THE TWO HAVE TO WORK TOGETHER **SEAMLESSLY** ENOUGH THAT READERS BARELY NOTICE WHEN SWITCHING FROM ONE TO ANOTHER.

I HAVE A WHOLE **CHAPTER** ON THIS SUBJECT, BUT FOR NOW, SUFFICE IT TO SAY THAT THE SECRET OF COMMUNICATING CLEARLY WITH WORDS IS JUST TO LET WORDS DO WHAT WORDS DO **BEST** --

-- AND WHEN A **PICTURE** IS THE BETTER SOLUTION, TO LET THEM **GET OUT OF THE WAY.**

PANEL TWO: ART BY DEREK KIRK KIM (SEE ART CREDITS, PAGE 258).

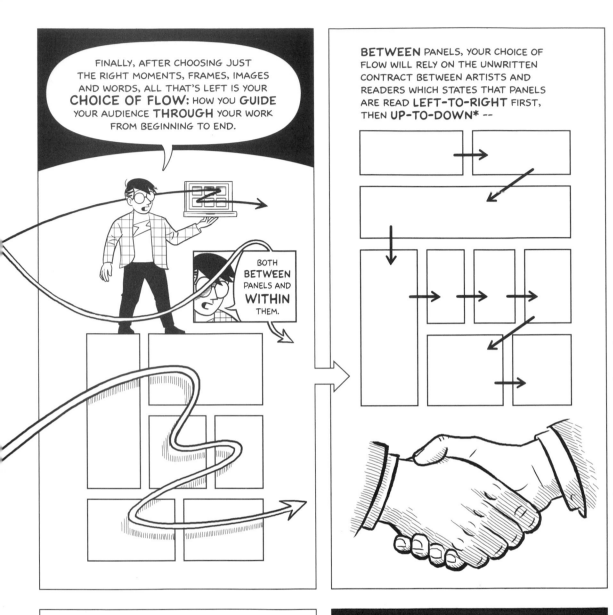
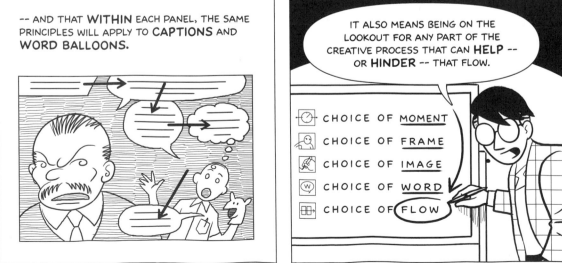

THE EASIEST WAY TO AVOID PANEL-TO-PANEL CONFUSION IS TO JUST **KEEP IT SIMPLE,** BUT IF YOU LIKE TO MIX THINGS UP, KEEP A LOOK OUT FOR CERTAIN INHERENTLY **CONFUSING** ARRANGEMENTS LIKE THIS ONE --

-- IN WHICH HABIT WILL SEND YOUR READERS **LEFT TO RIGHT,** LEAVING THE LOWER LEFT-HAND PANEL **UNREAD --**

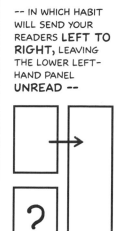

-- AND PRODUCING JUST ENOUGH SPLIT-SECOND CONFUSION TO YANK READERS OUT OF THE WORLD OF THE STORY.

SURE, THERE ARE WAYS TO **COMPEL** READERS' EYES TO MOVE IN THE RIGHT DIRECTION.

JUST MAKE SURE YOUR LAYOUT IS SERVING YOUR **STORY --**

-- INSTEAD OF THE **OTHER WAY AROUND --**

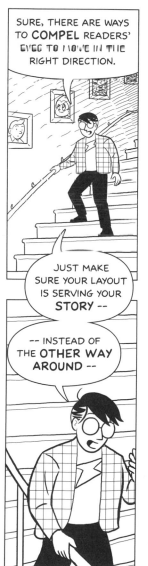

-- **UNLESS,** OF COURSE, YOU WANT TO GO THE **EXPERIMENTAL** ROUTE, AS I SOMETIMES DO, BUT THAT'S A WHOLE OTHER BOOK!

ANOTHER SOURCE OF "WHICH COMES NEXT?" CONFUSION OCCURS WHEN PANEL ARRANGEMENTS ARE OBSCURED BY TOO MANY **"FOURTH WALL"** BREAKS AND **BORDERLESS** IMAGES.

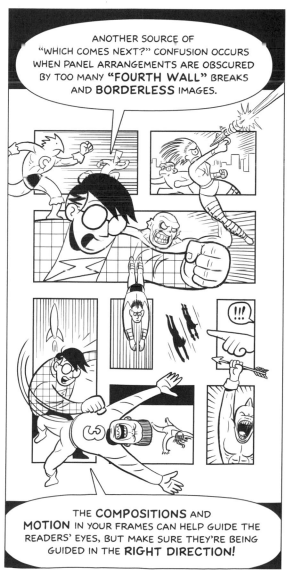

THE **COMPOSITIONS** AND **MOTION** IN YOUR FRAMES CAN HELP GUIDE THE READERS' EYES, BUT MAKE SURE THEY'RE BEING GUIDED IN THE **RIGHT DIRECTION!**

HOW YOUR **CHOICE OF FRAME** CHANGES FROM PANEL TO PANEL CAN ALSO AFFECT THE **READING FLOW.**

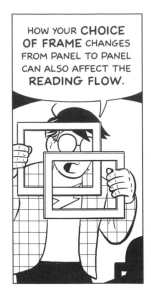

BY ROTATING THE **VIEWING ANGLE** TOO FAR BETWEEN PANELS, CHARACTERS CAN SEEM TO **SWITCH PLACES,** CREATING **CONFUSION.**

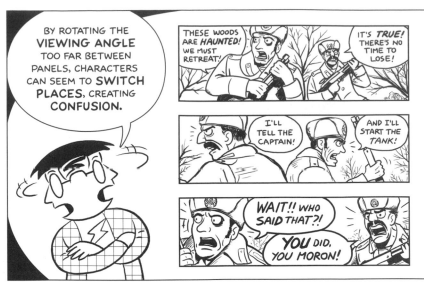

THESE WOODS ARE *HAUNTED!* WE MUST RETREAT!

IT'S *TRUE!* THERE'S NO TIME TO LOSE!

I'LL TELL THE CAPTAIN!

AND I'LL START THE *TANK!*

WAIT!! WHO SAID THAT?!

YOU DID, YOU MORON!

CONSIDER SHOWING YOUR WORK-IN-PROGRESS TO A FRIEND TO CATCH SUCH MIX-UPS IN THE ROUGH PLANNING STAGE -- AND IN THE **FINISHED ART,** OF COURSE.

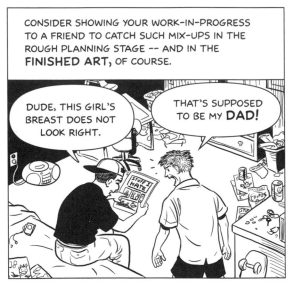

DUDE, THIS GIRL'S BREAST DOES NOT LOOK RIGHT.

THAT'S SUPPOSED TO BE MY **DAD!**

CHOICE OF FLOW IS PARTIALLY ABOUT CLEARING YOUR READERS' PATHS OF **OBSTACLES** TO A SMOOTH READING EXPERIENCE.

EQUALLY IMPORTANT THOUGH, IS HOW THE SIGHTS ALONG THAT PATH **DRAW THE READERS' EYES.**

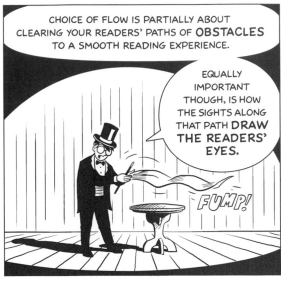

FUMP!

NOT ALL PICTURES ARE CREATED **EQUAL.** READERS FOCUS ON AREAS OF **CHANGE** AND RELEVANCE TO THE **STORY**--

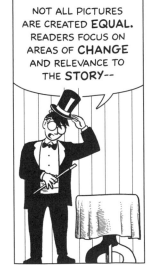

-- WHILE BACKGROUND DETAILS AND REPEATED ELEMENTS JUST FADE FROM VIEW AND ARE **IGNORED.**

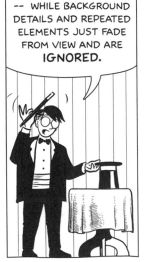

LOOKING AT THE **TABLE-CLOTH** IN THAT LAST PANEL?

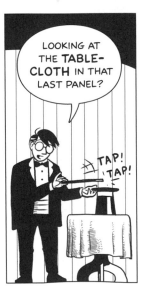

TAP! TAP!

DIDN'T THINK SO.

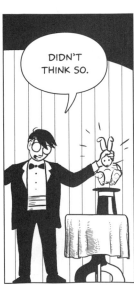

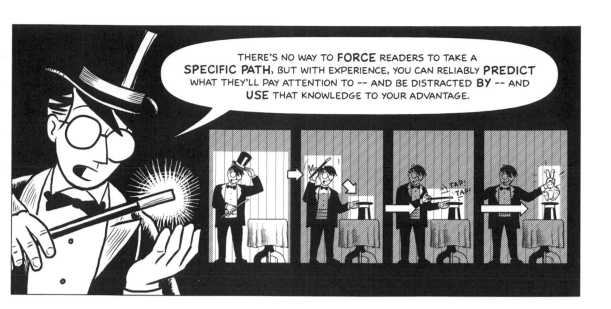

THERE'S NO WAY TO **FORCE** READERS TO TAKE A **SPECIFIC PATH**, BUT WITH EXPERIENCE, YOU CAN RELIABLY **PREDICT** WHAT THEY'LL PAY ATTENTION TO -- AND BE DISTRACTED **BY** -- AND **USE** THAT KNOWLEDGE TO YOUR ADVANTAGE.

YOUR READERS ARE **HUMANS**, JUST LIKE YOU AND ME, AND WE ALL **SORT INFORMATION** THE SAME WAY.

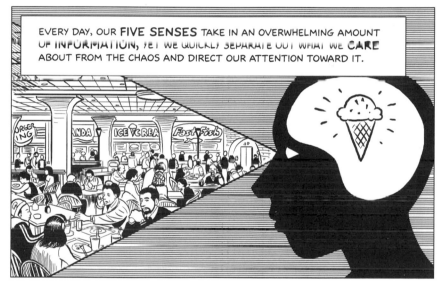

EVERY DAY, OUR **FIVE SENSES** TAKE IN AN OVERWHELMING AMOUNT OF **INFORMATION**, YET WE QUICKLY SEPARATE OUT WHAT WE **CARE** ABOUT FROM THE CHAOS AND DIRECT OUR ATTENTION TOWARD IT.

AND AT THE END OF THE DAY, IT'S THAT FLOW OF SELECTED MOMENTS THAT WE REMEMBER --

-- AND ALL THOSE **OTHER** SENSATIONS ARE LEFT ON THE **CUTTING ROOM FLOOR**.

IN COMICS, YOU CAN DO A LOT OF THAT "CUTTING" **BEFOREHAND** TO INSURE THAT THE FLOW OF IMAGES READERS SEE ARE EXACTLY THE ONES YOU **WANT** THEM TO SEE, IN THE **ORDER** THAT BEST SERVES YOUR **STORYTELLING GOALS**.

WEBCOMICS HAVE INTRODUCED NEW OPPORTUNITIES FOR -- AND POTENTIAL OBSTACLES TO -- FLOW.

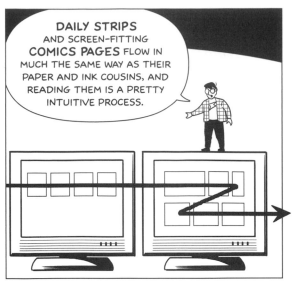

DAILY STRIPS AND SCREEN-FITTING **COMICS PAGES** FLOW IN MUCH THE SAME WAY AS THEIR PAPER AND INK COUSINS, AND READING THEM IS A PRETTY INTUITIVE PROCESS.

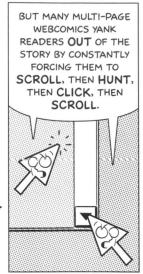

BUT MANY MULTI-PAGE WEBCOMICS YANK READERS **OUT** OF THE STORY BY CONSTANTLY FORCING THEM TO **SCROLL**, THEN **HUNT**, THEN **CLICK**, THEN **SCROLL**.

SOME NEW **EXPERIMENTAL FORMATS** ARE DISTRACTING BY THEIR NATURE, OF COURSE, BUT EVEN THESE CAN ALLOW FOR SMOOTH READING IF ALL THE NAVIGATING IS DONE WITH A **SINGLE CONTROL** LIKE AN ARROW KEY.

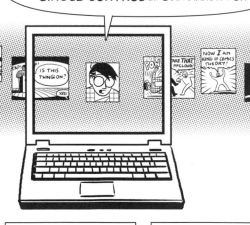

NO MATTER WHAT SHAPE YOUR COMICS TAKE, AS LONG AS **NAVIGATING** THROUGH THEM IS A SIMPLE, INTUITIVE PROCESS, THAT PROCESS WILL BE **TRANSPARENT** TO THE READER --

-- AND THE READING FLOW CAN CONTINUE **UNINTERRUPTED**.

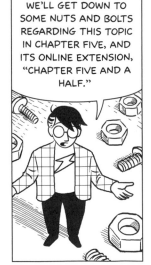

WE'LL GET DOWN TO SOME NUTS AND BOLTS REGARDING THIS TOPIC IN CHAPTER FIVE, AND ITS ONLINE EXTENSION, "CHAPTER FIVE AND A HALF."

FOR NOW, THOUGH, WHETHER YOU WORK IN **PRINT**, THE **WEB** OR **BOTH**: IMPROVING FLOW CAN HELP YOUR AUDIENCE ENTER THE WORLD OF YOUR STORY AND PASS FROM ONE END TO THE OTHER WITHOUT EVER BEING **TORN AWAY** BY THE WORLD OUTSIDE.

DO **THAT**, AND YOUR STORYTELLING CAN PUT ITS FULL WEIGHT BEHIND THE **"STORY"** WITHOUT THE **"TELLING"** GETTING IN THE WAY.

TOGETHER THESE FIVE KINDS OF **CHOICES** ARE WHAT COMMUNICATING THROUGH COMICS REQUIRES --

CLARITY

-- AND COMMUNICATING WITH **CLARITY** MEANS MAKING READER COMPREHENSION YOUR ULTIMATE **GOAL.**

 CHOICE OF **MOMENT**

 CHOICE OF **FRAME**

 CHOICE OF **IMAGE**

CHOICE OF **WORD**

CHOICE OF **FLOW**

CHOICE OF MOMENT	CHOICE OF FRAME	CHOICE OF IMAGE	CHOICE OF WORD	CHOICE OF FLOW
GOALS: "CONNECTING THE DOTS," SHOWING THE MOMENTS THAT MATTER AND CUTTING THOSE THAT DON'T.	**GOALS:** SHOWING READERS WHAT THEY NEED TO SEE. CREATING A SENSE OF PLACE, POSITION AND FOCUS.	**GOALS:** CLEARLY AND QUICKLY EVOKING THE APPEARANCE OF CHARACTERS, OBJECTS, ENVIRONMENTS AND SYMBOLS.	**GOALS:** CLEARLY AND PERSUASIVELY COMMUNICATING IDEAS, VOICES AND SOUNDS IN SEAMLESS COMBINATION WITH IMAGES	**GOALS:** GUIDING READERS BETWEEN AND WITHIN PANELS, AND CREATING A TRANSPARENT AND INTUITIVE READING EXPERIENCE.
TOOLS: THE SIX TRANSITIONS: 1. MOMENT TO MOMENT 2. ACTION TO ACTION 3. SUBJECT TO SUBJECT 3. SCENE TO SCENE 4. ASPECT TO ASPECT 5. NON SEQUITUR MINIMIZING PANEL COUNT FOR EFFICIENCY, OR ADDING PANELS FOR EMPHASIS. CHARACTER OF MOMENT, MOOD AND IDEA.	**TOOLS:** FRAME SIZE AND SHAPE. CHOICE OF "CAMERA" ANGLES, DISTANCE, HEIGHT, BALANCE AND CENTERING. THE "ESTABLISHING SHOT." REVEALING AND WITHOLDING INFORMATION. DIRECTING READER FOCUS.	**TOOLS:** EVERY ARTISTIC/ GRAPHIC DEVICE EVER INVENTED. RESEMBLANCE, SPECIFICITY, EXPRESSION, BODY LANGUAGE AND THE NATURAL WORLD. STYLISTIC AND EXPRESSIONISTIC DEVICES TO AFFECT MOOD AND EMOTION.	**TOOLS:** EVERY LITERARY AND LINGUISTIC DEVICE EVER INVENTED. RANGE, SPECIFICITY, THE HUMAN VOICE, ABSTRACT CONCEPTS, THE EVOCATION OF OTHER SENSES. BALLOONS, SOUND EFFECTS AND WORD / PICTURE INTEGRATION*	**TOOLS:** THE ARRANGE- MENT OF PANELS ON A PAGE OR SCREEN, AND THE ARRANGEMENT OF ELEMENTS WITHIN A PANEL. DIRECTING THE EYE THROUGH READER EXPECTATIONS AND CONTENT. USING MOMENT, FRAME, IMAGE AND WORD IN TANDEM.

THESE AREN'T "STEPS" THAT HAVE TO BE TAKEN IN SOME PREDETERMINED ORDER.

MOST COMICS ARTISTS JUGGLE **ALL FIVE** AS NEEDED.

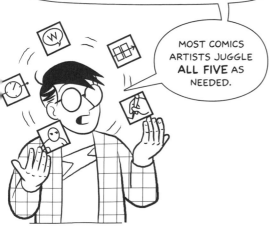

DECISIONS HAVING TO DO WITH MOMENT, FRAME AND FLOW ARE LIKELY TO BE MADE IN THE **PLANNING STAGES** OF A COMIC, WHILE IMAGE AND WORD DECISIONS ARE USUALLY BEING MADE RIGHT UP TO THE **FINISH LINE** --

-- BUT YOU'LL FIND THESE CHOICES CAN FIT INTO ANY NUMBER OF **WORKING METHODS.**

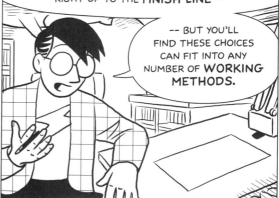

* SEE CHAPTER THREE: "THE POWER OF WORDS" FOR MORE ON DIFFERENT TYPES OF WORD/PICTURE INTEGRATION AND OTHER TECHNIQUES RELATED TO CHOICE OF WORD.

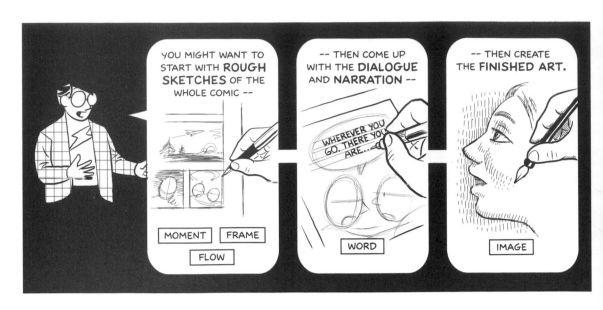

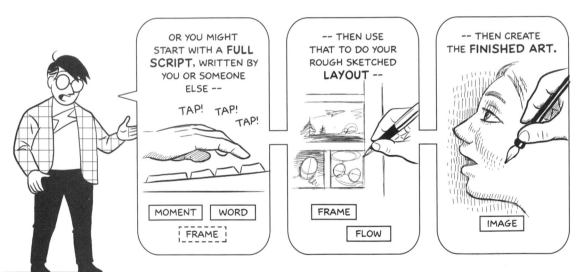

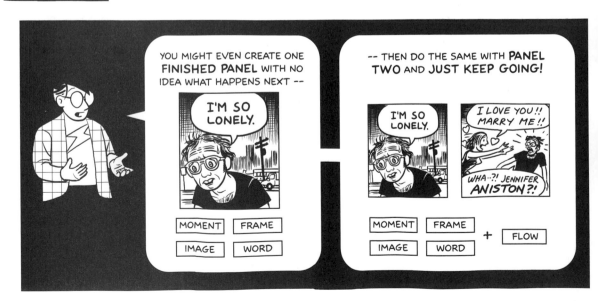

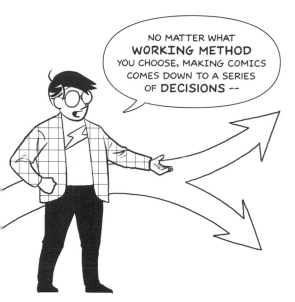

NO MATTER WHAT **WORKING METHOD** YOU CHOOSE, MAKING COMICS COMES DOWN TO A SERIES OF **DECISIONS** --

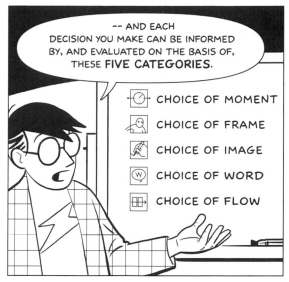

-- AND EACH DECISION YOU MAKE CAN BE INFORMED BY, AND EVALUATED ON THE BASIS OF, THESE **FIVE CATEGORIES.**

CHOICE OF MOMENT

CHOICE OF FRAME

CHOICE OF IMAGE

CHOICE OF WORD

CHOICE OF FLOW

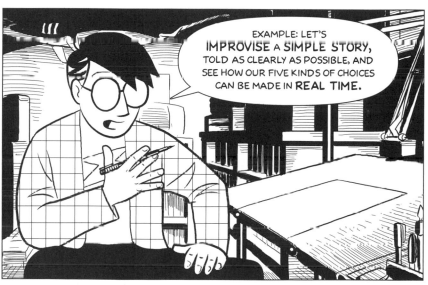

EXAMPLE: LET'S **IMPROVISE** A **SIMPLE STORY,** TOLD AS CLEARLY AS POSSIBLE, AND SEE HOW OUR FIVE KINDS OF CHOICES CAN BE MADE IN **REAL TIME.**

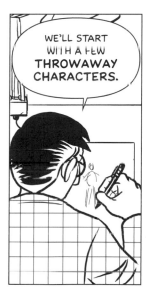

WE'LL START WITH A FEW **THROWAWAY CHARACTERS.**

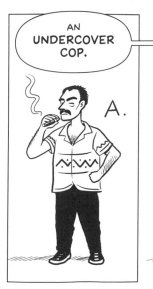

AN **UNDERCOVER COP.**

A.

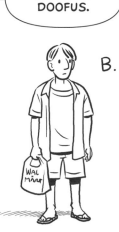

A **HAPLESS DOOFUS.**

B.

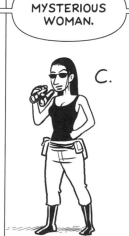

A **MYSTERIOUS WOMAN.**

C.

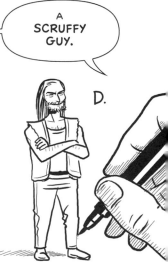

A **SCRUFFY GUY.**

D.

LET'S START THEIR STORY WITH A BIG **ESTABLISHING SHOT** TO SHOW WHERE THE ACTION IS TAKING PLACE, THEN A **MIDDLE SHOT** TO INTRODUCE CHARACTERS **A** AND **B**, AND THEN A **CLOSE-UP** ON CHARACTER **A**.

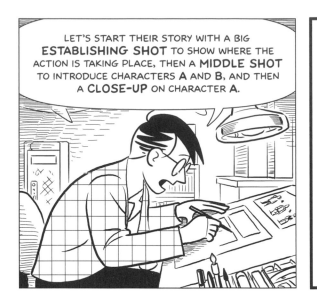

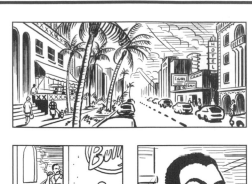

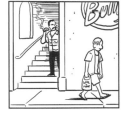

THREE **MOMENTS**, ACCOMMODATING THREE DIFFERENT **FRAMES** ON THE SAME SCENE.

WE COULD HAVE DONE MANY **MORE** FRAMES, BUT THREE GETS THE JOB DONE.

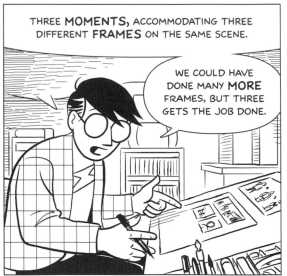

NO FIREWORKS IN THE **IMAGES** DEPARTMENT. JUST A FEW RECOGNIZABLE DETAILS, BUT OUR CHOICE OF IMAGE IS AT LEAST **SPECIFIC**. WE KNOW WE'RE IN A MIAMI-LIKE CITY; WE KNOW CHARACTER **A** IS A SERIOUS GUY.

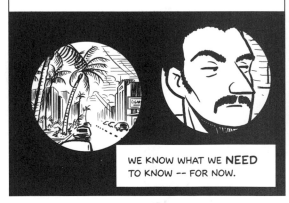

WE KNOW WHAT WE **NEED** TO KNOW -- FOR NOW.

NOW AS **A** STARTS FOLLOWING **B**, NOTICE HOW BOTH ARE SHOWN **IN FRAME**, TO REINFORCE THEIR RELATIVE **POSITIONS**. ALSO, DESPITE CHANGING VIEWING ANGLES, BOTH MAINTAIN A LEFT-TO-RIGHT FORWARD **FLOW**, TRACKING THE READER'S USUAL READING DIRECTION.

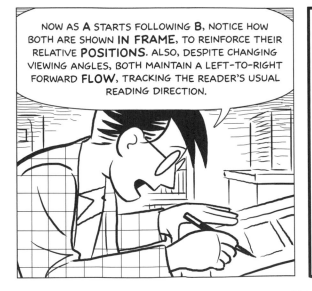

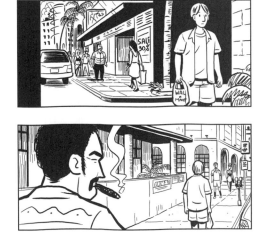

NEXT, BY SHOWING CHARACTERS **A** AND **B** FROM CHARACTER **C**'S POINT OF VIEW, WE GIVE READERS A CLEAR SENSE OF **WHERE** ALL THREE CHARACTERS ARE IN RELATION TO ONE ANOTHER.

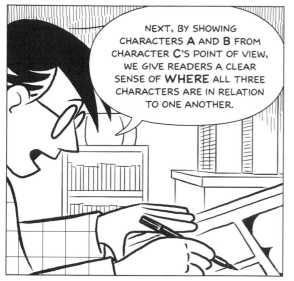

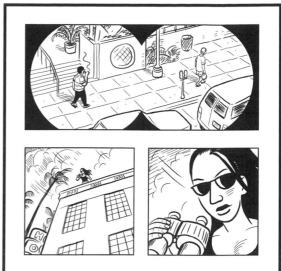

IT WASN'T PRACTICAL TO SHOW ALL THREE CHARACTERS IN A SINGLE FRAME THEY'D BE TOO SMALL IN A LONG-SHOT -- BUT THE VISUAL FRAGMENTS STILL ADD UP TO A **SINGLE IDEA.**

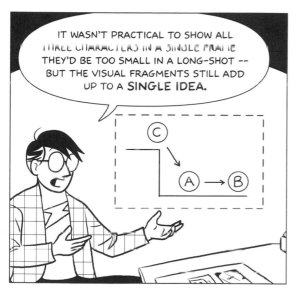

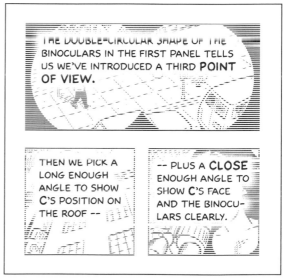

THE DOUBLE-CIRCULAR SHAPE OF THE BINOCULARS IN THE FIRST PANEL TELLS US WE'VE INTRODUCED A THIRD **POINT OF VIEW.**

THEN WE PICK A LONG ENOUGH ANGLE TO SHOW C'S POSITION ON THE ROOF --

-- PLUS A **CLOSE** ENOUGH ANGLE TO SHOW C'S FACE AND THE BINOCULARS CLEARLY.

WE'VE ARRIVED AT THE NEXT IMPORTANT LOCATION, SO THE CAMERA PULLS BACK AGAIN FOR ANOTHER **ESTABLISHING SHOT.**

ALSO, WITH D'S INTRODUCTION, COMES OUR FIRST **DIALOGUE.**

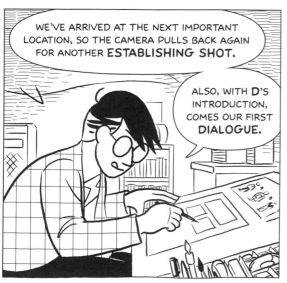

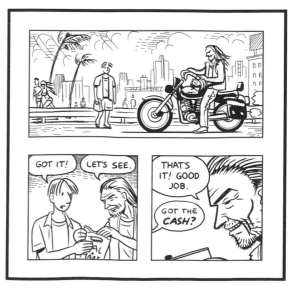

GOT IT! LET'S SEE.

THAT'S IT! GOOD JOB.

GOT THE **CASH?**

THE NEXT TWO MOMENTS ARE FRAMED A BIT TOO **CLOSE** TO SHOW US EXACTLY **WHAT** IS BEING BOUGHT OR FOR **HOW MUCH** OR THE **WORDS** AREN'T VERY SPECIFIC EITHER. CHOICE OF **FRAME** AND CHOICE OF **WORD** ARE BOTH **HOLDING OUT** ON US!

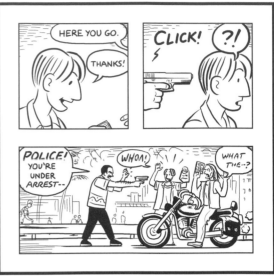

BECAUSE OF THAT DELIBERATE **LACK** OF INFORMATION, WE ONLY KNOW WHAT CHARACTER **A** KNOWS. IN FACT, PANEL TWO HERE IS SHOT FROM A'S **POINT OF VIEW**, SO HIS DISCOVERY FEELS LIKE **OUR OWN.**

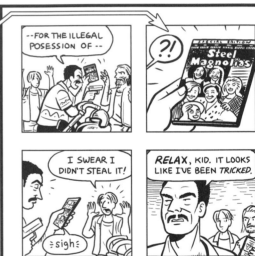

NOW, AS SOON AS **WORDS** ENTER, THE PICTURES ALONE WOULDN'T QUITE TELL THE WHOLE STORY.

WITHOUT **"POLICE!"** FOR EXAMPLE, YOU MIGHT MISS THE BADGE AND JUST ASSUME THAT CHARACTER **A** WAS A **CROOK.**

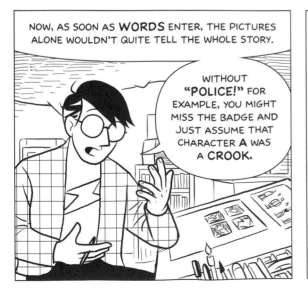

NOTICE TOO HOW MANY OF THESE **ACTION TO ACTION** CHOICES ARE COMPOSED FOR LEFT-TO-RIGHT **FLOW** RESULTING IN A SENSE OF **FORWARD MOMENTUM.**

YET, WHEN CHARACTER **A** TURNS HIS HEAD **AGAINST** THE FLOW, IT HELPS PUT ON THE **BRAKES** JUST AS THE ACTION SLOWS DOWN.

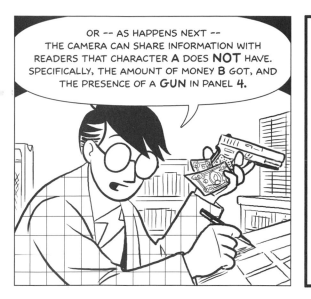

OR -- AS HAPPENS NEXT -- THE CAMERA CAN SHARE INFORMATION WITH READERS THAT CHARACTER **A** DOES **NOT** HAVE. SPECIFICALLY, THE AMOUNT OF MONEY **B** GOT, AND THE PRESENCE OF A **GUN** IN PANEL **4.**

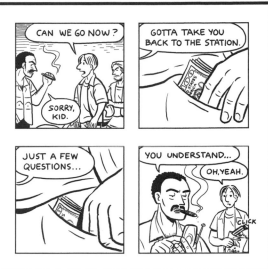

CAN WE GO NOW?

GOTTA TAKE YOU BACK TO THE STATION.

SORRY, KID.

JUST A FEW QUESTIONS...

YOU UNDERSTAND...

OH, YEAH.

CLICK

NOTICE HOW **MOMENT, FRAME** AND **IMAGE** ACCOMMODATE EACH OTHER: ADDING MOMENTS TO INCLUDE ANGLES WHICH REVEAL MEANINGFUL **DETAILS.**

HERE ALSO, WE SEE HOW **WORDS** AND **PICTURES** CAN OPERATE ON **DIFFERENT PLANES**: ONE RELAYING DIALOGUE THAT **ALL** CAN HEAR; THE OTHER SHOWING INFORMATION (THE AMOUNT OF MONEY) THAT ONLY **SOME** KNOW ABOUT.

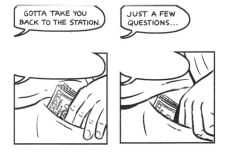

GOTTA TAKE YOU BACK TO THE STATION.

JUST A FEW QUESTIONS...

AND BY LETTING READERS "IN ON THE SECRET," OUR CHOICE OF **FRAME** AND **IMAGE** MAY LEAVE THEM FEELING A BIT LIKE **COLLABORATORS.**

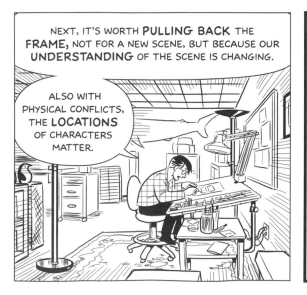

NEXT, IT'S WORTH **PULLING BACK** THE **FRAME,** NOT FOR A NEW SCENE, BUT BECAUSE OUR **UNDERSTANDING** OF THE SCENE IS CHANGING.

ALSO WITH PHYSICAL CONFLICTS, THE **LOCATIONS** OF CHARACTERS MATTER.

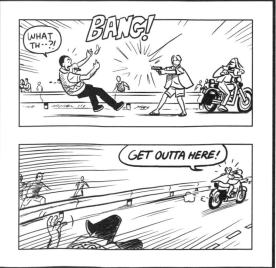

WHAT TH--?!

BANG!

GET OUTTA HERE!

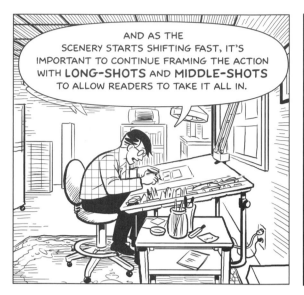

AND AS THE SCENERY STARTS SHIFTING FAST, IT'S IMPORTANT TO CONTINUE FRAMING THE ACTION WITH **LONG-SHOTS** AND **MIDDLE-SHOTS** TO ALLOW READERS TO TAKE IT ALL IN.

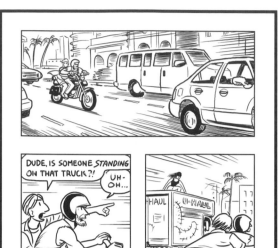

DUDE, IS SOMEONE *STANDING* ON THAT TRUCK?!

UH-OH...

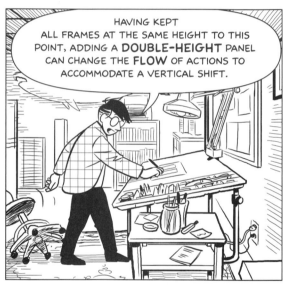

HAVING KEPT ALL FRAMES AT THE SAME HEIGHT TO THIS POINT, ADDING A **DOUBLE-HEIGHT** PANEL CAN CHANGE THE **FLOW** OF ACTIONS TO ACCOMMODATE A VERTICAL SHIFT.

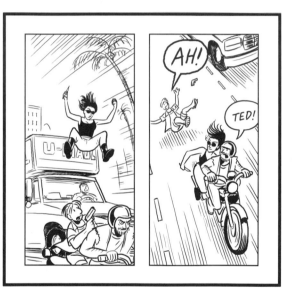

AH!

TED!

AND FINALLY, A FEW **CLOSE-UPS** AS WE MOVE IN FOR SOME CHARACTERIZATION --

-- OR WHAT **PASSES** FOR IT WITH A **THROW-AWAY STORY** LIKE THIS ONE.*

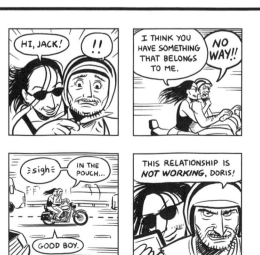

HI, JACK!

!!

I THINK YOU HAVE SOMETHING THAT BELONGS TO ME.

NO WAY!!

≥sigh≤

IN THE POUCH...

GOOD BOY.

THIS RELATIONSHIP IS *NOT WORKING*, DORIS!

TO BE CONT-- OH, NEVERMIND.

* OBVIOUSLY, THERE'S A DIFFERENCE BETWEEN GOOD STORYTELLING AND A GOOD **STORY**. I'M OFFERING THIS AS AN EXAMPLE OF THE FORMER ONLY.

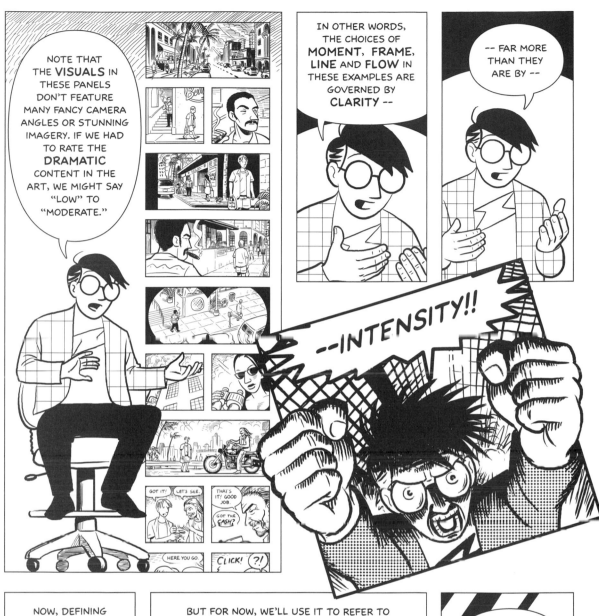

NOTE THAT THE **VISUALS** IN THESE PANELS DON'T FEATURE MANY FANCY CAMERA ANGLES OR STUNNING IMAGERY. IF WE HAD TO RATE THE **DRAMATIC** CONTENT IN THE ART, WE MIGHT SAY "LOW" TO "MODERATE."

IN OTHER WORDS, THE CHOICES OF **MOMENT, FRAME, LINE** AND **FLOW** IN THESE EXAMPLES ARE GOVERNED BY **CLARITY** --

-- FAR MORE THAN THEY ARE BY --

GOT IT! LET'S SEE. THAT'S IT! GOOD JOB. GOT THE *CASH*?

HERE YOU GO. CLICK! ?!

--INTENSITY!!

NOW, DEFINING "INTENSITY" IS A SUBJECTIVE BUSINESS. FOR SOME PEOPLE, A COMIC FILLED WITH NOTHING BUT PANELS OF ONE PERSON ASLEEP IN THEIR BED, SHOT FROM THE SAME ANGLE AGAIN AND AGAIN, MIGHT BE CONSIDERED "INTENSE."

BUT FOR NOW, WE'LL USE IT TO REFER TO THOSE **VISUAL TECHNIQUES** WHICH ADD **CONTRAST, DYNAMISM, GRAPHIC EXCITEMENT** OR A SENSE OF **URGENCY** TO A PANEL.

TECHNIQUES SUCH AS...

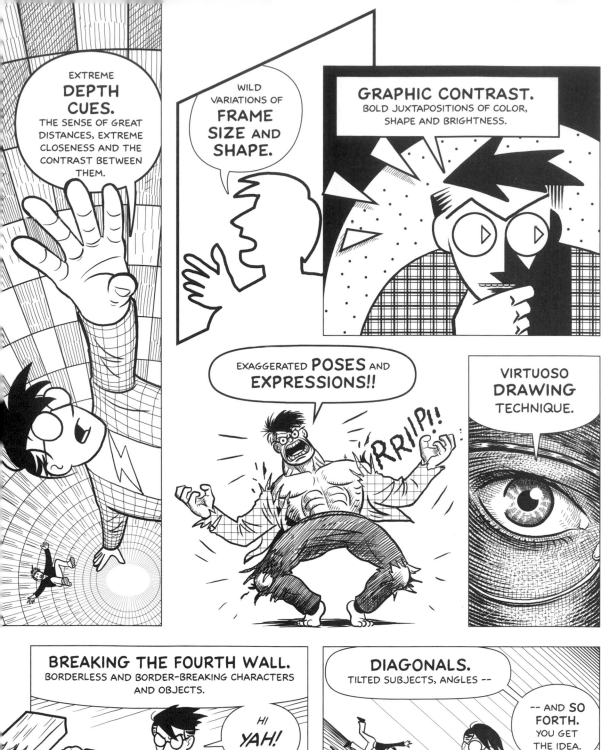

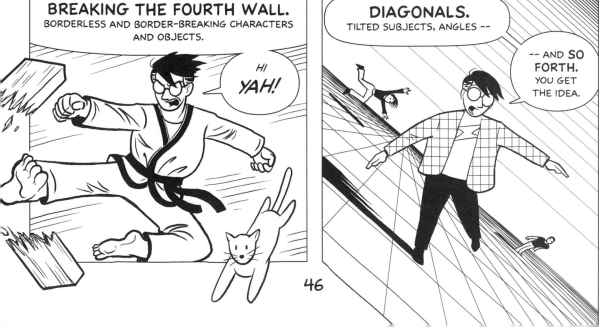

46

NOW, THE WAY I'VE ILLUSTRATED THEM HERE, THESE QUALITIES MAY RECALL CERTAIN **GENRES** OF COMICS.

PARTICULARLY THOSE INVOLVING A HIGH INCIDENCE OF **HITTING, BLEEDING, COLLISIONS, EXPLOSIONS** OR PEOPLE SAYING "OH MY GOD, NO!" ON A REGULAR BASIS.

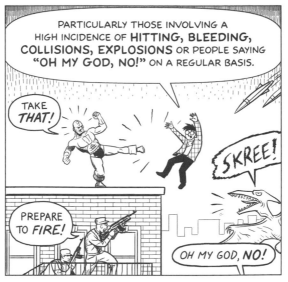

TAKE *THAT!*

SKREE!

PREPARE TO *FIRE!*

OH MY GOD, **NO!**

BUT WHILE THE "EXAGGERATED POSES AND EXPRESSIONS" --

-- OR "VIRTUOSO DRAWING TECHNIQUES" OF OTHER GENRES MIGHT TAKE ON **DIFFERENT FLAVORS** --

-- THE BASIC **EFFECT** OF SUCH TECHNIQUES STAYS CONSTANT: **ATTRACTING** AND/OR **EXCITING** READERS AS SOON AS THEY PICK A COMIC OFF THE SHELF OR LOAD IT INTO THEIR BROWSER.

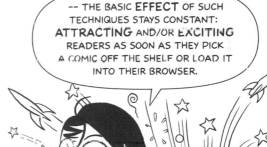

THIS IDEA OF ADDING A LITTLE **PIZAZZ** TO A STORYTELLER'S STYLE IS A TIME-HONORED TRADITION.

CLARITY WITHOUT ANY PRESENTATIONAL FLAIR WHATSOEVER CAN BE A BITTER PILL FOR SOME TO SWALLOW.

THING IS, WHILE **CLARITY** AND **INTENSITY** CAN GO HAND IN HAND, YOU CAN ONLY LEAN ON ONE SIDE SO HARD BEFORE THE OTHER STARTS TO **SUFFER.**

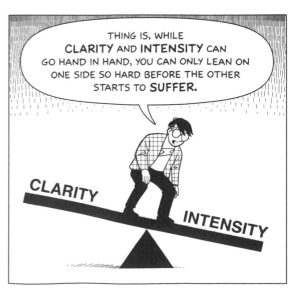

CLARITY

INTENSITY

PANEL THREE: ART BY EIICHIRO ODA. PANEL FOUR: ART BY FRANCOIS SCHUITEN (SEE ART CREDITS, PAGE 258).

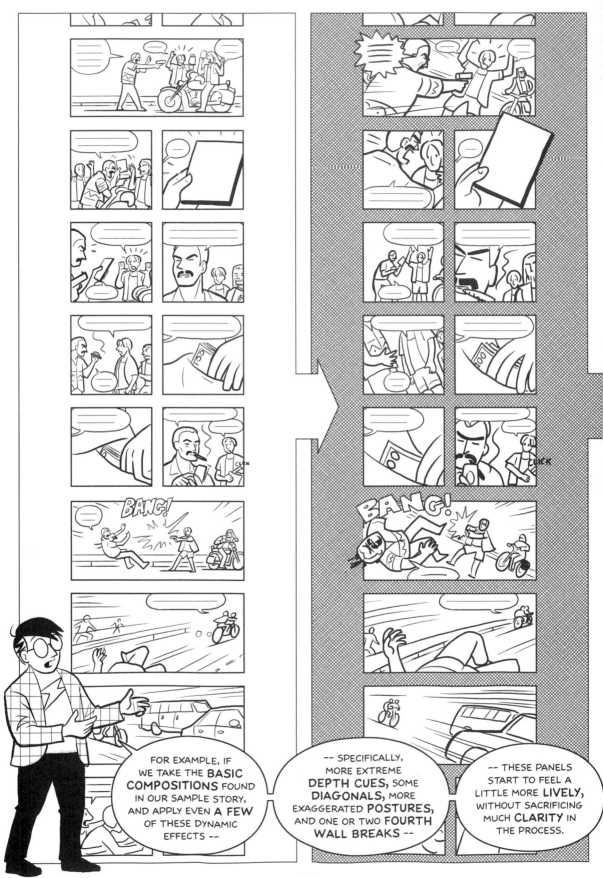

48

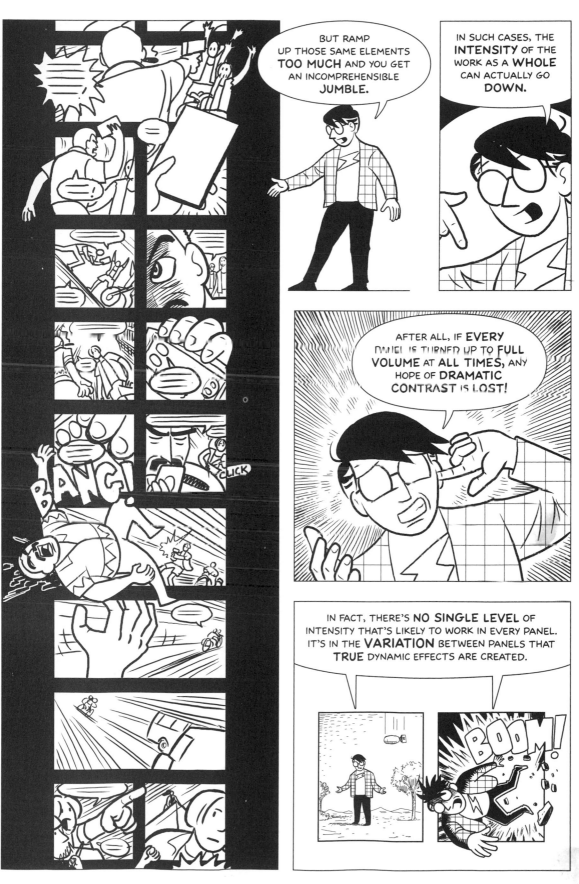

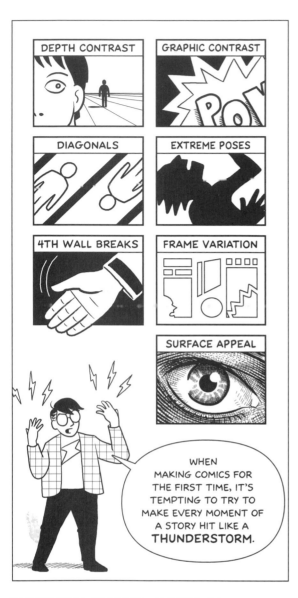

DEPTH CONTRAST

GRAPHIC CONTRAST

DIAGONALS

EXTREME POSES

4TH WALL BREAKS

FRAME VARIATION

SURFACE APPEAL

WHEN MAKING COMICS FOR THE FIRST TIME, IT'S TEMPTING TO TRY TO MAKE EVERY MOMENT OF A STORY HIT LIKE A **THUNDERSTORM**.

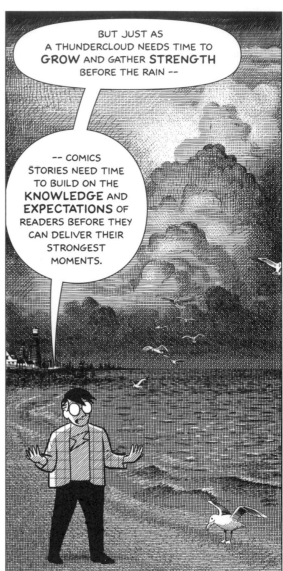

BUT JUST AS A THUNDERCLOUD NEEDS TIME TO **GROW** AND GATHER **STRENGTH** BEFORE THE RAIN --

-- COMICS STORIES NEED TIME TO BUILD ON THE **KNOWLEDGE** AND **EXPECTATIONS** OF READERS BEFORE THEY CAN DELIVER THEIR STRONGEST MOMENTS.

READERS CRAVE DRAMATIC CHANGES, BUT TO **HIGHLIGHT** CHANGE REQUIRES AN **UN**CHANGING **POINT OF REFERENCE**.

THE FIXED, QUIET **BACKGROUND** SETS THE STAGE FOR THE CACOPHONOUS INTRUDER.

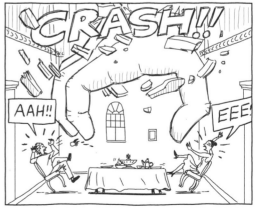

PASS THE TEA, DEAR.

RIGHT AWAY, DEAR.

CRASH!!

AAH!!

EEE!

THE FIXED CAMERA **ANGLE** DRAWS ATTENTION TO THE **ZOOM.**

THE FIXED THREE-BY-THREE **PANEL GRID** PREPARES FOR THE IMPACT OF THE **FULL-PAGE PANEL.**

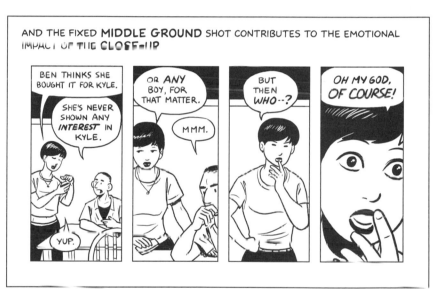

CRASH!

AND THE FIXED **MIDDLE GROUND** SHOT CONTRIBUTES TO THE EMOTIONAL IMPACT OF THE **CLOSE-UP**

BEN THINKS SHE BOUGHT IT FOR KYLE.

SHE'S NEVER SHOWN ANY **INTEREST** IN KYLE.

YUP.

OR **ANY** BOY, FOR THAT MATTER.

MMM.

BUT THEN **WHO--?**

OH MY GOD, **OF COURSE!**

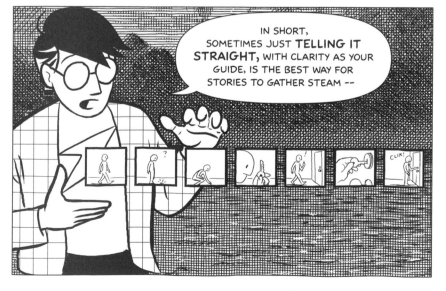

IN SHORT, SOMETIMES JUST **TELLING IT STRAIGHT,** WITH CLARITY AS YOUR GUIDE, IS THE BEST WAY FOR STORIES TO GATHER STEAM --

CLIK!

-- AND THEN **STRIKE LIKE LIGHTNING** WHEN IT COUNTS.

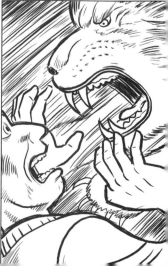

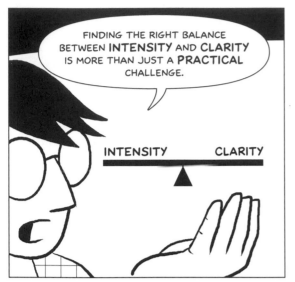

FINDING THE RIGHT BALANCE BETWEEN **INTENSITY** AND **CLARITY** IS MORE THAN JUST A **PRACTICAL** CHALLENGE.

INTENSITY CLARITY

IT ECHOES A BROADER **PHILOSOPHICAL DIVIDE** IN COMICS CULTURE --

-- BETWEEN THE JOY OF TELLING STORIES WITH A STRONG **PERSONAL** FLAIR, MAKING OLD STORIES SEEM **NEW,** TAKING READERS ON A **THRILLING RIDE** AND CELEBRATING **VIRTUOSITY OF TECHNIQUE** --

-- AND THE BELIEF THAT THE STORIES MOST **WORTH** TELLING CAN BE TOLD WITHOUT ANY BELLS AND WHISTLES; THAT THE **CHARACTERS** AND **EVENTS** IN A STORY WILL BE REASON ENOUGH TO KEEP READING, **IF** THE PRESENTATION IS **CLEAR** AND **EFFECTIVE.**

COMICS HAS SEEN PLENTY OF GREAT TALENTS ON **BOTH** ENDS OF THE SCALE. THERE'S NO "RIGHT" CHOICE.

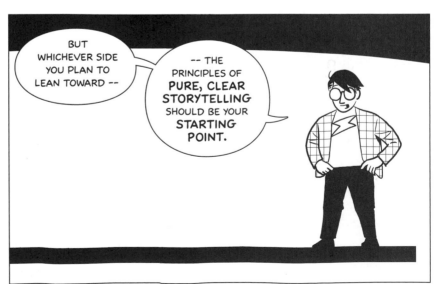

BUT WHICHEVER SIDE YOU PLAN TO LEAN TOWARD --

-- THE PRINCIPLES OF **PURE, CLEAR STORYTELLING** SHOULD BE YOUR **STARTING POINT.**

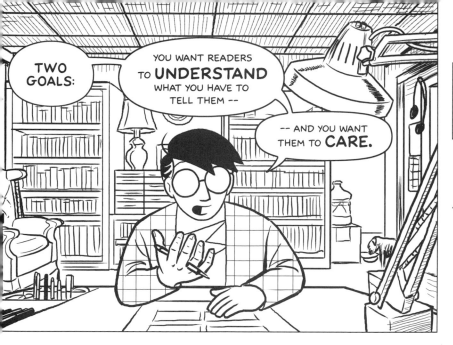

TWO GOALS:

YOU WANT READERS TO **UNDERSTAND** WHAT YOU HAVE TO TELL THEM --

-- AND YOU WANT THEM TO **CARE.**

CLARITY IS THE PATH THAT LEADS TO THE GOAL OF **UNDERSTANDING** --

⊘ MOMENT

☺ FRAME

✎ IMAGE

Ⓦ WORD

▦ FLOW

-- BUT THERE ARE **TWO PATHS** YOU CAN TAKE TO GET YOUR READERS TO **CARE.**

ONE RELIES ON THE **INTENSITY** OF YOUR PRESENTATION --

-- WHILE THE OTHER RELIES ON THE CONTENT OF **THE STORY ITSELF.**

THE HUMAN BEINGS THAT LIVE **WITHIN** THAT STORM

THE **IDEAS** EXPRESSED THROUGH THEM AND BETWEEN THEM.

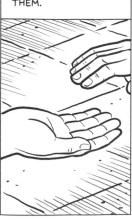

AND THE SENSATIONS OF THE **WORLD** YOUR STORY BRINGS TO LIFE.

TAKE A BREAK. MAYBE TRY SOME OF THE **EXERCISES** LISTED IN THE FOLLOWING NOTES PAGES.

THEN WE'LL SEE WHERE THAT **SECOND PATH** LEADS.

53

NOTES

INTRODUCTION

CHAPTER I: WRITING WITH PICTURES*

PAGE I - GUESSING WHAT YOU WANT

OKAY, I'M STARTING WITH SOME BIG ASSUMPTIONS HERE! THE KIND OF COMIC I DESCRIBE ON PAGE ONE ISN'T THE ONLY KIND OUT THERE. (IN FACT, I'LL TALK ABOUT THE VERY DIFFERENT GOALS SOME CARTOONISTS HAVE IN CHAPTER SIX.) BUT I DO THINK THIS IS THE GOAL MOST OF US START WITH: TO TELL A STORY THAT SWALLOWS THE READER WHOLE, USUALLY BECAUSE THAT'S THE EXPERIENCE WE HAD AS READERS THAT LED US TO COMICS IN THE FIRST PLACE.

TELLING STORIES IS WHY COMICS EXISTS, AND THE DRIVE TO MAKE THOSE STORIES MEMORABLE, MOVING AND INTOXICATING IS WHAT GIVES COMICS ITS CURRENT SHAPE, EVEN IF TOO MANY ARTISTS FAIL AT THAT MISSION.

IT'S LIKE LEARNING ABOUT SEX. EVEN IF MAKING BABIES IS THE LAST THING ON YOUR MIND, UNDERSTANDING HUMAN SEXUALITY STILL STARTS WITH THE REPRODUC-TIVE SYSTEM.

PAGE 2, PANEL 2 - TEACHING MYSELF

NO JOKE. I'M PLANNING A MAJOR GRAPHIC NOVEL AS MY NEXT BIG PROJECT AND CREATING THIS BOOK HAS HELPED ME PREPARE FOR IT. I HAVE A LOT OF BAD HABITS TO GET RID OF!

PAGE 5, PANEL I - ON MY EXAMPLES

THIS BOOK IS BLACK AND WHITE SO MOST OF MY EXAMPLES COME FROM GRAPHIC NOVELS, MANGA OR COMIC STRIPS WHICH FEATURE REPRODUCIBLE BLACK LINE ART. MOST WEBCOMICS, SUPERHERO COMICS AND CLASSIC EUROPEAN COMICS ARE IN COLOR AND HARDER TO REPRODUCE, SO YOU WON'T SEE AS MUCH OF THAT WORK REPRESENTED UNLESS THOSE SUBJECTS COME UP DIRECTLY. IT'S NOT MY PERSONAL PREFERENCE, JUST KEEPING THE EXAMPLES AS SHARP AND READABLE AS POSSIBLE. MOST OF THESE IDEAS SHOULD APPLY TO ALL KINDS OF COMICS. THAT SAID, IF I CAN PICK A COMIC I ADMIRE TO MAKE A GIVEN POINT, I PROBABLY WILL.

PAGE 19-25 - FRAMES AND GENRES

CHOICE OF FRAME CAN DIFFER FROM GENRE TO GENRE. SUPERHERO COMICS TEND TO FEATURE CONTRASTING DISTANCES, CHANGES OF HEIGHT AND LOTS OF DIAGO-NALS TO KEEP THINGS LOOKING DYNAMIC (AT LEAST

SINCE KIRBY REINVENTED THE GENRE, WHICH WE'LL DISCUSS IN CHAPTER SIX):

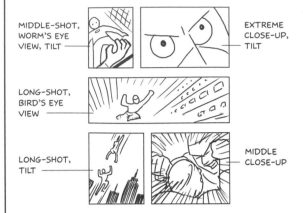

MIDDLE-SHOT, WORM'S EYE VIEW, TILT

EXTREME CLOSE-UP, TILT

LONG-SHOT, BIRD'S EYE VIEW

LONG-SHOT, TILT

MIDDLE CLOSE-UP

IN A DAILY GAG STRIP, ON THE OTHER HAND, AN ARTIST MIGHT GO FOR MONTHS WITHOUT EVER MOVING THE "CAMERA" TO GIVE THE COMIC A MUNDANE, DOWN TO EARTH FEELING ON THE ASSUMPTION THAT DRAMATIC STAGING WOULD UNDERCUT THE HUMOR:

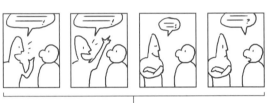

FIXED MIDDLE-SHOT, FIXED ANGLE, NO TILT

PAGE 29 - DRAWING STYLES AND MOOD

FOR A WHOLE CHAPTER ON HOW DRAWING STYLES CAN AFFECT MOOD, SEE *UNDERSTANDING COMICS*, CHAPTER FIVE, "LIVING IN LINE."

PAGE 36 - FLOW AND PANEL SHAPE

FLOW CAN BE AFFECTED BY PANEL SHAPE IN VARIOUS WAYS. YOUR READERS INSTINCTIVELY KNOW THAT AS THEIR EYES MOVE ACROSS A ROW OF PANELS, THEY'RE MOVING FORWARD IN TIME, SO A ROW OF NARROW PANELS WHICH DIVIDE THE READING FLOW INTO SHORT BURSTS ARE USEFUL FOR FAST, CHOPPY SEQUENCES:

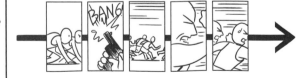

WHILE WIDER PANELS CAN BE USED FOR MOMENTS THAT SHOULD PASS MORE SLOWLY.

* WILL EISNER HAS REFERRED TO HIMSELF AS "A WRITER WHO WRITES WITH PICTURES" AND I'VE HEARD ART SPIEGELMAN TALK ABOUT COMICS AS A FORM OF "PICTURE WRITING" SO THIS ISN'T MY TERM.

PAGE 37 - CATEGORIES AND LIMITATIONS

ARTISTS HAVE BEEN DRAWING WONDERFUL COMICS STORIES FOR WELL OVER A HUNDRED YEARS WITHOUT WORRYING ABOUT TERMS LIKE MY FIVE CHOICES, OF COURSE. A LOT OF PURE INSTINCT GOES INTO MAKING COMICS. THESE IDEAS ARE MEANT TO **SUPPLEMENT** AND **INFORM** THOSE INSTINCTS, NOT **REPLACE** THEM.

IF YOU'RE CREATING A COMIC, AND A PARTICULAR PANEL OR PAGE DESIGN JUST FEELS RIGHT TO YOU, GO FOR IT. JUST BECAUSE YOU DIDN'T GO DOWN ONE OF MY NERDY CHECKLISTS FIRST DOESN'T MAKE IT ANY LESS VALID.

BUT, WHEN YOU COME BACK TO THAT COMIC AND SOMETHING NO LONGER FEELS QUITE RIGHT, OR WHEN A FRIEND READS IT AND DOESN'T GET IT, THAT'S WHEN I CAN PROMISE THAT YOUR SOLUTION LIES IN ONE OF THOSE FIVE COLUMNS. THAT'S WHEN YOU MAY WANT TO RECONSIDER SOME OF THE CHOICES YOU'VE MADE AND CONSIDER THE ALTERNATIVES.

PAGE 38 - ART STAGES

CREATING FINISHED ART HAS TRADITIONALLY INCLUDED SOME KIND OF UNDER-DRAWING WITH LIGHT (HARD) PENCIL AND/OR LIGHT BLUE PENCIL TO GET DETAILS AND PROPORTIONS RIGHT, FOLLOWED BY FINISHED INK DRAWINGS. IN THE INDUSTRY OVER THE YEARS, THESE SEPARATE TASKS -- OFTEN PERFORMED BY SEPARATE ARTISTS -- BECAME KNOWN AS "PENCILLING" (SIC) AND "INKING."

A LOT OF LONE COMICS ARTISTS STILL SPLIT THEIR COMICS ART INTO THESE SEPARATE STAGES. IT MAKES SENSE TO HAVE A NON-PERMANENT WAY TO WORK OUT WHERE LINES ARE GOING TO GO BEFORE INK HITS PAPER. STILL, I'M RELUCTANT TO USE THE TERMS BECAUSE THEY DON'T FIT WELL WITH OTHER TYPES OF FINISHED ART LIKE PAINT OR DIGITAL MEDIA.

THAT SAID, MOST CARTOONISTS GO THROUGH A FEW STAGES ON THEIR WAY TO FINISHED ART, INCLUDING:

- A ROUGH LAYOUT STAGE WHEN THEY FIGURE OUT WHERE EVERYTHING IS GOING TO GO ON THE PAGE.
- A PENCILLING-LIKE STAGE WHEN THEY WORK OUT THE PROPORTIONS AND DETAILS OF CHARACTERS AND OBJECTS IN THEIR STORY
- A FINISHED ART STAGE WHEN RENDERING DECISIONS ARE MADE FINAL.

PAGE 46 - INTENSITY BOOSTERS

ALTHOUGH THESE TECHNIQUES ARE DISCUSSED HERE AS WAYS TO PUNCH UP THE SURFACE APPEAL OF A WORK, THERE ARE ALSO PLENTY OF STRAIGHTFORWARD NARRATIVE USES, INCLUDING:

EXTREME DEPTH CUES TO IMPLY THE EXTREME SIZE OR MASS OF A CHARACTER OR OBJECT:

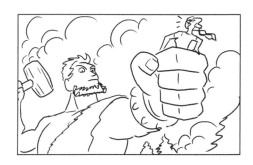

TILTED ANGLES TO REFLECT A CHARACTER'S SENSE OF DISORIENTATION:

OR HYPER-RENDERING TO SHOW IMPORTANT DETAILS OF AN OBJECT:

PAGE 47, PANEL 7 - CLARITY WITHOUT INTENSITY

IT'S ACTUALLY PRETTY INTERESTING WHEN CARTOON-ISTS TRY DIALING DOWN THE INTENSITY NEARLY ALL THE WAY. CHESTER BROWN'S *LOUIS RIEL* INCLUDES STATIC CHARACTER POSTURES, VERY FEW CLOSE-UPS AND SOME DELIBERATELY MONOTONOUS LAYOUTS, BUT THE DRAMATIC EVENTS STILL PULL THE READER IN:

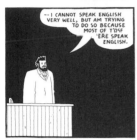

GENERALLY SPEAKING, THE "ALTERNATIVE COMICS" SCENE, INCREASINGLY ASSOCIATED WITH THE LITERATE GRAPHIC NOVEL MOVEMENT, USES THE DYNAMIC ACCENTS DISCUSSED ON PAGE 46 ONLY SPARINGLY, CREATING MOODS MORE AKIN TO A STAGE PLAY THAN A HOLLYWOOD BLOCKBUSTER. BROWN'S *LOUIS RIEL* IS AN EXTREME EXAMPLE, BUT LOOK AT MATURE GRAPHIC NOVELS LIKE SPIEGELMAN'S *MAUS*, WARE'S *JIMMY CORRIGAN* OR MARJANE SATRAPI'S *PERSEPOLIS* FOR EXAMPLES OF THAT GENRE'S MORE RESTRAINED ANGLES AND COMPOSITIONS.

OPTIONAL EXERCISES

NOTE: IF YOU'D LIKE TO EXPLORE SOME OF THESE TOPICS FURTHER (OR IF YOU'RE A TEACHER WHO'D LIKE TO INCORPORATE SOME OF THESE IDEAS INTO A CLASSROOM SETTING) I'VE INCLUDED SUGGESTIONS FOR EXERCISES IN THE NOTES SECTIONS OF THE FIRST FOUR CHAPTERS. THEY AREN'T NECESSARY TO GRASP THE IDEAS IN THIS BOOK, BUT YOU MIGHT FIND THEM USEFUL FOR GETTING A MORE HANDS-ON UNDERSTAND-ING OF THE COMICS-MAKING PROCESS.

1 - CHOICE OF MOMENT (PAGES 11-18)

PICK A FAVORITE MOVIE AND TRY ROUGHLY BREAKING DOWN THE STORY INTO JUST SIXTEEN KEY MOMENTS USING ONLY PICTURES, NO WORDS. MAKE SURE THEY'RE CLEAR ENOUGH AND CONNECTED ENOUGH THAT A FRIEND WHO HASN'T SEEN THE MOVIE CAN TELL YOU WHAT'S GOING ON WITHOUT ANY ADDITIONAL EXPLANA-TION. QUESTION: IF YOU HAD TO CUT TO JUST EIGHT PANELS, WHICH ONES WOULD YOU DROP? HOW MANY PANELS WOULD BE ENOUGH TO SHOW ALL OF THE KEY MOMENTS OF THE STORY?

2 - CHOICE OF MOMENT/CONNECTING THE DOTS (PAGES 13-14)

PICK A FEW OF YOUR FAVORITE COMICS AND TRY TO FIND AT LEAST ONE PANEL THAT COULD HAVE BEEN CUT WITHOUT ADVERSELY AFFECTING THE CLARITY OF THE STORY. CONSIDER WHAT MIGHT HAVE PROMPTED THE CREATOR(S) OF THE COMIC TO INCLUDE IT IN THE FIRST PLACE. WAS IT MEANT TO SLOW DOWN THE ACTION? OR FILL SPACE BEFORE A PAGE TURN? WAS IT GENUINELY USELESS OR WAS THERE A SUBTLER PURPOSE IN MIND?

3 - THE SIX TRANSITIONS (PAGES 15-18)

PICK ONE OF THESE THREE MINI-PLOTS AND CREATE A ROUGH SINGLE PAGE COMIC ABOUT IT USING ONLY ONE OF THE TRANSITION TYPES FROM PAGES 16 AND 17:

- THE QUEEN DIED AND THE KING DIED OF GRIEF AFTER HER.
- BOY MEETS GIRL, BOY LOSES GIRL.
- DOG EATS DOG, DOG BURPS, DOG FIGURE SKATES.

THEN TRY DRAWING A NEW PAGE OF THE SAME PLOT USING A DIFFERENT KIND OF TRANSITION AND SEE HOW IT AFFECTS THE STORYTELLING STYLE AND MOOD OF YOUR COMIC.

4 - CHOICE OF FRAME (PAGES 19-25)

BUY THE LATEST COMIC BY YOUR FAVORITE CREATOR. DON'T LOOK INSIDE, BUT INSTEAD GET A COMICS-SAVVY FRIEND TO COPY JUST THE PANEL BORDERS FROM A FEW PAGES AND WRITE A SHORT DESCRIPTION OF WHAT'S GOING ON IN EACH PANEL. TRY TO GUESS HOW YOUR FAVORITE CREATOR COMPOSED EACH PANEL AND DRAW A ROUGH VERSION INSIDE THE BORDERS. THEN TAKE A LOOK AT THE PRINTED COMIC AND COMPARE YOUR ROUGH VERSION TO THE REAL THING.

5 - CHOICE OF FRAME (PAGES 19-25)

SKETCH A 16-PANEL GRID ON A PIECE OF TYPING PAPER WITH A SIMPLE STANDING FIGURE IN THE FIRST PANEL:

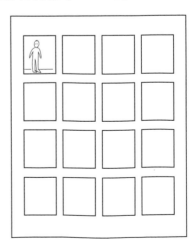

ASK A FRIEND TO DECIDE WHAT YOUR CHARACTER SHOULD DO IN PANEL TWO. DRAW THE SUGGESTION AND CONSIDER WHETHER IT WAS NECESSARY TO CHANGE THE VIEWING ANGLE. IF YOUR CHARACTER ENCOUNTERS AN ELEPHANT, DO YOU HAVE TO PULL BACK? IF HE/SHE CLIPS A TOENAIL, DO YOU HAVE TO PULL IN? DO ANY OF THE SUGGESTIONS REQUIRE A TILT OR ROTATION OF VIEWING ANGLE? DO ANY REQUIRE A CHANGE OF ELEVATION? REPEAT UNTIL THE PAGE IS FILLED!

6 - CHOICE OF IMAGE (PAGES 26-29)

TEST YOUR VISUAL MEMORY. TRY MAKING SIMPLE DRAWINGS OF FIVE COMPLEX ITEMS FROM MEMORY (EXAMPLES: A FIRE HYDRANT, YOUR FAVORITE SKYSCRAPER, A PAIR OF SCISSORS, A SNEAKER, A GAME CONTROLLER...). THEN FIND THE REAL THING OR CHECK THE WEB FOR PHOTOS. STUDY THE DIFFERENCES. THEN DRAW THE SAME ITEMS AGAIN FROM MEMORY AND SEE IF YOU CAN CAPTURE THEM MORE EFFECTIVELY.

ALTHOUGH DRAWING FROM MEMORY ISN'T AS NECESSARY TODAY AS IT WAS FOR MY GENERATION (YOU CAN PRETTY MUCH FIND A PHOTO OF ANYTHING ONLINE) PRACTICING IT CAN HELP ISOLATE THE MOST IMPORTANT STRUCTURAL DETAILS OF SUBJECTS THAT CAN JOG READERS MEMORIES WITHOUT OVERLOADING THEM WITH UNNECESSARY DETAILS.

FOR EXAMPLE, IF ASKED TO QUICKLY SKETCH A BICYCLE FROM MEMORY, A LOT OF PEOPLE MIGHT SKETCH SOMETHING LIKE THIS:

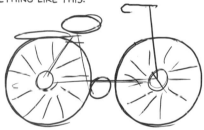

BUT WITH REFERENCE, THE SAME NUMBER OF LINES MIGHT BETTER CAPTURE THE BASIC SHAPES OF A REAL BICYCLE:

7 - CHOICE OF IMAGE (PAGES 26-29)

CAN YOU DRAW AN UNOCCUPIED ROOM WITH ENOUGH DETAIL THAT A FRIEND CAN TELL YOU AT LEAST TEN MEANINGFUL THINGS ABOUT THE KIND OF PERSON THAT LIVES THERE, JUST BY LOOKING AT YOUR DRAWING?

[NOTE: SEE CHAPTER 3 FOR CHOICE OF WORD EXERCISES.]

8 - CHOICE OF FLOW (PAGES 32-36)

FIND A COMIC OR GRAPHIC NOVEL WITH A LOT OF VARIATIONS IN FRAME SIZE AND SHAPE. PICK AT LEAST TEN PAGES AND CONSIDER HOW YOU MIGHT ARRANGE THE SAME PANELS IF YOU HAD TO FIT THEM ONTO THE PAGES OF A DIFFERENTLY-SHAPED BOOK. WOULD SOME PANELS HAVE TO BE ADDED OR SUBTRACTED? HOW DOES THE NEW LAYOUT AFFECT TURN-OF-PAGE MOMENTS? CAN YOU KEEP THE READING ORDER EASY TO FOLLOW?

9 - CLARITY VERSUS INTENSITY (PAGES 45-52)

CAN YOU FIND A COMIC WHERE THE CLARITY OF SOME SCENES COULD BE IMPROVED BY DIALING DOWN THE INTENSITY OF SOME LAYOUTS? CAN YOU DO A ROUGH SKETCH OF YOUR IMPROVED VERSION? CONVERSELY, CAN YOU FIND A COMIC WHICH COULD BENEFIT FROM THE **ADDITION** OF SOME INTENSITY, WITHOUT SACRIFICING CLARITY IN THE PROCESS? HOW WOULD YOU GO ABOUT IT?

10 - LOOSENING-UP EXERCISES

A. QUANTO COMICS (INVENTED BY THE LEGENDARY DEWAN BROTHERS, TED AND BRIAN). GET TOGETHER WITH ONE OR MORE COMICS-MAKING FRIENDS. GET A FEW BLACK MARKERS AND SOME PLAIN WHITE PAPER. EACH ARTIST TAKES A FEW MINUTES MAKING A TITLE LOGO ON THE TOP OF A PAGE (TITLES SHOULD BE SOMETHING GENERAL LIKE "IS THAT YOUR DAD?," "BLIND DATE," "IGNORE IT AND IT WILL GO AWAY," "CLOSED MONDAYS," ETC.; AVOID OVERLY SPECIFIC TITLES LIKE "POPE BENEDICT AND JAMIROQUAI GO SKYDIVING OVER PENNSYLVANIA"). EACH ARTIST THEN TRADES PAGES AND DRAWS A ONE-PAGE COMIC TO MATCH SOMEONE ELSE'S TITLE. REPEAT UNTIL SLEEPY.

B. THE 24-HOUR COMIC (BEGUN IN 1990 AS A CHALLENGE TO MY PAL STEVE BISSETTE). DRAW AN ENTIRE 24 PAGE COMIC BOOK IN A SINGLE 24-HOUR PERIOD. NO SCRIPT. NO PREPARATION. ONCE THE CLOCK STARTS TICKING, IT DOESN'T STOP UNTIL YOU'RE DONE. GREAT SHOCK THERAPY FOR THE CREATIVELY BLOCKED. OVER 1,000 ARTISTS HAVE GIVEN IT A TRY SO FAR!

SUGGESTIONS: START IN THE MORNING, AFTER A FULL NIGHT'S SLEEP. PLAN TO HAVE PLENTY OF FOOD, CAFFEINE AND MUSIC AT THE READY. AND IF YOU DON'T DO IT AT HOME, YOU MIGHT WANT TO HAVE A FRIEND OR FAMILY MEMBER GIVE YOU A RIDE WHEN YOU'RE DONE.

IF YOU WANT TO MAKE YOUR COMIC IN THE COMPANY OF OTHER CRAZY ARTISTS, CHECK OUT 24HOURCOMICS.COM FOR DETAILS ON 24-HOUR COMICS DAY, AN ANNUAL CELEBRATION DURING WHICH GROUP EVENTS ARE HELD AT COMICS STORES AND OTHER LOCATIONS IN SEVERAL COUNTRIES.

ADDITIONAL NOTES (INCLUDING MORE DETAILS ON THE 24-HOUR COMICS CHALLENGE) CAN BE FOUND AT: WWW.SCOTTMCCLOUD.COM/MAKINGCOMICS

Chapter Two

Stories for Humans

Character Design, Facial Expressions and Body Language

FOR MOST OF US IN THE ANIMAL KINGDOM, IT STILL TAKES **TWO** TO CREATE NEW LIFE, AND CREATING NEW LIVES THROUGH **COMICS** IS NO DIFFERENT.

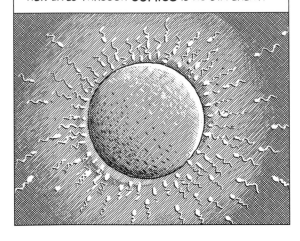

YOU PROVIDE THE SHAPES, LINES AND COLORS OF YOUR CHOSEN ART --

-- AND THE READER PROVIDES THE HUMAN EXPERIENCE NEEDED TO BREATHE **LIFE** INTO THEM.

BUT THEY CAN'T BE JUST **ANY** SHAPES, LINES AND COLORS.

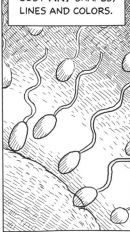

THEY NEED TO INCLUDE JUST A FEW **KEY ELEMENTS** THAT WILL TRIGGER RECOGNITION IN YOUR READERS --

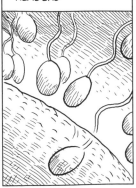

-- STARTING WITH ONE OF THE MOST BASIC VISUAL QUALITIES THAT MARK ALL LIVING THINGS, AND **SEPARATE** US FROM THE NON-LIVING WORLD --

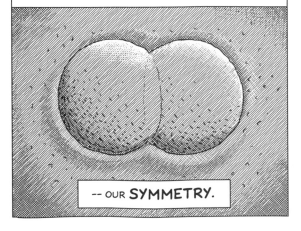

-- OUR **SYMMETRY**.

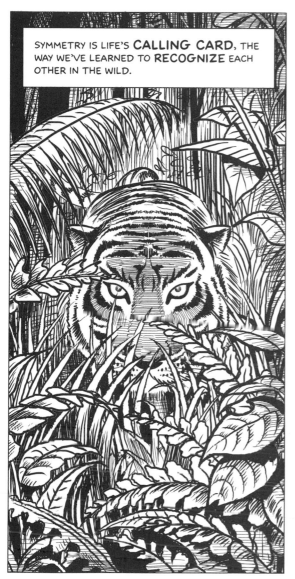

SYMMETRY IS LIFE'S **CALLING CARD**, THE WAY WE'VE LEARNED TO **RECOGNIZE** EACH OTHER IN THE WILD.

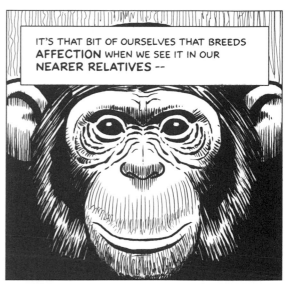

IT'S THAT BIT OF OURSELVES THAT BREEDS **AFFECTION** WHEN WE SEE IT IN OUR **NEARER RELATIVES** --

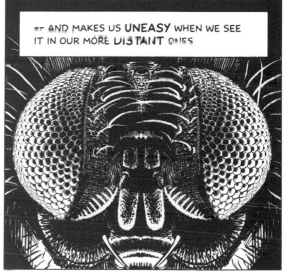

-- AND MAKES US **UNEASY** WHEN WE SEE IT IN OUR MORE **DISTANT** ONES.

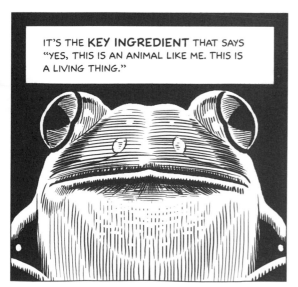

IT'S THE **KEY INGREDIENT** THAT SAYS "YES, THIS IS AN ANIMAL LIKE ME. THIS IS A LIVING THING."

EVEN WHEN **NOTHING** COULD BE **FURTHER** FROM THE **TRUTH.**

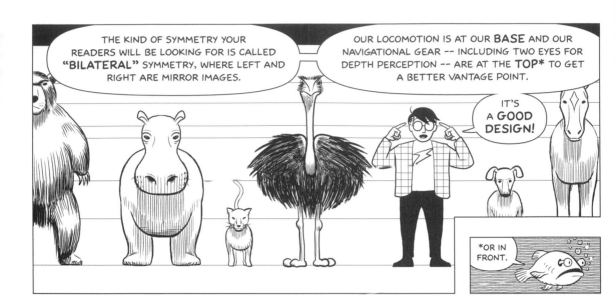

THE KIND OF SYMMETRY YOUR READERS WILL BE LOOKING FOR IS CALLED **"BILATERAL"** SYMMETRY, WHERE LEFT AND RIGHT ARE MIRROR IMAGES.

OUR LOCOMOTION IS AT OUR **BASE** AND OUR NAVIGATIONAL GEAR -- INCLUDING TWO EYES FOR DEPTH PERCEPTION -- ARE AT THE **TOP*** TO GET A BETTER VANTAGE POINT.

IT'S A **GOOD** DESIGN!

*OR IN FRONT.

NO MATTER HOW **ABSTRACT** OR **STYLIZED** A PIECE OF ART IS, IF IT DISPLAYS THAT BASIC ARRANGEMENT, HUMANS WILL SEE **THEMSELVES** IN ITS FEATURES.

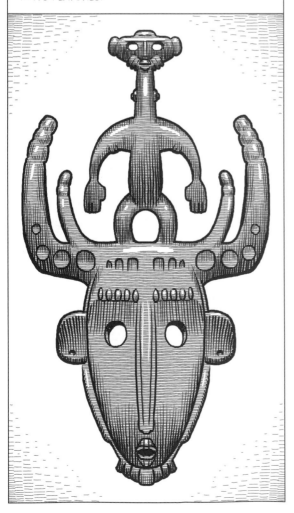

IN FACT, EVEN WHEN A SET OF LINES IS SO SPARE THAT IT COULD AS EASILY DESCRIBE AN APE, A BEAR OR A FISH, THEY'LL STILL SEE A **HUMAN** IF THEY CAN.

HUMANS **LOVE** HUMANS! THEY CAN'T GET ENOUGH OF THEMSELVES. THEY CRAVE THE **COMPANY** OF HUMANS, THEY VALUE THE **OPINIONS** OF HUMANS --

-- AND THEY LOVE HEARING **STORIES** ABOUT HUMANS!

IN FACT, THEY LOVE SUCH STORIES SO MUCH, THEY'LL MAKE ONE UP FROM THE SLIGHTEST HINT.

EVEN THE LOOSEST SCRIBBLE WILL SUGGEST A FIGURE --

-- AN EMOTION --

-- OR A GESTURE.

IN SHORT, CREATING A HUMAN BEING IN THE MIND OF THE READER IS **EASY.** JUST A FEW LINES IS ALL IT TAKES AND YOUR READERS WILL DO THE REST.

BUT IF YOU WANT THEM TO SEE A **SPECIFIC** PERSON, WITH A SPECIFIC APPEARANCE AND SPECIFIC **HOPES** AND **DREAMS,** THAT'LL TAKE A FEW **EXTRA STEPS.**

IN THIS CHAPTER, I'LL TALK ABOUT **THREE** SUCH MEASURES YOU CAN TAKE TO BRING YOUR DRAWINGS TO LIFE AS **VIVID, BELIEVABLE HUMAN BEINGS.**

1. CHARACTER DESIGN

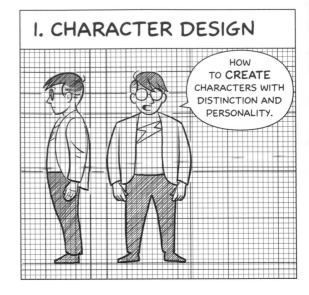

HOW TO **CREATE** CHARACTERS WITH DISTINCTION AND PERSONALITY.

2. FACIAL EXPRESSIONS

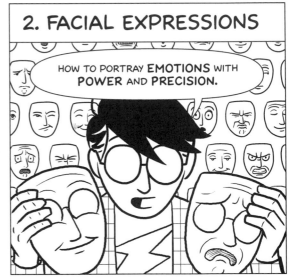

HOW TO PORTRAY **EMOTIONS** WITH **POWER** AND **PRECISION.**

3. BODY LANGUAGE

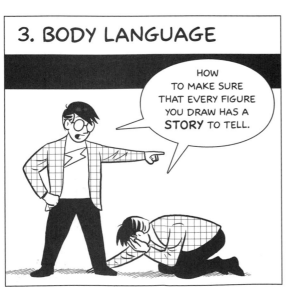

HOW TO MAKE SURE THAT EVERY FIGURE YOU DRAW HAS A **STORY** TO TELL.

MASTER THESE ELEMENTS, PLUS THE EFFECTIVE USE OF **WORDS** (COMING UP IN CHAPTER THREE) --

-- AND YOU CAN GIVE BIRTH TO CHARACTERS THAT READERS WILL **BELIEVE** IN AND **REMEMBER** FOR YEARS TO COME.

WAA!

I. CHARACTER DESIGN

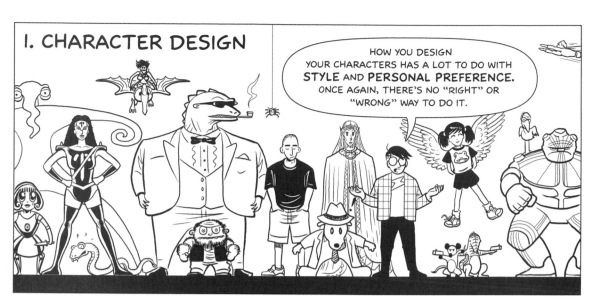

HOW YOU DESIGN YOUR CHARACTERS HAS A LOT TO DO WITH **STYLE** AND **PERSONAL PREFERENCE.** ONCE AGAIN, THERE'S NO "RIGHT" OR "WRONG" WAY TO DO IT.

SOME CHARACTERS ARE BORN AS DOODLES IN A **SKETCHBOOK,** SOME ARE **IMPROVISED** IN THE MIDDLE OF A STORY, SOME ARE CONCEIVED IN THE **SCRIPT** STAGE -- MAYBE TO BE VISUALLY DESIGNED BY OTHERS.

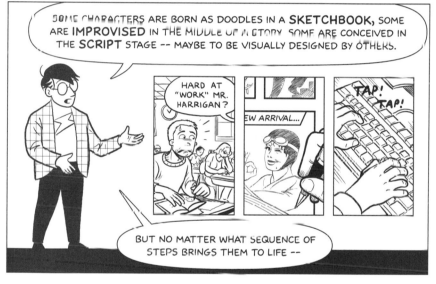

HARD AT "WORK" MR. HARRIGAN?

EW ARRIVAL...

TAP! TAP!

BUT NO MATTER WHAT SEQUENCE OF STEPS BRINGS THEM TO LIFE --

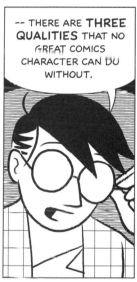

-- THERE ARE **THREE QUALITIES** THAT NO GREAT COMICS CHARACTER CAN DO WITHOUT.

AN INNER LIFE

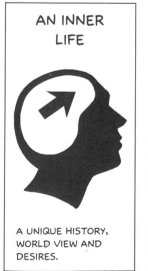

A UNIQUE HISTORY, WORLD VIEW AND DESIRES.

VISUAL DISTINCTION

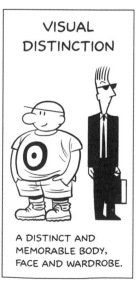

A DISTINCT AND MEMORABLE BODY, FACE AND WARDROBE.

EXPRESSIVE TRAITS

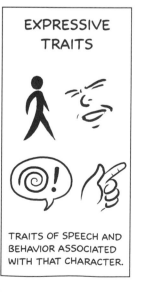

TRAITS OF SPEECH AND BEHAVIOR ASSOCIATED WITH THAT CHARACTER.

LET'S TAKE A CLOSER LOOK AT EACH.

CREATING A COMPELLING **INNER LIFE** FOR YOUR CHARACTERS MAY BE THE MOST IMPORTANT, AND LEAST **UNDERSTOOD,** ASPECT OF CHARACTER CREATION.

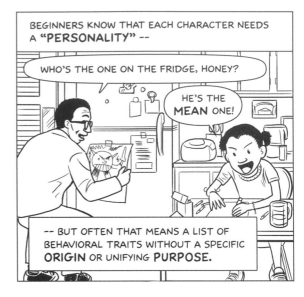

BEGINNERS KNOW THAT EACH CHARACTER NEEDS A **"PERSONALITY"** --

WHO'S THE ONE ON THE FRIDGE, HONEY?

HE'S THE **MEAN** ONE!

-- BUT OFTEN THAT MEANS A LIST OF BEHAVIORAL TRAITS WITHOUT A SPECIFIC **ORIGIN** OR UNIFYING **PURPOSE.**

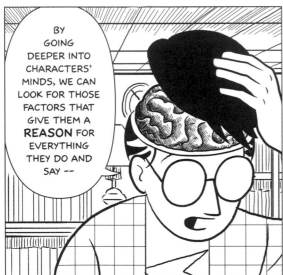

BY GOING DEEPER INTO CHARACTERS' MINDS, WE CAN LOOK FOR THOSE FACTORS THAT GIVE THEM A **REASON** FOR EVERYTHING THEY DO AND SAY --

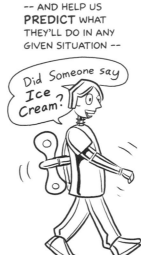

-- AND HELP US **PREDICT** WHAT THEY'LL DO IN ANY GIVEN SITUATION --

Did Someone say Ice Cream?

-- TO SUCH AN EXTENT THAT THEY VIRTUALLY **WRITE THEMSELVES!**

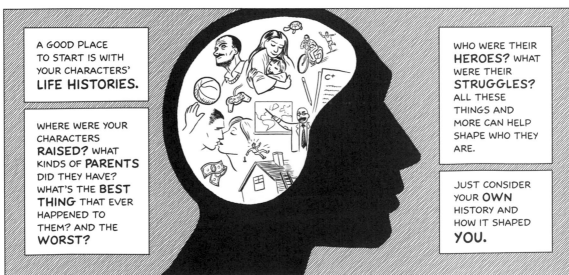

A GOOD PLACE TO START IS WITH YOUR CHARACTERS' **LIFE HISTORIES.**

WHERE WERE YOUR CHARACTERS **RAISED?** WHAT KINDS OF **PARENTS** DID THEY HAVE? WHAT'S THE **BEST THING** THAT EVER HAPPENED TO THEM? AND THE **WORST?**

WHO WERE THEIR **HEROES?** WHAT WERE THEIR **STRUGGLES?** ALL THESE THINGS AND MORE CAN HELP SHAPE WHO THEY ARE.

JUST CONSIDER YOUR **OWN** HISTORY AND HOW IT SHAPED **YOU.**

FINDING **COMMON GROUND** BETWEEN THE EXPERIENCES OF YOUR CHARACTERS AND THOSE OF THE READER CAN HELP EMOTIONALLY **CONNECT** THEM --

-- WHILE THE **DIFFERENCES** IN LIFE EXPERIENCE BETWEEN ONE CHARACTER AND ANOTHER CAN TRIGGER MANY STORIES.

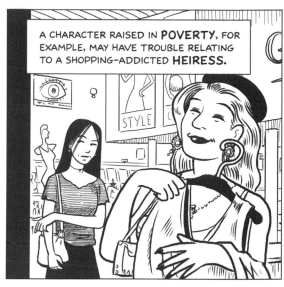

A CHARACTER RAISED IN **POVERTY**, FOR EXAMPLE, MAY HAVE TROUBLE RELATING TO A SHOPPING-ADDICTED **HEIRESS**.

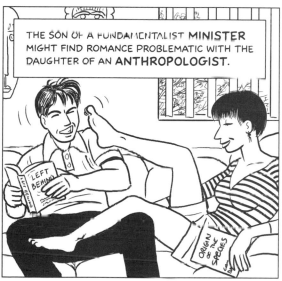

THE SON OF A FUNDAMENTALIST **MINISTER** MIGHT FIND ROMANCE PROBLEMATIC WITH THE DAUGHTER OF AN **ANTHROPOLOGIST**.

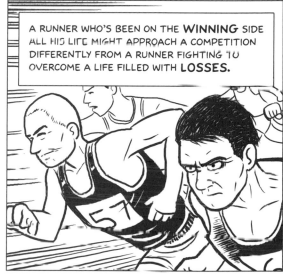

A RUNNER WHO'S BEEN ON THE **WINNING** SIDE ALL HIS LIFE MIGHT APPROACH A COMPETITION DIFFERENTLY FROM A RUNNER FIGHTING TO OVERCOME A LIFE FILLED WITH **LOSSES**.

THESE LIFE HISTORIES -- OR "BACKSTORIES" -- DON'T HAVE TO BE TOO ELABORATE, ESPECIALLY FOR MINOR CHARACTERS.

IN FACT, OBSESSING **TOO** MUCH OVER SUCH DETAILS IS A CLASSIC BEGINNER'S MISTAKE!

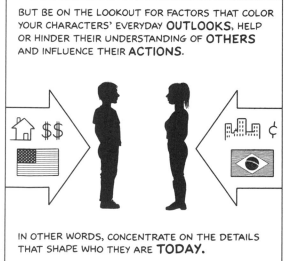

BUT BE ON THE LOOKOUT FOR FACTORS THAT COLOR YOUR CHARACTERS' EVERYDAY **OUTLOOKS**, HELP OR HINDER THEIR UNDERSTANDING OF **OTHERS** AND INFLUENCE THEIR **ACTIONS**.

IN OTHER WORDS, CONCENTRATE ON THE DETAILS THAT SHAPE WHO THEY ARE **TODAY**.

SOMETIMES, A SINGLE, LIFE-CHANGING EVENT CAN BECOME A CHARACTER'S **DEFINING MOMENT.**

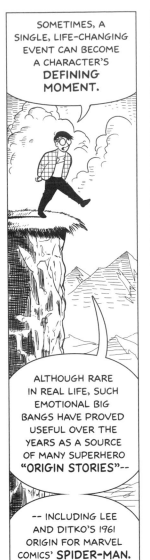

ALTHOUGH RARE IN REAL LIFE, SUCH EMOTIONAL BIG BANGS HAVE PROVED USEFUL OVER THE YEARS AS A SOURCE OF MANY SUPERHERO **"ORIGIN STORIES"**--

-- INCLUDING LEE AND DITKO'S 1961 ORIGIN FOR MARVEL COMICS' **SPIDER-MAN.**

PETER PARKER'S FIRST IMPULSE WHEN GETTING HIS UNIQUE POWERS WASN'T TO FIGHT CRIME AT ALL BUT TO MAKE MONEY AS A **CELEBRITY.**

ONLY AFTER PETER'S UNCLE IS MURDERED BY A CROOK HE'D EARLIER **REFUSED** TO CATCH AS SPIDER-MAN --

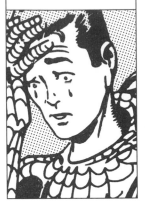

-- DOES PETER UNDERSTAND THAT WITH GREAT POWER COMES "GREAT **RESPONSIBILITY"** AND EMBARK ON THE DIFFICULT PATH OF DOING GOOD.

WITH THEIR HERO'S MORAL BURDEN FIRMLY ESTABLISHED, WRITERS HAD A FIELD DAY THROWING ONE THORNY MORAL DILEMMA AFTER ANOTHER AT THE POOR GUY, GENERATING A LONG RUN OF SUCCESSFUL STORIES.

THEY KNEW THAT AS MANY STORIES COULD STEM FROM CONFLICTS **UNDER** THE MASK AS OUT ON THE **STREET.**

OUR HISTORY AFFECTS HOW WE SEE THE WORLD.

HOW WE SEE THE WORLD AFFECTS WHAT WE **WANT** AND **EXPECT** FROM THE WORLD.

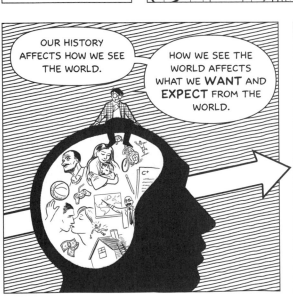

AND WHEN THOSE DESIRES AND EXPECTATIONS COLLIDE WITH THE DESIRES OF **OTHERS** OR WITH **NATURE** --

-- THAT'S THE SOURCE OF MANY OF THE **BEST STORIES** EVER TOLD,

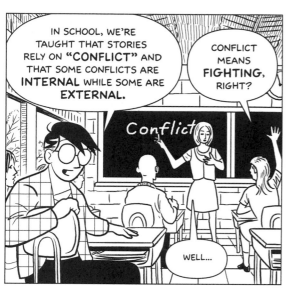

IN SCHOOL, WE'RE TAUGHT THAT STORIES RELY ON "CONFLICT" AND THAT SOME CONFLICTS ARE INTERNAL WHILE SOME ARE EXTERNAL.

CONFLICT MEANS FIGHTING, RIGHT?

WELL...

TRACK THEM TO THEIR SOURCE, THOUGH, AND NEARLY ALL CONFLICTS ARE INTERNAL --

-- BECAUSE THEY ALL START WITH SOMEONE, SOMEWHERE, WANTING SOMETHING.

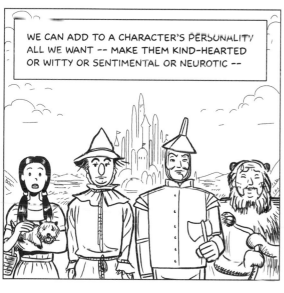

WE CAN ADD TO A CHARACTER'S PERSONALITY ALL WE WANT -- MAKE THEM KIND-HEARTED OR WITTY OR SENTIMENTAL OR NEUROTIC --

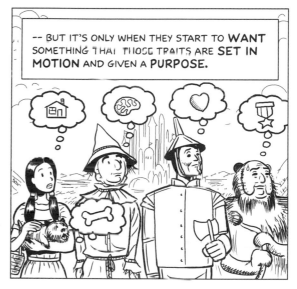

-- BUT IT'S ONLY WHEN THEY START TO WANT SOMETHING THAT THOSE TRAITS ARE SET IN MOTION AND GIVEN A PURPOSE.

EVERYBODY IS A HERO IN THEIR OWN MIND.

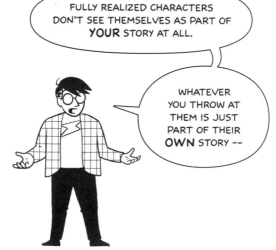

FULLY REALIZED CHARACTERS DON'T SEE THEMSELVES AS PART OF YOUR STORY AT ALL.

WHATEVER YOU THROW AT THEM IS JUST PART OF THEIR OWN STORY --

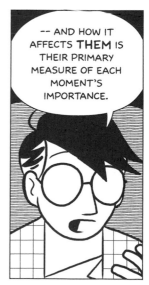

-- AND HOW IT AFFECTS THEM IS THEIR PRIMARY MEASURE OF EACH MOMENT'S IMPORTANCE.

MOST WRITERS PUT A BIT OF **THEMSELVES** INTO EVERY CHARACTER, WHICH CAN ADD **WARMTH** AND **CREDIBILITY** TO A STORY, BUT CAN ALSO DULL THE VARIETY OF A CAST IF TAKEN TOO FAR.

ONE WAY TO BOLSTER THAT VARIETY IS TO BASE EACH CAST MEMBER ON A DIFFERENT **UNIFYING IDEA.**

THAT'S WHAT I DID IN THE EARLY '80S WHEN I PARTIALLY MODELED THE FOUR MAIN CHARACTERS FOR MY FIRST COMIC BOOK SERIES *ZOT!* AFTER CARL JUNG'S FOUR PROPOSED TYPES OF HUMAN THOUGHT.

ZOT
INTUITION

JENNY
FEELING

PEABODY
INTELLECT

BUTCH
SENSATION

SOUNDS WEIRD, I KNOW, BUT BECAUSE OF THAT, I COULD PREDICT HOW EACH CHARACTER WOULD **REACT** IN ANY GIVEN SITUATION.

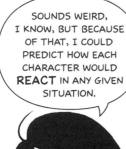

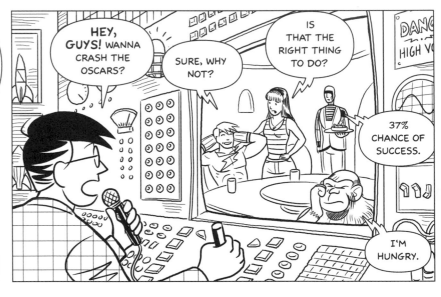

HEY, **GUYS!** WANNA CRASH THE OSCARS?

SURE, WHY NOT?

IS THAT THE RIGHT THING TO DO?

37% CHANCE OF SUCCESS.

I'M HUNGRY.

ARCHETYPES FROM MYTH AND LEGEND LIKE THE "OLD WISE MAN," THE "HERO" OR "THE TRICKSTER" CAN ALSO BE USED TO INSURE A VARIETY OF DESIRES AND WORLD VIEWS --

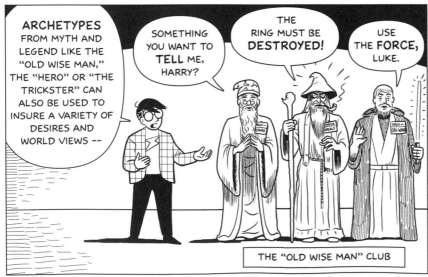

SOMETHING YOU WANT TO **TELL** ME, HARRY?

THE RING MUST BE **DESTROYED!**

USE THE **FORCE,** LUKE.

THE "OLD WISE MAN" CLUB

-- WHILE TAPPING INTO UNIVERSAL VALUES THAT TRANSCEND ANY ONE GENRE OR CULTURE.

CAN I GET YOUR *AUTOGRAPH?*

HANDS OFF THE CLOAK.

HUMAN BEINGS ARE **COMPLICATED CREATURES** WITH A LOT OF SUBTLE VARIATIONS.

CAPTURING THAT SUBTLETY AND COMPLEXITY IS A CHALLENGE MANY MODERN CARTOONISTS ARE TRYING TO MEET, ESPECIALLY IN THE **GRAPHIC NOVEL** MOVEMENT.

THE RELIANCE ON A **SINGLE THEME** FOR A CHARACTER'S INNER LIFE MAY SEEM TO RUN **AGAINST** THAT AMBITION --

-- AND IT **CAN** IF USING SUCH THEMES JUST PRODUCES CHARACTERS MIRED IN **CLICHES** AND **STEREOTYPES** --

-- BUT EVEN **BROADLY-CONCEIVED** CHARACTERS CAN EVOKE **SUBTLER** ASPECTS OF THE HUMAN CONDITION THROUGH THEIR **INTERACTIONS** WITH ONE ANOTHER.

THE IDEA ISN'T TO **SIMPLIFY** A CHARACTER AT ALL, BUT TO INSURE, BY WHATEVER MEANS, THAT YOUR CAST OF CHARACTERS REPRESENTS A **FULL SPECTRUM** OF APPROACHES TO LIFE --

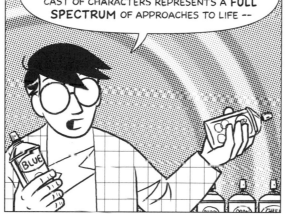

-- BECAUSE **WITHOUT** THAT VARIATION, YOUR CHARACTERS AREN'T GOING TO HAVE MUCH TO TALK ABOUT!

ONE OF THE REASONS WE ALL LOVE STORIES IS THAT THEY OFFER PROPOSALS FOR LIFE'S MEANING AND PURPOSE.

BY PRESENTING CHARACTERS WITH **COMPETING** PHILOSOPHIES OF LIFE YOU CAN OFFER A TRIANGULATED, FULLER PICTURE OF THE WORLD YOUR CHARACTERS LIVE IN.

AND FOR ALL THE BEAUTIFUL ART OR WORDPLAY YOU MIGHT DELIVER, IT'S THAT **PICTURE OF THE WORLD** THAT YOUR READERS MAY REMEMBER BEST.

PANEL FOUR: ART BY WALT KELLY (SEE ART CREDITS, PAGE 258).

OF COURSE, COMICS IS A **VISUAL MEDIUM** --

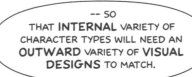

-- SO THAT **INTERNAL** VARIETY OF CHARACTER TYPES WILL NEED AN **OUTWARD** VARIETY OF **VISUAL DESIGNS** TO MATCH.

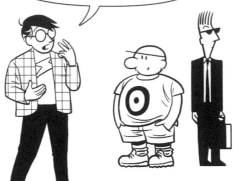

VARIETY AND **DISTINCTION** IN CHARACTER DESIGN ARE IMPORTANT FOR A FEW REASONS.

ON A PURELY **PRACTICAL** LEVEL, THEY HELP THE READER KEEP TRACK OF **WHO'S WHO**. A CAST OF CHARACTERS THAT ALL LOOK THE SAME CAN BE CONFUSING.

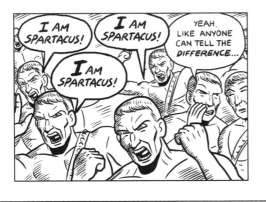

I AM SPARTACUS!

I AM SPARTACUS!

I AM SPARTACUS!

YEAH. LIKE ANYONE CAN TELL THE **DIFFERENCE**...

AND EVEN IF DETAILS LIKE **FACIAL HAIR** AND **CLOTHING** ARE THROWN IN TO DISTINGUISH THEM, TOO MUCH SIMILARITY IN CHARACTERS' UNDERLYING APPEARANCE CAN LEAD TO A BLAND **COOKIE-CUTTER** LOOK.

NO! IT CAN'T BE TRUE!

NO, IT CAN'T BE **TRUE!**

NO, IT **CAN'T** BE TRUE!

NO, IT CAN'T **BE** TRUE!

SOME STRIVE TO MAKE EVERY ONE OF THEIR CHARACTERS **BEAUTIFUL**, AND IN DOING SO RELY ON THE SAME **IDEAL FACE** AND **BODY** REPEATEDLY.

BUT BEAUTY IS MORE EFFECTIVE WHEN GIVEN A BASIS FOR **COMPARISON** --

-- AND THERE ARE MANY DIFFERENT **KINDS** OF BEAUTY TO CHOOSE FROM.

PANEL SEVEN: ART BY RUMIKO TAKAHASHI (SEE ART CREDITS, PAGE 258).

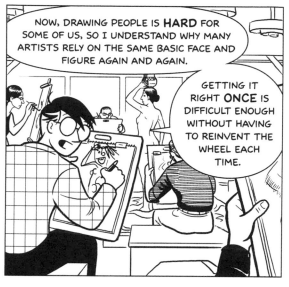

NOW, DRAWING PEOPLE IS **HARD** FOR SOME OF US, SO I UNDERSTAND WHY MANY ARTISTS RELY ON THE SAME BASIC FACE AND FIGURE AGAIN AND AGAIN.

GETTING IT RIGHT **ONCE** IS DIFFICULT ENOUGH WITHOUT HAVING TO REINVENT THE WHEEL EACH TIME.

BUT ADDING **VARIETY** DOESN'T REQUIRE YOU TO BE A **MASTER DRAFTSMAN.**

IT JUST MEANS TAKING A CLOSER LOOK AT YOUR ARTWORK AND ASKING YOURSELF A FEW **QUESTIONS.**

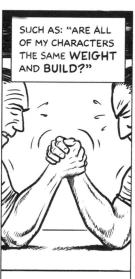

SUCH AS: "ARE ALL OF MY CHARACTERS THE SAME **WEIGHT** AND **BUILD?**"

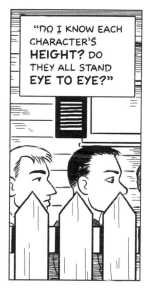

"DO I KNOW EACH CHARACTER'S **HEIGHT?** DO THEY ALL STAND **EYE TO EYE?**"

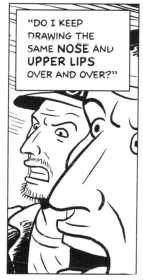

"DO I KEEP DRAWING THE SAME **NOSE** AND **UPPER LIPS** OVER AND OVER?"

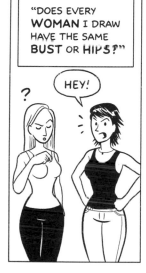

"DOES EVERY **WOMAN** I DRAW HAVE THE SAME **BUST** OR **HIPS?**"

?

HEY!

DEEPER DIFFERENCES OF FACE AND BODY TYPE HELP READERS KEEP TRACK OF YOUR CAST, AND GIVES THEM A **UNIQUE VISUAL REMINDER** OF CHARACTERS' DIFFERENT **PERSONALITIES.**

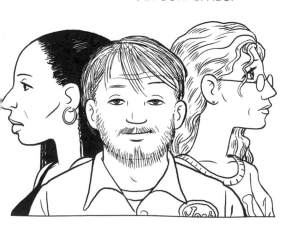

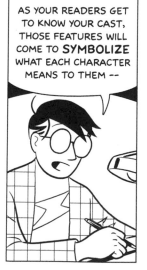

AS YOUR READERS GET TO KNOW YOUR CAST, THOSE FEATURES WILL COME TO **SYMBOLIZE** WHAT EACH CHARACTER MEANS TO THEM --

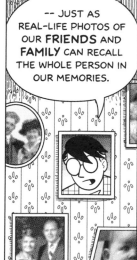

-- JUST AS REAL-LIFE PHOTOS OF OUR **FRIENDS** AND **FAMILY** CAN RECALL THE WHOLE PERSON IN OUR MEMORIES.

CARTOONY STYLES ACCOMMODATE MORE DRAMATIC VARIATIONS IN BODY TYPES, SO SUCH EXTREME DIFFERENCES HAVE TRADITIONALLY BEEN ASSOCIATED WITH **ALL-AGES** TITLES.

BUT IN SOME COMICS CULTURES, **DRAMATIC** STORIES HAVE ALSO BENEFITED FROM THEM --

-- AND EVEN **REALISTICALLY** PROPORTIONED FIGURES CAN SHOW DISTINCT VARIATIONS IN **SHAPE, SIZE** AND OTHER FEATURES.

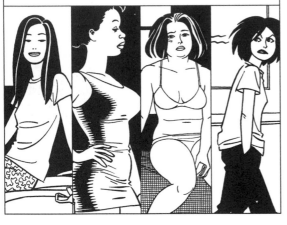

PAY SPECIAL ATTENTION TO **EYES.** I FOUND WHEN DOING *ZOT!* THAT I COULD HIGHLIGHT CHARACTERS' UNIQUE QUALITIES BY GIVING EACH ONE A **UNIQUE** AND **EASILY RECOGNIZED** PAIR OF **EYES.**

AS WITH INNER DRIVES, SOMETIMES A CHARACTER'S OUTER APPEARANCE CAN BE BUILT AROUND A **SINGLE IDEA.**

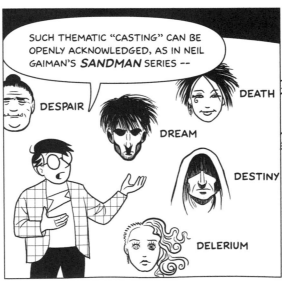

SUCH THEMATIC "CASTING" CAN BE OPENLY ACKNOWLEDGED, AS IN NEIL GAIMAN'S *SANDMAN* SERIES --

DESPAIR

DREAM

DEATH

DESTINY

DELERIUM

-- OR JUST UNDER THE SURFACE, AS IN LEE AND KIRBY'S *FANTASTIC FOUR.*

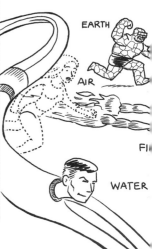

EARTH

AIR

FI

WATER

EISNER SUGGESTS USING **ANIMALS*** AS A BASIS FOR CHARACTERS, IN PART TO TAP INTO READERS' PRIMORDIAL REACTIONS. AND LUCKILY THERE ARE A LOT OF ANIMALS OUT THERE TO CHOOSE FROM!

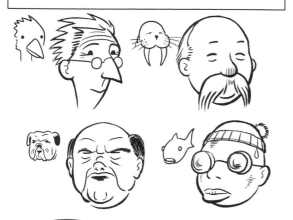

ANYTHING GOES. EVEN AFTER ONE SET OF THEMES HAS BEEN USED, IT CAN ALWAYS BE USED AGAIN -- SO LONG AS YOUR TAKE ON IT IS **FRESH.**

EARTH AIR FIRE WATER

USE YOUR **IMAGINATION** AND YOU CAN PROBABLY COME UP WITH **MANY** SUCH THEMATIC GROUPS TO USE.

TAP! TAP!

SOME SUGGESTIONS:

- THE FOUR SEASONS
- CHESS PIECES
- THE FIVE SENSES
- MYTHOLOGICAL FIGURES
- COUNTRIES/STATES
- CULTURAL ERAS
- THE PLANETS
- HISTORICAL FIGURES
- TREES/PLANTS
- TOYS
- TAROT CARDS
- THE SEVEN DEADLY SINS
- SONGS
- HAND TOOLS
- ASTROLOGICAL SIGNS

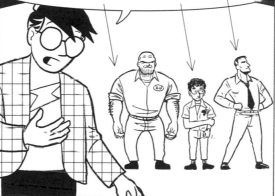

YOU MAY EVEN WANT TO TAP SOME OF THE VARIOUS PHYSICAL **STEREOTYPES** CARTOONISTS HAVE USED OVER THE YEARS, THE **FACE** AND **BODY TYPES** THAT CAN MARK A CHARACTER AS **"HEROIC"** OR **"BRUTISH"** OR **"NERDY,"** ETC.

THESE HAVE THE ADVANTAGE OF BEING INSTANTLY RECOGNIZABLE AND CONFORMING TO **READER EXPECTATIONS.**

OF COURSE, YOU COULD ALSO **CONTRADICT** THOSE ASSUMPTIONS, GIVE YOUR READERS A SURPRISE, AND PUNCTURE SOME **REAL-LIFE** STEREOTYPES IN THE PROCESS!

AT TIMES, I THINK POETRY IS CIVILIZATION'S ONLY RATIONAL RESPONSE TO THE FUTILITY OF LINGUISTIC REPRESENTATION.

HEY! WHAT THE **HELL** ARE YOU **TALKING** ABOUT?!

EEK!! A **MOUSE!**

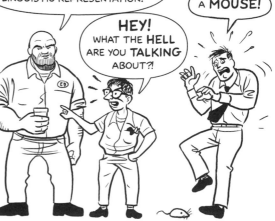

*IN HIS BOOK *GRAPHIC STORYTELLING* (SEE BIBLIOGRAPHY)

ONCE YOU'VE DECIDED ON A BASIC **DESIGN** FOR YOUR CHARACTER, YOU MAY WANT TO LOCK THAT DESIGN IN WITH A **"MODEL SHEET."**

THIS IS A SERIES OF DRAWINGS OF YOUR CHARACTER FROM VARIOUS ANGLES -- A KIND OF **BLUEPRINT** YOU CAN REFER TO WHEN DRAWING.

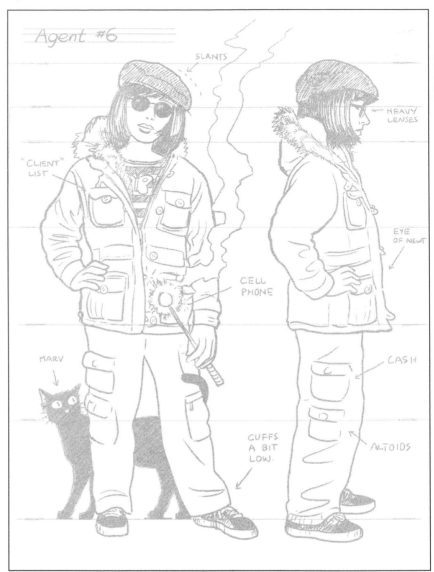

A GOOD MODEL SHEET WILL USUALLY INCLUDE BOTH **FULL FIGURE** AND FACIAL **CLOSE-UPS** --

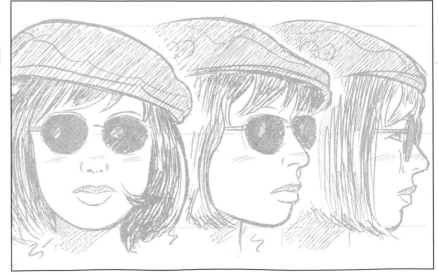

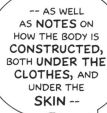

-- AS WELL AS **NOTES** ON HOW THE BODY IS **CONSTRUCTED,** BOTH **UNDER THE CLOTHES,** AND UNDER THE **SKIN** --

-- **COSTUME** DETAILS, IF THERE **IS** A COSTUME --

-- OR THE DIFFERENT STYLES OF **CLOTHING** YOUR CHARACTER LIKES TO WEAR.

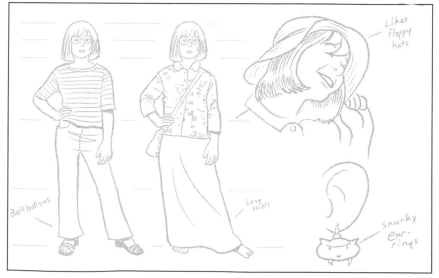

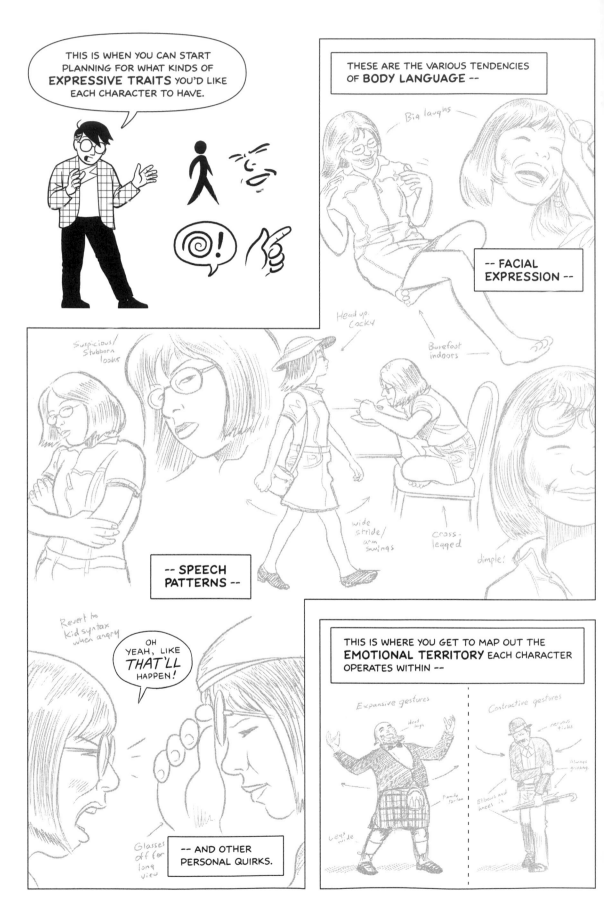

THIS IS WHEN YOU CAN START PLANNING FOR WHAT KINDS OF **EXPRESSIVE TRAITS** YOU'D LIKE EACH CHARACTER TO HAVE.

THESE ARE THE VARIOUS TENDENCIES OF **BODY LANGUAGE** --

-- FACIAL EXPRESSION --

-- SPEECH PATTERNS --

OH YEAH, LIKE *THAT'LL* HAPPEN!

-- AND OTHER PERSONAL QUIRKS.

THIS IS WHERE YOU GET TO MAP OUT THE **EMOTIONAL TERRITORY** EACH CHARACTER OPERATES WITHIN --

-- AND LOOK FOR THOSE TWO OR THREE **KEY EXPRESSIONS** OR **POSES** UNIQUE TO EACH CHARACTER.

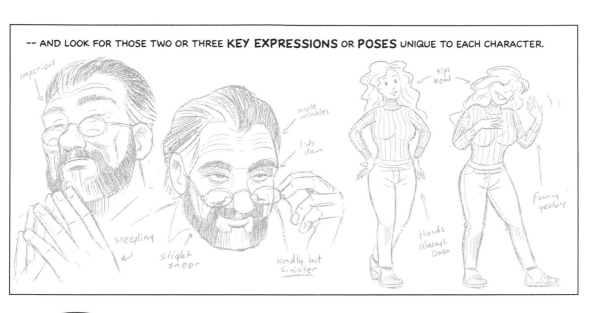

YOU CAN EVEN **BUILD** YOUR CHARACTERS WITH CERTAIN TYPES OF EXPRESSIONS IN MIND!

SLIGHTLY **CROSSED EYES** FOR A SLIGHTLY FLAKY **CHARACTER**, FOR EXAMPLE.

OR A FULL SUPPLY OF **WRINKLES**, TAILOR-MADE FOR **SNEERING.**

OR A PERMANENT **SLOUCH** FOR A **GRUMPY, DEFEATED** PERSONALITY.

NOW, TO BE HONEST, NOT EVERY CARTOONIST GOES TO THIS MUCH TROUBLE, ESPECIALLY FOR ONE-SHOT MINOR CHARACTERS.

SOME TRUST THEMSELVES TO DESIGN CHARACTERS ON THE FLY --

-- AND MANY MODEL SHEETS ARE LITTLE MORE THAN **ROUGH SKETCHES.**

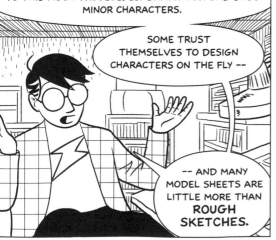

BUT WHETHER YOU PLAN TO THE **LAST DETAIL** OR PREFER TO **WING IT**, YOUR GOALS SHOULD BE THE **SAME** --

-- TO FIGURE OUT WHAT MAKES EACH CHARACTER **UNIQUE** AND PUT THOSE QUALITIES **FRONT** AND **CENTER.**

THESE ARE THE THREE COMPONENTS OF **SUCCESSFUL CHARACTER DESIGN.**

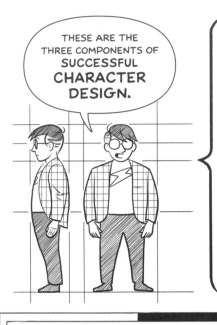

AN INNER LIFE

VISUAL DISTINCTION

EXPRESSIVE TRAITS

THEY PRESENT **DIFFERENT CHALLENGES,** BUT ALL SHARE A **COMMON STRATEGY:**

TO MAKE SURE EACH CHARACTER HAS A **MENTAL, VISUAL** AND **BEHAVIORAL TERRITORY** ALL THEIR OWN, BY HIGHLIGHTING THE DIFFERENCES **BETWEEN** CHARACTERS --

-- AND UNIFYING THE LOOK AND FEEL **WITHIN** EACH ONE.

LIKE **PLANETS,** KEPT APART IN THEIR SEPARATE ORBITS BUT HELD TOGETHER BY GRAVITY.

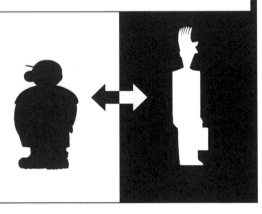

THE READER WILL BE GETTING TO KNOW YOUR CHARACTERS ACROSS HUNDREDS OR EVEN THOUSANDS OF PANELS, THROUGH SMALL FRAGMENTS OF **SPEECH, SIGHT** AND **ACTION** --

-- WHICH CAN ADD UP TO A SINGLE CONTINUOUS ILLUSION OF **HUMAN LIFE** --

-- **IF** THOSE FRAGMENTS DO THEIR JOB **CONSISTENTLY** AND **EFFECTIVELY** FROM BEGINNING TO END.

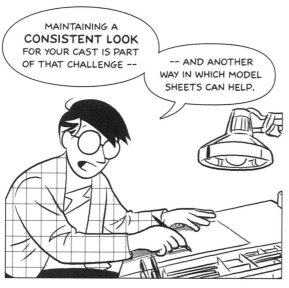

MAINTAINING A **CONSISTENT LOOK** FOR YOUR CAST IS PART OF THAT CHALLENGE --

-- AND ANOTHER WAY IN WHICH MODEL SHEETS CAN HELP.

DON'T WORRY ABOUT MATCHING YOUR ART TO THE MODEL SHEET **EXACTLY.** THERE'S NOTHING WRONG WITH A LITTLE DYNAMIC **VARIATION** --

-- AND OVER THE YEARS, SOME **CHANGES** ARE BOUND TO OCCUR IN THE WAY YOU DRAW YOUR CHARACTERS --

MY CHARACTER AND I HAVE BOTH GOTTEN A BIT, UM... **ROUNDER** OVER THE YEARS, FOR EXAMPLE.

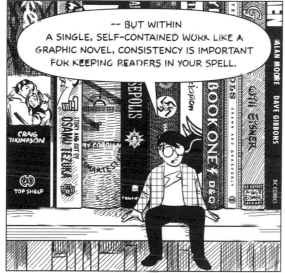

-- BUT WITHIN A SINGLE, SELF-CONTAINED WORK LIKE A GRAPHIC NOVEL, CONSISTENCY IS IMPORTANT FOR KEEPING READERS IN YOUR SPELL.

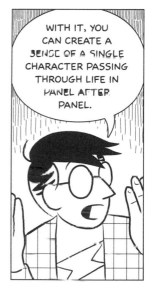

WITH IT, YOU CAN CREATE A SENSE OF A SINGLE CHARACTER PASSING THROUGH LIFE IN PANEL AFTER PANEL.

WITHOUT IT, THAT SPELL CAN **BREAK,** AND LEAVE YOUR READERS WITH NOTHING BUT **LINES ON A PAGE.**

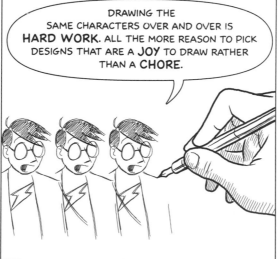

DRAWING THE SAME CHARACTERS OVER AND OVER IS **HARD WORK.** ALL THE MORE REASON TO PICK DESIGNS THAT ARE A **JOY** TO DRAW RATHER THAN A **CHORE.**

AFTER ALL, YOU'RE GOING TO BE **FACE-TO-FACE** WITH THESE GUYS A **LOT.**

2. FACIAL EXPRESSIONS

IT IS, IN FACT, A PICTURE OF **NO** EXPRESSION WHATSOEVER!

THIS IS A FACE IN WHICH **NONE** OF THE FACIAL MUSCLES ARE BEING USED, EXCEPT MAYBE THE **EYELIDS** KEEPING THE EYES OPEN.

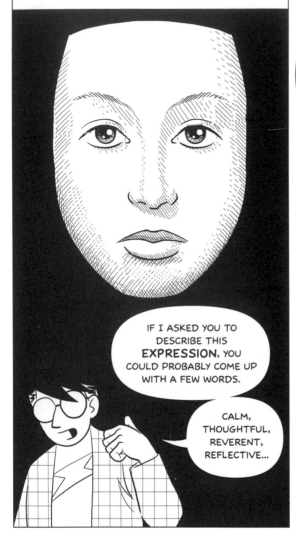

IF I ASKED YOU TO DESCRIBE THIS **EXPRESSION**, YOU COULD PROBABLY COME UP WITH A FEW WORDS.

CALM, THOUGHTFUL, REVERENT, REFLECTIVE...

THIS MIGHT BE THE MOST **COMMON** EXPRESSION OF ALL. PEOPLE DO IT **OFTEN**, EVERY DAY.

BUT YOU'LL ALMOST NEVER GET TO SEE IT **HEAD-ON** LIKE THIS --

--BECAUSE, AS SOON AS THAT OTHER FACE'S EYES MEET YOURS, YOU'LL PROBABLY GET A **REACTION** -- AND **RESPOND** IN KIND.

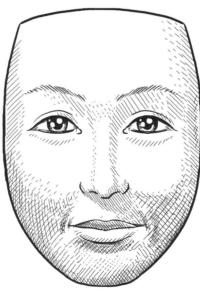

IN FACT, **YOUR OWN** EXPRESSION MAY HAVE **SOFTENED** A BIT JUST NOW, SIMPLY FROM LOOKING AT THIS PICTURE!

EXPRESSIONS AREN'T SOMETHING WE CAN **OPT OUT** OF EASILY, AS WITH WORDS.

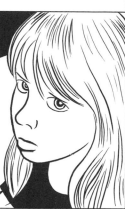

THEY'RE A COMPULSIVE FORM OF **VISUAL COMMUNICATION** ALL OF US USE.

WE ALL KNOW HOW TO **"READ"** AND **"WRITE"** THEM WITH OUR FACES --

-- BUT FEW OF US CAN CONSCIOUSLY **REPRO-DUCE** THEM IN **ART** WITH AS MUCH STYLE AND GRACE --

-- AS WE DO IN **LIFE.**

YET, AS **COMICS ARTISTS,** WE NEED TO DO EXACTLY **THAT** IF WE WANT THE EMOTIONS OF OUR CHARACTERS TO **COME THROUGH** ON THE **PAGE.**

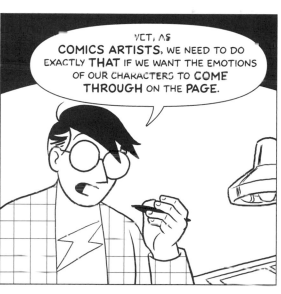

ALMOST ANY STORY CAN BE EVALUATED BY ITS ABILITY TO **PROVOKE EMOTION** IN THE READER, EVEN IF EMOTIONS AREN'T ITS PRIMARY FOCUS --

-- AND THERE'S NO STRONGER CONDUIT TO YOUR READERS' EMOTIONS THAN THROUGH THE EMOTIONS OF THE **CHARACTERS** YOU CREATE **FOR** THEM.

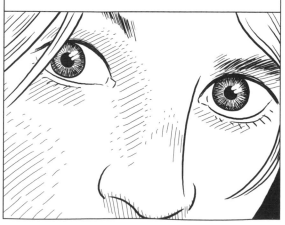

AND WITH FOUR SENSES, MOST NOTABLY **SOUND,** UNAVAILABLE TO YOU --

-- YOU'LL WANT TO GET THE MOST OUT OF THE ONE YOU **HAVE.**

TAP TAP

PUTTING **FACIAL EXPRESSIONS** TO USE IN **COMICS** REQUIRES YOU TO TACKLE **FOUR SUBJECTS:**

THE DIFFERENT **KINDS** OF FACIAL EXPRESSIONS AND WHERE THEY COME FROM.

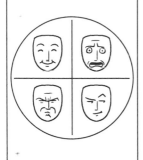

HOW THOSE EXPRESSIONS ARE FORMED BY THE **MUSCLES** OF THE FACE.

THE VARIOUS STRATEGIES FOR **RENDERING** THOSE EXPRESSIONS **GRAPHICALLY.**

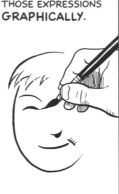

AND HOW FACIAL EXPRESSIONS WORK IN COMICS-STYLE **SEQUENCES.**

WHO?

OH! HA! HA! HA! HA!

THE HUMAN FACE CAN TAKE ON ANY NUMBER OF SHAPES IN THE COURSE OF A DAY.

SOME INDICATE **PHYSICAL STATES** SUCH AS PAIN OR EXHAUSTION.

SOME ARE MEANT TO COMMUNICATE WITH OTHERS **DIRECTLY.**

BUT THE LION'S SHARE OF THE FACE'S POWER TO MOVE US LIES IN ITS ABILITY TO CONVEY **BASIC HUMAN EMOTIONS.**

THE RESULTS OF THAT PROCESS CAN BE VARIED AND COMPLEX, BUT AT ITS SOURCE ARE A FEW SIMPLE **BUILDING BLOCKS.**

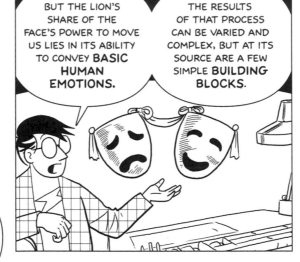

IN 1872, DARWIN WROTE THAT SOME EXPRESSIONS MIGHT BE **UNIVERSAL,** A VIEW SHARED BY MODERN EXPRESSIONS EXPERTS LIKE PAUL EKMAN.*

THESE ARE THE **BASIC EMOTIONS** WHICH **ALL** HUMAN BEINGS EXHIBIT, REGARDLESS OF **CULTURE, LANGUAGE** OR **AGE,** A SMALL HANDFUL OF "PURE" EXPRESSIONS FROM WHICH OTHERS ARE DERIVED.

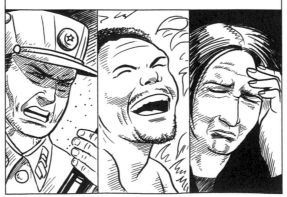

SIX OF THEM, TO BE EXACT.

* SEE BIBLIOGRAPHY.

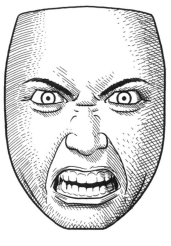

ANGER

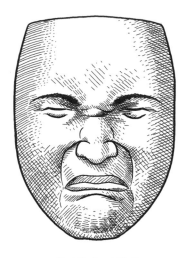

DISGUST

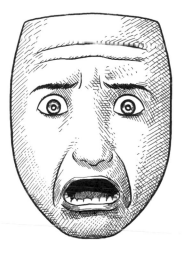

FEAR

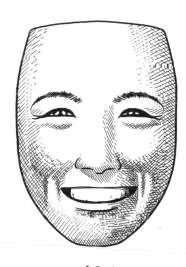

JOY

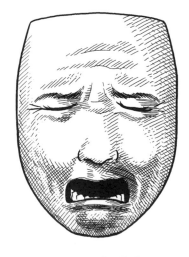

SADNESS

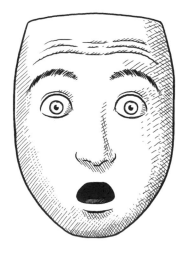

SURPRISE

NOW, SOME OF YOU MIGHT BE THINKING: "THAT CAN'T BE IT! THERE ARE **FAR** MORE EXPRESSIONS THAN **THOSE**."

AND THERE **ARE!** BUT JUST AS THREE PRIMARY **COLORS** CAN BE **MODIFIED** OR **MIXED** TO ACHIEVE EVERY COLOR OF THE **RAINBOW** --

-- SO TOO CAN THESE **EMOTIONAL PRIMARIES** BE **MODIFIED** AND **MIXED** TO CREATE MANY OF THE EXPRESSIONS WE SEE EVERY DAY.

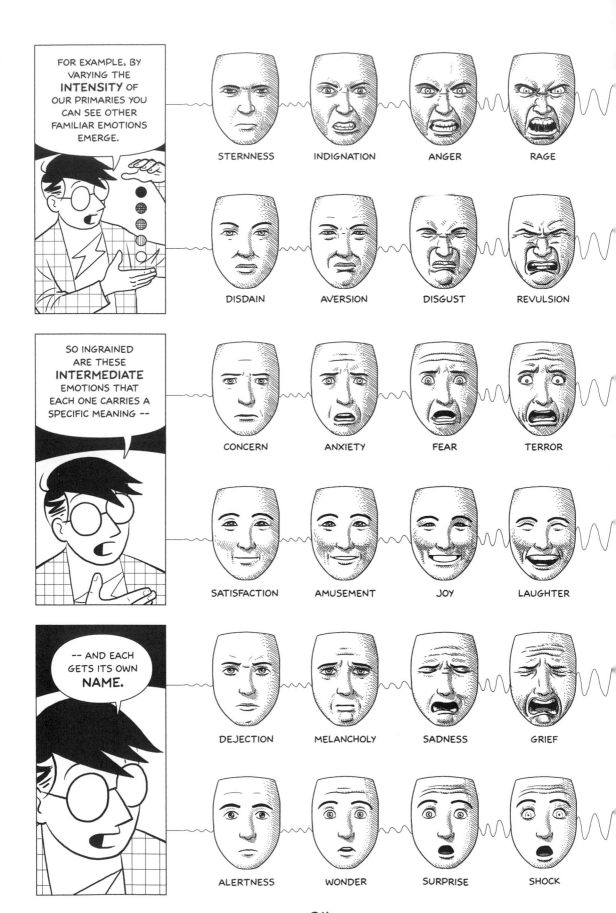

FOR EXAMPLE, BY VARYING THE **INTENSITY** OF OUR PRIMARIES YOU CAN SEE OTHER FAMILIAR EMOTIONS EMERGE.

STERNNESS INDIGNATION ANGER RAGE

DISDAIN AVERSION DISGUST REVULSION

SO INGRAINED ARE THESE **INTERMEDIATE** EMOTIONS THAT EACH ONE CARRIES A SPECIFIC MEANING --

CONCERN ANXIETY FEAR TERROR

SATISFACTION AMUSEMENT JOY LAUGHTER

-- AND EACH GETS ITS OWN **NAME.**

DEJECTION MELANCHOLY SADNESS GRIEF

ALERTNESS WONDER SURPRISE SHOCK

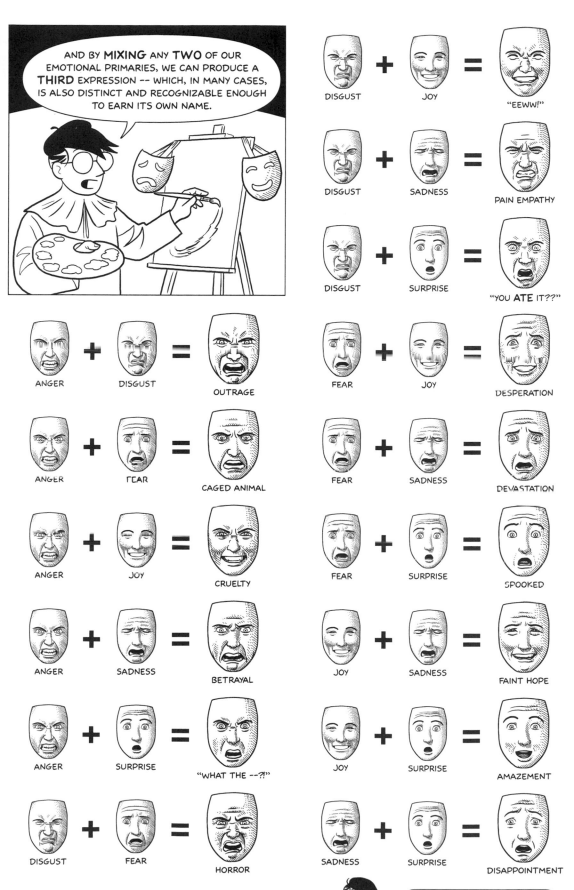

AND BY **MIXING** ANY **TWO** OF OUR EMOTIONAL PRIMARIES, WE CAN PRODUCE A **THIRD** EXPRESSION -- WHICH, IN MANY CASES, IS ALSO DISTINCT AND RECOGNIZABLE ENOUGH TO EARN ITS OWN NAME.

DISGUST + JOY = "EEWW!"

DISGUST + SADNESS = PAIN EMPATHY

DISGUST + SURPRISE = "YOU **ATE** IT??"

ANGER + DISGUST = OUTRAGE

ANGER + FEAR = CAGED ANIMAL

ANGER + JOY = CRUELTY

ANGER + SADNESS = BETRAYAL

ANGER + SURPRISE = "WHAT THE --?!"

DISGUST + FEAR = HORROR

FEAR + JOY = DESPERATION

FEAR + SADNESS = DEVASTATION

FEAR + SURPRISE = SPOOKED

JOY + SADNESS = FAINT HOPE

JOY + SURPRISE = AMAZEMENT

SADNESS + SURPRISE = DISAPPOINTMENT

CREEPY, YES -- BUT **USEFUL**. SEE THE CHAPTER NOTES FOR MORE ON WHY.

THROW IN **MIXTURES** OF THE OTHER **INTENSITIES** --

MILD DISGUST **+** MILD SADNESS **=** PUZZLEMENT

MILD JOY **+** MILD SADNESS **=** PITY

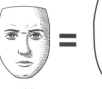

-- OR EVEN COMBINATIONS OF **THREE** OR MORE --

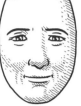

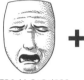

STRONG SADNESS **+**

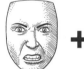

MODERATE ANGER **+**

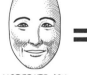

MODERATE JOY **=**

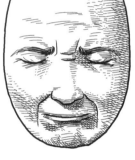

REMEMBERING A DECEASED LOVED ONE.

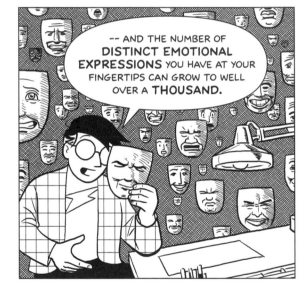

-- AND THE NUMBER OF **DISTINCT EMOTIONAL EXPRESSIONS** YOU HAVE AT YOUR FINGERTIPS CAN GROW TO WELL OVER A **THOUSAND.**

AND THERE ARE **OTHER FACTORS** WHICH CAN ADD EVEN **MORE** VARIETY.

FOR EXAMPLE, NOTICE HOW ALL OF THE FACES STEMMING FROM THE EMOTIONAL PRIMARIES HAVE BEEN LARGELY **SYMMETRICAL?**

EMOTION HAS NO **DIRECTION.** IT COMES FROM **WITHIN.**

BUT THERE'S A WORLD **OUTSIDE** THOSE FACES THAT CAN ALSO PLAY A PART IN **FACIAL EXPRESSIONS.**

PHYSICAL STATES ARE AS **INBORN** AND **ANCIENT** A FACTOR IN FACIAL EXPRESSIONS AS **BASIC EMOTIONS** --

-- BUT BECAUSE THEY INVOLVE OUR CHAOTIC INTERACTIONS WITH THE **PHYSICAL WORLD**, THE SHAPES THEY TAKE CAN BE LESS **BALANCED** AND **PREDICTABLE,**

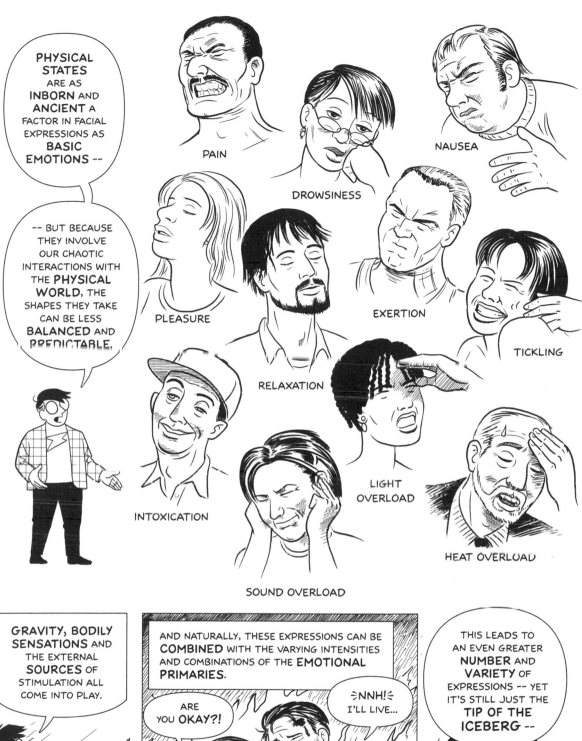

PAIN

DROWSINESS

NAUSEA

PLEASURE

RELAXATION

EXERTION

TICKLING

INTOXICATION

LIGHT OVERLOAD

HEAT OVERLOAD

SOUND OVERLOAD

GRAVITY, BODILY **SENSATIONS** AND THE EXTERNAL **SOURCES** OF STIMULATION ALL COME INTO PLAY.

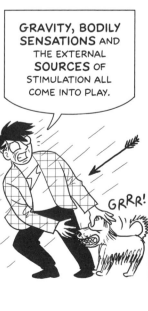

GRRR!

AND NATURALLY, THESE EXPRESSIONS CAN BE **COMBINED** WITH THE VARYING INTENSITIES AND COMBINATIONS OF THE **EMOTIONAL PRIMARIES.**

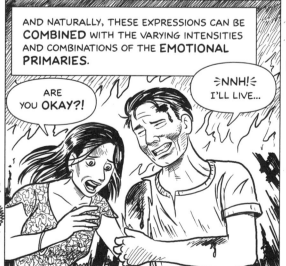

ARE YOU **OKAY?!**

⇒NNH!⇐ I'LL LIVE...

THIS LEADS TO AN EVEN GREATER **NUMBER** AND **VARIETY** OF EXPRESSIONS -- YET IT'S STILL JUST THE **TIP OF THE ICEBERG** --

87

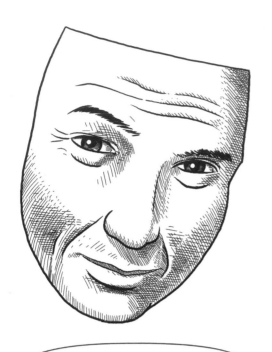

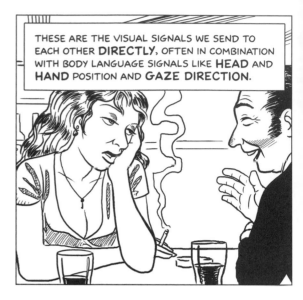

THESE ARE THE VISUAL SIGNALS WE SEND TO EACH OTHER **DIRECTLY**, OFTEN IN COMBINATION WITH BODY LANGUAGE SIGNALS LIKE **HEAD** AND **HAND** POSITION AND **GAZE DIRECTION**.

-- BECAUSE WHEN YOU THROW IN ALL THE MANY WAYS WE USE OUR FACES AS A FORM OF **DIRECT SPECIALIZED SIGNAL** --

-- NO SYSTEM OF ANALYSIS COULD EVER BEGIN TO **CATALOG** ALL THE DIFFERENT TYPES OF FACIAL EXPRESSIONS YOUR CHARACTERS COULD WEAR!

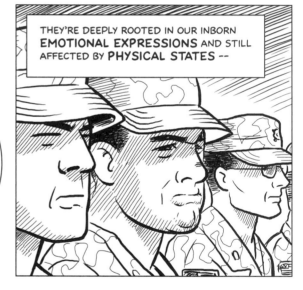

THEY'RE DEEPLY ROOTED IN OUR INBORN **EMOTIONAL EXPRESSIONS** AND STILL AFFECTED BY **PHYSICAL STATES** --

-- BUT THEY **ADD** AN EVER-CHANGING GLOSSARY OF CULTURALLY-SPECIFIC **SIGNS** AND **SYMBOLS** UNDERSTOOD BY BOTH **SENDER** AND **RECEIVER**.

THEY ARE, FOR ALL INTENTS AND PURPOSES, A **LANGUAGE** -- THOUGH A LANGUAGE ONLY PARTIALLY UNDER OUR CONSCIOUS CONTROL.

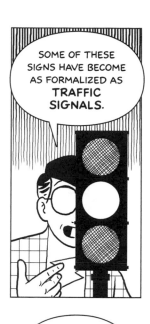

SOME OF THESE SIGNS HAVE BECOME AS FORMALIZED AS **TRAFFIC SIGNALS.**

THE WINK.

THE OUTSTRETCHED TONGUE.

THE "OH, MOM...!" LOOK.

BUT MOST ARE MORE **SUBTLE** AND **IDIOSYNCRATIC,** TAILORED TO SPECIFIC **PEOPLE** IN SPECIFIC **SITUATIONS,** AND SUBJECT TO THE INDIVIDUAL **STYLE** OF THE SENDER.

BY ADDING **HEAD POSITION** AND **GAZE DIRECTION** TO THE MIX, AND ALLOWING FOR **ASYMMETRY,** THEY ACHIEVE FAR MORE **VARIETY** THAN THE BASIC EMOTIONAL EXPRESSIONS --

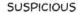

SUSPICIOUS

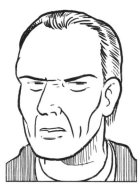

COY

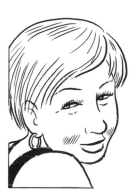

SELF-RIGHTEOUS

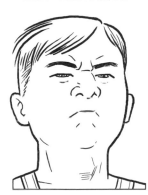

-- BUT THEY'RE ALSO HARDER TO PIN DOWN, OR MAKE UNIVERSALLY RECOGNIZABLE, SO **CONTEXT** IS IMPORTANT WHEN SEPARATING "PLEADING," SAY, FROM MERELY SAD, OR "REGRETFUL" FROM FORGETFUL.

SELF-SATISFIED

PLEADING

REGRETFUL

BUT, ONCE THOSE KEY FEATURES ARE IN PLACE, THE SENDER CAN **SPIN** THAT EXPRESSION IN ANY NUMBER OF DIRECTIONS.

EACH EXPRESSION HAS TO MATCH A FEW **KEY FEATURES** TO BE RECOGNIZABLE.

 HEAD TURNED AWAY

PLUS
↓

NARROWED EYES & EYE CONTACT

PLUS
↓

 LOWERED BROW

EQUALS
↓

SUSPICION

FOUR VARIATIONS ON SUSPICION:

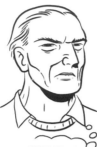 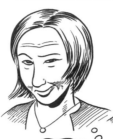 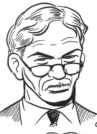 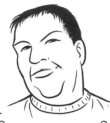

MISTREAT MY DAUGHTER AND I'LL HAVE YOU KILLED.

OH, C'MON. YOU DON'T REALLY EXPECT ME TO BELIEVE THAT?

WE CATCH YOU MAKING PERSONAL CALLS AGAIN, YOU'RE FIRED.

YEAH, YOU'RE A LIAR... BUT YOU'RE MY KIND OF LIAR!

A BIT OF AN EMOTION LIKE DISGUST CAN BE ADDED, FOR EXAMPLE, TO GIVE SUSPICION A **DISDAINFUL AIR.**

BUT IF THAT EMOTION BECOMES THE FACE'S DOMINANT VISUAL STATEMENT, THE EXPRESSION CAN BE **HIJACKED.**

IN REAL LIFE, WE ACHIEVE THESE KINDS OF PRECISE EFFECTS WITHOUT MUCH CONSCIOUS KNOWLEDGE OF **HOW** WE DO IT.

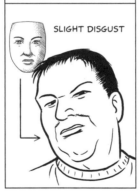 SLIGHT DISGUST

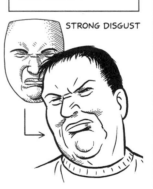 STRONG DISGUST

YET, WE MUST UNDERSTAND ON **SOME** LEVEL HOW OUR FACES ACHIEVE THESE LOOKS --

-- BECAUSE WE CAN ALSO CONSCIOUSLY **IMITATE** ANY OF THESE EXPRESSIONS, AND EVEN ADD AN ELEMENT OF STYLIZATION OR EXAGGERATION TO PRODUCE A **MOCK VERSION** OF EACH ONE.

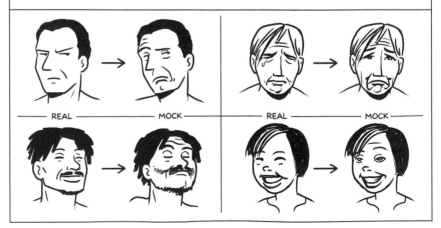

REAL → MOCK REAL → MOCK

IN SOME CASES, AN ATTEMPT TO **STOP** SHOWING EMOTION CAN ACTUALLY BE ONE OF THE KEY FACTORS THAT MAKE A GIVEN FACIAL EXPRESSION RECOGNIZABLE.

EMBARRASSMENT:

AVERTED, FEARFUL GAZE. MOUTH EXPRESSIONLESS.

RESENTMENT:

AVERTED, ANGRY GAZE. MOUTH CLOSED TIGHTLY.

IN FACT, ADULT SOCIETY RELIES, IN LARGE PART, ON THE **SUPPRESSION** OF BASIC EMOTIONS. THE WAYS IN WHICH WE SUPPRESS AND REDIRECT THEM ARE THE SOURCE OF MUCH OF OUR EXPRESSIONS' **VARIETY** AND **DEPTH**.

LOOK AT THE **SMILES** IN SNAPSHOTS AND EACH WILL SEEM AS **UNIQUE** AS A **SNOWFLAKE**.

BUT UNDERNEATH THEM ALL ARE THESE SAME **BASIC PRINCIPLES** PLAYED OUT AGAIN AND AGAIN.

AS **PART** OF HUMAN SOCIETY, WE ALL WANT TO SEE PAST EACH OTHER'S FACES TO THE PERSON **WITHIN**.

-- WE NEED TO UNDERSTAND THAT THE HUMAN FACE **IS** A MACHINE OF SORTS, FOR ALL ITS BEAUTY AND SUBTLETY.

WE DON'T WANT TO DECONSTRUCT THEM TO THE POINT WHERE THE HUMAN FACE SEEMS LIKE A **MACHINE**.

BUT AS ARTISTS HOPING TO **REPRODUCE** THOSE INNER PERSONALITIES IN THE MINDS OF OUR READERS --

AND THE ONLY WAY TO **UNDERSTAND** THAT MACHINE IS TO GO **BENEATH THE SURFACE** --

-- AND SEE ITS **PARTS** IN **ACTION**.

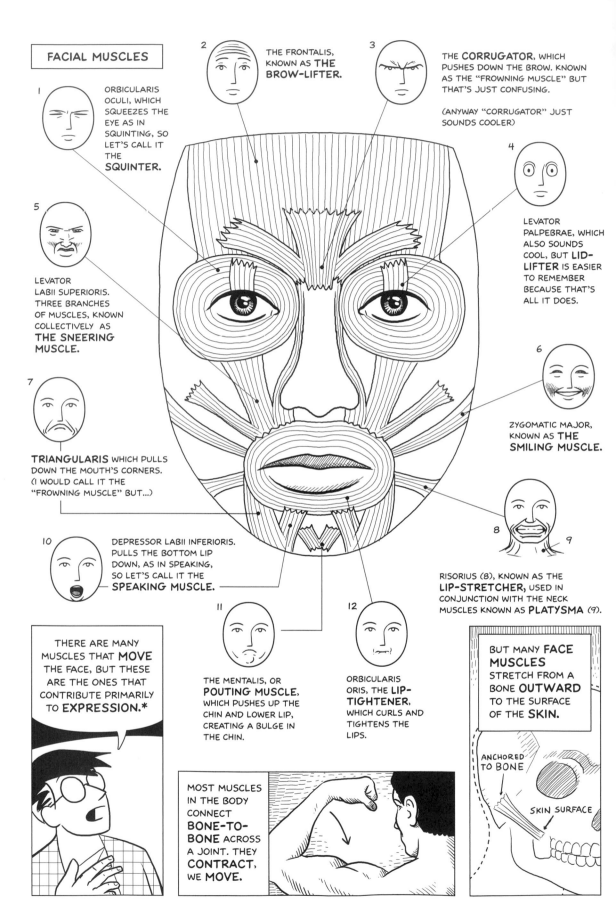

FACIAL MUSCLES

1. ORBICULARIS OCULI, WHICH SQUEEZES THE EYE AS IN SQUINTING, SO LET'S CALL IT THE **SQUINTER.**

2. THE FRONTALIS, KNOWN AS **THE BROW-LIFTER.**

3. THE **CORRUGATOR,** WHICH PUSHES DOWN THE BROW. KNOWN AS THE "FROWNING MUSCLE" BUT THAT'S JUST CONFUSING.

(ANYWAY "CORRUGATOR" JUST SOUNDS COOLER)

4. LEVATOR PALPEBRAE, WHICH ALSO SOUNDS COOL, BUT **LID-LIFTER** IS EASIER TO REMEMBER BECAUSE THAT'S ALL IT DOES.

5. LEVATOR LABII SUPERIORIS. THREE BRANCHES OF MUSCLES, KNOWN COLLECTIVELY AS **THE SNEERING MUSCLE.**

6. ZYGOMATIC MAJOR, KNOWN AS **THE SMILING MUSCLE.**

7. **TRIANGULARIS** WHICH PULLS DOWN THE MOUTH'S CORNERS. (I WOULD CALL IT THE "FROWNING MUSCLE" BUT...)

8/9. RISORIUS (8), KNOWN AS THE **LIP-STRETCHER,** USED IN CONJUNCTION WITH THE NECK MUSCLES KNOWN AS **PLATYSMA** (9).

10. DEPRESSOR LABII INFERIORIS. PULLS THE BOTTOM LIP DOWN, AS IN SPEAKING, SO LET'S CALL IT THE **SPEAKING MUSCLE.**

11. THE MENTALIS, OR **POUTING MUSCLE,** WHICH PUSHES UP THE CHIN AND LOWER LIP, CREATING A BULGE IN THE CHIN.

12. ORBICULARIS ORIS, THE **LIP-TIGHTENER,** WHICH CURLS AND TIGHTENS THE LIPS.

THERE ARE MANY MUSCLES THAT **MOVE** THE FACE, BUT THESE ARE THE ONES THAT CONTRIBUTE PRIMARILY TO **EXPRESSION.***

MOST MUSCLES IN THE BODY CONNECT **BONE-TO-BONE** ACROSS A JOINT. THEY **CONTRACT,** WE **MOVE.**

BUT MANY **FACE MUSCLES** STRETCH FROM A BONE **OUTWARD** TO THE SURFACE OF THE **SKIN.**

ANCHORED TO BONE

SKIN SURFACE

*I GOT THESE TWELVE FROM GARY FAIGIN'S EXCELLENT BOOK ON THE SUBJECT (SEE BIBLIOGRAPHY), THOUGH I MADE SOME NAME CHANGES AS NOTED.

92

WHEN YOU **SMILE**, FOR EXAMPLE, THE **SURFACE** END OF THAT MUSCLE (#6) IS **PULLED** TOWARD THE **ANCHORED** END --

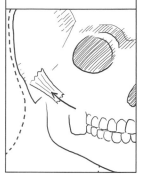

-- **PULLING** THE FLESH FROM **UNDERNEATH** TOWARD THE CHEEK BONE WHERE IT **BUNCHES UP** AND LEADS TO THE IRREGULAR WRINKLES WE CALL **"DIMPLES."**

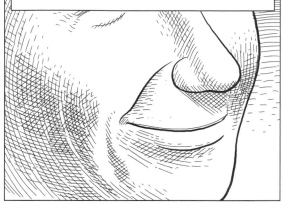

TAKE ANOTHER LOOK AT OUR **EMOTIONAL PRIMARIES** WITH THESE MUSCLES IN MIND.

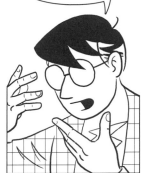

CORRUGATOR PLUS LID-LIFTER ADDS UP TO AN ANGRY GLARE, WHILE THE ACTIVE SNEERING, SPEAKING AND LIP-STRETCHER MUSCLES PRODUCE THE SQUARE MOUTH OF THE CORNERED PREDATOR.

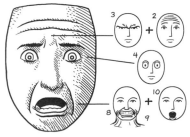

THE SMILING MUSCLE PULLS THE CORNER OF THE MOUTH UP AND OUT, COMPRESSING CHEEKS WHICH, TOGETHER WITH THE SQUINTER, PRODUCE THE ARCHED EYES OF JOY.

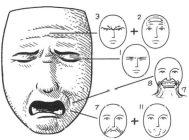

CORRUGATOR PLUS SQUINTING MUSCLE SHUTS THE EYES TIGHT IN REACTION TO THE DISGUST-ING OBJECT OF ATTENTION, WHILE THE MOUTH AND NOSE RECOIL VIA THE POUTING AND SNEERING MUSCLES.

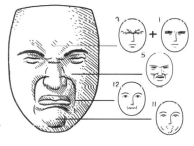

CORRUGATOR/BROW-LIFTER STRUGGLE OVER SQUINTED EYES, WHILE THE LIP-STRETCHER, TRIANGULARIS AND POUTING MUSCLE PRODUCE THE SIDEWAYS '8' SHAPE OF THE CRYING MOUTH.

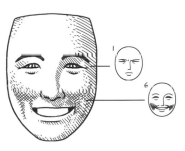

CORRUGATOR AND BROW-LIFTER COMPRESS AND RAISE THE FOREHEAD OVER THE LIFTED LIDS OF FEAR-FILLED EYES, WHILE THE LIPS ARE TIGHTLY STRETCHED APART AND OPENED.

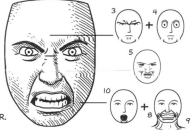

THE BROW-LIFTER PULLS THE UPPER FACE STRAIGHT UP IN SURPRISE OVER WIDE OPEN LID-LIFTED EYES, WHILE THE MOUTH FALLS OPEN. ALL OTHER MUSCLES REMAIN INACTIVE.

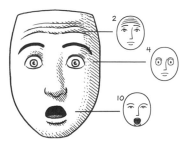

BY LEARNING WHAT'S GOING ON **UNDER** THE **SKIN** YOU CAN BETTER SHOW WHAT'S HAPPEN-ING ON THE **SURFACE** --

-- AND SHOW YOUR **READERS** WHAT'S GOING ON INSIDE YOUR CHARACTERS **MINDS**.

WHEN **DRAWING** EXPRESSIONS, YOU CAN CHOOSE FROM A FEW DIFFERENT **GRAPHIC STRATEGIES.**

REALISM.
REPRODUCING THE REAL-LIFE APPEARANCE OF EXPRESSIONS WITH REALISTIC TONES AND DETAILS.

SIMPLIFICATION.
SEARCHING FOR A FEW KEY LINES OR SHAPES WHICH CLEARLY CONVEY AN EXPRESSION.

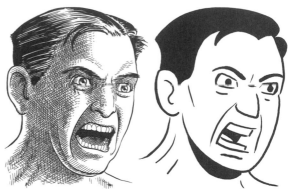

EXAGGERATION.
AMPLIFYING THE KEY FEATURES THAT MAKE AN EXPRESSION RECOGNIZABLE.

SYMBOLISM.
IMAGES THAT DEPICT EMOTIONS SYMBOLICALLY RATHER THAN WITH REAL-WORLD RESEMBLANCE.

AND YOU CAN **INDIRECTLY** AFFECT HOW YOUR AUDIENCE READS AN EXPRESSION BY ITS CONTEXT **WITHIN** A STORY, OR HOW IT'S PAIRED WITH **WORDS.**

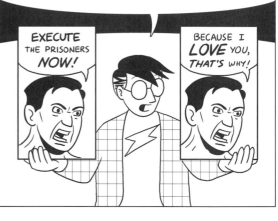

EXECUTE THE PRISONERS **NOW!**

BECAUSE I **LOVE** YOU, **THAT'S** WHY!

IF CHOOSING A MORE **REALISTIC** APPROACH, YOU MIGHT NEED TO USE **LIVE MODELS** OR **PHOTOGRAPHIC REFERENCE.**

FRIENDS AND FAMILY CAN BE ESPECIALLY HELPFUL WHEN GOING FOR REAL-LIFE DETAILS.

OF COURSE, YOUR FRIENDS MAY NOT ALWAYS BE GREAT **ACTORS** --

-- SO GET READY TO USE YOUR KNOWLEDGE OF EXPRESSIONS TO **BRIDGE THE GAP** WHEN NECESSARY.

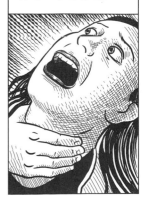

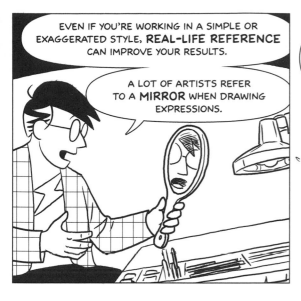

EVEN IF YOU'RE WORKING IN A SIMPLE OR EXAGGERATED STYLE, **REAL-LIFE REFERENCE** CAN IMPROVE YOUR RESULTS.

A LOT OF ARTISTS REFER TO A **MIRROR** WHEN DRAWING EXPRESSIONS.

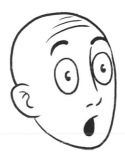

JUST MAKE SURE YOU DON'T START DRAWING ALL YOUR CHARACTERS TO LOOK LIKE **YOU!**

SIMPLIFICATION IS MOST EFFECTIVE WHEN IT CAPTURES THE **KEY FEATURES** OF AN EXPRESSION.

THE ARCHED EYES AND BUNCHED CHEEKS OF **JOY,** FOR EXAMPLE.

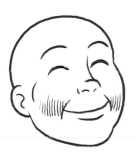

OR THE PINCHED BROW AND NOSE, SQUARED UPPER LIP AND BULGING CHIN OF **DISGUST.**

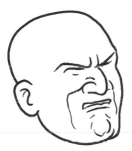

OR THE RAISED BROW, POPPED EYES AND SLACK JAW OF **SURPRISE** --

-- AND HOW IT DIFFERS FROM THE TORTURED BROW AND STRETCHED MOUTH OF **FEAR.**

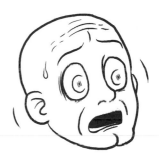

EXAGGERATION SEIZES ON THESE SAME KEY FEATURES AND SIMPLY **RAMPS UP** THEIR GEOMETRIC EXTREMES.

CHEEKS BULGING LIKE GRAPEFRUIT...

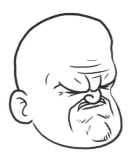

A FACE **PINCHED** NEARLY OUT OF EXISTENCE...

A HEAD **STRETCHED THIN...**

EYES **LITERALLY** "BULGING OUT OF THEIR SOCKETS..."

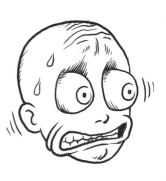

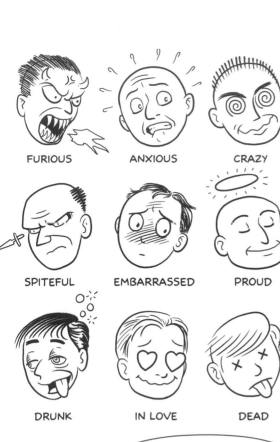

FURIOUS ANXIOUS CRAZY

SPITEFUL EMBARRASSED PROUD

DRUNK IN LOVE DEAD

SOME BEGIN THEIR LIVES AS SIMPLE **PICTURES** OF ACTUAL PHYSICAL REACTIONS SUCH AS SWEAT --

-- THEN DRIFT INTO THE MORE **ABSTRACT** TERRITORY OF PURE SYMBOLS.

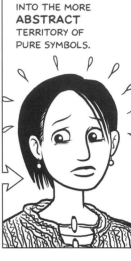

SYMBOLIC EXPRESSIONS DON'T RELY ON AN UNDERSTANDING OF REAL FACIAL EXPRESSIONS TO WORK.

A SIMPLE DOODLE OR TWO IS USUALLY ALL IT TAKES.

OTHERS ARE STRICTLY **METAPHORICAL** AND REQUIRE YOU AND YOUR AUDIENCE TO BOTH **"KNOW THE CODE"** BEFORE THE MESSAGE CAN GET THROUGH.

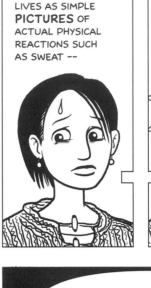

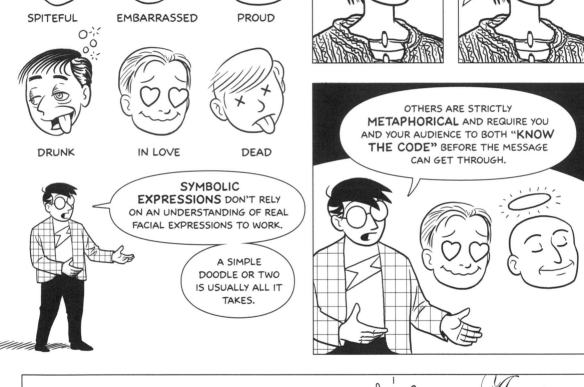

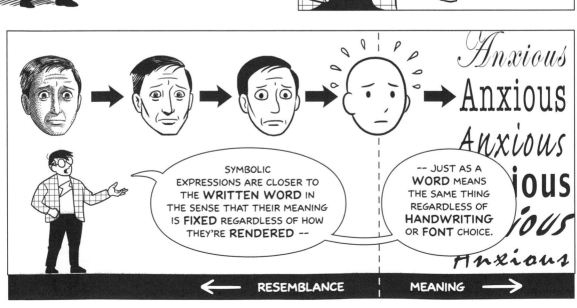

SYMBOLIC EXPRESSIONS ARE CLOSER TO THE **WRITTEN WORD** IN THE SENSE THAT THEIR MEANING IS **FIXED** REGARDLESS OF HOW THEY'RE **RENDERED** --

-- JUST AS A **WORD** MEANS THE SAME THING REGARDLESS OF **HANDWRITING** OR **FONT** CHOICE.

Anxious
Anxious
Anxious
ious
ious
Anxious

← RESEMBLANCE MEANING →

UNLIKE THE BASIC EMOTIONAL EXPRESSIONS, WHICH **ANYONE, ANYWHERE** CAN RECOGNIZE, SYMBOLIC EXPRESSIONS VARY FROM **CULTURE** TO **CULTURE.**

RECENTLY SOME SYMBOLS FROM **JAPANESE** COMICS, LIKE THE BULGING VEIN-ON-FOREHEAD, HAVE BECOME MORE **FAMILIAR** IN ENGLISH LANGUAGE COMICS --

-- BUT OTHER MANGA SYMBOLS STILL SEEM PRETTY **STRANGE** TO WESTERN READERS, SO BEFORE USING ANY SYMBOL, CONSIDER WHETHER YOUR READERS CAN DECODE IT OR NOT.

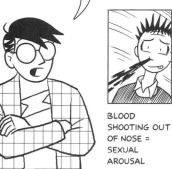

BLOOD SHOOTING OUT OF NOSE = SEXUAL AROUSAL

MUCUS BUBBLE COMING OUT OF NOSE = ASLEEP

SYMBOLS ARE A GREAT WAY TO GET AN EXPRESSION ACROSS, REGARDLESS OF YOUR **DRAWING** ABILITY --

-- BUT DON'T LET THEM BECOME A **CRUTCH!**

A FACE SURROUNDED BY **SWEAT BEADS** WILL READ AS ANXIOUS NO MATTER HOW IT'S DRAWN --

-- BUT THE RIGHT EXPRESSION WILL ADD **STRENGTH** AND **PRECISION** THAT YOU CAN'T ACHIEVE ANY OTHER WAY.

IN THE END, MOST COMICS ARTISTS INCORPORATE AT LEAST A LITTLE REALISM, SIMPLIFICATION, EXAGGERATION **AND** SYMBOLISM INTO THEIR STYLES --

-- WHATEVER IT TAKES TO SPECIFY THE EMOTION AND **GET THE JOB DONE.**

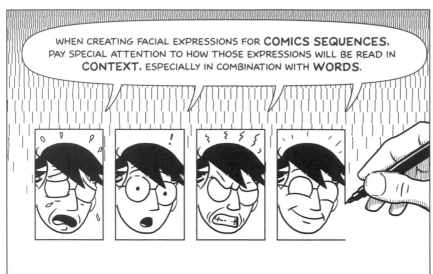

WHEN CREATING FACIAL EXPRESSIONS FOR **COMICS SEQUENCES**, PAY SPECIAL ATTENTION TO HOW THOSE EXPRESSIONS WILL BE READ IN **CONTEXT**, ESPECIALLY IN COMBINATION WITH **WORDS**.

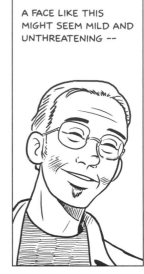

A FACE LIKE THIS MIGHT SEEM MILD AND UNTHREATENING --

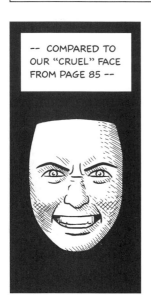

-- COMPARED TO OUR "CRUEL" FACE FROM PAGE 85 --

-- BUT IN THE RIGHT CONTEXT, EVEN THE **KINDEST** SMILE CAN CONVEY CRUELTY.

I'M GOING TO TELL MY FRIEND TO **CUT OFF YOUR FINGERS** NOW.

SOCIETY DISCOURAGES US FROM DISPLAYING OVERLY STRONG EMOTIONS, SO MOST OF US KEEP IT **DIALED DOWN** MOST OF THE TIME.

AS SOCIAL CREATURES, YOUR READERS WILL NOTICE **SMALL CHANGES** OF EXPRESSION IN YOUR CHARACTERS, JUST AS YOUR CHARACTERS NOTICE SUCH CHANGES IN **EACH OTHER**.

HEY, **EARTH TO CLAIRE...** ARE YOU **OKAY**?

YEAH, I'M FINE.

98

DON'T GET **TOO** SUBTLE, THOUGH! IN REAL LIFE, WE CAN COMMUNICATE THE INTENSITY OF OUR FEELINGS THROUGH **VOCAL INFLECTION,** WHILE OUR FACES' EXPRESSIONS STAY FAIRLY **MUTED** --

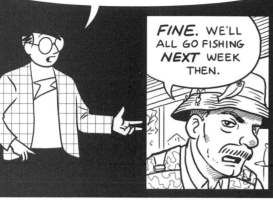

FINE. WE'LL ALL GO FISHING *NEXT* WEEK THEN.

-- BUT IN **COMICS,** WE CAN ONLY APPROXIMATE THE **SOUNDS** OF VOICES --

-- AND READERS AREN'T LOOKING DIRECTLY AT YOUR CHARACTERS' FACES AS THEY **READ** THEIR WORDS --

-- SO YOU MIGHT NEED TO TURN UP THE **EMOTIONAL VOLUME** ON SOME FACES TO COMPENSATE.

FINE. WE'LL ALL GO FISHING *NEXT* WEEK THEN.

CHOOSING THE RIGHT EXPRESSION CAN BE A FUNCTION OF CHOOSING THE RIGHT **MOMENT.** OUR FACES CYCLE THROUGH A LOT OF EXPRESSIONS WHEN SPEAKING.

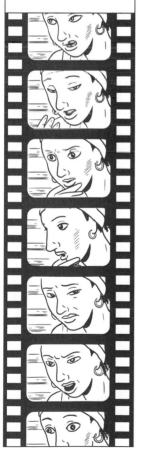

WHEN A SINGLE FACE HAS TO REPRESENT ALL THE WORDS IN A BALLOON OR TWO, SUCH FACES ACT AS A SORT OF **"EMOTIONAL AVERAGE"** SUMMING UP THE BALLOON AS A WHOLE.

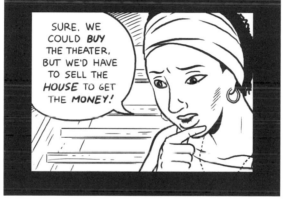

SURE, WE COULD **BUY** THE THEATER, BUT WE'D HAVE TO SELL THE *HOUSE* TO GET THE *MONEY!*

THEN AGAIN, IF EMOTIONAL CHANGES ARE THE **FOCUS** OF A GIVEN SCENE --

-- DEVOTING A PANEL TO **EACH CHANGE OF EMOTION** MIGHT ACHIEVE THE INTENSITY THE SCENE REQUIRES.

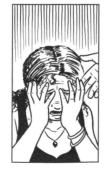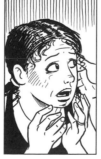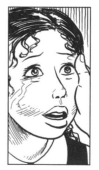

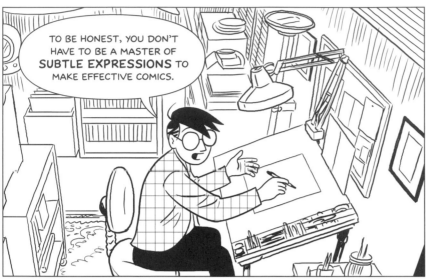

TO BE HONEST, YOU DON'T HAVE TO BE A MASTER OF **SUBTLE EXPRESSIONS** TO MAKE EFFECTIVE COMICS.

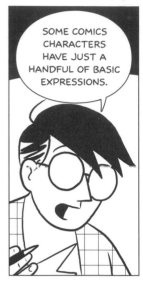

SOME COMICS CHARACTERS HAVE JUST A HANDFUL OF BASIC EXPRESSIONS.

HELL, YOU'RE **LOOKING** AT ONE!

I KNOW I CAN TRUST YOU TO FILL IN THE BLANKS **EMOTIONALLY,** JUST AS YOU FILL IN THE BLANKS **BETWEEN PANELS.**

EVEN WITH THE BAREST OF EVIDENCE YOU'LL WANT TO SEE ME AS A **PERSON,** NOT JUST A SERIES OF DRAWINGS.

SOME OF THE MOST **EMOTIONALLY COMPLEX** COMICS IN HISTORY HAVE FEATURED PROTAGONISTS WITH A **LIMITED PALETTE** OF EXPRESSIONS, YET IN **CONTEXT,** THOSE FACES SEEM TO HAVE BOTH **BREADTH** AND **DEPTH.**

ART SPIEGELMAN'S *MAUS* (LEFT) FEATURES ONLY A FEW BASIC EXPRESSIONS, WHILE CHRIS WARE'S CHARACTER JIMMY CORRIGAN STICKS MOSTLY TO JUST THIS ONE.

READERS MAY EVEN "SEE" EXPRESSIONS THAT **AREN'T THERE,** BASED SOLELY ON THE SURROUNDING **STORY** AND **TEXT.**

PANELS FROM *JACK'S LUCK RUNS OUT* BY JASON LITTLE, A COMIC WITH UNCHANGING FACES TAKEN FROM PLAYING CARDS.

BUT IN MANY POPULAR COMICS OVER THE YEARS, CHARACTERS FEATURE SEVERAL **BASIC TYPES** OF **EXPRESSIONS** --

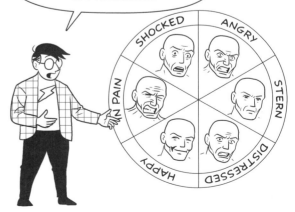

PANEL FIVE: ART BY ART SPIEGELMAN AND CHRIS WARE. PANEL SIX: ART BY JASON LITTLE (SEE ART CREDITS, PAGE 258).

100

-- WHICH CAN THEN BE **FINE-TUNED** BY THEIR CORRESPONDING **WORD BALLOONS**.

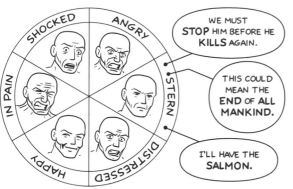

WE MUST **STOP** HIM BEFORE HE **KILLS** AGAIN.

THIS COULD MEAN THE **END** OF **ALL MANKIND**.

I'LL HAVE THE **SALMON**.

SO WHY BOTHER LEARNING TO MAKE A **THOUSAND** EXPRESSIONS WHEN JUST **A FEW** WILL DO IT?

IN PART, BECAUSE **UNDERSTANDING** THE THOUSANDS WILL HELP YOU DRAW THE **FEW** WITH GREATER **CONTROL** AND **PRECISION**.

BUT ALSO BECAUSE FACIAL EXPRESSIONS -- IN PART, AS A **RESULT** OF THEIR TRADITIONALLY LIMITED ROLE -- MAY REPRESENT ONE OF COMICS' GREATEST AREAS OF **UNTAPPED POTENTIAL**: A CHANCE FOR A NEW GENERATION OF **CREATORS** TO CONNECT WITH A NEW GENERATION OF **READERS** --

-- MANY OF WHOM FIND THE **EMOTIONAL** ARENA AS COMPELLING AS THE **PHYSICAL** ONE --

-- AND WHO WILL EXPECT, WHEN THEY LOOK INTO THE EYES OF YOUR CHARACTERS --

-- TO FIND A REAL HUMAN BEING **LOOKING BACK**.

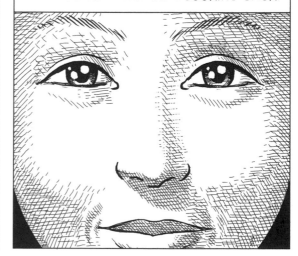

3. BODY LANGUAGE.

JUST AS **FACES** EXPRESS A LOT OF WHAT'S GOING ON INSIDE A CHARACTER EMOTIONALLY, THEIR **BODIES** CAN SEND SOME POWERFUL MESSAGES OF THEIR OWN.

AND AS WITH FACES, THEY CAN SEND SOME OF THOSE MESSAGES **DELIBERATELY** --

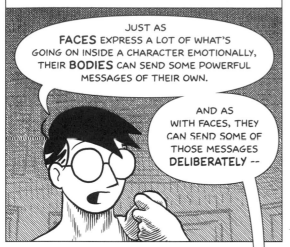

BODY LANGUAGE CAN TELL READERS **WHO** YOUR CHARACTERS ARE BEFORE THEY EVEN **SPEAK**.

ARE THEY **DOUBTFUL** OR **CONFIDENT**?

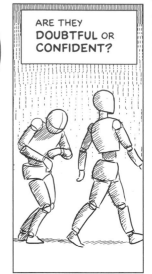

-- AND SEND **OTHERS** WITHOUT EVER **REALIZING** IT.*

AFFECTIONATE OR **COLD**?

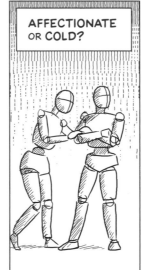

DOMINEERING OR **SUBMISSIVE**?

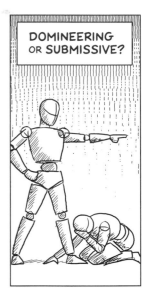

IT TAKES TIME TO LEARN HOW TO **PORTRAY** IT IN **COMICS**, BUT WHEN DONE WELL, BODY LANGUAGE CAN FILL A PAGE WITH **LIFE, ENERGY** AND **PERSONALITY** FROM TOP TO BOTTOM!

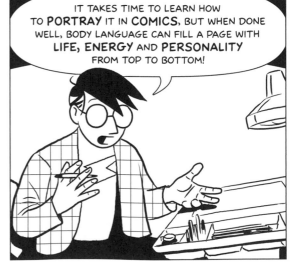

*MORE ON WORD BALLOON PLACEMENT IN CHAPTER 3.

FACIAL EXPRESSIONS AND BODY LANGUAGE EXPRESS MANY OF THE **SAME FEELINGS** AND OFTEN WORK **TOGETHER** --

-- BUT THERE ARE IMPORTANT **DIFFERENCES.**

THE BASIC EXPRESSIONS ARE FAIRLY **CONSISTENT** IN APPEARANCE. A FACE OF EXTREME FEAR, WHATEVER THE CAUSE, TENDS TOWARD THE SAME FAMILIAR SHAPE.

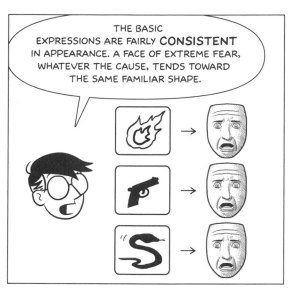

BODY LANGUAGE IS MORE **SITUATIONALLY-BASED,** AFFECTED BY DIRECTION, TERRAIN, SOURCE OF DANGER, PHYSICAL OPPORTUNITY, ETC...

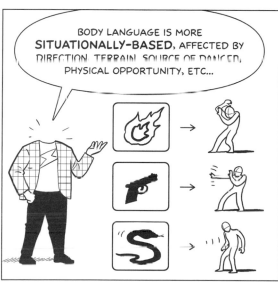

BODY LANGUAGE IS MORE **GRAVITY-BOUND** THAN FACIAL EXPRESSIONS --

-- AND EVERYDAY ACTIVITIES LEAD TO A SPLIT BETWEEN WHAT WE'RE DOING ON THE **OUTSIDE** AND WHAT WE'RE FEELING ON THE **INSIDE.**

DO YOU WANT **ME** TO DRIVE?

I'M FINE.

MOST IMPORTANTLY, FOR COMICS ARTISTS, FACIAL EXPRESSIONS ARE MORE **SURFACE-ORIENTED,** MORE AFFECTED BY NUANCE, SKIN SHADOWS, ETC. --

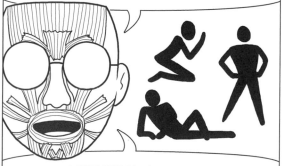

-- WHILE BODY LANGUAGE IS MORE **SILHOUETTE-BASED,** ALL ABOUT HOW OUR LIMBS, HANDS AND HEAD ARE POSITIONED.

THERE'S A KIND OF **CALLIGRAPHY** TO BODY LANGUAGE. JUST AS AN **"A"** IS AN **"A"** NO MATTER HOW IT'S **WRITTEN** --

A A A A A A

-- SO, TOO, DO **GESTURES** AND **POSES** COMMUNICATE THEIR MEANINGS NO MATTER HOW THEY'RE **DRAWN.**

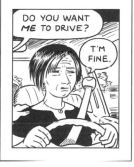

JUST AS WITH FACIAL EXPRESSIONS, MASTERING **BODY LANGUAGE** IN COMICS MEANS TACKLING FOUR SUBJECTS: THE VARIOUS **KINDS** OF BODY SIGNALS, THE **ANATOMY** THAT UNDERLIES THEM, STRATEGIES FOR **DRAWING** SUCH POSES AND HOW BODY LANGUAGE WORKS IN **COMICS SEQUENCES.**

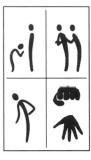

UNLIKE FACIAL EXPRESSIONS, THERE AREN'T ANY KINDS OF **"PRIMARY"** BODY POSES FROM WHICH ALL OTHERS ARE DERIVED.

BUT THERE ARE A FEW BASIC KINDS OF **RELATIONSHIPS** BETWEEN OUR PHYSICAL ACTIONS AND THE MESSAGES THEY CONVEY, WHICH SURFACE OFTEN.

THESE INCLUDE:

ELEVATION AND STATUS

DISTANCE AND RELATIONSHIPS

IMBALANCE AND DISCONTENT

GESTURE AND COMMUNICATION

AT THE HEART OF EACH OF THESE RELATIONSHIPS IS A SIMPLE STATEMENT OF **SPACE** AND **GEOMETRY.**

FOR EXAMPLE, IF I MADE TWO BRUSH STROKES AND ASKED YOU WHICH ONE LOOKED MORE **"PROUD"** YOU MIGHT THINK IT WAS A WEIRD QUESTION --

-- BUT WITH LINES LIKE THESE, YOU'D HAVE NO TROUBLE GUESSING **WHICH ONE** I WAS THINKING OF.

THAT'S YOUR UNDERSTANDING OF **ELEVATION** AND **STATUS** AT WORK.

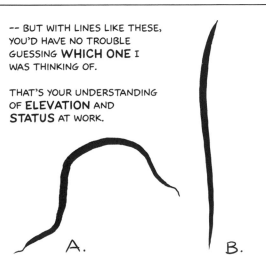

A.

B.

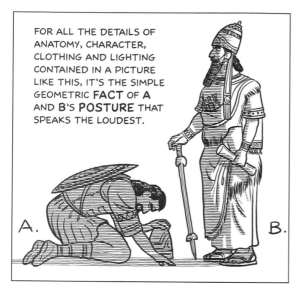

FOR ALL THE DETAILS OF ANATOMY, CHARACTER, CLOTHING AND LIGHTING CONTAINED IN A PICTURE LIKE THIS, IT'S THE SIMPLE GEOMETRIC **FACT** OF **A** AND B'S **POSTURE** THAT SPEAKS THE LOUDEST.

A.

B.

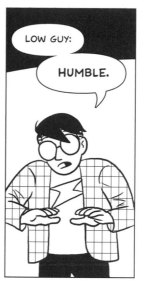

LOW GUY:

HUMBLE.

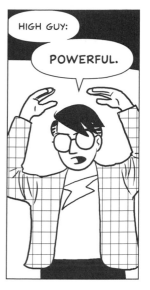

HIGH GUY:

POWERFUL.

WHETHER IT COMES FROM OUR OLD MAMMALIAN COMBAT INSTINCTS OR THE PARENT/CHILD ARCHETYPE, THE IDEA OF HEIGHT AS POWER CAN STILL BE SEEN IN EVERYTHING FROM CEREMONIES TO ARCHITECTURE.

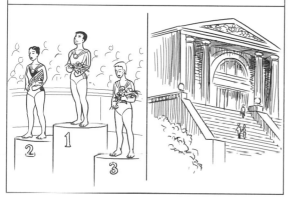

TODAY, WE MAY NOT BOW AS **LOW** AS WE USED TO --

THOSE PAPERS, SIR.

THANK YOU. THAT'LL BE ALL.

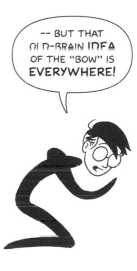

-- BUT THAT OLD-BRAIN **IDEA** OF THE "BOW" IS **EVERYWHERE!**

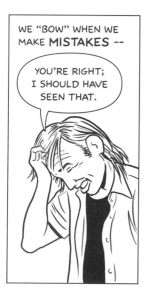

WE "BOW" WHEN WE MAKE **MISTAKES** --

YOU'RE RIGHT; I SHOULD HAVE SEEN THAT.

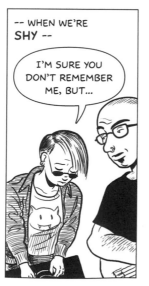

-- WHEN WE'RE **SHY** --

I'M SURE YOU DON'T REMEMBER ME, BUT...

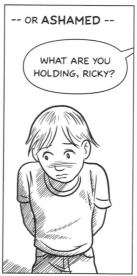

-- OR **ASHAMED** --

WHAT ARE YOU HOLDING, RICKY?

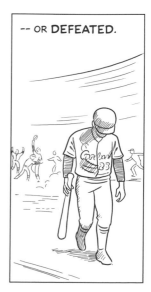

-- OR **DEFEATED.**

WE ALSO TAKE THE **"HIGH GROUND"** IN A LOT OF WAYS.

TOLD'JA SO.

WELL, WELL... LOOK WHO'S COME BACK.

OH, YOU **LIKED** *THE DA VINCI CODE,* I SEE...

QUIET PLEAS[E]

A RAMROD STRAIGHT POSTURE, LIKE THE ONE SEEN IN A LOT OF SUPERHERO BOOKS, WILL COMMUNICATE **STRENGTH** AND **CONFIDENCE** BY BEING SYMBOLICALLY TALLER.

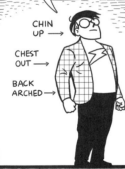

CHIN UP →
CHEST OUT →
BACK ARCHED →

LIKEWISE, A BENT, LOWERED POSTURE WILL BE IDENTIFIED WITH THE **WEAK** AND **DISPOSSESSED,** AND IS FREQUENTLY SEEN ON PROTAGONISTS FROM UNDERGROUND, AUTO-BIO AND ALTERNATIVE COMIX.

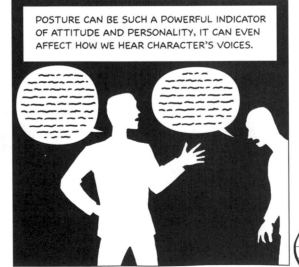

← CHIN DOWN
← BENT OVER
← HANDS PASSIVE OR OUT OF SITE

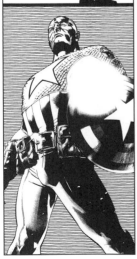

POSTURE CAN BE SUCH A POWERFUL INDICATOR OF ATTITUDE AND PERSONALITY, IT CAN EVEN AFFECT HOW WE HEAR CHARACTER'S VOICES.

WITHOUT WORDS, I'LL BET YOU CAN STILL **"HEAR"** THE DIFFERENCE.

PANEL FIVE: ART BY BRYAN HITCH AND PAUL NEARY/ANDREW CURRIE. PANEL SIX: ART BY CHRIS WARE, R. CRUMB, SETH AND ERIC DROOKER (SEE ART CREDITS, PAGE 258).

ANOTHER PRINCIPLE AT WORK IN BODY LANGUAGE IS THE CORRELATION BETWEEN **DISTANCE** AND **RELATIONSHIPS**.

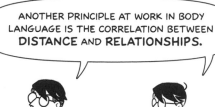

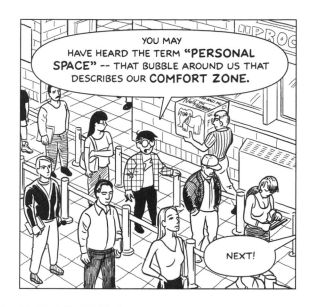

YOU MAY HAVE HEARD THE TERM **"PERSONAL SPACE"** -- THAT BUBBLE AROUND US THAT DESCRIBES OUR **COMFORT ZONE**.

NEXT!

THE **SIZE** OF THAT ZONE DEPENDS ON WHO WE'RE INTERACTING WITH. FOR PUBLIC ENCOUNTERS WITH **STRANGERS**, WE LIKE TO KEEP A DISTANCE OF **SEVERAL FEET**, FOR EXAMPLE.

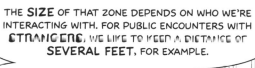

EXCUSE ME, DO YOU HAVE THE **TIME?**

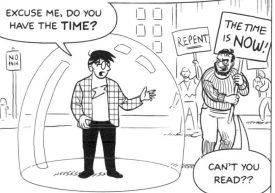

REPENT

THE TIME IS **NOW!**

NO 1414

CAN'T YOU READ??

IN **SOCIAL GATHERINGS**, THAT BUBBLE **SHRINKS** AS WE'RE EXPECTED TO INTERACT ON A MORE **PERSONAL** LEVEL WITH OUR FELLOW HUMANS.

HEY, LOVED THE FIRST BOOK! I'M STILL, UH...

...WORKING ON THAT SECOND ONE.

AND IN INTIMATE RELATIONSHIPS WITH **FRIENDS** AND **FAMILY**, THE BUBBLE SHRINKS OR POPS.

CAN'T TALK NOW, I'M IN A PANEL.

BEEP BOOP BEEP

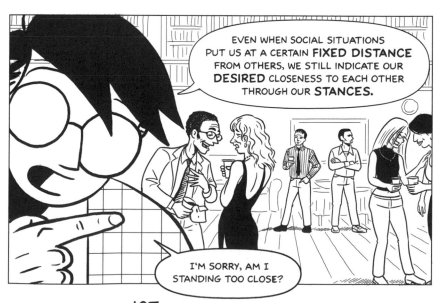

EVEN WHEN SOCIAL SITUATIONS PUT US AT A CERTAIN **FIXED DISTANCE** FROM OTHERS, WE STILL INDICATE OUR **DESIRED** CLOSENESS TO EACH OTHER THROUGH OUR **STANCES**.

I'M SORRY, AM I STANDING TOO CLOSE?

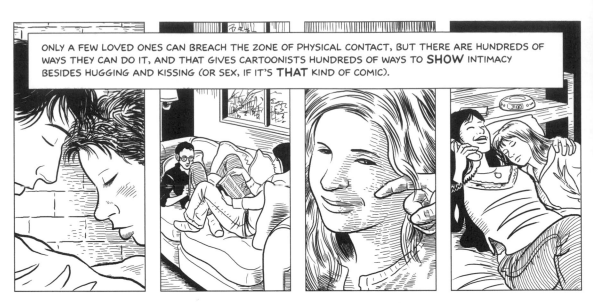

ONLY A FEW LOVED ONES CAN BREACH THE ZONE OF PHYSICAL CONTACT, BUT THERE ARE HUNDREDS OF WAYS THEY CAN DO IT, AND THAT GIVES CARTOONISTS HUNDREDS OF WAYS TO **SHOW** INTIMACY BESIDES HUGGING AND KISSING (OR SEX, IF IT'S **THAT** KIND OF COMIC).

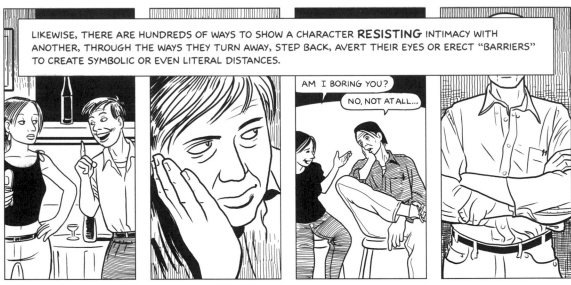

LIKEWISE, THERE ARE HUNDREDS OF WAYS TO SHOW A CHARACTER **RESISTING** INTIMACY WITH ANOTHER, THROUGH THE WAYS THEY TURN AWAY, STEP BACK, AVERT THEIR EYES OR ERECT "BARRIERS" TO CREATE SYMBOLIC OR EVEN LITERAL DISTANCES.

AM I BORING YOU?

NO, NOT AT ALL...

THE RELATIONSHIPS YOU COME UP WITH FOR YOUR CHARACTERS CAN HAVE A POWERFUL EFFECT ON THE RELATIONSHIPS YOUR CHARACTERS HAVE WITH YOUR **READERS.**

AND YOU CAN BUILD AND STRENGTHEN THOSE RELATIONSHIPS IN EVERY PANEL, BY SHOWING HOW THEY PLAY THEMSELVES OUT IN **SPACE.**

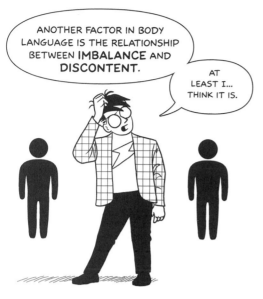

ANOTHER FACTOR IN BODY LANGUAGE IS THE RELATIONSHIP BETWEEN **IMBALANCE** AND **DISCONTENT**.

AT LEAST I... THINK IT IS.

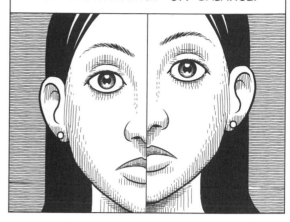

MAYBE BECAUSE SYMMETRY IS THE NATURAL ORDER OF THINGS, WE TEND TO REACT TO FEELINGS OF DISCONTENT BY MIMING WITH OUR BODIES THAT SOMETHING IS FIGURATIVELY **"OFF-BALANCE."**

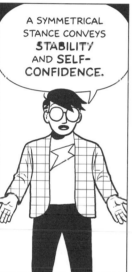

A SYMMETRICAL STANCE CONVEYS **STABILITY** AND **SELF-CONFIDENCE.**

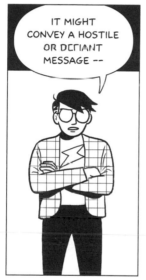

IT MIGHT CONVEY A HOSTILE OR DEFIANT MESSAGE --

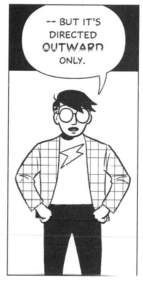

-- BUT IT'S DIRECTED **OUTWARD** ONLY.

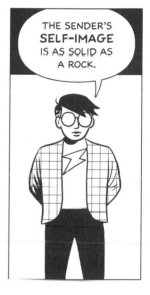

THE SENDER'S **SELF-IMAGE** IS AS SOLID AS A ROCK.

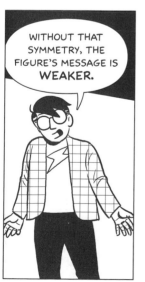

WITHOUT THAT SYMMETRY, THE FIGURE'S MESSAGE IS **WEAKER.**

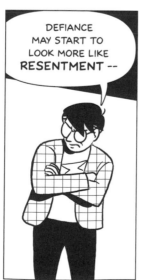

DEFIANCE MAY START TO LOOK MORE LIKE **RESENTMENT** --

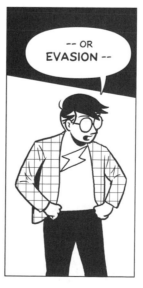

-- OR **EVASION** --

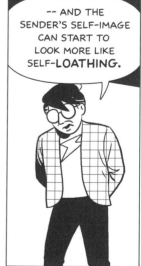

-- AND THE SENDER'S SELF-IMAGE CAN START TO LOOK MORE LIKE SELF-**LOATHING.**

OF COURSE, **GRAVITY**, **FATIGUE** AND **PHYSICAL OBSTACLES** OFTEN REQUIRE US TO TAKE ASSYMMETRICAL POSES. THESE DON'T NECESSARILY INDICATE ANY KINDS OF **EMOTIONAL** IMBALANCE --

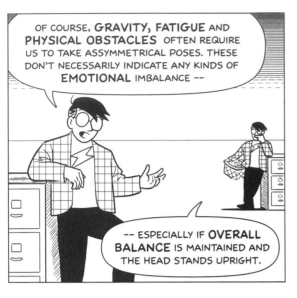

-- ESPECIALLY IF **OVERALL BALANCE** IS MAINTAINED AND THE HEAD STANDS UPRIGHT.

AND EVEN BLATANTLY LOPSIDED POSES DON'T HAVE TO SEEM WEAK IF **EYE CONTACT** IS MAINTAINED.

SUCH COMBOS HAVE A **REBEL** FLAVOR, A SORT OF "YEAH, I'M LOPSIDED; WHAT ARE YOU GONNA DO ABOUT IT?" LOOK, SIMILAR TO EXPRESSIONS OF SUSPICION.

BUT GENERALLY SPEAKING, IF YOU WANT TO TAKE A CALM, CONFIDENT POSE AND INTRODUCE A LITTLE **UNREST** --

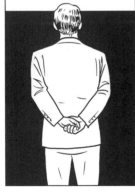

-- THROWING IN A LITTLE **IMBALANCE** IS A GREAT WAY TO DO IT.

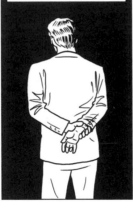

WHETHER WE'RE SHOWING OUR **FEELINGS** OR COMMUNICATING OUR **OPINIONS**, IMBALANCE IS EVERYWHERE. WE TIP OUR HEADS AT **UNSOLVED PROBLEMS** --

-- ARCH AN EYEBROW AT **DISTURBANCES** IN THE **NATURAL ORDER** --

-- EVEN THROW OUR **WHOLE BODIES** NEARLY INTO A FALL --

YOU... WHAT?!

-- ALL JUST TO SHOW THE IMBALANCES WE SEE IN **OURSELVES** --

-- OR IN THE **WORLD** AROUND US!

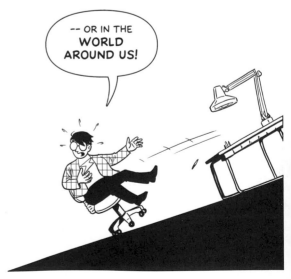

ELEVATION, DISTANCE and IMBALANCE ARE JUST A FEW OF THE WAYS OUR BODIES LET OTHERS KNOW HOW WE FEEL ABOUT OURSELVES, EACH OTHER AND THE WORLD.

KEEP YOUR EYES OPEN AND YOU'LL SEE MANY MORE.

THE WAY AN EXTREME POSTURE OF GRIEF CAN RESEMBLE A FETAL POSITION.

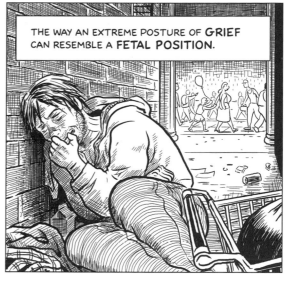

THE WAY ONE PERSON WILL TURN TOWARD A STRANGER IN A CROWDED DOORWAY WHILE ANOTHER WILL TURN AWAY.

THE WAY WE POINT HIGHER WHEN WE'RE POINTING AT SOMETHING FURTHER AWAY, AS IF SHOOTING AN ARROW.

THE WAY WE SIGNAL OUR INTEREST IN SOME KINDS OF ADVANCES AND DISINTEREST IN OTHERS.

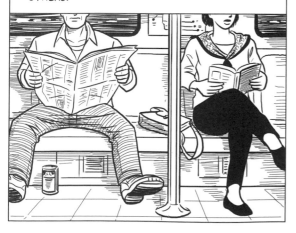

THE WAY WE WAIT FOR A CO-WORKER COMPARED TO THE WAY WE WAIT FOR SOMEONE WE LOVE.

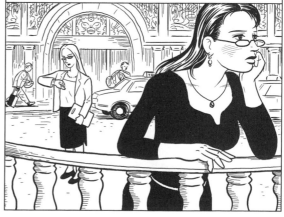

HANDS PLAY AN IMPORTANT ROLE IN BODY LANGUAGE, BUT UNLIKE WHOLE-BODY POSTURES, THEY TEND TO SPECIALIZE IN MORE **DELIBERATE** MESSAGES.

SOME TAKE THE SHAPE OF SYMBOLS WITH **FIXED MEANINGS**, LIKE AN INFORMAL **SIGN LANGUAGE** --

-- AND AS WITH ANY LANGUAGE, SUCH SIGNS MAY BE SUBJECT TO **REGIONAL DIFFERENCES**, SO KNOW YOUR AUDIENCE BEFORE USING THEM IN YOUR COMICS.

"I'M STRONG!" (WESTERN WORLD)

"SPEAK-UP!" (WORLD-WIDE)

"I SWEAR" (MIDDLE EAST)

"I DON'T GET IT." (NORTHERN AFRICA)

"JEALOUS" (JAPAN)

HANDS CAN ALSO AMPLIFY THE SORTS OF **SPATIAL** RELATIONSHIPS WE DISCUSSED IN THE LAST FEW PAGES.

CONTACT WITH ONE'S HANDS, FOR EXAMPLE, IS A KEY STEP TAKEN TO BRIDGE **DISTANCE** IN HOPES OF **INTIMACY** --

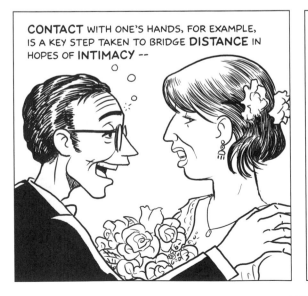

-- AND A LOT OF **IMBALANCE** SIGNALS CAN INCORPORATE HAND SIGNALS.

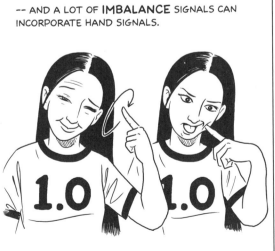

HANDS CAN USE **HEIGHT** CUES TO COLOR WHAT WE SAY IN VARIOUS SUBTLE WAYS.

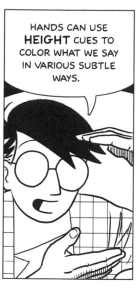

POLITICIANS, CAR SALESMEN AND PROFESSIONAL LIARS WILL TELL YOU THAT A **PALMS-UP** GESTURE CAN MAKE A STATEMENT SEEM MORE **FRIENDLY, NONTHREATENING** AND **HONEST.**

AN UPTURNED PALM SYMBOLICALLY **LOWERS** SPEAKERS, PLACING THEM AT THE MERCY OF LISTENERS.

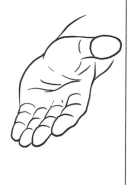

IN CONTRAST, A DOWNTURNED PALM SYMBOLICALLY **RAISES** THE SPEAKER, CLAIMING **AUTHORITY, POWER** AND **CONTROL** OVER OTHERS --

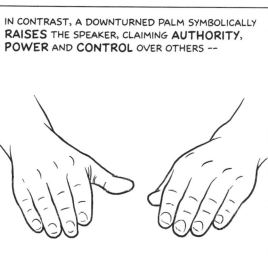

-- JUST AS AN **ADULT** MAINTAINS CONTROL OVER A **CHILD.**

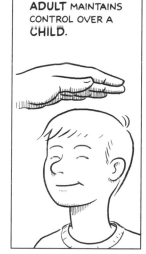

HANDS ARE A BIG PART OF HOW WE COMMUNICATE WITH EACH OTHER. IF YOUR CHARACTERS **REFLECT** THAT --

-- THEN HANDS CAN BE A BIG PART OF HOW **YOU** COMMUNICATE WITH YOUR **READERS.**

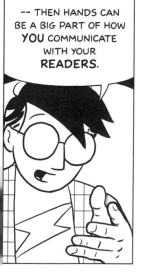

DO YOU SEE WHAT I MEAN? DOES THAT SOUND **REASONABLE?**

I'M ONLY MAKING THIS POINT **ONCE,** YOU KNOW.

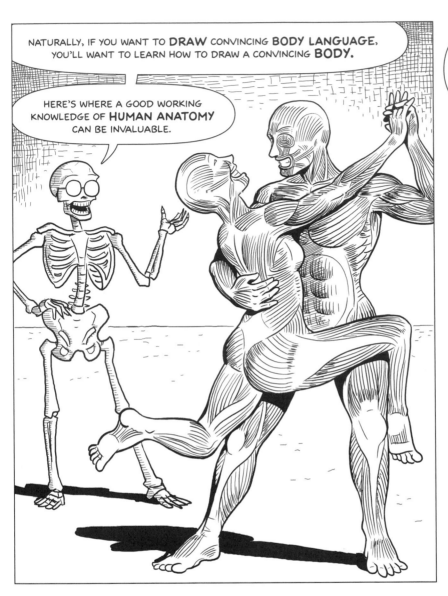

NATURALLY, IF YOU WANT TO **DRAW** CONVINCING **BODY LANGUAGE,** YOU'LL WANT TO LEARN HOW TO DRAW A CONVINCING **BODY.**

HERE'S WHERE A GOOD WORKING KNOWLEDGE OF **HUMAN ANATOMY** CAN BE INVALUABLE.

I WON'T ATTEMPT A WHOLE COURSE IN **ANATOMY** AND **FIGURE DRAWING** HERE.

THERE ARE SOME GOOD **BOOKS** ON THE SUBJECT, WHICH I'LL MENTION IN THE **BIBLIOGRAPHY.**

BESIDES WHICH, IT'D TAKE A **HUNDRED PAGES** AND, UM... WELL...

MY OWN FIGURE DRAWING ISN'T EXACTLY THE GREATEST.

BUT EVEN IF YOU'RE LIKE ME AND ANATOMY DOESN'T COME EASILY, YOU CAN STILL **IMPROVE** YOUR STORYTELLING DRAMATICALLY BY JUST GETTING THE **GESTURE** ACROSS IN EVERY FIGURE YOU DRAW.

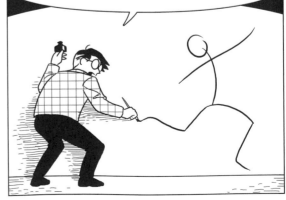

THE GESTURES OF FIGURES HAVE A **FLOW** AND **RHYTHM** WHICH HAVE INSPIRED ARTISTS FOR CENTURIES.

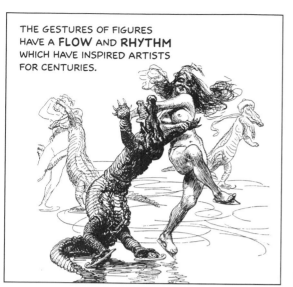

MASTERS USE THEIR KNOWLEDGE OF **ANATOMY** TO MAKE SUCH GESTURES **VIVID** AND **CREDIBLE.**

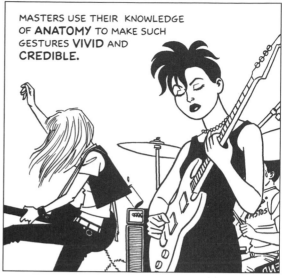

ARTISTS WHO CONCENTRATE ON ANATOMICAL ACCURACY BUT **NEGLECT** GESTURE, MAY CREATE TECHNICALLY "CORRECT" FIGURES, BUT THE RESULTS MAY BE UTTERLY **LIFELESS** --

IT'S TIME!

LET'S GO. I AM READY TO *FIGHT.*

MY HEART IS FILLED WITH *REMORSE.*

I LIKE CHEESE!

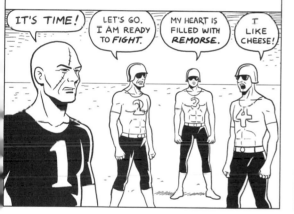

-- WHILE ARTISTS WITH TECHNICALLY "INCORRECT" FIGURES BUT A **STRONG** SENSE OF GESTURE MAY PRODUCE ART THAT SEEMS **REAL** AND **ALIVE.**

THAT SAID, DON'T PLAN TO GET BY ON **GESTURE ALONE!**

I HAVEN'T GIVEN UP ON LEARNING TO IMPROVE MY FIGURE DRAWING AND NEITHER SHOULD **YOU.**

JUST REMEMBER THAT IN ANY COMICS PANEL, IT'S THE MESSAGE OF YOUR CHARACTER'S **GESTURE** THAT READERS WILL BE WAITING FOR, AND THE FIRST JOB OF FIGURE DRAWING IS TO **DELIVER** THAT MESSAGE --

-- LOUD AND CLEAR.

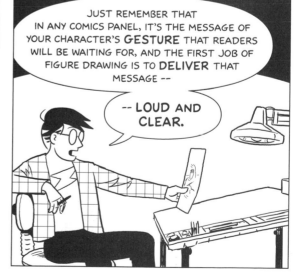

115

LET'S TAKE A LOOK NOW AT HOW FACIAL EXPRESSIONS AND BODY LANGUAGE CAN WORK **TOGETHER** BY ADAPTING SOME WRITTEN DIALOGUE INTO COMICS FORM.

WE'LL START IN A HIGH SCHOOL STUDY LOUNGE. TWO STUDENTS MEET AND START TALKING...

TAP TAP TAP TAP

Pete: Hey, are you okay?

Carrie: Not so much. I got a "D" on the history test.

Pete: Huh. Lucky you. I got an "F"

Carrie: No way! You always ace those things!

Pete: Actually, I think Mr. Duncan kinda lost it. I heard everybody got a "D" or an "F" today.

Carrie: Really? Wow. He was acting kind of weird in class. All that stuff about Jif Peanut Butter and the Communists.

Miller(entering): Room for one more?

Carrie: No.

Pete: Hey, Miller.

Miller: So, did you hear? Duncan went on a rampage!

Carrie: What?

Miller: I was there! He smashed all the iMacs in Room 4 with a baseball bat! Then he stole the rhino head off the wall and ran off!

Pete: You're kidding!

Carrie: Oh my God!

Pete: Wow. I kinda love Mr. D. now.

Carrie: You swear you're not making this up!

Miller: I swear! The police are looking for him and everything.

Pete: Y'know, I always heard Mr. D. was nuts. Did you guys know that last year, he was --

Carrie: Uh...

Pete: What?

Mr. Duncan: Hello, children.

THESE ARE THROWAWAY CHARACTERS, SO WE CAN JUST **IMPROVISE** THEIR DESIGNS ON THE SPOT. LET'S PICK A CRISP, SMART LOOK FOR CARRIE, A LAID-BACK SLOPPINESS FOR PETE AND A DORKY, GREGARIOUS LOOK FOR MILLER.

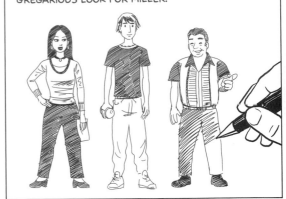

CARRIE STARTS OUT DEPRESSED AND WE CAN **SHOW** THAT BEFORE SHE EVEN OPENS HER MOUTH, BUT HOW **INTENSE** SHOULD THE EMOTION BE?

WE COULD DRAW HER CLOSE TO **TEARS**, AS IF THE TEST WAS VERY IMPORTANT TO HER.

HEY, ARE YOU OKAY?

NOT SO MUCH...

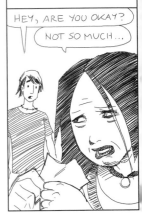

BUT BASED ON HOW QUICKLY SHE RECOVERS IN THE SCRIPT, IT SOUNDS LIKE SHE'S JUST FEELING A BIT **DEFEATED**, AN EMOTION BEST EXPRESSED BY A **SLUMPED POSTURE** AND **TIRED FACE**.

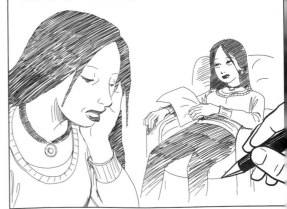

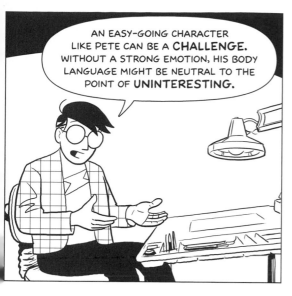

AN EASY-GOING CHARACTER LIKE PETE CAN BE A **CHALLENGE.** WITHOUT A STRONG EMOTION, HIS BODY LANGUAGE MIGHT BE NEUTRAL TO THE POINT OF **UNINTERESTING.**

LET'S PUT A COUPLE OF **VENDING MACHINES** INTO THAT LOUNGE SO PETE WILL AT LEAST HAVE SOMETHING TO DO WITH HIS **HANDS.**

IN FACT, WE CAN JUST INCLUDE THE MACHINES IN A BIG **ESTABLISHING SHOT** ON THE **FIRST PAGE.**

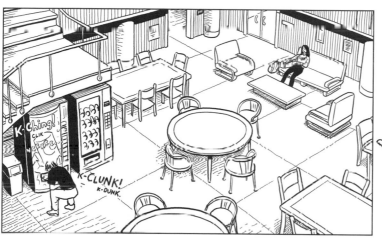

K-ching!
CLIK

K-CLUNK!
K-DUNK.

NOW, NOTICE HOW EVEN IN A LONG-SHOT, WE CAN ALREADY "READ" CARRIE'S **POSTURE?**

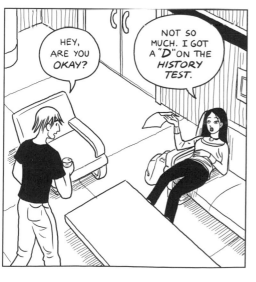

HEY, ARE YOU **OKAY?**

NOT SO MUCH. I GOT A *"D"* ON THE **HISTORY TEST.**

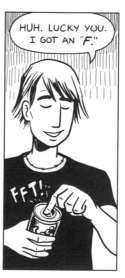

HUH. LUCKY YOU. I GOT AN *"F."*

FFT!

AND "LISTEN" TO PETE'S **VOICE.** WITH A DIFFERENT **POSE** AND **EXPRESSION,** THE EXACT SAME DIALOGUE WOULD FEEL **DIFFERENT.**

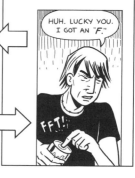

HUH. LUCKY YOU. I GOT AN *"F."*

FFT!

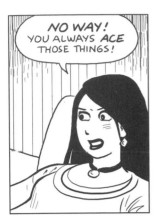

NO WAY! YOU ALWAYS *ACE* THOSE THINGS!

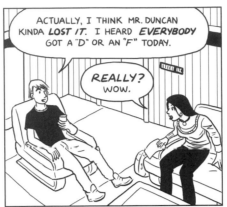

ACTUALLY, I THINK MR. DUNCAN KINDA *LOST IT*. I HEARD *EVERYBODY* GOT A "D" OR AN "F" TODAY.

REALLY? WOW.

CARRIE IS TRANSITIONING TOWARD THE POSE OF THE **WILLING LISTENER** NOW, BECAUSE SOMEONE SHE **LIKES** IS SAYING SOMETHING THAT **INTERESTS** HER.

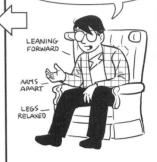

LEANING FORWARD

ARMS APART

LEGS RELAXED

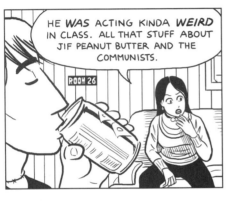

HE *WAS* ACTING KINDA *WEIRD* IN CLASS. ALL THAT STUFF ABOUT JIF PEANUT BUTTER AND THE COMMUNISTS.

ROOM 26

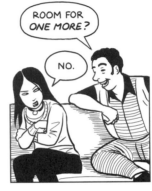

ROOM FOR *ONE MORE?*

NO.

NOT TRUE FOR POOR **MILLER**, THOUGH, WHOSE UNWELCOMED INVASION OF HER PERSONAL SPACE EARNS HIM EVERY **"BARRIER"** SIGNAL IN THE BOOK.

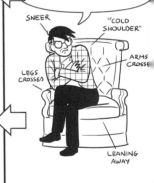

SNEER

"COLD SHOULDER"

ARMS CROSSED

LEGS CROSSED

LEANING AWAY

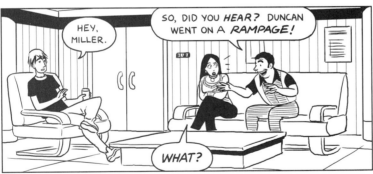

HEY, MILLER.

SO, DID YOU *HEAR?* DUNCAN WENT ON A *RAMPAGE!*

WHAT?

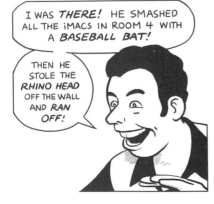

I WAS *THERE!* HE SMASHED ALL THE iMACS IN ROOM 4 WITH A *BASEBALL BAT!*

THEN HE STOLE THE *RHINO HEAD* OFF THE WALL AND *RAN OFF!*

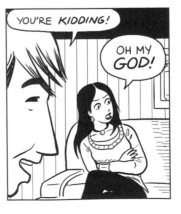

YOU'RE *KIDDING!*

OH MY *GOD!*

WITH MILLER'S **NEWS**, HOWEVER, HER POSE **SOFTENS** AND HER EXPRESSION ACKNOWLEDGES HIM (**ALL** STUDENTS ARE FAMILY WHEN DISSING TEACHERS).

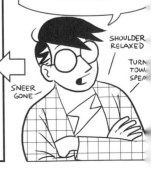

SHOULDER RELAXED

TURN TOW SPEA

SNEER GONE

SHE STILL DOESN'T WANT TO **DATE** THE GUY OR ANYTHING -- THE BARRIERS ARE STILL UP -- BUT MILLER AT LEAST HAS HER ATTENTION.

PETE SEEMS A LITTLE MORE **ACCEPTING** OF MILLER, BUT JUDGING BY THE LEG, LAME WAVE AND FIFTEEN-WATT SMILE, HE'S **NOT** A BIG FAN.

MEANWHILE, MILLER'S BODY IS ALL ABOUT **FORWARD MOMENTUM.** HE'S CONFIDENT THAT HE'S GOT THE GOODS.

SO CONFIDENT, IN FACT, THAT HE'S GOT HIS HANDS DOWN IN THAT "QUIET! YOU WANNA HEAR THIS." WAY.

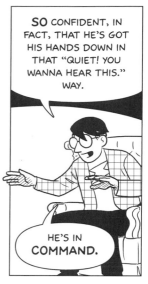

HE'S IN **COMMAND.**

WOW, I KINDA LOVE MR. D. NOW.

YOU **SWEAR** YOU'RE NOT MAKING THIS UP!

I SWEAR! THE POLICE ARE LOOKING FOR HIM AND EVERYTHING!

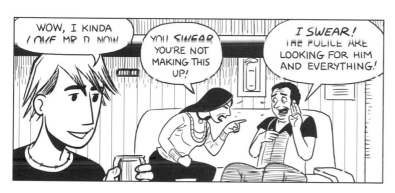

SEE CARRIE'S FOREFINGER JAB? THAT'S **SERIOUS.** SHE'D **KICK HIS ASS** IF HE LIED TO HER.

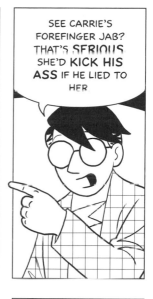

Y'KNOW, I ALWAYS *HEARD* MR. D WAS A LITTLE *NUTS.* DID YOU GUYS KNOW THAT LAST YEAR, HE WAS--

UH...

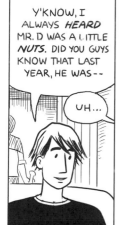

WHAT?

HELLO, CHILDREN...

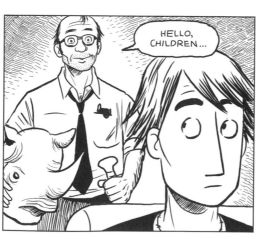

HENCE MILLER'S COMICALLY FORMAL GESTURE INCLUDES AN ELEMENT OF **ACTUAL FEAR**, BOTH IN THE CONSTRICTED POSE AND IN ASPECTS OF HIS EXPRESSION.

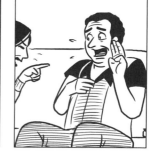

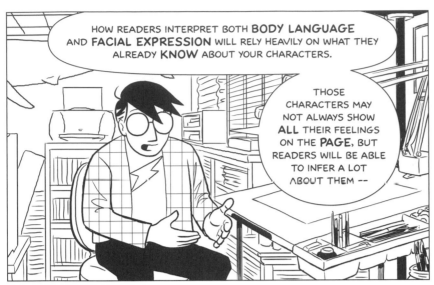

HOW READERS INTERPRET BOTH **BODY LANGUAGE** AND **FACIAL EXPRESSION** WILL RELY HEAVILY ON WHAT THEY ALREADY **KNOW** ABOUT YOUR CHARACTERS.

THOSE CHARACTERS MAY NOT ALWAYS SHOW **ALL** THEIR FEELINGS ON THE **PAGE**, BUT READERS WILL BE ABLE TO INFER A LOT ABOUT THEM --

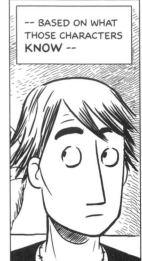

-- BASED ON WHAT THOSE CHARACTERS **KNOW** --

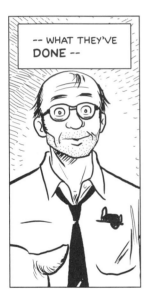

-- WHAT THEY'VE **DONE** --

-- AND WHAT THEY **WANT.**

PUT ALL OF YOUR STORYTELLING SKILLS TO USE MAKING THAT **INNER LIFE** OF YOUR CHARACTERS CLEAR AND MEMORABLE --

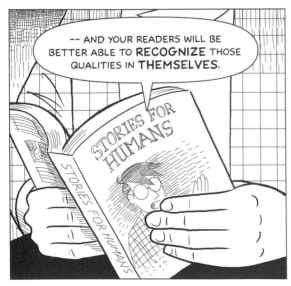

-- AND YOUR READERS WILL BE BETTER ABLE TO **RECOGNIZE** THOSE QUALITIES IN **THEMSELVES.**

STORIES FOR HUMANS

FROM **CHARACTER DESIGN** TO **FACIAL EXPRESSION** TO **BODY LANGUAGE,** IT'S THAT SENSE OF RECOGNITION THAT MANY OF YOUR READERS WILL **VALUE** IN YOUR COMICS ABOVE ALL ELSE.

COMICS HISTORY IS BURSTING WITH SIMPLE, POPULAR CHARACTERS WHO ONLY SCRATCH THE SURFACE OF THESE COMPLEX HUMAN QUALITIES.

SOME HAVE EVEN SUGGESTED THAT COMICS' CHILDLIKE INNOCENCE AND **LACK** OF HUMAN SUBTLETY IS PART OF ITS STRENGTH.

MAYBE IT IS.

OR MAYBE IT'S JUST EVIDENCE OF AN ARTFORM WITH ROOM TO **GROW.**

FOR DECADES, EACH GENERATION OF COMICS CREATORS HAS DUG A LITTLE DEEPER INTO THE EMOTIONAL LIVES OF THEIR CHARACTERS.

HOW MUCH OF THE SUBTLETY OF HUMAN BEHAVIOR YOU PUT INTO YOUR COMICS IS UP TO YOU.

IT ALL DEPENDS ON WHAT YOU CHOOSE TO SHOW THE HUMAN BEINGS WHO READ YOUR STORIES --

DIGGING **DEEPER STILL** COULD BE ONE OF THE WAYS THAT FUTURE GENERATIONS OF CREATORS WILL DEFINE THEMSELVES.

MAKING LIFE THROUGH COMICS CAN BE AS SIMPLE AS PLACING A FEW LINES ON A PIECE OF PAPER --

-- OR IT CAN BE AS COMPLEX, CHALLENGING AND MYSTERIOUS AS CREATING THE REAL THING.

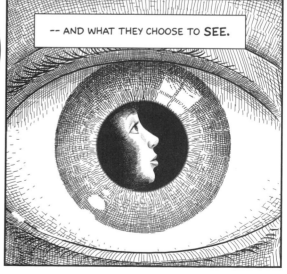

-- AND WHAT THEY CHOOSE TO **SEE.**

NOTES

CHAPTER 2: STORIES FOR HUMANS

PAGE 58-61 - SYMMETRY AND RECOGNITION

GRANTED, THERE ARE PLENTY OF WAYS TO DISTINGUISH AN ANIMAL FROM ITS ENVIRONMENT (GROWTH AND REPRODUCTION, MOVING, RESPONDING TO STIMULI...) THE REASON I CHOSE TO FOCUS ON SYMMETRY -- BESIDES THE FACT THAT I LIKE WEIRD DIGRESSIONS -- IS THAT IT'S THE ASPECT OF LIFE MOST AT HOME IN A STATIC VISUAL MEDIUM LIKE COMICS.

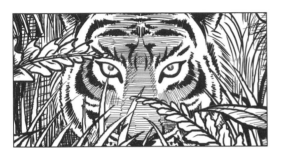

THE ABOVE IMAGE IS FROZEN IN TIME. YOU CAN'T SEE IT MOVE. YOU DON'T KNOW WHAT'S GOING ON IN IT'S HEAD. BUT YOU KNOW IT'S ALIVE. AND YOU'D KNOW IT EVEN IF YOU'D NEVER SEEN A TIGER IN YOUR LIFE.

NATURE PROVIDES OTHER EXAMPLES OF SYMMETRY, LIKE CRYSTALS, AND THERE ARE PLANTS THAT EXHIBIT IT, BUT ANIMALS HAVE ENOUGH OF A MONOPOLY ON THE BILATERAL DESIGN THAT I DESCRIBE ON PAGE 60 THAT I THINK IT'S FAIR TO DUB IT OUR "CALLING CARD."

ON PAGE 61, I ALSO TOUCH ON OUR PREFERENCE FOR SEEING HUMANS IN SIMPLE IMAGES, SOMETHING I TALK ABOUT AT LENGTH IN *UNDERSTANDING COMICS*, CHAPTER TWO.

FYI: THE SCULPTURE ON PAGE 60 IS AN INVENTION, BUT IT'S BASED ON VARIOUS SIMILAR SCULPTURES FROM AFRICA.

PAGE 64, PANEL FIVE - CHARACTERS THAT "WRITE THEMSELVES"

I'VE HEARD CREATORS LITERALLY SAY THAT THEY'RE NOT SO MUCH WRITING THEIR CHARACTERS AS RELAYING WHAT THE CHARACTERS THEMSELVES WANT TO DO, AN INTUITIVE APPROACH THAT COMES UP IN CONNECTION WITH THE "ANIMIST" CAMPFIRE DISCUSSED IN CHAPTER SIX. IT'S ACTUALLY A PRETTY COMMON ATTITUDE AMONG SUCCESSFUL COMICS ARTISTS.

AND LUNATICS, OF COURSE.

PAGE 65, PANEL FIVE - THE BACKSTORY TRAP

SERIOUSLY, THERE ARE MANY SAD, LONELY WOULD-BE COMICS AUTHORS WHO ADD COMPULSIVELY TO THE BACKSTORIES OF CHARACTERS NO ONE WILL EVER SEE INSTEAD OF PRODUCING READABLE, FINISHED STORIES. DON'T LET THIS HAPPEN TO YOU! FOR A CAUTIONARY TALE, TRY GOOGLING THE NAME "HENRY DARGER," OR GET THE DOCUMENTARY ABOUT DARGER CALLED *IN THE REALMS OF THE UNREAL*.

PAGE 65, PANEL SIX - WHEN LIFE HISTORIES COLLIDE

CHARACTERS WHOSE DIFFERING ORIGINS GOVERN THE NATURE OF THEIR RELATIONSHIPS INCLUDE:

- BETTY AND VERONICA
- SUPERMAN AND LOIS LANE
- FRODO AND GOLLUM
- TARZAN AND JANE
- POPEYE AND OLIVE OYL
- JEAN VALJEAN AND INSPECTOR JAVERT
- THE LITTLE MERMAID AND PRINCE WHATSISNAME
- BUFFY AND SPIKE

PAGE 66 - LIFE LESSONS

A FRIEND OF MINE SAW A SCREENING OF SAM RAIMI'S 2002 *SPIDER-MAN* MOVIE DURING WHICH HE SAT BEHIND A FATHER AND HIS SON. EARLY IN THE FILM, THE NOT-YET-HEROIC SPIDER-MAN IS RIPPED OFF BY A FIGHT PROMOTER AND WHEN THE FIGHT PROMOTER IS ROBBED MOMENTS LATER, SPIDER-MAN LETS THE CROOK GET AWAY TO GET EVEN.

SCREENWRITER DAVID KOEPP (WHO STAYS CLOSE TO THE COMICS ORIGIN FOR THE MOST PART) CONSTRUCTS THE SCENE TO MAXIMIZE OUR SYMPATHY WITH SPIDER-MAN. SURE ENOUGH, MY FRIEND REPORTS THAT THE FATHER LEANED OVER TO HIS SON AT THIS POINT IN THE MOVIE AND SAID, "NOW THAT'S JUSTICE!"

THE FATHER AT THAT SCREENING (AND PRESUMABLY HIS SON) WAS INSIDE SPIDER-MAN'S HEAD TO SUCH A DEGREE THAT WHEN THE CHARACTER'S UNCLE IS MURDERED BY THAT SAME CROOK IN THE VERY NEXT SCENE, HE AND THE CHARACTER RECEIVED THE MOVIE'S MORAL WAKE-UP CALL AT THE SAME TIME, DOUBLING THE EFFECTIVENESS OF THE MOMENT.

IF MANY OF OUR BEST STORIES INCLUDE A MAJOR CHANGE IN THE OUTLOOK OF A MAIN CHARACTER, THE **BEST** OF THE BEST HELP US TO UNDERGO THAT CHANGE **WITH** THEM.

PAGE 67, PANEL FIVE - SHOW IT, DON'T SING IT!

IN *THE WIZARD OF OZ*, CHARACTERS LITERALLY SING ABOUT THEIR DESIRES, BUT IN MORE NATURALISTIC STORIES, YOUR CHARACTERS SHOULD SHOW WHAT THEY

WANT THROUGH THEIR ACTIONS AND RARELY, IF EVER, SPELL IT OUT LIKE THAT. IN REAL LIFE, ESPECIALLY WHERE BASIC DESIRES LIKE LOVE OR MONEY ARE CONCERNED, PEOPLE ARE CONSTANTLY ANGLING FOR THE THINGS THEY WANT WITHOUT ADMITTING IT TO OTHERS -- OR EVEN TO THEMSELVES.

AUDIENCES FEEL SMARTER AND HAVE MORE FUN IF THEY CAN GUESS A CHARACTER'S FEELINGS EVEN BEFORE THE CHARACTER DOES.

PAGE 67, PANEL SIX - "EVERYBODY IS A HERO IN THEIR OWN MIND"

PROPS TO WRITER/ARTIST JIM STARLIN FOR INCLUDING THAT LINE IN THE FIRST COMIC I EVER BOUGHT, AN EARLY ISSUE OF WARLOCK (#9, I THINK) WHEN I WAS ABOUT 13 YEARS OLD.

PAGE 68, PANEL TWO - JUNG AT HEART

YOU DON'T HAVE TO BE AN EXPERT IN JUNGIAN PSYCHOLOGY TO USE IDEAS LIKE THESE AS JUMPING OFF POINTS. I'M CERTAINLY NOT. MY TOTAL GRASP OF JUNG'S "FOUR FUNCTIONS" OF MENTAL ACTIVITY IN 1982 WHEN I CREATED THOSE FOUR CHARACTERS WAS THAT "THINKING" EMPHASIZED LOGIC AND REASONING, "SENSATION" WAS ABOUT SENSORY EXPERIENCE, "FEELING" ASSIGNED VALUES AND JUDGEMENTS, AND "INTUITION" WAS ABOUT THE PERCEPTION OF THINGS UNSEEN.

EVEN IF I WAS WAY OFF THE MARK, JUNG GAVE ME A STARTING POINT THAT HELPED SEPARATE THOSE CHARACTERS ENOUGH TO GIVE THEM UNIQUE DESIRES IN MOST SITUATIONS.

PAGE 68, PANEL FIVE - MYTHOLOGY AND ARCHETYPES

JOSEPH CAMPBELL'S BOOK THE HERO WITH A THOUSAND FACES COMES UP A LOT WHEN DISCUSSING ARCHETYPES IN LITERATURE, IN PART BECAUSE OF HIS INFLUENCE ON GEORGE LUCAS' ORIGINAL STAR WARS CHARACTERS. LUCAS' DOCUMENTARY ON CAMPBELL, THE POWER OF MYTH, WAS ANOTHER TOUCHSTONE FOR MANY WRITERS DURING THAT PERIOD. AGAIN, YOU DON'T NEED TO HAVE A DEGREE IN MYTHOLOGY TO PUT SUCH IDEAS TO USE. FEEL FREE TO USE ANYTHING THAT INSPIRES YOU AS A JUMPING OFF POINT.

PAGE 69, PANEL FOUR - SUBTLETY THROUGH INTERACTION

WHEN I THINK OF THIS PRINCIPLE, I USUALLY THINK OF THE FRENCH PAINTER GEORGES SEURAT (1859-1891).

SEURAT USED MANY SMALL DOTS OF PURE COLOR IN HIS PAINTINGS, WHICH APPEARED TO MIX IN THE VIEWER'S EYES WHEN SEEN FROM A DISTANCE TO CREATE THE ILLUSION OF A SUBTLER AND MORE VARIED RANGE OF TONES AND COLORS (TODAY, COLOR PRINTING PRODUCES

SIMILAR EFFECTS WITH HALFTONE DOTS OF CYAN, MAGENTA AND YELLOW).

HERE'S A TINY PIECE OF HIS BEST KNOWN PAINTING, SUNDAY AFTERNOON ON THE ISLAND OF LA GRANDE JATTE, THE ONLY PAINTING EVER MADE INTO A MUSICAL, AS FAR AS I KNOW:

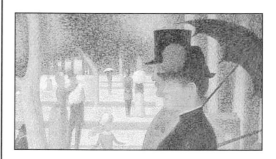

WHEN SIMPLY-CONCEIVED CHARACTERS INTERACT, THEY'RE LIKE SEURAT'S DOTS, REFERENCE POINTS TO DIFFERENT BASIC ASPECTS OF HUMAN BEHAVIOR THAT CAN ILLUMINATE ASPECTS OF LIFE THAT ARE MUCH MORE SUBTLE.

I FIRST NOTICED THIS WHEN READING GILBERT HERNANDEZ'S CLASSIC STORY HEARTBREAK SOUP.

PAGE 70, PANELS FOUR AND FIVE - COOKIE-CUTTER CHARACTERS

THIS IS DEPRESSINGLY COMMON. MAYBE A THIRD OF ALL WOULD-BE COMICS ARTISTS JUST DRAW THE SAME CHARACTER OVER AND OVER AND OVER. PLEASE, DON'T BE ONE OF THEM!

PAGE 70, PANELS SEVEN AND EIGHT - THE REPERTORY APPROACH

SOME ARTISTS, NOTABLY JAPAN'S OSAMU TEZUKA, HAVE A CAST OF VARIED CHARACTER TYPES THAT APPEAR IN DIFFERENT STORIES AS IF THEY WERE ACTORS IN A REPERTORY COMPANY TAKING ON DIFFERENT ROLES. OTHERS, LIKE WILL EISNER AND RUMIKO TAKAHASHI, HAVE A NARROWER RANGE OF FEATURES FOR HEROIC OR BEAUTIFUL PROTAGONISTS, BUT A WIDE RANGE OF FACE AND BODY TYPES AMONG SUPPORTING CHARACTERS.

PAGE 71 - CHARACTER VARIATION

YOU DON'T HAVE TO MAKE EVERY CHARACTER DIFFER-ENT FROM EVERY OTHER CHARACTER IN EVERY WAY, OF COURSE, BUT SEE EXERCISE #3 FOR SOME OF THE PARAMETERS YOU MIGHT WANT TO CONSIDER.

PAGE 72, PANEL SEVEN - KIRBY'S BRAIN

I HAVEN'T TURNED UP ANY DIRECT EVIDENCE THAT JACK KIRBY OR STAN LEE BASED THE FANTASTIC FOUR ON THE FOUR GREEK CLASSICAL ELEMENTS, THOUGH KIRBY FOLLOWED A SIMILAR TEMPLATE FOR THE F.F.'S

NON-SUPERHERO PREDECESSORS *THE CHALLENGERS OF THE UNKNOWN*, SO IT'S PROBABLY NOT A COINCIDENCE.

PAGE 73, PANELS FOUR THROUGH SEVEN - COMICS AND STEREOTYPES

THE CONNECTION BETWEEN COMICS AND STEREOTYPES REACHES ALL THE WAY BACK TO ITS ORIGINS. SWISS ARTIST RODOLPHE TOPFFER (1799-1846) -- OFTEN CONSIDERED A STARTING POINT FOR COMICS AS WE KNOW THEM TODAY -- FLIRTED WITH THE PSEUDO-SCIENCE OF PHRENOLOGY, WHICH HELD THAT YOU COULD TELL ANYONE'S PERSONALITY AND MENTAL CAPABILITY JUST BY MEASURING THEIR HEAD-SHAPE. TOPFFER DIDN'T NECESSARILY BUY INTO THE "SCIENCE'S" MORE TOXIC CONCLUSIONS, BUT HE CONSIDERED SUCH VISUAL STEREOTYPING USEFUL FOR VISUAL ARTISTS WORKING IN THE SIMPLE STYLE OF NARRATIVE DRAWING HE DEVELOPED.

FROM ITS BEGINNINGS IN THE LATE NINETEENTH CENTURY, AMERICAN COMIC STRIPS CONTAINED NEGATIVE DEPICTIONS OF ETHNIC MINORITIES, AND RACIST DEPICTIONS OF AFRICAN-AMERICANS. SOME OF COMICS' SEMINAL ARTISTS, LIKE WINDSOR MCKAY AND WILL EISNER, INTRODUCED CHARACTERS VISUALLY MODELLED AFTER OLD RACIAL STEREOTYPES. IN EISNER'S CASE, ATTEMPTS WERE MADE TO HUMANIZE THE BLACK SIDEKICK EBONY IN EISNER'S SERIES *THE SPIRIT*, BUT THE STEREOTYPED VISUAL DESIGN CONTINUED TO WEIGH HEAVILY ON THE SERIES, WHICH EVENTUALLY DROPPED THE CHARACTER.

SINCE THIS BOOK IS DEDICATED TO WILL, WHO I CONSIDERED A FRIEND AND MENTOR, IT'S IMPORTANT TO ACKNOWLEDGE THE LEGITIMATE CRITICISMS LEVELED AGAINST EBONY -- ESPECIALLY THE EARLIEST VERSIONS OF THE CHARACTER. TO HIS CREDIT, THOUGH, THE VERY YOUNG EISNER WOULD MOVE ON TO WORK IN COMICS FOR SIX DECADES AFTER LEAVING THOSE EARLY PAGES BEHIND, AND PRODUCE MANY SOCIALLY PROGRESSIVE STORIES, ESPECIALLY IN THE YEARS FOLLOWING 1978'S *A CONTRACT WITH GOD*.

MORE GENERALIZED STEREOTYPES LIKE THOSE SHOWN ON PAGE 73 (THE BIG BRUTE, LITTLE NERD AND HEROIC LEADING MAN) DON'T NECESSARILY CARRY THE SAME SOCIAL CHARGE, AND THEY'RE TEMPTING FOR CARTOONISTS HOPING TO MAKE A FAST IMPRESSION. BUT EVEN HERE, SOME PREJUDICES CAN CREEP IN. NOTICE THE SHIRT PATCH OVER THE "BRUTE'S" POCKET, MARKING HIM AS BLUE COLLAR? AND DOES THE "NERD" HAVE STEREOTYPICALLY "JEWISH" FEATURES? IN SHORT: EVERY STEREOTYPE COMES FROM SOMEWHERE, AND THAT PLACE MAY NOT ALWAYS BE OBVIOUS.

PAGE 74-77 - MODEL SHEETS AND CHAR-ACTER CONSTRUCTION

BOOKS ON ANIMATION ARE ESPECIALLY HELPFUL FOR LEARNING HOW CHARACTERS CAN BE CONSTRUCTED IN THE MODEL SHEET PHASE TO INSURE A CONSISTENT APPEARANCE THROUGHOUT A STORY. I LEARNED A LOT FROM AN OLD PRESTON BLAIR BOOK, AND HE SEEMS TO

STILL HAVE SOME OTHERS IN PRINT, BUT LOOK AROUND AND YOU CAN PROBABLY FIND QUITE A FEW.

HERE'S AN EXAMPLE FROM PRESTON BLAIR'S RECENT BOOK *CARTOON ANIMATON*:

PAGE 78 - GRAVITY AND SEPARATION

THE BIGGEST PROBLEM WITH KEEPING CHARACTERS INTERNALLY CONSISTENT AND DIFFERENT FROM ONE ANOTHER IS THAT AFTER A WHILE, CHARACTERS WIND UP SOUNDING MORE AND MORE LIKE THEIR AUTHOR— ONE OF MANY REASONS TO HAVE AN HONEST FRIEND READING YOUR STUFF AND LOOKING OUT FOR SUCH UNWANTED HABITS.

PAGE 80-101 - FACIAL EXPRESSIONS: GENERAL COMMENTS

ONE OF THE BIG PROBLEMS WITH HOW-TO-DRAW BOOKS IS THE IMPLICIT ASSUMPTION THAT READERS SHOULD STUDY THE MASTER'S DRAWINGS AND IMITATE THEM (AN ESPECIALLY BAD IDEA IN MY CASE, SINCE I'M HARDLY A "MASTER").

THE DRAWINGS IN THIS SECTION ARE MY BEST ATTEMPTS TO ILLUSTRATE THE PRINCIPLES OF FACIAL EXPRESSION I'M DESCRIBING, BUT THEY'RE NOT SUPPOSED TO SHOW THE "RIGHT WAY" TO DRAW SPECIFIC EXPRESSIONS. THERE ARE COUNTLESS WAYS TO DRAW ANY EXPRESSION, AND COUNTLESS ARTISTS WHOSE TECHNIQUES YOU CAN STUDY.

THE BEST SOURCES I FOUND FOR FACIAL EXPRESSIONS (BESIDES REAL-LIFE OBSERVATIONS) WERE DARWIN, PAUL EKMAN AND ARTIST GARY FAIGIN. SEE BIBLIOGRA-PHY FOR MORE INFORMATION ON EACH. FAIGIN'S BOOK, *THE ARTIST'S COMPLETE GUIDE TO FACIAL EXPRESSIONS*, WAS ESSENTIAL AND HIGHLY RECOMMENDED.

PAGE 84-85 - THE CREEP FACTOR

OKAY, EVEN I FIND THESE TWO PAGES KIND OF CREEPY AND REDUCTIVE, SO I CAN HARDLY BLAME YOU IF YOU FEEL THE SAME WAY. NOBODY WANTS TO THINK OF THEIR FACE AS A MACHINE, REACTING TO INTERNAL

SWITCHES OF EMOTION LIKE A THREE-WAY FLOOR LAMP. FACES ARE INFINITELY MORE SUBTLE THAN THAT, AND THE EMOTIONS THAT GOVERN THEM ARE SUBTLER STILL.

THIS IS ANOTHER PLACE WHERE A COLOR ANALOGY MIGHT BE USEFUL. A PURE RED, GREEN OR BLUE IS RARELY SEEN IN NATURE WHERE VARIATIONS OF HUE, SATURATION AND VALUE LEAD TO AN INCREDIBLY SUBTLE WORLD OF COLORS. DESCRIBING A HILLSIDE AS "GREEN" OR A RUSTY ABANDONED CAR AS "ORANGE" BARELY SCRATCHES THE SURFACE. BUT UNTIL WE UNDERSTAND THE BASIC PRINCIPLES OF HOW PRIMARY COLORS COMBINE WITH ONE ANOTHER, OUR CHANCES OF REPRODUCING THAT SUBTLETY IN ART IS REDUCED. THE CHARTS ON PAGES 84 AND 85 ARE JUST MY WAY OF SHOWING WHAT HAPPENS WHEN THE "RED" AND "BLUE" OF EMOTIONS COMBINE.

FACES **ARE** MACHINES, BY THE WAY. THAT DOESN'T MAKE THEM ANY LESS BEAUTIFUL.

PAGE 91, PANELS ONE AND TWO - HIDING EMOTIONS

CHRIS WARE, IN A NEW YORKER "MASTER CLASS" WITH CHARLES BURNS (AVAILABLE ON ITUNES, THOUGH A BIT PRICEY) QUESTIONED THE USEFULNESS OF EVEN TRYING TO TEACH BASIC EMOTIONAL EXPRESSIONS TO CARTOONISTS, LARGELY BECAUSE OF THE WAY ADULTS HIDE EMOTIONS:

"I JUST RECENTLY HAD A DAUGHTER, AND I THINK THE ONLY HUMAN BEINGS ON THE PLANET WHO COMMUNI-CATE THIS WAY ARE BABIES. ONLY THEY REALLY USE THEIR FACES TO EXPRESS THEMSELVES, AND BY ABOUT AGE TWO, THEY START TO TRY TO [CONTROL THEIR FACES] OR LIE TO YOU. I THINK ONLY A CHILD IS COMPLETELY HONEST IN THEIR FACIAL EXPRESSIONS, AND BEYOND THAT, ONE OF THE SECRETS OR TRICKS TO DRAWING A SUCCESSFUL COMIC STRIP ABOUT ADULTS, IF YOU'RE DRAWING THEM FROM THE OUTSIDE IN, IS TO REMEMBER THAT MOST ADULTS LIE WITH THEIR FACES."

PAGE 94-99 - WHEN NOT TO BE SUBTLE

EVEN IF YOUR DRAWING STYLE INCLUDES A SOME VERY SUBTLE EXPRESSIONS, YOU'LL NEED TO KEEP THEM SIMPLE IN LONGSHOT. HERE'S PART OF A PANEL BY JAIME HERNANDEZ:

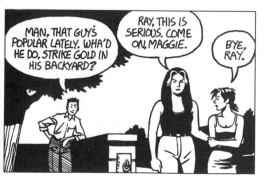

EACH EXPRESSION IS ALMOST STICK FIGURE SIMPLE, BUT IT HELPS US TO HEAR THE SARCASM, STERN RESOLVE AND INNOCENT AFFECTION IN THEIR CORRESPONDING WORD BALLOONS.

MORE COMPLEX EXPRESSIONS ARE BEST USED FOR CHARACTERS IN CLOSE-UP THAT READERS WILL BE GETTING A GOOD LOOK AT. FACES IN THE BACKGROUND, OR THOSE THAT ARE PART OF A CROWD MIGHT NEED TO TELEGRAPH THEIR EMOTIONS A BIT MORE.

PAGE 96 - THEY HAVE NAMES!

MORT WALKER'S *THE LEXICON OF COMICANA* GIVES SOME GREAT, FUNNY NAMES TO A LOT OF FAMILIAR CARTOON SYMBOLS (THOSE SWEAT BEADS? MORT CALLS 'EM "PLEWDS!"). SEE BIBLIOGRAPHY TO TRACK DOWN A COPY.

Jarns *Quimps* *Nittles*

PAGE 99, PANEL SEVEN - PANEL-TO-PANEL CHANGES

HERE ARE FOUR CONSECUTIVE FACES FROM A FOUR-PAGE SILENT COMIC BY KYLE BAKER. CAN YOU FIGURE OUT THE SITUATION FROM THE FACES ALONE?

EVEN IN SIMPLER CARTOON STYLES, ONE OR TWO WELL CHOSEN LINES CAN GO A LONG WAY TOWARD SPECIFYING AN EMOTION, AS IN THIS TWO PANEL TRANSITION FROM CHARLES SCHULZ'S PEANUTS:

ORDINARILY, WHEN LUCY YELLS, SHE HAS A HEAVY, ANGRY BROW, AS IF ON THE VERGE OF PUNCHING SOMEBODY. IN THIS SEQUENCE, THOUGH, THE BROW IS UP, INDICATING A MORE REASONABLE KIND OF OUTRAGE. MEANWHILE, LINUS' SMILE IS STILL ON ITS WAY DOWN (REAL SMILES FADE GRADUALLY) BUT WE CAN BEGIN TO SEE THE LOWER LIP HEADING OUT A BIT INTO THE STRETCH THAT DENOTES FEAR (ALONG WITH THE BODY LANGUAGE TO MATCH):

PAGE 102-111 - BODY LANGUAGE

HERE ARE SOME BETTER ARTISTS THAN ME, DEMON-STRATING THE TYPES OF RELATIONSHIPS I DESCRIBE IN THE BODY LANGUAGE SECTION, STARTING WITH JAIME HERNANDEZ ON **ELEVATION** AND **STATUS**:

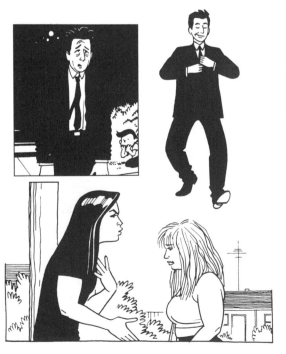

WILL EISNER ON **DISTANCE** AND **RELATIONSHIPS**:

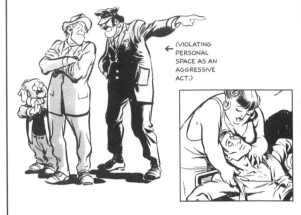

(VIOLATING PERSONAL SPACE AS AN AGGRESSIVE ACT.)

AND CRAIG THOMPSON ON **IMBALANCE** AND **DISCONTENT**:

PAGE 104 - BODY LANGUAGE FACTORS

THESE ARE MY OWN CATEGORIES AND THEY'RE BY NO MEANS COMPLETE (AS I MENTION ON PAGE 111). MY REFERENCES FOR BODY LANGUAGE WERE A BIT MORE SPOTTIER THAN THOSE FOR FACIAL EXPRESSIONS. IN THIS SECTION, I RELIED MORE ON MY OWN OBSERVA-TIONS FOR PUTTING IT ALL INTO SOME USEFUL ORDER.

PAGE 111 - OTHER BODY SIGNALS

ART BY CHARLES SCHULZ, JAIME HERNANDEZ, WILL EISNER AND CRAIG THOMPSON (SEE ART CREDITS, PAGE 258).

PARTS OF THIS PAGE DRAW ON IDEAS IN DESMOND MORRIS' 1977 BOOK *MANWATCHING* (SEE BIBLIOGRAPHY).

OPTIONAL EXERCISES

#1 - CHARACTER LIFE HISTORY (PAGES 64-66)

FROM PAGE 64, PANEL SIX: "JUST CONSIDER YOUR OWN HISTORY AND HOW IT SHAPED YOU."

TRY LISTING THE FIVE MOST IMPORTANT ASPECTS OF YOUR OWN HISTORY. YOUR FAMILY LIFE, PLACE OF BIRTH, BIG EVENTS, ETC... THEN CREATE A NEW CHARACTER THAT LOOKS NOTHING LIKE YOU, BUT HAS THOSE SAME KEY EXPERIENCES IN HIS/HER PAST. CONSIDER WHAT KIND OF PERSON COULD HAVE EMERGED FROM THAT HISTORY.

NOW CREATE A SECOND CHARACTER THAT HAD AN OPPOSITE LIFE HISTORY IN THOSE SAME FIVE WAYS. HOW WOULD THE TWO OF THEM RELATE TO ONE ANOTHER IF CIRCUMSTANCES THREW THEM TOGETHER?

#2 - CASTING A WIDE NET (PAGE 71)

CREATE A CAST OF THREE TO FIVE CHARACTERS THAT ARE ALL DIFFERENT IN AT LEAST FOUR OF THE FOLLOW-ING WAYS, BUT ALL THE **SAME** IN ONE OTHER RESPECT. HOW DO THEIR DIFFERENCES HELP TO HIGHLIGHT THE ONE THING THEY ALL HAVE IN COMMON?

- HEIGHT
- WEIGHT
- FACIAL PROFILE
- BEAUTY
- STRENGTH
- RACE AND ETHNICITY
- BACKGROUND
- DESIRES
- AGE
- INTELLIGENCE
- STYLE OF OUTFIT
- TEMPERAMENT
- OBLIGATIONS
- ALLEGIANCE
- GENDER

#3 - DIFFERENT DESIRES (PAGE 67)

TRY CREATING A 1-2 PAGE ROUGH COMIC FEATURING ONE OF THESE PAIRINGS IN CONVERSATION. USING DIALOGUE, FACIAL EXPRESSIONS AND BODY LANGUAGE, CAN YOU MAKE IT CLEAR TO THE READER WHAT EACH CHARACTER WANTS, WITHOUT THEM HAVING TO COME OUT AND SAY IT DIRECTLY?:

- AN UNDERCOVER FEMALE COP LOOKING FOR A KILLER IN A SINGLES BAR, AND A GUY TRYING TO HIT ON HER.
- A NEWSPAPER REPORTER DOING TAPED INTERVIEWS OF "LIFE ON THE STREET" AND A HUNGRY HOMELESS MAN HOPING HE'LL BE OFFERED PART OF THE SANDWICH THE REPORTER IS HOLDING.
- A SUPERHERO TRACKING A VILLAIN AND THAT SAME VILLAIN IN DISGUISE, POSING AS A CIVILIAN OFFERING TO "HELP" THE HERO.

#4 - EXPRESSIONS AND BODY LANGUAGE (PAGES 80-120)

TRY A ONE PAGE SEQUENCE OF A PERSON HOLDING A PHONE TO THEIR EAR, SPEAKING ONLY OCCASIONALLY, MAKING SHORT UNSPECIFIC ANSWERS OR COMMENTS ON WHAT THE UNSEEN CALLER IS TELLING THEM ("I SEE," "UH-HUH," "NO, OF COURSE," ETC...). SEE IF YOU CAN COMMUNICATE HOW THE OTHER CALLER IS AFFECTING THEM EMOTIONALLY, THROUGH THEIR CHANGES OF EXPRESSION AND BODY LANGUAGE ALONE.

EXTRA CHALLENGE: CAN YOU THEN TAKE THE EXACT SAME DIALOGUE AND REDRAW THE CONVERSATION TO HAVE A COMPLETELY DIFFERENT EMOTIONAL MEANING?

#5 - TARGETING EXPRESSIONS

PICK TWO EXPRESSIONS FROM THIS LIST, AND DRAW A FACE TO MATCH EACH :

- CONFIDENT
- UNCERTAIN
- FRUSTRATED
- HURT (EMOTIONALLY)
- FLIRTATIOUS
- MISCHIEVOUS
- TIRED

THEN GIVE THE SAME LIST TO A FRIEND, ALONG WITH YOUR DRAWINGS, AND ASK HIM/HER TO GUESS WHICH EXPRESSION YOU WERE GOING FOR.

#6 - TARGETING POSES

PICK ONE OR TWO ATTITUDES FROM THIS LIST, AND DRAW A BODY TO MATCH:

- POMPOUS
- UNEASY
- IMPATIENT
- AGGRESSIVE
- TIRED
- HUMBLE
- STUBBORN

NO FACIAL EXPRESSION FOR THIS ONE, JUST A NOSE AND EARS TO SHOW HEAD POSITION.

AGAIN, GIVE THE SAME LIST TO A FRIEND AND ASK HIM/HER TO GUESS WHICH POSE YOU WERE GOING FOR.

#7 - BODY LANGUAGE IN SEQUENCE

TRY DRAWING A SHORT COMIC SHOWING TWO FACELESS STICK FIGURES IN CONVERSATION. WITHOUT USING ANY WORDS AT ALL, CAN A FRIEND DESCRIBE EACH CHARACTER'S CHANGING EMOTIONS?

ADDITIONAL NOTES AT:
WWW.SCOTTMCCLOUD.COM/MAKINGCOMICS

THE POWER OF WORDS IS AN UNDENIABLE PART OF THE APPEAL OF THIS ART FORM WE CALL COMICS. SO STRONG IS THE ROLE OF WORDS IN THE VAST MAJORITY OF GREAT COMIC STRIPS, COMIC BOOKS AND GRAPHIC NOVELS DURING THE LAST 100 YEARS, THAT SOME COMICS SCHOLARS SUCH AS R.C. HARVEY HAVE SUGGESTED THAT THE ARTFUL COMBINATION OF WORDS AND PICTURES SHOULD BE INCLUDED IN ANY COMPREHENSIVE DEFINITION OF COMICS. I THINK IT'S POSSIBLE TO CREATE WORDLESS COMICS (AND IN THESE BOOKS I'M PROCEEDING FROM A DEFINITION BASED INSTEAD ON THE IDEA OF COMICS AS PICTURES IN SEQUENCE, WITH OR WITHOUT WORDS) SO I WOULDN'T NECESSARILY GO THAT FAR, BUT CLEARLY ANY EXAMINATION OF THE ART OF MAKING COMICS SHOULD PLACE THE ROLE OF WORDS FRONT AND CENTER. • WORDS EVOKE FEELINGS, SENSATIONS AND ABSTRACT CONCEPTS WHICH PICTURES ALONE CAN ONLY BEGIN TO CAPTURE; THEY'RE COMICS' ONLY TRADITIONAL LINK WITH THE WARMTH AND NUANCE OF THE HUMAN VOICE; THEY OFFER COMICS CREATORS THE OPPORTUNITY TO COMPRESS AND EXPAND TIME; AND WHEN WORDS AND PICTURES WORK INTERDEPENDENTLY, THEY CAN CREATE NEW IDEAS AND SENSATIONS BEYOND THE SUM OF THEIR PARTS. • WORDS HAVE ALSO PLAYED A ROLE IN THE GRAPHIC EVOLUTION OF MODERN COMICS AND THROUGH THEIR OFFSPRING -- THE WORD BALLOON, CAPTION AND SOUND EFFECT -- HAVE GIVEN RISE TO A WEALTH OF UNIQUE GRAPHIC DEVICES, MANY OF THEM NOW CLOSELY ASSOCIATED WITH COMICS AND APPROPRIATED IN OTHER MEDIA ON A REGULAR BASIS. • SOME APPROACH THE COMICS PROFESSION HOPING TO WRITE FOR OTHERS TO DRAW, AND FOR THEM, WORDS ARE THE VERY SUBSTANCE OF THEIR CRAFT. BUT WHETHER YOU PLAN TO WRITE FOR OTHERS, OR WRITE AND DRAW EVERYTHING YOURSELF, IT'S A STRONG VISUAL IMAGINATION AND THE SEAMLESS INTEGRATION OF WORDS AND PICTURES WHICH MARKS COMICS' BEST WRITING. • TODAY, WITH A CENTURY OF MODERN COMICS UNDER THEIR BELT, CARTOONISTS HAVE EVOLVED AN ARTFUL, SOPHISTICATED DANCE BETWEEN WORDS AND PICTURES WHICH EMPHASIZES EACH ONE'S STRENGTHS, BUT ALSO STRIVES, WHENEVER POSSIBLE, TO FIND THE PERFECT --

Chapter Three

The Power of Words

Seamless Integration and the "Desperation Device"

-- BALANCE BETWEEN THE TWO.

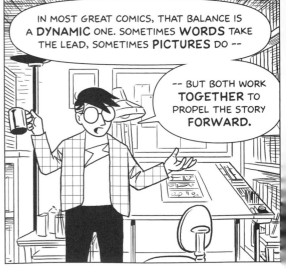

IN MOST GREAT COMICS, THAT BALANCE IS A **DYNAMIC** ONE. SOMETIMES **WORDS** TAKE THE LEAD, SOMETIMES **PICTURES** DO --

-- BUT BOTH WORK **TOGETHER** TO PROPEL THE STORY **FORWARD.**

COMICS IS A MEDIUM OF **FRAGMENTS** -- A PIECE OF TEXT HERE, A CROPPED PICTURE THERE -- BUT WHEN IT WORKS, YOUR READERS WILL **COMBINE** THOSE FRAGMENTS AS THEY READ AND EXPERIENCE YOUR STORY AS A CONTINUOUS **WHOLE**.

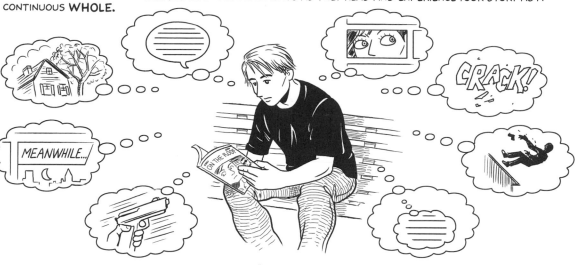

AND AS NOTED IN CHAPTER ONE, IT'S THAT SENSE OF CONTINUOUS EXPERIENCE THAT CAN HELP MAKE **READING** FEEL LIKE **LIVING**.

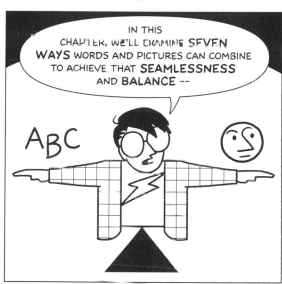

IN THIS CHAPTER, WE'LL EXAMINE **SEVEN WAYS** WORDS AND PICTURES CAN COMBINE TO ACHIEVE THAT **SEAMLESSNESS** AND **BALANCE** --

ABC

-- PLUS THE ART OF USING **WORD BALLOONS** TO GIVE VOICE TO YOUR CHARACTERS --

-- CAPTURING THE ESSENCE OF SOUND WITH **SOUND EFFECTS** --

BOOM

-- AND SOME NOTES ON COMBINING WORDS AND PICTURES THROUGH THE JOINT EFFORTS OF **WRITER-ARTIST TEAMS**.

IN *UNDERSTANDING COMICS*, I IDENTIFIED A FEW DISTINCT **CATEGORIES** OF WORD/PICTURE **COMBINATIONS.***

IT MIGHT HELP TO THINK OF THESE SEVEN CATEGORIES **DIAGRAMMATICALLY.**

I. WORD-SPECIFIC

WORDS PROVIDING ALL YOU NEED TO KNOW, WHILE THE PICTURES ILLUSTRATE ASPECTS OF THE SCENE BEING DESCRIBED.

WORD-SPECIFIC

2. PICTURE-SPECIFIC

PICTURES PROVIDING ALL YOU NEED TO KNOW, WHILE THE WORDS ACCENTUATE ASPECTS OF THE SCENE BEING SHOWN.

PICTURE-SPECIFIC

3. DUO-SPECIFIC

WORDS AND PICTURES BOTH SENDING ROUGHLY THE SAME MESSAGE.

DUO-SPECIFIC

4. INTERSECTING

WORDS AND PICTURES WORKING TOGETHER IN SOME RESPECTS WHILE ALSO CONTRIBUTING INFORMATION INDEPENDENTLY.

INTERSECTING

5. INTERDEPENDENT

WORDS AND PICTURES COMBINING TO CONVEY AN IDEA THAT NEITHER WOULD CONVEY ALONE.

INTERDEPENDENT

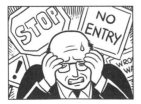

6. PARALLEL

WORDS AND PICTURES FOLLOWING SEEMINGLY DIFFERENT PATHS WITHOUT INTERSECTING.

PARALLEL

7. MONTAGE

WORDS AND PICTURES COMBINED PICTORIALLY.

MONTAGE

*SEE **UNDERSTANDING COMICS** PAGES 153-155. NOTE THAT I'VE CHANGED THE NAME OF ONE CATEGORY. "ADDITIVE" IS NOW "INTERSECTING"

MMMMM...

DIAGRAMS...

SO, HERE'S HOW -- ≶AHEM≶ -- EACH OF THESE SEVEN CAN HELP YOU ADVANCE YOUR STORY.

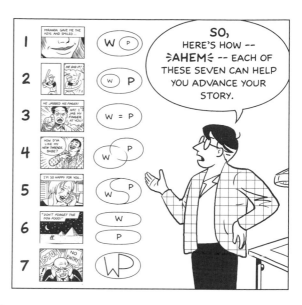

1. MIRANDA GAVE ME THE KEYS AND SMILED... — W P
2. HE DID IT! — W P
3. HE JABBED HIS FINGER! / HA! I JAB MY FINGER AT YOU! — W = P
4. HOW D'YA LIKE MY NEW THREADS, BABE? — W P
5. I'M SO HAPPY FOR YOU... — W P
6. "DON'T FORGET THE DOG FOOD!" — W / P
7. STOP! NO ENTRY! — WP

WORD-SPECIFIC COMBINATIONS OFFER SOME POWERFUL ADVANTAGES FOR STORYTELLERS.

MIRANDA GAVE ME THE KEYS AND SMILED...

1. WORD-SPECIFIC

W P

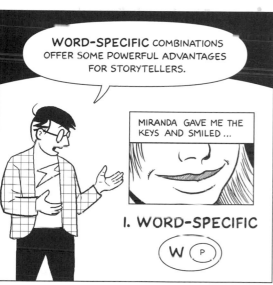

THE FIRST OF THESE ADVANTAGES, COMPRESSION, MAKES USE OF THE WRITTEN WORD'S ABILITY TO REDUCE BIG CHUNKS OF TIME AND INFORMATION DOWN TO A FEW TINY WORDS.

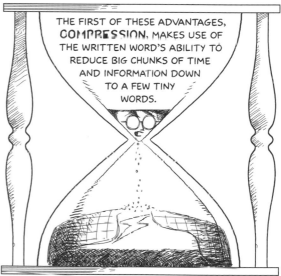

THIS IS ESPECIALLY USEFUL WHEN YOU'RE WRITING A SHORT AND/OR FIXED-LENGTH COMIC, AND YOU WANT TO JUMP AHEAD QUICKLY TO THE HEART OF YOUR STORY.

FIVE YEARS LATER, THAT TEN DOLLAR BILL HAD BECOME THIRTY MILLION!

YEE-HAW!

HONK! HONK!

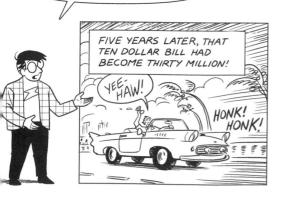

NO MATTER HOW BIG THE EVENT, WORDS CAN PACK IT DOWN FOR YOU.

"...and the Earth exploded."

YOU JUST NEED TO DECIDE HOW MUCH YOU WANT YOUR READERS TO SEE FOR THEMSELVES AND HOW MUCH YOU WANT THEM TO IMAGINE.

ANOTHER ADVANTAGE OF **WORD-SPECIFIC** COMBOS IS THE WAY THEY FREE UP THE **PICTURES** BY PULLING THE WHOLE WEIGHT OF THE STORY USING WORDS ALONE.

ZZZZZ...

STORY

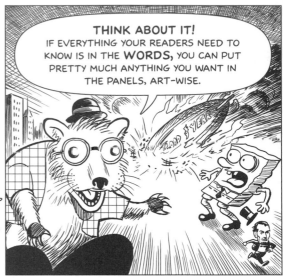

THINK ABOUT IT! IF EVERYTHING YOUR READERS NEED TO KNOW IS IN THE **WORDS,** YOU CAN PUT PRETTY MUCH ANYTHING YOU WANT IN THE PANELS, ART-WISE.

WELL, OKAY, NOT **"ANYTHING"** MAYBE -- BUT YOU DO HAVE A LOT OF **LATITUDE.**

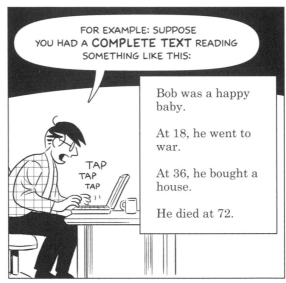

FOR EXAMPLE: SUPPOSE YOU HAD A **COMPLETE TEXT** READING SOMETHING LIKE THIS:

TAP
TAP
TAP

Bob was a happy baby.

At 18, he went to war.

At 36, he bought a house.

He died at 72.

WITH EVERYTHING SPELLED OUT IN THE **TEXT** LIKE THAT, YOUR ART CAN GO IN A LOT OF **DIFFERENT DIRECTIONS.**

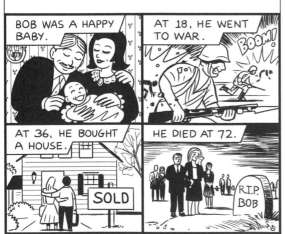

YOU COULD ILLUSTRATE THE EVENTS IN A FAIRLY **STRAIGHTFORWARD** WAY.

BOB WAS A HAPPY BABY.

AT 18, HE WENT TO WAR.

BOOM!

AT 36, HE BOUGHT A HOUSE.

SOLD

HE DIED AT 72.

R.I.P. BOB

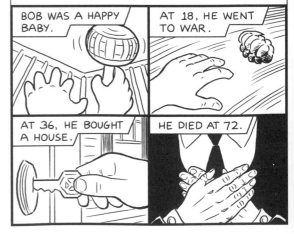

YOU COULD DRAW THE WHOLE THING USING JUST **HANDS.**

BOB WAS A HAPPY BABY.

AT 18, HE WENT TO WAR.

AT 36, HE BOUGHT A HOUSE.

HE DIED AT 72.

PANEL TWO: SEE ART CREDITS, PAGE 258.

YOU COULD SHOW A **NARRATOR** SPEAKING DIRECTLY TO THE READER.

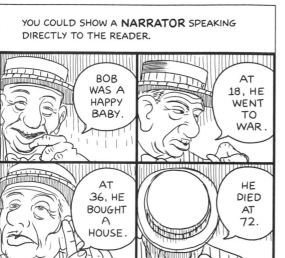

BOB WAS A HAPPY BABY.

AT 18, HE WENT TO WAR.

AT 36, HE BOUGHT A HOUSE.

HE DIED AT 72.

YOU COULD EVEN ILLUSTRATE IT ENTIRELY WITH **SYMBOLS.**

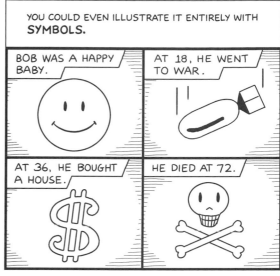

BOB WAS A HAPPY BABY.

AT 18, HE WENT TO WAR.

AT 36, HE BOUGHT A HOUSE.

HE DIED AT 72.

MOST WORD-SPECIFIC COMBOS OCCUR ALONGSIDE **OTHER** SORTS OF COMBOS.

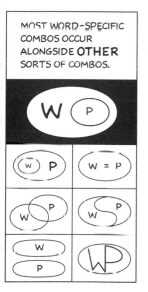

MOST CARTOONISTS LIKE TO LET THE **PICTURES** TELL THE STORY JUST AS OFTEN AS **WORDS.**

BUT THERE ARE LARGELY WORD-SPECIFIC COMICS THAT MAKE USE OF THAT "ARTISTIC LICENSE" ON A REGULAR BASIS.

IN FACT, YOU'RE READING ONE **NOW.**

PICTURE-SPECIFIC COMBINATIONS SIMILARLY GIVE LICENSE TO THE **WORDS,** AND THEY OFFER OTHER BENEFITS.

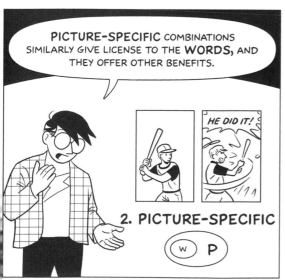

HE DID IT!

2. PICTURE-SPECIFIC

W P

AMONG THEM, A CLOSER LINK TO THE WHOLE IDEA OF SEQUENTIAL **VISUAL** STORYTELLING WHICH THE ART OF COMICS IS BASED ON.

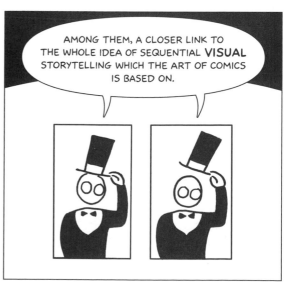

133

BECAUSE OF THE **PICTORIAL NATURE** OF COMICS, PICTURE-SPECIFIC SEQUENCES CAN FUNCTION WITHOUT ANY WORDS AT ALL FOR AS LONG AS NECESSARY --

-- unlike word-specific sequences, which can't go picture-less for more than a panel or two without simply becoming prose.

SURPRISE!!

HAPPY BIR

227

CLICK!

BAG

WHA--?

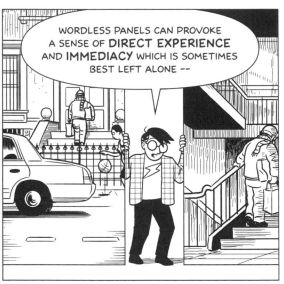

WORDLESS PANELS CAN PROVOKE A SENSE OF **DIRECT EXPERIENCE** AND **IMMEDIACY** WHICH IS SOMETIMES BEST LEFT ALONE --

-- BUT THERE ARE COMPELLING REASONS TO CONSIDER ADDING **TEXT** --

-- SUCH AS IF YOU WANTED TO EVOKE THE **SOUNDS** OF A FAMILIAR **LANDSCAPE.**

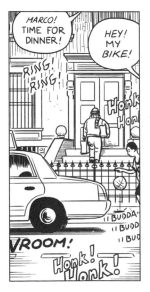

MARCO! TIME FOR DINNER!

HEY! MY BIKE!

RING! RING!

Honk Hon

BUDDA BUDD BUD

VROOM!

Honk! Honk!

OR GIVE US A **WINDOW** INTO A CHARACTER'S **INNER LIFE** AND **SENSATIONS.**

EWW...

60 YEARS TO THE DAY... AND WHAT DO I HAVE TO *SHOW* FOR IT?

HEY... DO I SMELL FRESH-BAKED *COOKIES?*

227

CLICK!

BAG

WHEN BOTH WORDS **AND** PICTURES ARE TELLING THE SAME STORY, YOU'VE GOT A **DUO-SPECIFIC** COMBO.

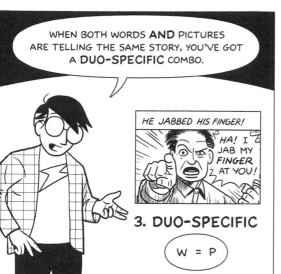

HE JABBED HIS FINGER!

HA! I JAB MY **FINGER** AT YOU!

3. DUO-SPECIFIC

W = P

HERE'S ONE NOW:

I AM STANDING IN A **PANEL!**

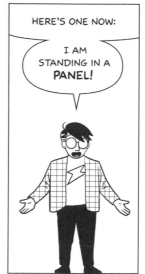

THERE IS A **WATERMELON** ON MY HEAD!

NOW IT IS **GONE...**

...SCOTT SAID **SADLY.**

WELL, OBVIOUSLY I'M NOT A FAN OF COMBINATIONS THAT ARE JUST POINTLESSLY **REDUNDANT** LIKE THAT. FORTUNATELY, MODERN COMICS WRITERS AVOID REDUNDANCY MOST OF THE TIME.

AND DUO-SPECIFIC COMBINATIONS DO HAVE SOME **LEGITIMATE USES.**

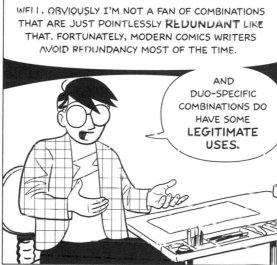

INFO-COMICS, FOR EXAMPLE, USE REDUNDANCY TO INSURE MAXIMUM **CLARITY.**

EXIT

WALK, DON'T RUN, TO THE NEAREST EXIT.

DUO-SPECIFIC COMBINATIONS CAN ALSO BE USED TO EVOKE A **CHILDREN'S BOOK** TONE --

Rollo and Squeeker, the dummy, shared a bath.

-- OR TO LEND AN AIR OF **ANTIQUE** STORYTELLING TRADITIONS.

AND JUST AS HE TOOK HER INTO HIS ARMS, THE FORTRESS WALL GAVE WAY TO THE FLOOD.

PANELS SEVEN-EIGHT: ART BY RENEE FRENCH AND PATRICK ATANGAN (SEE ART CREDITS, PAGE 258).

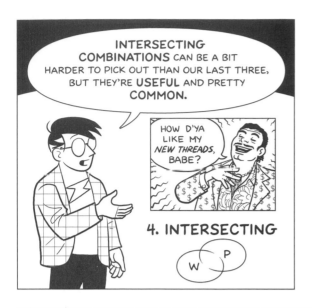

INTERSECTING COMBINATIONS CAN BE A BIT HARDER TO PICK OUT THAN OUR LAST THREE, BUT THEY'RE USEFUL AND PRETTY COMMON.

HOW D'YA LIKE MY NEW THREADS, BABE?

4. INTERSECTING

THESE ARE PANELS IN WHICH THE WORDS AND PICTURES COVER SOME OF THE SAME GROUND, BUT EACH ADDS SIGNIFICANT DETAIL OR PERSPECTIVE TO THE SCENE.

HOW D'YA LIKE MY NEW THREADS, BABE?

IMPORTANT INFO ABOUT THE CHARACTER'S ATTITUDE AND HIS TARGET AUDIENCE.

IMPORTANT INFO ABOUT THE CHARACTER'S PHYSICAL APPEARANCE AND FASHION CHOICES.

LEFT TO THEIR INSTINCTS, MANY CARTOONISTS WILL USE A LOT OF INTERSECTING COMBINATIONS, CREATING PAGES WHICH READERS COULD PARTIALLY MAKE SENSE OF WITHOUT THE WORDS, AND PARTIALLY MAKE SENSE OF WITHOUT THE ART.

WHAT'S WRONG, SHUICHI?

WHAT'S THIS?

TWO EGGS, PAL! WHAT? DID TH' PRICE GO UP?

WHAT'S YOUR NAME KID?

"WILLIE"

Heading for town?

Sure, get in.

HERE'S A LITTLE SOMETHING FOR YOUR EFFORTS

GOSH

WOW

DO THEY WORK?

I CAN MOVE 'EM A BIT... BUT I DON'T THINK I CAN FLY.

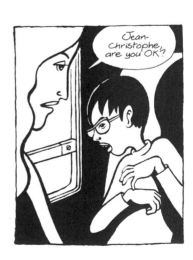

Jean-Christophe, are you OK?

INTERDEPENDENT COMBINATIONS AREN'T AS COMMON, BUT WHEN DONE WELL THEY CAN ACHIEVE MEMORABLE EFFECTS.

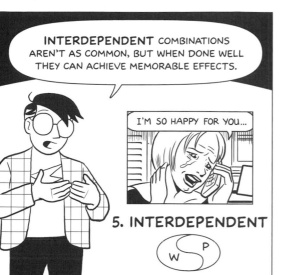

I'M SO HAPPY FOR YOU...

5. INTERDEPENDENT

HERE, THE RESULT OF WORDS AND PICTURES IN **COMBINATION** IS UTTERLY UNLIKE WHAT EITHER COULD ACHIEVE **ALONE**.

WITHOUT THE ART, WE WOULD TAKE HER WORDS AT FACE VALUE.

I'M SO HAPPY FOR YOU...

WITHOUT THE WORDS, WE WOULDN'T KNOW SHE WAS LYING.

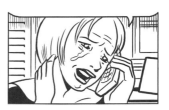

IN THE COMICS ADAPTATION OF PAUL AUSTER'S *CITY OF GLASS*, STORYTELLERS KARASIK AND MAZZUCCHELLI USE SUCH A COMBINATION TO SYMBOLICALLY SHOW THE **INNER TURMOIL** OF A MAN ("QUINN") WHOSE WIFE AND CHILD HAD DIED.

IN PANEL TWO, ONLY THE **WORDS** TELL US THE **SOURCE** OF QUINN'S EMOTIONAL "WOUND" AND ONLY THE **ART** PORTRAYS THE MOMENT AS ANYTHING MORE THAN A **POLITE CONVERSATION.**

QUINN FELT AS THOUGH AUSTER WERE TAUNTING HIM WITH THE THINGS HE HAD LOST.

I KNOW IT'S SORT OF LAST MINUTE...

...BUT WHY DON'T YOU STAY AND HAVE DINNER?

AH... THAT'S VERY KIND, BUT I MUST BE GOING.

INTERDEPENDENT COMBINATIONS KEEP READERS' MINDS **FULLY ENGAGED** BECAUSE THEY REQUIRE THEM TO **ASSEMBLE MEANINGS** OUT OF SUCH DIFFERENT **PARTS.** SUCH EFFECTS CAN BE STIMULATING, GRATIFYING --

AND THIS IS MY DEAR WIFE *HELEN.*

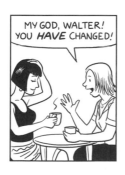

MY GOD, WALTER! YOU *HAVE* CHANGED!

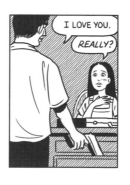

I LOVE YOU.

REALLY?

-- AND A **KIND** OF EXPERIENCE RARELY FOUND OUTSIDE OF **COMICS.**

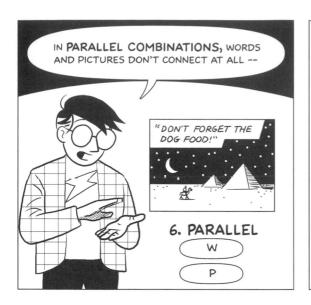

IN **PARALLEL COMBINATIONS**, WORDS AND PICTURES DON'T CONNECT AT ALL --

"DON'T FORGET THE DOG FOOD!"

6. PARALLEL

W

P

-- THOUGH THEIR PATHS MAY BEND **TOWARD** EACH OTHER IN **LATER** PANELS.

TED! ARE YOU **LISTENING** TO ME?!

HUH?

SUCH COMBINATIONS CAN HAVE BOTH **PRACTICAL** AND **AESTHETIC** APPLICATIONS.

DIALOGUE FROM **ONE SCENE** CAN RUN THROUGHOUT **ANOTHER** TO SAVE ROOM AND CREATE A DENSE, LAYERED TEXTURE --

"MIND GIVING ME A *BACK-RUB*?"

THERE.

"AS YOU WISH."

"DO YOU MISS CHARLIE?"

ON THE RIDGE.

"I GUESS."

-- OR IT CAN BE USED TO SOFTEN A **TRANSITION** FROM ONE SCENE TO ANOTHER.

...AND THAT'S HOW I MET MY *REAL* FATHER.

HERE, YOU LOOK *SLEEPY*...

"...*LET ME DRIVE* FOR A WHILE."

ICE TEA, ANYONE?

PARALLEL COMBINATIONS CAN ALSO BE PUT TO MORE **EXPERIMENTAL** USES --

(# = x/y)

MY CABLE BILL IS PAID UP FOR THE NEXT THREE MONTHS

...I HAVE A ROOM WITH A VIEW....

...AND WHOEVER LIVED HERE BEFORE LEFT A STACK OF LIFE MAGAZINES .

-- SUCH AS IN ART SPIEGELMAN'S 1973 PAGE "DON'T GET AROUND MUCH ANYMORE" WHERE THE CONTENTS OF THE CAPTIONS REFER PRIMARILY TO THE PICTURES THAT **PRECEDE** THEM, CREATING A DISORIENTING SENSE OF PSYCHOLOGICAL **INERTIA.***

* FOR THIS READER, AT LEAST.

ART BY ART SPIEGELMAN (SEE ART CREDITS, PAGE 258).

AND FINALLY THERE'S THE **MONTAGE** WHERE WORDS AND LETTERS TAKE ON PICTORIAL QUALITIES AND ARE COMBINED MORE FREELY WITH THE PICTURES THAT SURROUND THEM.

7. MONTAGE

THE USE OF PURE COLLAGE TECHNIQUES IN COMICS HAS BEEN PRETTY **RARE** OVER THE YEARS, BUT CARTOONISTS DABBLE IN IT FROM TIME TO TIME --

-- THE MOST FAMOUS EXAMPLE BEING **WILL EISNER** WHO DEVISED MANY INGENIOUS WAYS TO INCORPORATE **LOGOS** DIRECTLY INTO A STORY'S OPENING PANEL.

THE IDEA THAT WORDS MIGHT **"CROSS THE FENCE"** INTO PICTORIAL TERRITORY ONCE IN A WHILE SEEMS REASONABLE --

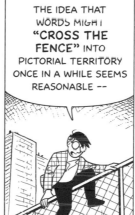

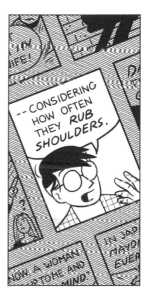

-- CONSIDERING HOW OFTEN THEY *RUB SHOULDERS.*

SOME MODERN CARTOONISTS HAVE TESTED THE POTENTIAL OF TREATING COMMON ELEMENTS LIKE **CAPTIONS** AND **WORD BALLOONS** WITH A STRONG PICTORIAL SENSIBILITY --

-- AND OF COURSE THE **SOUND EFFECT** SPILLS OVER INTO THIS TERRITORY OFTEN --

-- BUT FOR THE MOST PART, MONTAGE REMAINS A LARGELY **UNEXPLORED TERRITORY.**

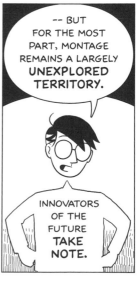

INNOVATORS OF THE FUTURE **TAKE NOTE.**

PANELS TWO, THREE AND SIX: ART BY STEVE DITKO, WILL EISNER DAVID CHOE AND CHRIS WARE (SEE ART CREDITS, PAGE 258).

1. WORD-SPECIFIC

MIRANDA GAVE ME THE KEYS AND SMILED ...

W P

2. PICTURE-SPECIFIC

HE DID IT!

W P

3. DUO-SPECIFIC

HE JABBED HIS FINGER!

HA! I JAB MY *FINGER* AT YOU!

W = P

4. INTERSECTING

HOW D'YA LIKE MY *NEW THREADS,* BABE?

W P

5. INTERDEPENDENT

I'M SO HAPPY FOR YOU...

W P

6. PARALLEL

"*DON'T FORGET THE DOG FOOD!*"

W

P

7. MONTAGE

STOP NO ENTRY

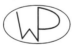

WP

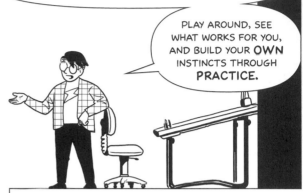

THERE'S NO SET RULE FOR **WHEN** AND **HOW** TO USE A GIVEN TYPE OF WORD PICTURE COMBINATION. MOST CARTOONISTS JUST RELY ON THEIR **INSTINCTS** AND DON'T GET HUNG UP ON **ANYONE'S** NERDY CATEGORIES.

PLAY AROUND, SEE WHAT WORKS FOR YOU, AND BUILD YOUR **OWN** INSTINCTS THROUGH **PRACTICE.**

BUT WHEN THOSE INSTINCTS **FAIL** -- AND IT HAPPENS TO **ALL** OF US --

-- THIS IS A **ROAD MAP** THAT CAN HELP YOU GET BACK **ON COURSE.**

ASK YOURSELF A FEW **QUESTIONS** NOW AND THEN:

AM I TAKING ADVANTAGE OF THE **FREEDOM** WORDS GIVE TO MY ART?

AT 36, HE BOUGHT A HOUSE.

AM I TAKING ADVANTAGE OF THE FREEDOM MY **ART** GIVES TO MY **WORDS?**

HEY... DO I SMELL FRESH-BAKED *COOKIES?*

227

CLICK!

ARE THERE GOOD REASONS TO TELL MY READERS ANYTHING **TWICE?**

D JUST AS HE TOOK HER O HIS ARMS, THE FORTRESS LL GAVE WAY TO THE FLOOD.

ARE BOTH PICTURES AND WORDS CONTRIBUTING SOMETHING OF **VALUE** TO EACH PANEL?

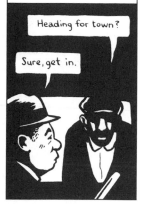

Heading for town?

Sure, get in.

COULD THE TWO **TOGETHER** BE MORE THAN THE SUM OF THEIR **PARTS**?

...BUT WHY DON'T YOU STAY AND HAVE DINNER?

OR COULD THEY EACH CARRY A VASTLY **DIFFERENT** MESSAGE?

"MIND GIVING ME A *BACK-RUB* ?"

THERE.

"AS YOU WISH."

DO WORDS AND PICTURES NEED TO BE TREATED ALL THAT **DIFFERENTLY**?

ONCE AGAIN, THERE'S NO "WRONG" WAY TO MIX WORDS WITH PICTURES, **BUT** IF YOU WANT TO HOLD YOUR READERS' ATTENTION --

-- THERE ARE A COUPLE OF THINGS TO WATCH FOR.

FIRST: KEEP YOUR **WORD COUNT** UNDER CONTROL! IF HALF OF EVERY PANEL IS COVERED IN WORDS, YOU MIGHT WANT TO CONSIDER SAYING MORE WITH THE PICTURES, ADDING MOMENTS TO BREAK UP THE TEXT INTO SMALLER CHUNKS, OR SIMPLY USING FEWER WORDS TO GET YOUR MESSAGE ACROSS. ALSO, DON'T THINK THAT, UM... OH CRAP, I'M, RUNNING OUT OF ROOM -- JUST **DON'T DO THIS!!**

CONSIDER USING A HEALTHY **VARIETY** OF COMBINATIONS SO THAT NEITHER SIDE OF YOUR READERS' BRAINS IS NEGLECTED.

W P

W P

W P

W P

W = P

MOST OF ALL, KEEP FOCUSED ON YOUR **STORY**, WHICH BOTH WORDS AND PICTURES SHOULD EQUALLY **SERVE** --

-- BECAUSE THAT'S WHAT YOUR **READERS** WILL BE FOCUSED ON IF YOU DO YOUR JOB **RIGHT**.

NOW THAT WE'VE COVERED THE DIFFERENT WAYS OF MIXING WORDS AND PICTURES TO TELL A STORY, LET'S EXAMINE HOW THE TWO ARE COMBINED **GRAPHICALLY** --

-- STARTING WITH THESE FREAKY, WORD-FILLED **BLOBS** OVER MY HEAD!

THE RELATIONSHIP OF **WORD BALLOONS** TO THE **DRAWINGS** THAT **SURROUND** THEM HAS ALWAYS BEEN AN **UNEASY** ONE.

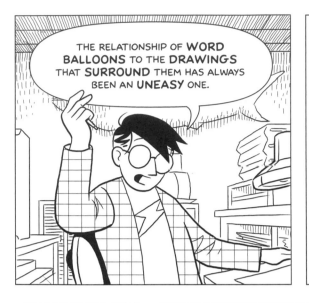

IN *COMICS AND SEQUENTIAL ART,* WILL EISNER CALLS THE WORD BALLOON A **"DESPERATION DEVICE"**; AN ATTEMPT TO "CAPTURE AND MAKE VISIBLE AN ETHEREAL ELEMENT: SOUND."

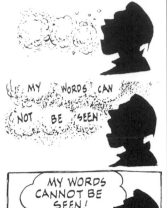

MY WORDS CAN NOT BE SEEN

MY WORDS CANNOT BE SEEN!

BALLOONS DON'T EXIST IN THE SAME PLANE OF REALITY AS THESE PICTURES, YET HERE THEY ARE, FLOATING ABOUT LIKE **PHYSICAL OBJECTS!**

SOME RESPOND TO THIS PARADOX BY DE-EMPHASIZING THE **PHYSICALITY** OF THE BALLOON SHAPE USING HAIRLINE BORDERS OR NO BORDERS AT ALL --

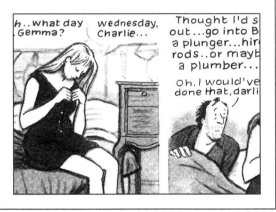

h..what day, Gemma?

wednesday, Charlie...

Thought I'd s out...go into B a plunger...hir rods..or mayb a plumber...

Oh. I would've done that, darli

-- AS IF TO SAY "HEY, I'M NOT REALLY HERE, THIS IS JUST WHERE THE PICTURE **ENDS**" --

ROLL ROLL

-- WHILE OTHERS **EMBRACE** THE PHYSICAL PRESENCE OF BALLOONS WITH HEAVY CONTOURS, MORE DELIBERATE SCULPTING OR DIRECT INTERACTIONS WITH THE SURROUNDING ART.

HI MY NAME IS BUTTERFLY~~

WHAT'S YOURS?

GO GO

...IT..IT DOESN'T MATTER

GONE.

HAD THROWN UP

You said I smiled fake in all those photographs,

but I remember being happy

SHAPE AND STYLE ARE ENTIRELY UP TO **YOU,** OF COURSE --

-- BUT DO KEEP AN EYE ON THE **SIZE** OF YOUR BALLOONS.

PARTIALLY FOR THE REASONS OF TEXT/IMAGE BALANCE CITED EARLIER --

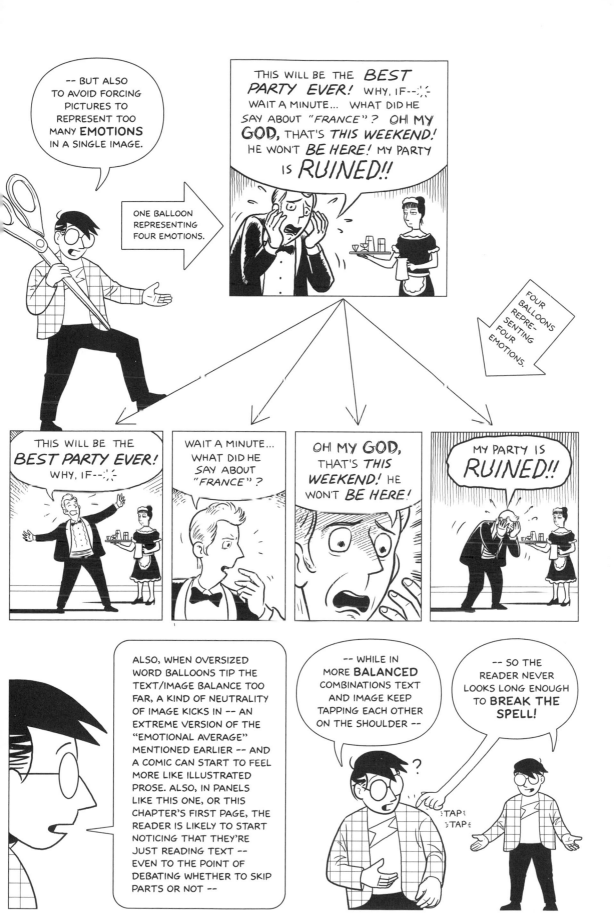

-- BUT ALSO TO AVOID FORCING PICTURES TO REPRESENT TOO MANY **EMOTIONS** IN A SINGLE IMAGE.

ONE BALLOON REPRESENTING FOUR EMOTIONS.

THIS WILL BE THE *BEST PARTY EVER!* WHY, IF-- WAIT A MINUTE... WHAT DID HE SAY ABOUT *"FRANCE"?* OH MY **GOD,** THAT'S *THIS WEEKEND!* HE WON'T *BE HERE!* MY PARTY IS *RUINED!!*

FOUR BALLOONS REPRESENTING FOUR EMOTIONS.

THIS WILL BE THE *BEST PARTY EVER!* WHY, IF--

WAIT A MINUTE... WHAT DID HE SAY ABOUT *"FRANCE"?*

OH MY **GOD,** THAT'S *THIS WEEKEND!* HE WON'T *BE HERE!*

MY PARTY IS *RUINED!!*

ALSO, WHEN OVERSIZED WORD BALLOONS TIP THE TEXT/IMAGE BALANCE TOO FAR, A KIND OF NEUTRALITY OF IMAGE KICKS IN -- AN EXTREME VERSION OF THE "EMOTIONAL AVERAGE" MENTIONED EARLIER -- AND A COMIC CAN START TO FEEL MORE LIKE ILLUSTRATED PROSE. ALSO, IN PANELS LIKE THIS ONE, OR THIS CHAPTER'S FIRST PAGE, THE READER IS LIKELY TO START NOTICING THAT THEY'RE JUST READING TEXT -- EVEN TO THE POINT OF DEBATING WHETHER TO SKIP PARTS OR NOT --

-- WHILE IN MORE **BALANCED** COMBINATIONS TEXT AND IMAGE KEEP TAPPING EACH OTHER ON THE SHOULDER --

-- SO THE READER NEVER LOOKS LONG ENOUGH TO **BREAK THE SPELL!**

TAP
TAP

THE QUESTION OF HOW MUCH **EMPHASIS** TO GIVE INDIVIDUAL WORDS IN A BALLOON IS LESS **CLEAR-CUT.**

THOSE OF US WHO STARTED OUT IN THE MELODRAMATIC WORLD OF **SUPERHERO COMICS** BECAME ACCUSTOMED TO FREQUENT USES OF **OVERSIZED, BOLD** OR **ITALICIZED** LETTERING.

BAH! WHO'S WORRIED? NOTHING HUMAN CAN STAND UP TO **THE THING!**

THAT'S THE **SCARY** PART, MISTER! **HE ISN'T** HUMAN!

ALLOWING FOR **STRONG VARIATIONS** IN LETTERING CAN HELP TO INTEGRATE WORDS AND PICTURES BY CELEBRATING THEIR **COMMON ROOTS** AS **GRAPHIC SYMBOLS.**

SOME CARTOONISTS USE DRAMATIC VARIATIONS OF SIZE AND SHAPE TO PORTRAY **VOCAL INFLECTION** ON A WORD-TO-WORD BASIS.

AHH.. DINNER!

GULP!

SHE **WHAT?!**

SHE... **SAID** THAT YOU HAD HAD A **VISION** --THAT THE **SPHERE** SHOULD BE FORTY-SIX METERS ACROSS INSTEAD OF THIRTY-THREE...

SHE INSTRUCTED MR. HAMMOND TO MAKE THE NECESSARY...

AND OF COURSE, NOTHING SAYS **LOUD** LIKE A **BIG FONT!**

ON THE OTHER HAND, WILL EISNER -- HIMSELF A LONG-TIME USER OF **BIG WORDS** -- POINTS OUT THAT HOW WE **"HEAR"** A WORD BALLOON IS ALSO AFFECTED BY THE **EXPRESSIONS** AND **BODY LANGUAGE** OF THE SPEAKER, REGARDLESS OF HOW THE DIALOGUE IS LETTERED* --

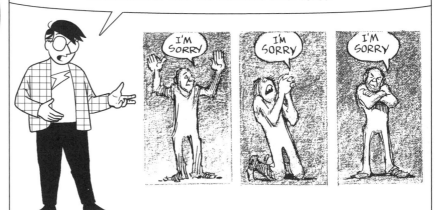

I'M SORRY

I'M SORRY

I'M SORRY

PANELS TWO, THREE, FOUR AND SIX: ART BY JACK KIRBY, PATRICK MCDONNELL, DAVE SIM/GERHARD AND WILL EISNER (SEE ART CREDITS, PAGE 258).

* I MAKE A SIMILAR POINT ON PAGE 106, PANEL SEVEN, BUT EISNER SAID IT FIRST BY 20 YEARS.

-- AND, AS PROSE WRITERS WILL TELL YOU, BY THE **MEANINGS** OF THE WORDS THEMSELVES.

THUS, A NUMBER OF THE CARTOONISTS WORKING ON QUIETER, MORE NATURALISTIC STORIES HAVE BEEN USING EMPHASIS MORE SPARINGLY IN RECENT YEARS.

EWW! LISTEN TO THIS: "BOGEY SEEKS BACALL. I AM DWM 40-ISH SINGER-SONGWRITER, NON-SMOKER. YOU ARE FEM. 30-40. NON-JUDGE-MENTAL, LOVES: HONESTY, PILLOW-FIGHTS, MOONLIGHT SERENADES. BE MY MUSE."

I THINK THE KEY WORD IS "NON-JUDGEMENTAL."

THE FREE PRESS

OH MY GOD! "BE THE OBJECT OF MY DESIRE. MARRIAGE-MINDED PROF SWM, 31 SEEKS PERFECT 10, 18-24. I WON'T TAKE NO FOR AN ANSWER."

GOD! THAT'S **SO** SCARY! MY GREATEST FEAR IS THAT SOME CREEP LIKE THAT WILL FALL IN LOVE WITH ME!

♀ SEEKING ♂

SIMILARLY, IN THE LAST DECADE A GROWING NUMBER OF ARTISTS ARE TURNING FROM COMICS' BRASSY **ALL-CAPS** TRADITION TO EMBRACE **UPPER-** AND **LOWERCASE** FONTS.

What time--? Who can tell in this torrent!

KAFFE

PERSONALLY, I GO BACK AND FORTH A LOT ON THE QUESTION OF WHETHER OR NOT TO USE UPPER- AND LOWERCASE LETTERING.

MY FIRST BOOK WAS HAND-LETTERED IN *ALL CAPS* BY PRO LETTERER *BOB LAPPAN.*

The next book used an **UPPER-** and *lowercase* font with *bold italics.**

TAP TAP TAP

* THE LAST TWO FONTS DESIGNED BY JOHN ROSHELL OF COMICRAFT.

THIS ONE USES A FONT BASED ON MY **HANDWRITING.**

Upper- and lowercase letters do have some advantages including their more distinct **word shapes** that facilitate scanning.

Is it possible that the whole ALL CAPS thing is just an *old habit* that comics needs to outgrow?

Maybe.

CHECK OUT THE **NOTES** SECTION AT THE END OF THIS CHAPTER FOR MORE ON THIS DEBATE AND WHY I'M **STILL** ON THE FENCE.

ALSO CHECK CHAPTER FIVE FOR SOME INFO ON TRADITIONAL AND DIGITAL LETTERING **TECHNIQUES.**

TOP RIGHT: ART BY DANIEL CLOWES. MIDDLE-LEFT: ART BY JASON LUTES (SEE ART CREDITS, PAGE 258).

145

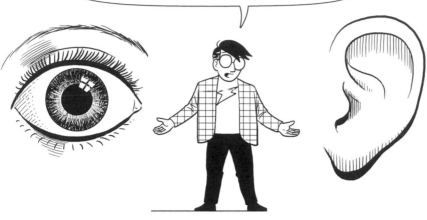

THANKS TO FILM AND TELEVISION, WE'VE GOTTEN USED TO STORIES THAT CONTINUOUSLY USE **SIGHT** AND **SOUND** AND OFFER RICH, IMMERSIVE EXPERIENCES.

BUT AS COMICS CREATORS, IF WE WANT TO **REPRODUCE** THAT KIND OF EXPERIENCE, WE NEED TO DO IT USING ONLY **ONE** SENSE.

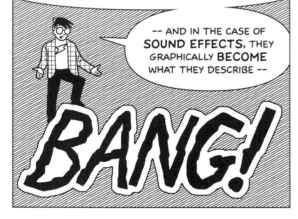

WORDS PLAY AN IMPORTANT ROLE IN COMICS BY **BRIDGING** THAT GAP. THEY GIVE **VOICE** TO OUR CHARACTERS, ALLOW US TO DESCRIBE ALL **FIVE** SENSES --

-- AND IN THE CASE OF **SOUND EFFECTS**, THEY GRAPHICALLY **BECOME** WHAT THEY DESCRIBE --

BANG!

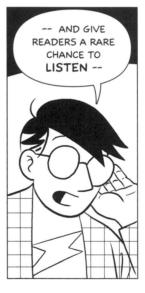

-- AND GIVE READERS A RARE CHANCE TO **LISTEN** --

-- WITH THEIR **EYES.**

CREATING GREAT SOUND EFFECTS DOESN'T REQUIRE THE SORT OF METHODICAL CONSISTENCY THAT GOOD BALLOON LETTERING NEEDS.

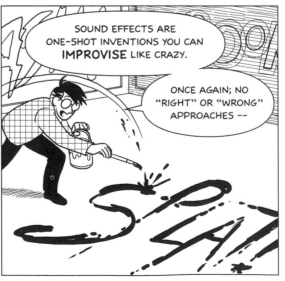

SOUND EFFECTS ARE ONE-SHOT INVENTIONS YOU CAN **IMPROVISE** LIKE CRAZY.

ONCE AGAIN; NO "RIGHT" OR "WRONG" APPROACHES --

-- BUT THERE ARE SOME SET **VARIABLES** THAT YOU CAN IMPROVISE **WITHIN,** INCLUDING...

LOUDNESS, AS INDICATED BY SIZE, BOLDNESS, TILT AND EXCLAMATION POINTS.

TIMBRE. THE QUALITY OF THE SOUND, ITS ROUGHNESS, WAVINESS, SHARPNESS, FUZZINESS, ETC...

ASSOCIATION. FONT STYLES AND SHAPES THAT REFER TO OR MIMIC THE SOURCE OF THE SOUND.

GRAPHIC INTEGRATION. PURE DESIGN CONSIDERATIONS OF SHAPE, LINE AND COLOR -- AS WELL AS HOW THE EFFECT MIXES WITH THE PICTURE.

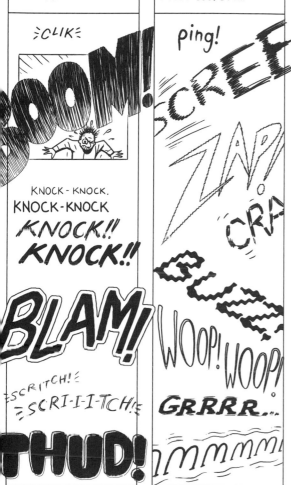

OF COURSE, IF YOU'RE GOING FOR A MORE **UNDERSTATED** KIND OF STORY YOU MAY WANT TO AVOID TOO MANY FLASHY EFFECTS --

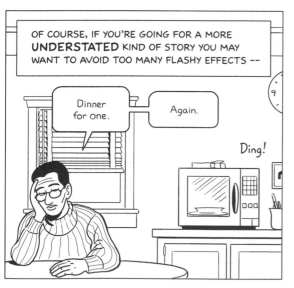

-- BUT IF YOU DON'T MIND **SHOWING-OFF** ONCE IN A WHILE --

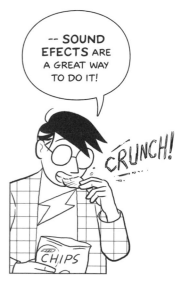

-- **SOUND EFECTS** ARE A GREAT WAY TO DO IT!

IN SOME CASES, THE COLLABORATION OF WORDS AND PICTURES INVOLVES THE COLLABORATION OF A SEPARATE **WRITER** AND **ARTIST**.

W P

IF YOU PLAN TO WRITE STORIES FOR **OTHERS** TO DRAW, HERE ARE SOME ADDITIONAL **SUGGESTIONS**.

FIRST, AND MOST OBVIOUSLY, **THINK VISUALLY**.

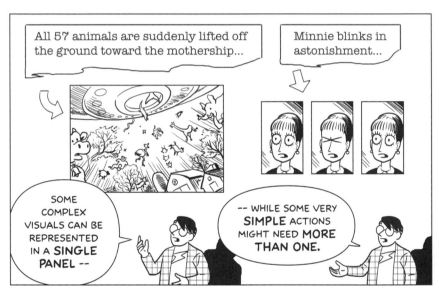

All 57 animals are suddenly lifted off the ground toward the mothership...

Minnie blinks in astonishment...

SOME COMPLEX VISUALS CAN BE REPRESENTED IN A **SINGLE PANEL** --

-- WHILE SOME VERY **SIMPLE** ACTIONS MIGHT NEED **MORE THAN ONE**.

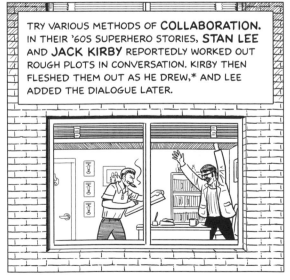

TRY VARIOUS METHODS OF **COLLABORATION**. IN THEIR '60S SUPERHERO STORIES, **STAN LEE** AND **JACK KIRBY** REPORTEDLY WORKED OUT ROUGH PLOTS IN CONVERSATION. KIRBY THEN FLESHED THEM OUT AS HE DREW,* AND LEE ADDED THE DIALOGUE LATER.

OTHERS LIKE **ALAN MOORE** HAVE BEEN KNOWN TO WRITE RICH, DETAILED DESCRIPTIONS OF EACH AND EVERY PANEL FOR HIS VARIOUS ARTISTS.

ASSUMING YOU KNOW WHO YOUR COLLABORATOR IS, YOU CAN ADJUST YOUR METHOD TO WHAT WORKS BEST FOR **BOTH** OF YOU.

*NOT RIGHT THERE IN THE OFFICE, OBVIOUSLY. I JUST WANTED TO SHOW WHICH ONE WAS JACK.

THE COMICS **SCRIPT** IS THE TOOL MOST ASSOCIATED WITH **WRITING** COMICS THAT **OTHERS** WILL DRAW --

-- THOUGH THERE ARE SOME **LONE** CARTOONISTS WHO WRITE FULL SCRIPTS FOR THEMSELVES.

TAP TAP

SCRITCH SCRATCH

WRITING COMICS SCRIPTS IS AN ART UNTO ITSELF; CHECK THE BIBLIOGRAPHY FOR SOME BOOKS THAT CAN GIVE YOU DETAILED GUIDES ON HOW IT'S DONE.

CLACKITY! CLACKITY! CLACKITY!

BUT REMEMBER, EVEN IF YOU **TEAM UP** WITH SOMEONE TO CREATE COMICS, YOUR STORIES WILL BE AT THEIR STRONGEST IF THEY FEEL LIKE THEY WERE CREATED WITH A **SINGLE-MINDED** PURPOSE.

TAP! TAP! TAP!

SCRITCH! SCRATCH!

BEWARE OF THE **WRITER-VERSUS-ARTIST** SYNDROME WHERE ONE COLLABORATOR TRIES TO WIN THE READER OVER WITH EVOCATIVE PROSE AND THE OTHER TRIES TO DAZZLE THE READER WITH SUMPTUOUS ART --

-- WHILE NEITHER ART **NOR** WRITING EVER FULLY ACKNOWLEDGES EACH OTHER.

NO MATTER WHAT KINDS OF WORD/PICTURE MIXTURES YOU PUT IN YOUR COMICS --

W P

W P

W = P

W P

W P

W

P

W P

-- IT'S WHEN WORDS AND PICTURES **COMBINE SEAMLESSLY** THAT COMICS ARE AT THEIR **BEST.**

WHETHER YOU WORK **ALONE** OR AS PART OF A **TEAM,** THAT'S A GOAL WORTH PURSUING.

PANEL FIVE: SEE ART CREDITS, PAGE 258.

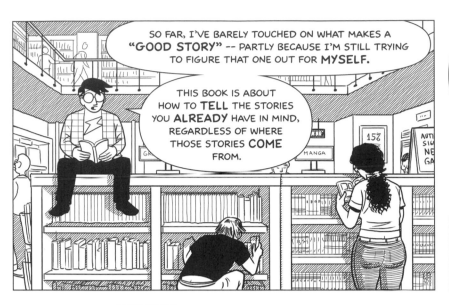

SO FAR, I'VE BARELY TOUCHED ON WHAT MAKES A **"GOOD STORY"** -- PARTLY BECAUSE I'M STILL TRYING TO FIGURE THAT ONE OUT FOR **MYSELF.**

THIS BOOK IS ABOUT HOW TO **TELL** THE STORIES YOU **ALREADY** HAVE IN MIND, REGARDLESS OF WHERE THOSE STORIES **COME** FROM.

STILL, THERE ARE SOME SUGGESTIONS FOR BASIC STORYTELLING GOALS THAT MOST WRITERS SEEM TO AGREE ON.

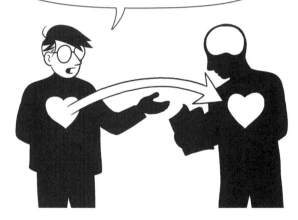

FIRST, LOOK FOR STORIES THAT ARE ROOTED IN YOUR OWN **EXPERIENCE**, AND THAT SPEAK TO THE EXPERIENCES OF YOUR **READERS.**

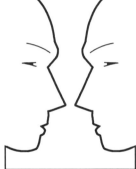

FIND NEW AND INTERESTING KINDS OF CONFLICTS **BETWEEN** CHARACTERS --

-- AND BETWEEN INDIVIDUALS AND THE WORLD **AROUND** THEM.

SURPRISE YOUR READERS! TAKE THEM TO PLACES THEY'VE NEVER BEEN.

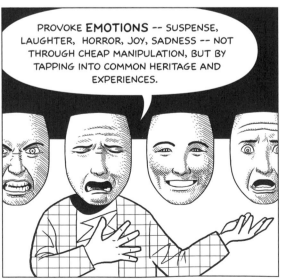

PROVOKE **EMOTIONS** -- SUSPENSE, LAUGHTER, HORROR, JOY, SADNESS -- NOT THROUGH CHEAP MANIPULATION, BUT BY TAPPING INTO COMMON HERITAGE AND EXPERIENCES.

MAKE YOUR READERS **CARE**, MAKE THEM WANT TO KNOW HOW IT ALL TURNS OUT, MAKE THEM COME BACK FOR **MORE...**

BASICALLY, IT'S THE **SAME** ADVICE YOU'LL GET, NO MATTER WHAT MEDIUM YOU CHOOSE TO TELL YOUR STORIES IN.

COMICS IS DIFFERENT FROM THESE OTHER MEDIA IN TERMS OF ITS **CHALLENGES, TOOLS** AND **WORKING METHODS** --

-- BUT THOSE BASIC GOALS ARE THE **SAME** --

-- BECAUSE ALL STORIES WIND UP IN THE SAME PLACE: THE MINDS OF THE **AUDIENCE.**

THIS IS WHY I DON'T THINK THERE'S A **TYPE** OF STORY THAT'S **"RIGHT"** FOR COMICS --

-- AND WHY IT'S A MISTAKE TO LIMIT THE **KINDS** OF STORIES WE TELL IN AN ATTEMPT TO SQUEEZE OURSELVES INTO SOMEONE ELSE'S **SHELF SPACE.**

NOBODY KNOWS WHAT WILL WORK UNTIL THEY **TRY IT.** SOME OF COMICS' BIGGEST SUCCESS STORIES IN RECENT YEARS HAVE EXPLORED SUBJECTS THAT **NO ONE** WAS WRITING ABOUT AT THE TIME.

STORIES NO ONE HAD ANY REASON TO THINK **WOULD** SUCCEED.

MY ADVICE? WRITE WHAT **YOU** WANT TO READ.

YOU'LL HAVE MORE **FUN** DOING IT --

-- AND IF ALL ELSE FAILS, YOU'LL ALWAYS HAVE AT LEAST **ONE LOYAL READER.**

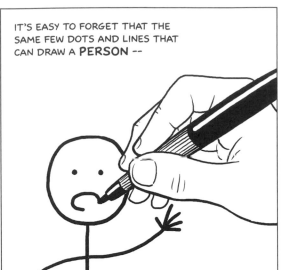

IT'S EASY TO FORGET THAT THE SAME FEW DOTS AND LINES THAT CAN DRAW A **PERSON** --

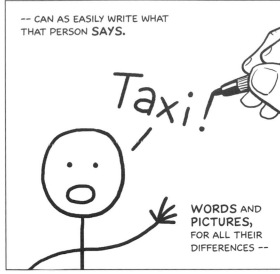

-- CAN AS EASILY WRITE WHAT THAT PERSON **SAYS.**

WORDS AND **PICTURES,** FOR ALL THEIR DIFFERENCES --

-- ARE JUST **TWO SIDES** OF THE **SAME COIN.**

BOTH SHARE A **COMMON PURPOSE** AND A **COMMON HERITAGE.**

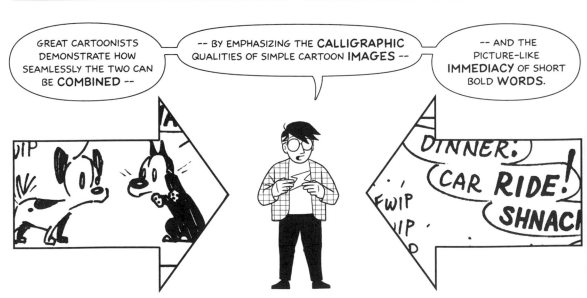

GREAT CARTOONISTS DEMONSTRATE HOW SEAMLESSLY THE TWO CAN BE **COMBINED** --

-- BY EMPHASIZING THE **CALLIGRAPHIC** QUALITIES OF SIMPLE CARTOON **IMAGES** --

-- AND THE PICTURE-LIKE **IMMEDIACY** OF SHORT BOLD **WORDS.**

PANEL FIVE: ART BY PATRICK MCDONNELL (SEE ART CREDITS, PAGE 258).

BUT **WORDS** AND **PICTURES** ALSO HAVE THEIR **SEPARATE** HISTORIES AND **SEPARATE** STRENGTHS --

-- AND THESE HAVE ALSO BEEN A RICH SOURCE OF **INSPIRATION** FOR MANY OF THE CREATORS WHO ARE DRAWN TO COMICS.

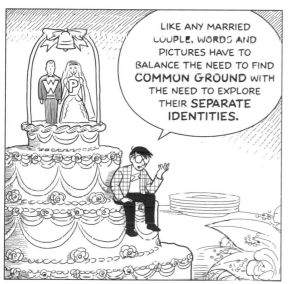

LIKE ANY MARRIED COUPLE, WORDS AND PICTURES HAVE TO BALANCE THE NEED TO FIND **COMMON GROUND** WITH THE NEED TO EXPLORE THEIR **SEPARATE IDENTITIES.**

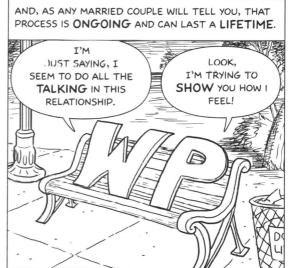

AND, AS ANY MARRIED COUPLE WILL TELL YOU, THAT PROCESS IS **ONGOING** AND CAN LAST A **LIFETIME.**

I'M JUST SAYING, I SEEM TO DO ALL THE **TALKING** IN THIS RELATIONSHIP.

LOOK, I'M TRYING TO **SHOW** YOU HOW I FEEL!

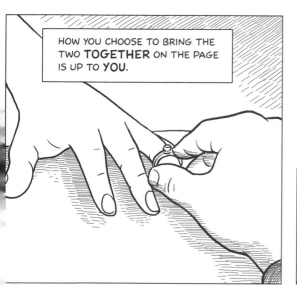

HOW YOU CHOOSE TO BRING THE TWO **TOGETHER** ON THE PAGE IS UP TO **YOU.**

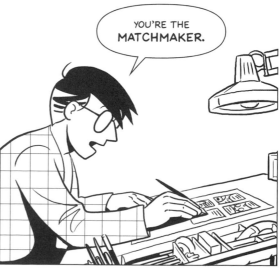

YOU'RE THE **MATCHMAKER.**

CHAPTER 3: THE POWER OF WORDS

PAGE 128, PANEL ONE - R.C. HARVEY ON COMICS

IN R.C. HARVEY'S OWN WORDS: "...COMICS CONSIST OF PICTORIAL NARRATIVES OR EXPOSITIONS IN WHICH WORDS (OFTEN LETTERED INTO THE PICTURE AREA WITHIN SPEECH BALLOONS) USUALLY CONTRIBUTE TO THE MEANING OF THE PICTURES AND VICE VERSA."*

PAGE 129, PANEL ONE - A MEDIUM OF FRAGMENTS

SEE *UNDERSTANDING COMICS*, CHAPTER THREE, FOR 34 PAGES' WORTH OF MUSINGS ON WHAT I USUALLY REFER TO AS "CLOSURE," THE TENDENCY WE ALL HAVE TO TAKE INCOMPLETE INFORMATION AND FILL IN THE BLANKS, AND WHY I THINK IT'S ONE OF THE ESSENTIAL BUILDING BLOCKS OF THE COMICS-READING EXPERIENCE.

PAGE 134, PANEL NINE - THE SMELL OF COOKIES

WRITERS FREQUENTLY OVERLOOK THE OPPORTUNITY WORDS GIVE US TO REVEAL WHAT'S GOING ON IN THE SENSES OF TOUCH, TASTE AND SMELL. ONE OF MY FAVORITE COMICS WHEN I WAS 14 YEARS OLD WAS *DAREDEVIL* (THE BLIND SUPERHERO WHO RELIES ON HIS HEIGHTENED OTHER SENSES TO FIGHT CRIME AND CHECK OUT JENNIFER GARNER IN THE RAIN) AND I STILL REMEMBER AN OVERVOICE CAPTION WHERE HE DESCRIBES TRACE SCENTS OF "CORDITE AND GUNPOW-DER" ALL THESE YEARS LATER.

THE INFLUENCE OF MOVIES ON COMICS PROBABLY TIPS US TOWARD SIGHT AND SOUND AS THE DOMINANT SENSES, BUT WE SHOULD ALSO TAKE A PAGE FROM PROSE AND POETRY WRITERS WHO GIVE ALL FIVE SENSES THEIR DUE. GIVING READERS A WINDOW INTO A CHARACTER'S SENSORY EXPERIENCES CAN INCREASE THE INTIMACY OF THEIR RELATIONSHIP WITH THAT CHARAC-TER, AND STRENGTHEN THEIR DESIRE TO STAY WITH THE STORY.

PAGE 139, PANEL THREE - DON'T TRIP ON MY LOGO!

HAVING A LOGO PHYSICALLY COEXIST WITH CHARACTERS RAISES QUESTIONS OF BELIEVABILITY. IF THE COMICS ARTISTS WANT US TO BELIEVE IN HIS OR HER WORLD AS A REAL PLACE, DOES A GIANT PLYWOOD BILLBOARD WITH THE CHARACTER'S NAME ON IT GET IN THE WAY OF THAT GOAL? I THINK THE ANSWER'S BOTH YES AND NO; IT'S ALL JUST A QUESTION OF TIMING.

THE SENSE OF LOSING YOURSELF IN A MOVIE, BOOK, COMIC OR PLAY DOESN'T HAPPEN INSTANTANEOUSLY. WHEN THE OPENING CREDITS TO A MOVIE START APPEARING, YOU'RE PERFECTLY AWARE THAT YOU'RE SITTING IN A DARK ROOM WITH STRANGERS WHILE LIGHT IS PROJECTED ON A SCREEN. IT'S ONLY A FEW MINUTES LATER, AFTER THOSE NAMES STOP APPEARING IN MID-AIR OVER THE ACTION, THAT THE MOVIE THEATER AND THE STRANGERS AND THE SCREEN ALL VANISH AND YOU'RE SIMPLY LIVING THE STORY. IF THE STORYTELLING IS GOOD ENOUGH (AND IF EVERYBODY TURNS OFF THEIR CELL PHONES AND SHUTS UP) YOU WON'T RETURN TO THAT DARK ROOM FILLED WITH STRANGERS UNTIL THE CLOSING CREDITS ROLE.

SIMILARLY, WHEN WE START READING A COMIC, A 16-FOOT HIGH LOGO ON PAGE ONE DOESN'T TAKE US OUT OF THE ACTION BECAUSE WE'RE NOT EVEN **IN** IT YET. WE KNOW THAT WE'RE HOLDING A STACK OF PAPER (OR LOOKING AT A GLOWING SCREEN) AND IT USUALLY TAKES A PAGE OR TWO TO FORGET. IT'S IN THAT ENTRY PHASE (AND ITS CORRESPONDING EXIT PHASE) THAT A LITTLE ARTIFICE CAN'T HURT, AND MIGHT ACTUALLY ENHANCE THE READING EXPERIENCE.

PAGE 139, PANEL SIX – DAVID CHOE, MONTAGE AND WORD-SPECIFIC

HERE'S A BIT MORE OF CHOE'S CUT-AND-PASTE APPROACH TO COMBINING WORDS AND ART (FROM HIS COMIC *SLOW JAMS*). NOTICE THAT THIS ALSO FOLLOWS THE WORD-SPECIFIC PATTERN. CHOE'S TYPED SENTENCES TELL US EVERYTHING WE NEED TO KNOW, SO THE PICTURES ARE FREED TO WANDER AS FAR AS THEY LIKE.

PAGE 140-141 – USING (AND ABUSING) THE WORD-PICTURE CATEGORIES

JUST TO REITERATE, I'M DEFINITELY NOT SUGGESTING THAT ANYONE SIT DOWN AND CAREFULLY CHOOSE THEIR WORD/PICTURE COMBINATIONS BEFORE CREATING A COMIC. AS WITH THE 6 PANEL TRANSITIONS IN CHAPTER ONE, I DON'T WANT THIS KIND OF CLASSIFICATION TO REPLACE WHATEVER INSTINCTS YOU HAVE. INSTEAD, BY ASKING THE KINDS OF QUESTIONS I POSE AT THE BOTTOM OF PAGE 140 AND AT TOP OF PAGE 141, I HOPE YOU CAN HONE YOUR INSTINCTS IN THE FUTURE TO TAKE ADVANTAGE OF THESE WORD-PICTURE POSSIBILITIES IN A NATURAL, INTUITIVE WAY.

EVERY TECHNIQUE WE USE BEGINS ITS LIFE AS A CONSCIOUS PROCESS AND, WITH LUCK, GRADUALLY BECOMES SECOND NATURE. BUT NOT EVERY TECHNIQUE WORKS TO OUR ADVANTAGE IN THE LONG RUN AND IT PAYS TO CONSCIOUSLY SEPARATE GOOD INSTINCTS FROM BAD HABITS ONCE IN A WHILE.

PAGE 142-145 – THE THOUGHT BALLOON AND ITS RELATIVES

THOUGHT BALLOONS AREN'T AS COMMON AS THEY ONCE WERE, BUT THEY'RE STILL A GREAT WAY TO QUICKLY REVEAL A CHARACTER'S INNER LIFE (SEE "THE SMELL OF COOKIES" ABOVE). IN THE LAST COUPLE OF DECADES, THOUGH, CHARACTERS' THOUGHTS ARE AS LIKELY TO BE EXPRESSED IN THE FORM OF A CAPTION -- THE EQUIVALENT OF A MOVIE OVERVOICE. SUCH CAPTIONS SEEM TO ACKNOWLEDGE THE AUDIENCE IN A WAY THAT BALLOONS DON'T, AS IF THE CHARACTER WAS SENDING THEIR THOUGHTS DIRECTLY TO THE READER, AND CAN GIVE THE TEXT AN EXTRA LEVEL OF INTIMACY. THEY ALSO DON'T REQUIRE THE THINKER TO BE IN PANEL TO SHOW WHERE THE THOUGHT ORIGINATES FROM, SO THEY CAN APPEAR IN PANELS THAT ARE FRAMED FROM THE THINKER'S POINT OF VIEW. SUCH "THOUGHT CAPTIONS" ARE USUALLY IN PRESENT TENSE AND FIRST PERSON (BELOW LEFT) BUT PAST TENSE NARRATION (BELOW RIGHT) CAN COVER A LOT OF THE SAME GROUND.

THE TRADITIONAL THOUGHT BALLOON HAS ADVAN-TAGES, THOUGH. IT CAN OFFER A GLIMPSE INTO ANY CHARACTER'S THOUGHTS AT ANY TIME, AND DOESN'T REQUIRE REPETITION THROUGHOUT THE STORY. A THOUGHT CAPTION ONLY WORKS AS RUNNING NARRA-TION, AND READERS HAVE TO KNOW WHICH CHARACTER IS DOING THE THINKING, EVEN IN PANELS OVERFLOWING WITH CHARACTERS. A THOUGHT BALLOON, ON THE OTHER HAND, CAN APPEAR ONCE IN A 200 PAGE GRAPHIC NOVEL POINTING TO A RANDOM BYSTANDER, AND AUDIENCES WILL THINK NOTHING OF IT.

PAGE 142, PANEL SEVEN - BALLOON SHAPES

SOME EXAMPLES OF BALLOON SHAPES:

PAGE 144, PANEL THREE - COMMON ROOTS

FOR MUCH MORE ON WHY I SEE WORDS AND PICTURES AS TWO BRANCHES OF THE SAME TREE, SEE *UNDERSTANDING COMICS*, CHAPTER SIX, "SHOW AND TELL."

PAGE 145, LAST PANEL - THE LOWERCASE DEBATE

I KEEP GOING BACK AND FORTH ON THE QUESTION OF WHETHER TO USE UPPER- AND LOWERCASE LETTERS IN WORD BALLOONS. THE FACT THAT I'M BACK TO ALL UPPERCASE IN THIS BOOK ISN'T IN ANY WAY AN INDICATION THAT I'VE MADE UP MY MIND.

ON THE ONE HAND, UPPERCASE COMIC BOOK LETTERING HAS THE FOLLOWING ARGUMENTS IN ITS FAVOR:

- ABOUT 98% OF ALL ENGLISH LANGUAGE COMICS IN THE LAST 100 YEARS HAVE USED IT, INCLUDING NEARLY ALL OF THE COMICS NOW CONSIDERED CLASSICS. IF IT AIN'T BROKE, WHY FIX IT?
- CAPITAL LETTERS ARE EASIER TO LETTER BY HAND.
- CAPS FILL THE SPACE MORE EFFICIENTLY.
- CAPS BLEND BETTER WITH PICTURES.
- CAPS LOOK BETTER WITH FREQUENT BOLD/ITALIC TYPE.

ON THE OTHER HAND, ADVOCATES OF USING UPPER AND LOWERCASE LETTERS MIGHT RESPOND:

- THERE ARE A LOT OF THINGS COMICS HAVE RARELY DONE IN THE LAST 100 YEARS, INCLUDING MATURE THEMES, SUBTLE CHARACTERIZATION AND SOPHISTICATED ARTWORK; THAT'S NO REASON NOT TO TRY THEM.
- ONE OF THE MOST POPULAR COMICS IN HISTORY, *TINTIN*, USES UPPER- AND LOWERCASE LETTERING, AS DO OTHER EUROPEAN COMICS, AND IT LOOKS GREAT.
- EASIER DOESN'T EQUAL BETTER.
- A LITTLE WHITE SPACE NEVER HURT ANYONE.
- IF UPPER AND LOWERCASE LETTERS DON'T BLEND WITH PICTURES, HOW DO WE EXPLAIN FIVE CENTURIES OF ILLUSTRATED BOOKS?
- BOLD TYPE IS OVER-USED AND MELODRAMATIC.

FOR NOW, I'M STICKING WITH THIS UPPERCASE FONT MADE FROM MY HANDWRITING, BECAUSE I LIKE THE WAY IT BLENDS WITH MY PICTURES. IRONICALLY, I DON'T THINK IT WORKS AS WELL HERE IN THE NOTES SECTION, BUT I LIKE THE CONTINUITY OF APPEARANCE FROM THE COMICS PAGES SO THAT'S WHY YOU'RE READING IT NOW.

SOME THINGS I DO KNOW FOR SURE:

- THE OCCASIONAL BIG, BOLD WORD DOES SEEM TO ANCHOR THE TEXT AND PICTURE WHEN YOU FIRST GLANCE AT A PAGE (I.E., NEITHER PICTURES NOR WORDS SEEM OVERPOWERED).
- INCLUDING UPPERCASE, LOWERCASE, BOLD, ITALICS AND SIZE VARIATION THE WAY I DID IN THE LAST BOOK WAS A BIT CLUTTERED.
- I'LL PROBABLY KEEP CHANGING MY MIND FOR A WHILE.

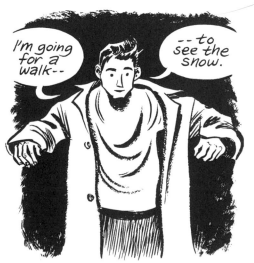

TOP DOWN: ART BY WILL EISNER, SHAWN MCMANUS (LETTERING BY TODD KLEIN), JORDAN CRANE AND MASASHI KISHIMOTO (LETTERED FOR ENGLISH BY HEIDI SZYKOWNY) (SEE ART CREDITS, PAGE 258).

ART BY CRAIG THOMPSON (SEE ART CREDITS, PAGE 258).

PAGE 148-149 - THE COMICS SCRIPT

SEE THE BIBLIOGRAPHY FOR POINTERS TO PRINTED COLLECTIONS OF WRITERS' SCRIPTS INCLUDING ALAN MOORE (AND ME, FOR THAT MATTER).

PAGE 149, PANEL FIVE - WRITER VERSUS ARTIST

I FIRST DESCRIBED THIS SYNDROME IN *UNDERSTANDING COMICS*, PAGE 48, AND AGAIN IN CHAPTER SIX.

PAGE 151 - WRITE FOR YOURSELF

IF YOU JUST WRITE THE KINDS OF STORIES YOU THINK OTHERS WILL WANT TO READ, YOU'LL BE COMPETING WITH CARTOONISTS WHO ARE FAR MORE ENTHUSIASTIC FOR THAT KIND OF COMIC THAN YOU ARE, AND THEY'LL KICK YOUR ASS EVERY TIME.

OR, TO PUT IT ANOTHER WAY:

JUST BECAUSE YOU'VE DECIDED TO SELL OUT, THAT DOESN'T MEAN THAT ANYONE'S GOING TO **BUY!**

OPTIONAL EXERCISES

#1 - WORD-SPECIFIC (PAGES 131-133)

TAKE A FEW PARAGRAPHS FROM A NOVEL OR SHORT STORY AND TRY BREAKING THE TEXT INTO SMALL CAPTIONS. TRY OUT AT LEAST TWO VERY DIFFERENT WAYS OF ILLUSTRATING THOSE CAPTIONS IN COMICS FORM, ONE PER PANEL.

#2 - PICTURE-SPECIFIC (PAGES 133-134)

FIND A COMIC WHERE THE PICTURES PRIMARILY TELL THE STORY. MAKE A COPY AND HAVE A FRIEND BLANK OUT ALL THE CAPTIONS. TRY OUT AT LEAST TWO VERY DIFFERENT WAYS OF FILLING THOSE CAPTIONS.

#3 - MONTAGE (PAGE 139)

CAN YOU MAKE AN ENTIRE COMIC USING NOTHING BUT PICTURES AND WORDS CUT FROM THE LATEST ISSUE OF A POPULAR MAGAZINE? HOW DOES THE CUT-AND-PASTE LOOK OF IT AFFECT THE READING EXPERIENCE?

#4 - BALLOON DISSECTING (PAGE 143)

FIND A COMICS PAGE WHERE THE WRITER HAS TRIED CRAMMING TOO MANY WORDS AND BALLOONS INTO EACH PANEL. IF YOU HAD ALL THE ROOM IN THE WORLD, HOW COULD YOU SPLIT THOSE BALLOONS INTO SEPARATE PANELS AND ILLUSTRATE THEM SO THAT EACH CHARACTER WAS EXPRESSING JUST ONE EMOTION PER BALLOON.

#5 - EXTREME EMPHASIS (PAGE 144)

FIND A 2-4 MINUTE AUDIO SAMPLE OF SOMEONE TALKING WITH A LOT OF EXPRESSION IN THEIR VOICE (E.G., A COMEDIAN, POLITICIAN, RELIGIOUS LEADER, ACTOR IN AN EMOTIONAL SCENE...) AND LETTER THEIR DIALOGUE IN A WAY THAT REFLECTS THEIR TONE OF VOICE INCLUDING VOLUME, TIMBRE, DURATION, ETC... WOULD SUCH EXTREME EXPRESSIVENESS IN LETTERING WORK IN A COMICS PANEL? IF NOT, HOW MUCH WOULD YOU NEED TO TONE IT DOWN?

#6 - SOUND EFFECTS LAB (PAGES 146-147)

PRODUCE AT LEAST TEN SOUNDS, USING OBJECTS IN THE ROOM YOU'RE IN RIGHT NOW. CAN YOU DRAW A SOUND EFFECT FOR EACH ONE THAT REFLECTS ITS VOLUME, DURATION AND TIMBRE? COULD A FRIEND SUCCESSFULLY GUESS THE SOURCE OF AT LEAST FIVE OF THEM, JUST BY LOOKING AT YOUR SKETCHES?

ALTERNATELY, THERE ARE SOME OLD SOUND EFFECTS RECORDS OUT THERE. THESE CAN ALSO BE A FUN JUMPING OFF POINT.

#7 - SCRIPTING FOR OTHERS (PAGE 149)

PICK A SCENE FROM A MOVIE YOU LIKE AND TRY ADAPTING IT INTO A COMICS SCRIPT. CHOOSE YOUR MOMENTS AND FRAMING WITH THE UNIQUE NEEDS OF COMICS IN MIND, RATHER THAN JUST USING THE SHOTS THAT APPEARED IN THE MOVIE. WHAT WORKS IN FILM THAT DOESN'T WORK AS WELL IN COMICS AND VICE VERSA?

ADDITIONAL NOTES AT:
WWW.SCOTTMCCLOUD.COM/MAKINGCOMICS

Chapter Four

World Building

Sense of Place, Perspective
and Research

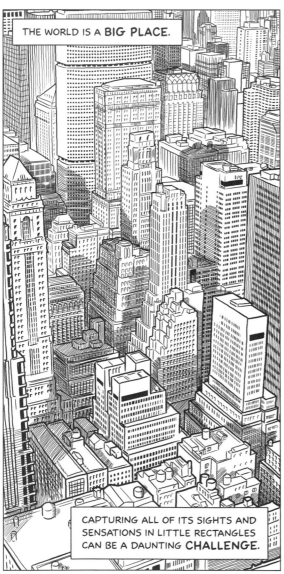

THE WORLD IS A **BIG PLACE.**

CAPTURING ALL OF ITS SIGHTS AND
SENSATIONS IN LITTLE RECTANGLES
CAN BE A DAUNTING **CHALLENGE.**

BUT WITH KNOWLEDGE --

-- EFFORT --

158

-- AND A WILLINGNESS TO GO BEYOND THE MERELY "ADEQUATE" --

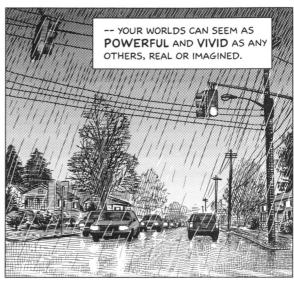

-- YOUR WORLDS CAN SEEM AS **POWERFUL** AND **VIVID** AS ANY OTHERS, REAL OR IMAGINED.

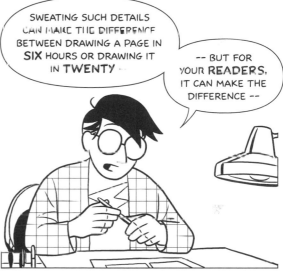

SWEATING SUCH DETAILS CAN MAKE THE DIFFERENCE BETWEEN DRAWING A PAGE IN **SIX** HOURS OR DRAWING IT IN **TWENTY** --

-- BUT FOR YOUR **READERS,** IT CAN MAKE THE DIFFERENCE --

-- BETWEEN **KNOWING** WHERE YOUR STORY TAKES PLACE --

-- AND **BEING THERE.**

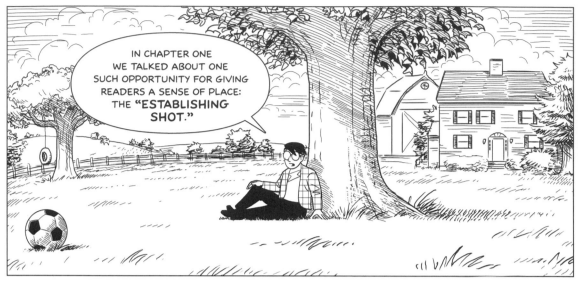

IN CHAPTER ONE WE TALKED ABOUT ONE SUCH OPPORTUNITY FOR GIVING READERS A SENSE OF PLACE: THE **"ESTABLISHING SHOT."**

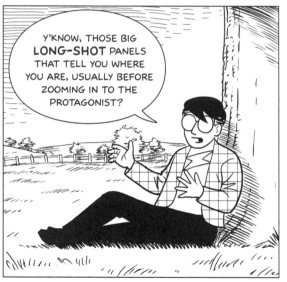

Y'KNOW, THOSE BIG **LONG-SHOT** PANELS THAT TELL YOU WHERE YOU ARE, USUALLY BEFORE ZOOMING IN TO THE PROTAGONIST?

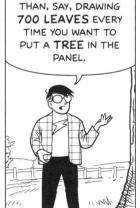

THAT ONE FOR EXAMPLE.

WELL, IF JUST **TELLING** YOUR READERS **WHERE** THE STORY TAKES PLACE IS YOUR PRIMARY GOAL --

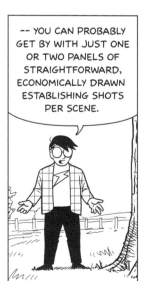

-- YOU CAN PROBABLY GET BY WITH JUST ONE OR TWO PANELS OF STRAIGHTFORWARD, ECONOMICALLY DRAWN ESTABLISHING SHOTS PER SCENE.

AFTER THAT IT CAN BE ALL **MEDIUM SHOTS** --

-- AND **CLOSE-UPS** --

-- WHICH USUALLY REQUIRE LESS WORK THAN, SAY, DRAWING **700 LEAVES** EVERY TIME YOU WANT TO PUT A **TREE** IN THE PANEL.

I MEAN **LOOK** AT THAT THING -- IT'S A **SQUIGGLE** FOR PETE'S SAKE! BUT YOU **KNOW** IT'S A TREE BASED ON THE PANELS BEFORE.

IF, ON THE OTHER HAND, YOU WANT **MORE** THAN JUST CLARITY AND EFFICIENCY --

-- YOU MAY WANT TO CONSIDER SOME **ADDITIONAL TECHNIQUES.**

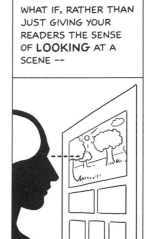

WHAT IF, RATHER THAN JUST GIVING YOUR READERS THE SENSE OF **LOOKING** AT A SCENE --

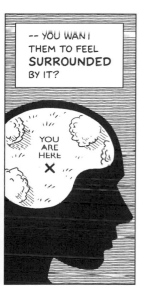

-- YOU WANT THEM TO FEEL **SURROUNDED** BY IT?

YOU ARE HERE X

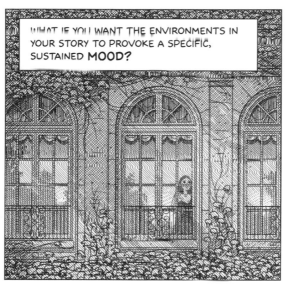

WHAT IF YOU WANT THE ENVIRONMENTS IN YOUR STORY TO PROVOKE A SPECIFIC, SUSTAINED **MOOD?**

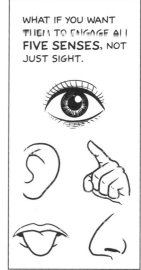

WHAT IF YOU WANT THEM TO ENGAGE ALL **FIVE SENSES,** NOT JUST SIGHT.

WHAT IF, IN FACT, YOUR STORY IS **ABOUT** THE PLACE YOU'RE DRAWING?

IN THIS CHAPTER, WE'LL CONSIDER HOW PANEL CHOICE, COMPOSITION, RESEARCH AND DRAWING TECHNIQUES CAN HELP YOU **ACHIEVE** THESE GOALS --

-- STARTING WITH SOME SLIGHT VARIATIONS ON THE STANDARD "ESTABLISHING SHOT."

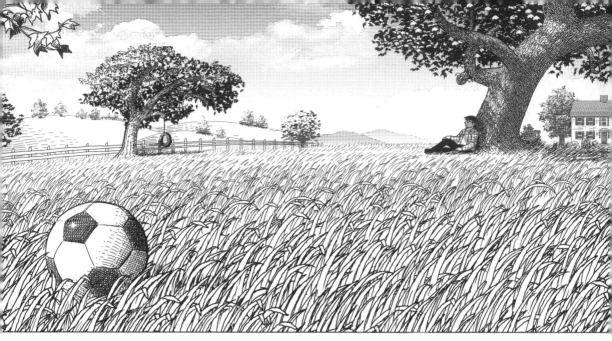

COMPARE THE PANEL ABOVE TO THE FIRST PANEL ON PAGE 160, AND YOU MIGHT NOTICE A FEW DIFFERENCES.

FIVE DIFFERENCES INCLUDING:

1. THE **EXPANSION** OF THE PANEL OUT TO THE PAGE **EDGES**, KNOWN IN THE PRINT INDUSTRY AS A **"BLEED."**

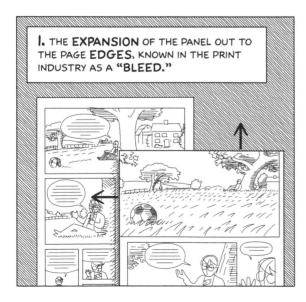

2. A GREATER LEVEL OF **REALISTIC DETAIL.**

3. ~~THE LACK OF A WORD BALLOON.~~

SNAP!

4. A LOWER, **OFF-CENTER** CAMERA ANGLE.

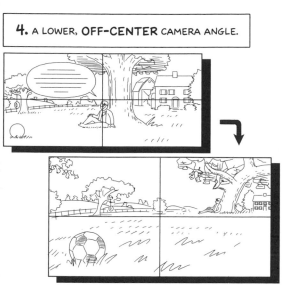

5. AN INCREASED **SENSE OF DEPTH**, BOTH IN TERMS OF PERCEIVED SIZE AND THE FADING OF DISTANT OBJECTS.

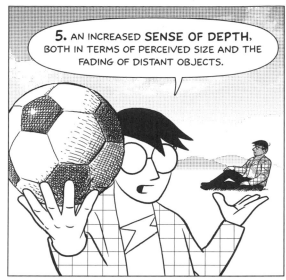

NOW, I CAN'T READ YOUR MIND.*

BUT I'D BE WILLING TO BET THAT THE **SECOND VERSION** OF THAT SHOT PRODUCED A DIFFERENT READING EXPERIENCE IN A FEW SUBTLE BUT IMPORTANT WAYS.

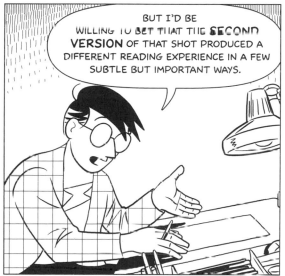

BLEEDS, FOR EXAMPLE, TEND TO **OPEN UP** A SCENE --

-- NOT JUST BECAUSE OF THE INCREASED PANEL **SIZES** --

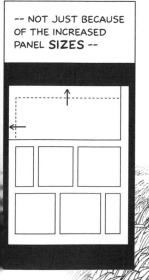

-- BUT ALSO BECAUSE THEY'RE NO LONGER FULLY **CONTAINED** BY THE PANEL BORDER AND CAN, WELL... "BLEED" INTO OUR WORLD --

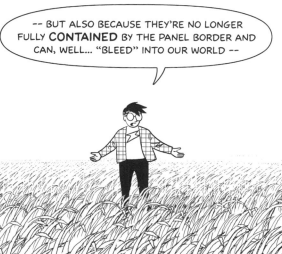

-- OR PERHAPS BECAUSE WE'RE CONDITIONED BY THE **PANEL-AS-WINDOW** EXPERIENCE --

* YET.

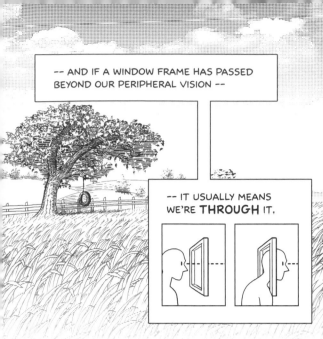

-- AND IF A WINDOW FRAME HAS PASSED BEYOND OUR PERIPHERAL VISION --

-- IT USUALLY MEANS WE'RE **THROUGH** IT.

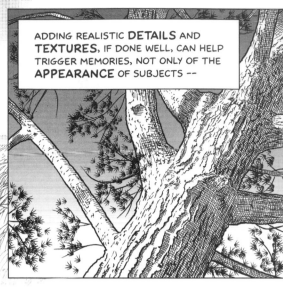

ADDING REALISTIC **DETAILS** AND **TEXTURES**, IF DONE WELL, CAN HELP TRIGGER MEMORIES, NOT ONLY OF THE **APPEARANCE** OF SUBJECTS --

-- BUT ALSO THE WAY THEY **FEEL** --

-- OR **SMELL** --

-- OR **SOUND** --

-- AND HELP BOLSTER A SENSE OF **RECOGNITION** ON THE PART OF THE READER.

SILENCE HAS THE EFFECT OF REMOVING A PANEL FROM ANY PARTICULAR SPAN OF TIME.

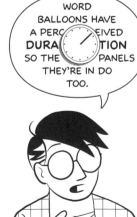

WORD BALLOONS HAVE A PERCEIVED **DURATION** SO THE PANELS THEY'RE IN DO TOO.

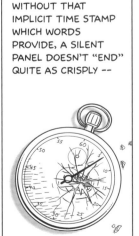

WITHOUT THAT IMPLICIT TIME STAMP WHICH WORDS PROVIDE, A SILENT PANEL DOESN'T "END" QUITE AS CRISPLY --

164

-- AND THE **EFFECT** OF IT CAN LINGER THROUGHOUT A PAGE.

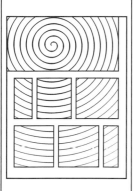

SILENCE ALSO ALLOWS READERS TO STEP OFF THE TWIN CONVEYOR BELTS OF PLOT AND DIALOGUE LONG ENOUGH TO LET THEIR EYES WANDER AND **EXPLORE** YOUR WORLD, INSTEAD OF VIEWING IT AS NOTHING MORE THAN A PASSING BACKDROP.

GIVING READERS THAT LICENSE TO "WANDER" IS ALSO A BYPRODUCT OF AN OFF-CENTER CHOICE OF FRAME.

SUCH COMPOSITIONS CREATE A SENSE OF ENTERING A SETTING WITH A PERSON **IN** IT, RATHER THAN MEETING A PERSON WITH A SETTING **BEHIND** THEM.

BY NOT "BLOCKING US AT THE DOOR," AN OFF-CENTER FIGURE, FACING AWAY FROM THE READER, CAN INVITE US TO **FOLLOW** IT MORE FULLY INTO A SCENE.

FINALLY, AN INCREASED **SENSE OF DEPTH**, CAN INCREASE THE PERCEIVED **SIZE** OF A SETTING -- REGARDLESS OF ITS SIZE ON THE PAGE --

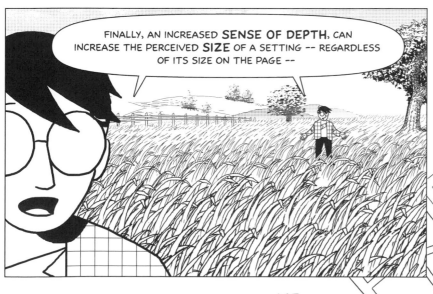

-- AND WITH IT, THE READER'S SENSE OF BEING **SURROUNDED** BY YOUR WORLD.

165

THE SECOND VERSION OF OUR ESTABLISHING SHOT IS A BIT LESS **EFFICIENT**, SINCE IT LEAVES OUT A WORD-BALLOON WHICH -- IF THIS WAS AN ORDINARY COMICS STORY -- WOULD PRESUMABLY HAVE TO GO **ELSEWHERE**.

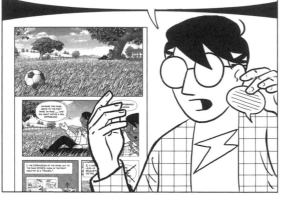

BUT OTHERWISE, NONE OF OUR MODIFICATIONS REQUIRED EXPANDING THE PANEL BEYOND THAT TOP THIRD OF A PAGE. EVERYTHING STILL HAPPENS IN **ONE PANEL**.

SUPPOSE, HOWEVER, THAT YOU HAVE PLENTY OF ROOM TO TELL YOUR STORY; IS THERE ANY REASON TO USE **MULTIPLE** PANELS TO ESTABLISH A SETTING?

ONE OPTION IS TO SPLIT AN OPENING SCENE INTO **FRAGMENTS** USING ASPECT TO ASPECT TRANSITIONS, A TECHNIQUE POPULAR IN JAPANESE COMICS.

IN THIS METHOD, THE SCENE IS "ASSEMBLED" IN THE READER'S **MIND**.

AS 300+ PAGE GRAPHIC NOVELS HAVE BECOME MORE COMMON, SOME NORTH AMERICAN CARTOONISTS ARE ALSO STARTING TO EXPLORE THE POTENTIAL OF **MULTI-PANEL** AND EVEN **MULTI-PAGE** SCENE-SETTERS IN HOPES OF CREATING MORE POWERFUL AND MEMORABLE WORLDS.

HERE THE READER EXPERIENCES THE WORLD IN MUCH THE SAME WAY THAT HE OR SHE WOULD IN **"REAL LIFE."**

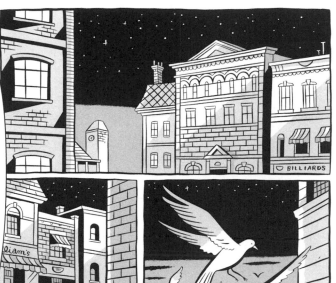

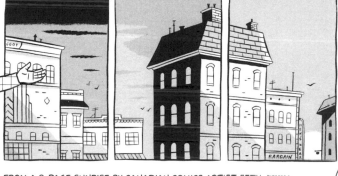

LOOKING AROUND... UP... DOWN...

WHATEVER CATCHES THE EYE.

ONE PIECE AT A TIME.

FROM A 3-PAGE SUNRISE BY CANADIAN COMICS ARTIST SETH, FROM *CLYDE FANS* BOOK ONE.

THIS LENDS AN AIR OF **FIRST-HAND EXPERIENCE** AND BOLSTERS THE ILLUSION OF WANDERING **THROUGH** A SCENE.

AND WHEN NO ONE IS IN SIGHT, AS IN THE ABOVE PAGE, YOUR READER IS FREE TO FORM A PERSONAL **RELATIONSHIP** WITH YOUR WORLD EVEN BEFORE YOUR **CHARACTERS** DO.

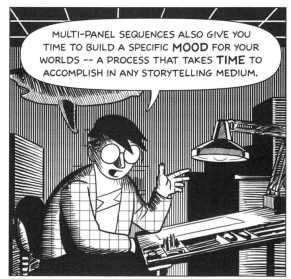

MULTI-PANEL SEQUENCES ALSO GIVE YOU TIME TO BUILD A SPECIFIC **MOOD** FOR YOUR WORLDS -- A PROCESS THAT TAKES **TIME** TO ACCOMPLISH IN ANY STORYTELLING MEDIUM.

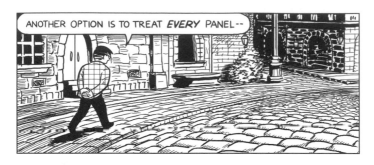

ANOTHER OPTION IS TO TREAT *EVERY* PANEL--

--AS IF IT WAS AN ESTABLISHING SHOT--

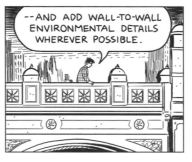

--AND ADD WALL-TO-WALL ENVIRONMENTAL DETAILS WHEREVER POSSIBLE.

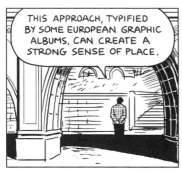

THIS APPROACH, TYPIFIED BY SOME EUROPEAN GRAPHIC ALBUMS, CAN CREATE A STRONG SENSE OF PLACE.

IF YOU DON'T MIND THE LONG HOURS AND SORE HANDS, IT MIGHT BE WORTH A TRY.

PICKING THE RIGHT APPROACH FOR YOUR STORY WILL DEPEND ON THAT STORY'S **PRIORITIES.**

SOME TYPES OF STORIES, LIKE SCIENCE FICTION, FANTASY OR HISTORICAL FICTION ARE AT LEAST PARTIALLY **ABOUT** THE WORLDS THEY INHABIT --

-- AND THEY MAY REQUIRE THAT YOU LAVISH CONSTANT ATTENTION UPON THE **DETAILS** OF THOSE WORLDS.

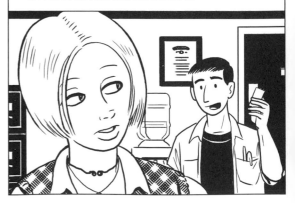

STORIES ABOUT **MODERN RELATIONSHIPS,** ON THE OTHER HAND, MAY ONLY NEED THEIR FAMILIAR, EVERYDAY SETTINGS REITERATED ONCE IN A WHILE, WHILE THEY FOCUS INSTEAD ON AN **EMOTIONAL** LANDSCAPE.

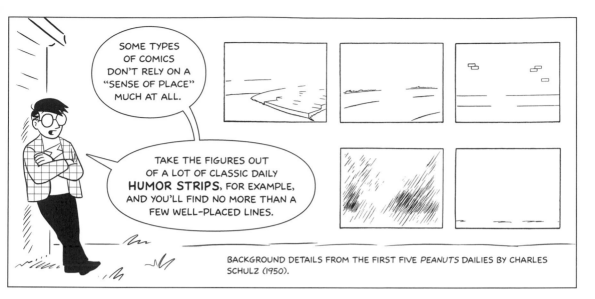

SOME TYPES OF COMICS DON'T RELY ON A "SENSE OF PLACE" MUCH AT ALL.

TAKE THE FIGURES OUT OF A LOT OF CLASSIC DAILY **HUMOR STRIPS**, FOR EXAMPLE, AND YOU'LL FIND NO MORE THAN A FEW WELL-PLACED LINES.

BACKGROUND DETAILS FROM THE FIRST FIVE *PEANUTS* DAILIES BY CHARLES SCHULZ (1950).

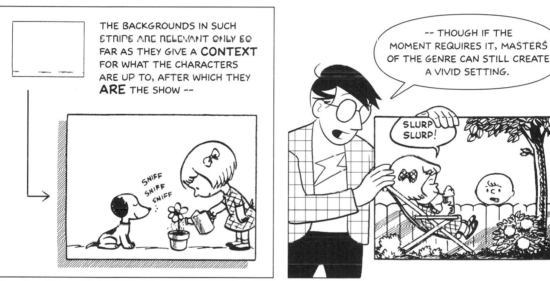

THE BACKGROUNDS IN SUCH STRIPS ARE RELEVANT ONLY SO FAR AS THEY GIVE A **CONTEXT** FOR WHAT THE CHARACTERS ARE UP TO, AFTER WHICH THEY **ARE** THE SHOW --

SNIFF SNIFF SNIFF

-- THOUGH IF THE MOMENT REQUIRES IT, MASTERS OF THE GENRE CAN STILL CREATE A VIVID SETTING.

SLURP SLURP!

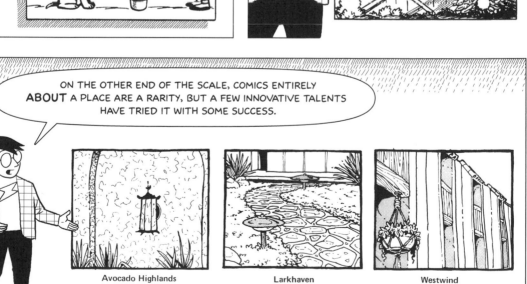

ON THE OTHER END OF THE SCALE, COMICS ENTIRELY **ABOUT** A PLACE ARE A RARITY, BUT A FEW INNOVATIVE TALENTS HAVE TRIED IT WITH SOME SUCCESS.

Avocado Highlands

Larkhaven

Westwind

PANELS FROM RICK GEARY'S BLEAK YET BEAUTIFUL "THE AGE OF CONDOS" FROM 1980.

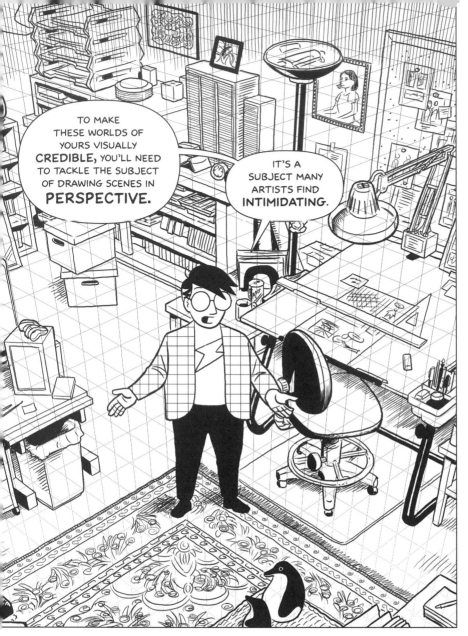

TO MAKE THESE WORLDS OF YOURS VISUALLY **CREDIBLE,** YOU'LL NEED TO TACKLE THE SUBJECT OF DRAWING SCENES IN **PERSPECTIVE.**

IT'S A SUBJECT MANY ARTISTS FIND **INTIMIDATING.**

FORTUNATELY, DRAWING IN PERSPECTIVE DOESN'T HAVE TO BE ALL THAT HARD.

IN FACT, WITH THE RIGHT APPROACH, IT CAN BE KIND OF **FUN!**

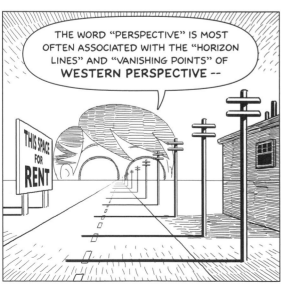

THE WORD "PERSPECTIVE" IS MOST OFTEN ASSOCIATED WITH THE "HORIZON LINES" AND "VANISHING POINTS" OF **WESTERN PERSPECTIVE** --

THIS SPACE FOR RENT

-- BUT IT CAN REFER TO ANY ATTEMPT TO REPRESENT A **3-D WORLD** ON A **2-D SURFACE** LIKE THIS PAGE.

170

THERE ARE PLENTY OF GRAPHIC DEVICES THAT CAN INDICATE **DEPTH**.

CLOSER OBJECTS CAN **OVERLAP** MORE DISTANT ONES --

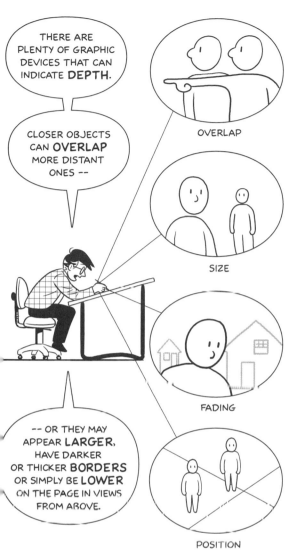

-- OR THEY MAY APPEAR **LARGER**, HAVE DARKER OR THICKER **BORDERS** OR SIMPLY BE **LOWER** ON THE PAGE IN VIEWS FROM ABOVE.

OVERLAP

SIZE

FADING

POSITION

AN ARTIST WITH A **MINIMAL STYLE** LIKE JOHN PORCELLINO MIGHT DRAW HUNDREDS OF PAGES WITHOUT EVER GOING NEAR A VANISHING POINT, BUT STILL CREATE A CONVINCING AND CONSISTENT WORLD USING SUCH BASIC DEPTH INDICATORS.

SOME ARTISTS BUILD THEIR SCENES ON A SLANTED CHECKERBOARD PATTERN WHERE PARALLEL LINES DON'T CONVERGE; A TYPE OF PERSPECTIVE SEEN IN EVERYTHING FROM PERSIAN PAINTING TO GAMES LIKE THE SIMS.

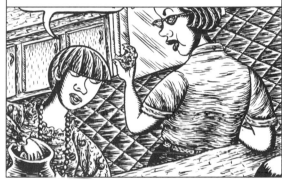

COMPELLING STORIES HAVE BEEN TOLD IN COMICS USING **DIAGRAMS** OF A WORLD SEEN ENTIRELY FROM ABOVE --

-- BIOMORPHIC LANDSCAPES WHERE THE ONLY INDICATION OF DEPTH WAS IN **OVERLAPPING** --

-- AND USING PERSPECTIVE THAT'S ALWAYS JUST A LITTLE BIT **WARPED**.

IF YOUR APPROACH IS **CONSISTENT**, AND THE CONTENTS OF YOUR STORY ARE **INTERESTING** ENOUGH, YOUR AUDIENCE WILL PROBABLY ACCEPT WHATEVER TYPE OF PERSPECTIVE YOU USE.

PANELS TWO-SIX: ART BY JOHN PORCELLINO, DEBBIE DRECHSLER, RICHARD MCGUIRE, GARY PANTER AND MARISCAL (SEE ART CREDITS, PAGE 258).

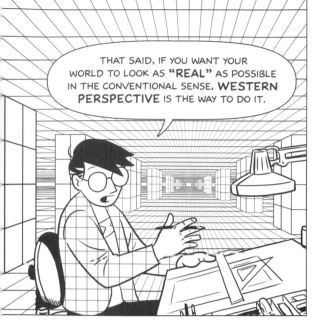

THAT SAID, IF YOU WANT YOUR WORLD TO LOOK AS "REAL" AS POSSIBLE IN THE CONVENTIONAL SENSE, **WESTERN PERSPECTIVE** IS THE WAY TO DO IT.

I CAN'T OFFER A FULL-LENGTH COURSE IN WESTERN PERSPECTIVE IN THESE PAGES. FOR THAT I SUGGEST DAVID CHELSEA'S BOOK ON THE SUBJECT* --

-- BUT HERE ARE SOME THOUGHTS ON HOW PERSPECTIVE AND COMICS CAN WORK **TOGETHER.**

IF YOU'VE TAKEN A FEW DRAWING CLASSES IN SCHOOL --

-- OR YOU'VE ALREADY READ CHELSEA'S BOOK --

-- YOU MAY ALREADY KNOW SOME OF THE **BASICS** --

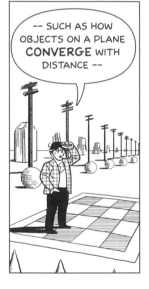

-- SUCH AS HOW OBJECTS ON A PLANE **CONVERGE** WITH DISTANCE --

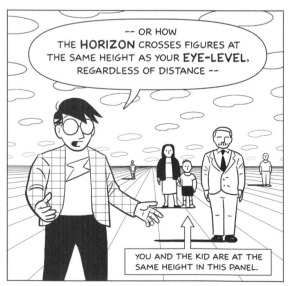

-- OR HOW THE **HORIZON** CROSSES FIGURES AT THE SAME HEIGHT AS YOUR **EYE-LEVEL**, REGARDLESS OF DISTANCE --

YOU AND THE KID ARE AT THE SAME HEIGHT IN THIS PANEL.

-- OR HOW **CIRCLES** COMPRESS TO **OVALS** WHEN VIEWED FROM THE SIDE.

AND YOU MIGHT HAVE SOME EXPERIENCE WITH APPLYING --

* *PERSPECTIVE! FOR COMIC BOOK ARTISTS* IS IN COMICS FORM LIKE THIS BOOK AND IS HIGHLY RECOMMENDED (SEE BIBLIOGRAPHY).

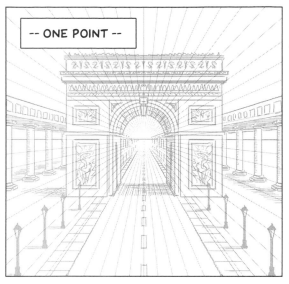

-- ONE POINT --

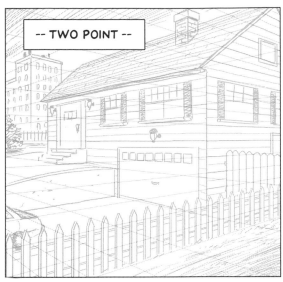

-- TWO POINT --

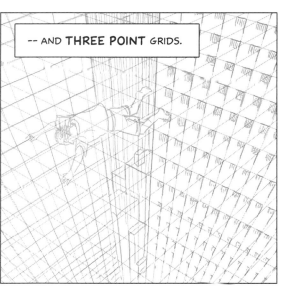

-- AND **THREE POINT** GRIDS.

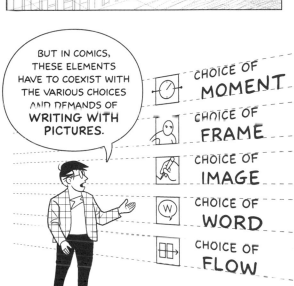

BUT IN COMICS, THESE ELEMENTS HAVE TO COEXIST WITH THE VARIOUS CHOICES AND DEMANDS OF **WRITING WITH PICTURES.**

CHOICE OF **MOMENT**

CHOICE OF **FRAME**

CHOICE OF **IMAGE**

CHOICE OF **WORD**

CHOICE OF **FLOW**

COMICS PAGES ARE STRUCTURED AROUND HOW PEOPLE, OBJECTS AND WORDS ARE PLACED ON THE **PAGE** --

-- SO MOST PANELS BEGIN THEIR LIVES AS A COLLECTION OF FLAT, **2-D** ELEMENTS.

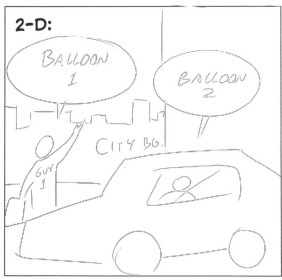

2-D:

BALLOON 1

BALLOON 2

CITY BG.

GUY 1

173

AND IT'S ONLY **AFTER** THOSE RELATIONSHIPS ARE WORKED OUT THAT A **GRID** IS LAID DOWN --

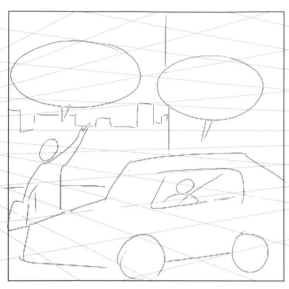

-- AND A MORE FULLY REALIZED **THREE-DIMENSIONAL** SCENE STARTS TO EMERGE.

3-D:

ROOM FOR ONE MORE?

SURE! GET IN!

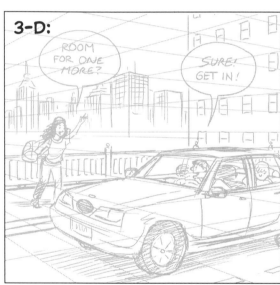

SO THE FIRST JOB OF PERSPECTIVE IS TO SERVE THE **LAYOUT** OF THE PAGE AND ENHANCE THE **STORY,** AND SOMETIMES THAT DOESN'T LEAVE MUCH ROOM FOR IMPROVISATION.

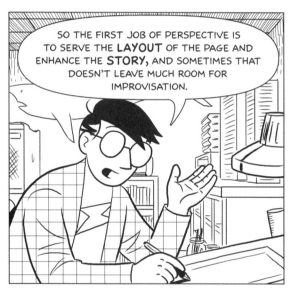

IN OTHER PANELS, THOUGH, THE **REQUIRED** ELEMENTS ARE **MINIMAL** AND THE **LATITUDE** FOR **IMPROVISATION** IS GREAT--

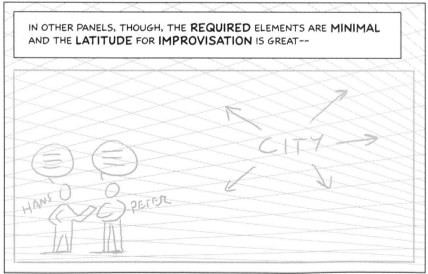

CITY

HANS PETER

-- AND THAT'S WHEN YOUR **IMAGINATION** CAN TAKE OVER!

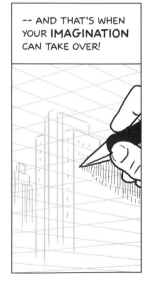

WORLD-BUILDING COMICS ARTISTS LIKE FRANCE'S **MOEBIUS** HAVE DEMONSTRATED JUST HOW FAR THAT **LICENSE TO IMPROVISE** CAN TAKE A PAGE.

ONCE A GRID IS IN PLACE, **WHOLE WORLDS** CAN BE SUGGESTED IN JUST A FEW SQUARE INCHES OF PAPER.

THE KEY IS TO LET YOUR **IMAGINATION** WORK IN THE **3-D** SPACES THE GRID SUGGESTS.

TRY IT NOW. STARE FOR A WHILE AT THE **GRID** IN PANEL TWO.

WHAT DO YOU **SEE?**

175

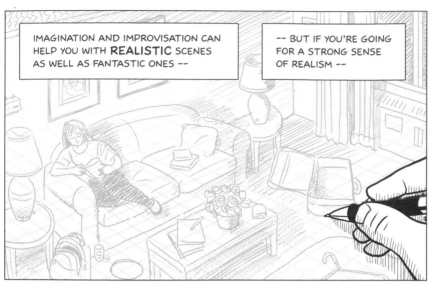

IMAGINATION AND IMPROVISATION CAN HELP YOU WITH **REALISTIC** SCENES AS WELL AS FANTASTIC ONES --

-- BUT IF YOU'RE GOING FOR A STRONG SENSE OF REALISM --

-- YOU'LL ALSO NEED TO DO SOME **RESEARCH**.

PAF!

IF THAT SOUNDS ABOUT AS MUCH FUN AS A ROOT CANAL TO YOU, YOU'RE NOT ALONE.

LOTS OF OTHERWISE TALENTED ARTISTS TEND TO **SKIMP** ON RESEARCH -- ESPECIALLY WHEN ON A **DEADLINE** --

IT'LL DO! IT'LL DO!

TICK! TICK!

-- WITH PREDICTABLY **BLAND,** BUT **PASSABLE,** RESULTS.

BUT EVEN A LITTLE **EXTRA EFFORT** IN THE RESEARCH DEPARTMENT CAN GO A **LONG WAY.**

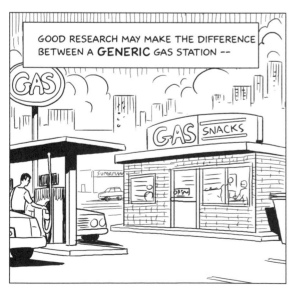

GOOD RESEARCH MAY MAKE THE DIFFERENCE BETWEEN A **GENERIC** GAS STATION --

GAS

GAS SNACKS

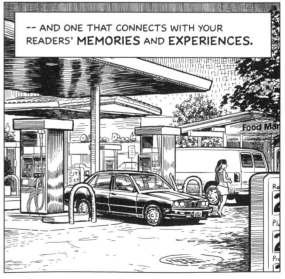

-- AND ONE THAT CONNECTS WITH YOUR READERS' **MEMORIES** AND **EXPERIENCES.**

Food Ma

OR BETWEEN A RUN-OF-THE-MILL BUILDING --

-- AND ONE WITH **CHARACTER** AND **CREDIBILITY**.

EVEN WHEN WORKING IN MINIMAL **CARTOONY** STYLES, GOOD RESEARCH CAN HELP YOU FIND THE **ESSENCE** OF A LOCATION --

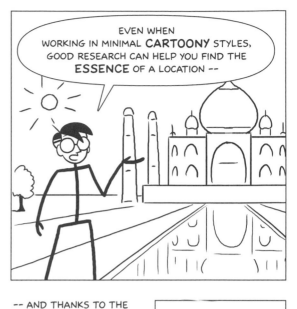

-- AND THANKS TO THE **WEB**, ARTISTS CAN NOW FIND **PHOTO REFERENCE** ON EVERYTHING FROM **AARDVARKS** TO **ZINNIAS** IN MINUTES.

STILL, IF YOU NEED TO DRAW ANYTHING WITHIN **DRIVING DISTANCE** --

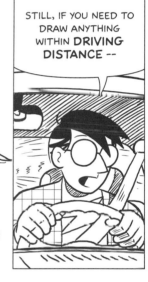

-- IT CAN REALLY PAY OFF TO GET SOME **ON-SITE** PHOTOS --

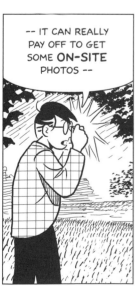

-- OR EVEN ON-SITE **DRAWINGS.**

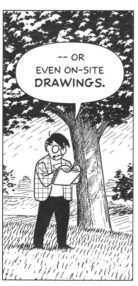

TAKE SOME TIME TO **LOSE YOURSELF** IN THE ENVIRONMENTS YOU DRAW --

-- AND YOUR **READERS** WILL TOO.

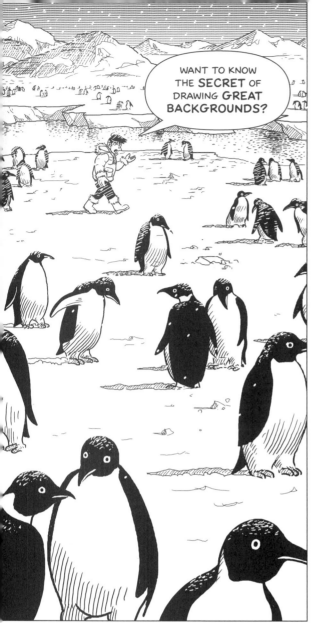

WANT TO KNOW THE **SECRET** OF DRAWING **GREAT** BACKGROUNDS?

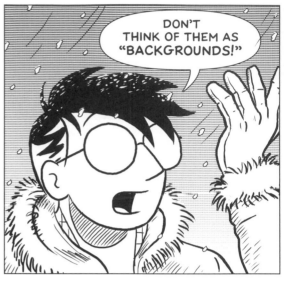

DON'T THINK OF THEM AS "BACKGROUNDS!"

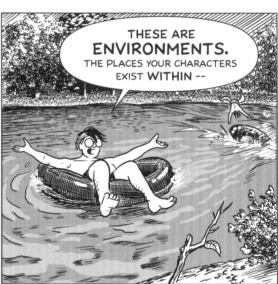

THESE ARE **ENVIRONMENTS.** THE PLACES YOUR CHARACTERS EXIST **WITHIN** --

-- NOT JUST **BACKDROPS** TO THROW BEHIND THEM AS AN AFTERTHOUGHT.

TOO MANY ARTISTS FORGET THIS AND BECOME WHAT EISNER CALLED **"SLAVES TO THE CLOSE-UP"**; STICKING WITH THE ONE THING -- PEOPLE -- THAT THEY'RE CONFIDENT THEY **CAN** DRAW --

-- AFRAID THAT IF THEY PULL THE "CAMERA" **BACK** THEY MIGHT HAVE TO DRAW A DOZEN THINGS THEY'VE NEVER DRAWN BEFORE.

THOSE WHO HAVE **SEIZED** ON THAT CHALLENGE, HOWEVER, HAVE CHANGED COMICS HISTORY WITH THE WORLDS THEY'VE CREATED.

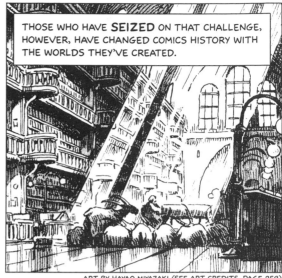

ART BY HAYAO MIYAZAKI (SEE ART CREDITS, PAGE 258).

AND SO CAN **YOU.**

JUST REMEMBER TO LET YOUR READERS STEP **INTO** YOUR WORLD --

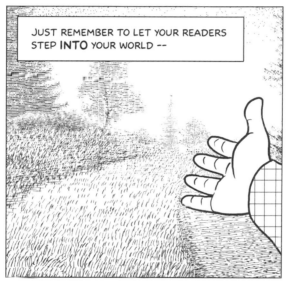

-- MAKE THAT WORLD **UNIQUE** --

-- AND GIVE THEM A REASON TO **COME BACK** AGAIN AND AGAIN.

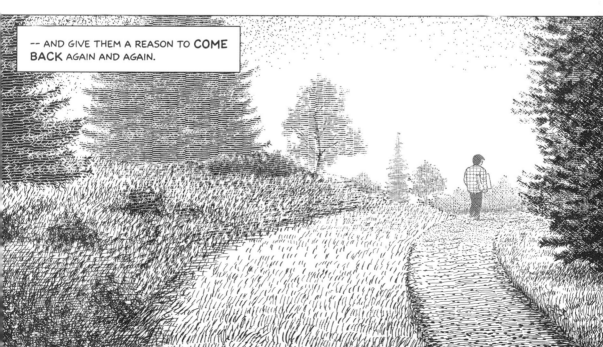

NOTES

CHAPTER FOUR - WORLD BUILDING

PAGES 158-159 - HOW MUCH IS ENOUGH?

I OPEN THIS CHAPTER WITH SOME LABOR-INTENSIVE PANELS, BUT I HOPE I'M NOT SCARING ANYONE OFF. YES, YOU CAN CREATE A STRONG SENSE OF PLACE WITHOUT SPENDING A DAY ON EVERY PANEL (AND THIS SPREAD TOOK A WEEK SO I MEAN THAT LITERALLY). THE REASON I'M PUTTING THE HARD WORK UP FRONT IS THAT THE RATIO OF ARTISTS PUTTING TOO LITTLE WORK INTO ENVIRONMENTS VERSUS THOSE PUTTING TOO MUCH IS ABOUT NINETY-NINE TO ONE. WE ALL FIND EXCUSES TO SKIMP ON WHAT WE DISMISSIVELY CALL "BACKGROUNDS" AND THIS CHAPTER IS MY ATTEMPT TO COUNTER THAT TREND.

PAGES 162-163 - ESTABLISHING SHOTS ON STEROIDS

IT SHOULD BE NOTED THAT THERE'S NOTHING TECHNI-CALLY WRONG WITH THE FIRST ESTABLISHING SHOT I SHOW ON PAGE 160. IT'S CLEAR AND COMPREHENSIVE. THE FIVE CHANGES FEATURED IN THE PUMPED UP VERSION SHOWN ON PAGE 162 AREN'T MEANT TO REPAIR ANYTHING; THEY'RE JUST OPTIONS FOR TAKING THE ESTABLISHING SHOT TO A DIFFERENT LEVEL, AND A WAY OF RECONSIDERING THE GOALS OF SUCH PANELS, FIVE TOOLS THAT ARE AVAILABLE IF YOU WANT TO USE THEM. I HAVE NO DISAGREEMENT WITH ANYONE WHO LIKED THE FIRST VERSION BETTER.

PAGE 164, PANELS 7-9 - SILENCE AND LENGTH

LENGTH OF STORY CAN AFFECT A COMICS ARTIST'S WILLINGNESS TO INCLUDE SILENT PANELS. THE RELATIVELY SHORT LENGTH OF AMERICAN COMIC BOOKS MADE SILENT PANELS RARE FOR MANY YEARS, WHILE MANGA, WITH ITS THICK ANTHOLOGIES BOUND FOR THICK COLLECTIONS, INDULGED IN LONG, SILENT SEQUENCES ON A REGULAR BASIS. STILL, EVEN SHORT STORIES CAN BENEFIT FROM THE OCCASIONAL PAUSE IN THE SOUNDTRACK.

PAGE 165 - A LICENSE TO WANDER

THIS CONNECTS TO THE DISCUSSION OF FRAMING ON PAGE 25. WHEN A CHARACTER IS DEAD-CENTER, THEN THE PANEL IS ABOUT THAT CHARACTER AND EVERY-THING ELSE IS "BACKGROUND"; WE DON'T HAVE TO SMELL THE GRASS OR FEEL THE BREEZE BECAUSE OUR PROTAGONIST WILL DO THAT FOR US. BUT WHEN THOSE IMAGINARY CROSS-HAIRS OF THE FRAME ARE POINTING INTO EMPTY SPACE, THEN THE PANEL IS -- AT LEAST

PARTIALLY -- **ABOUT** THAT SPACE, AND EXPLORING IT WILL BE THE READER'S FIRST IMPULSE.

THE IDEA OF NOT BLOCKING THE READER AT THE DOOR IS ALSO CONSISTENT WITH THE "RULE OF THIRDS," A TECHNIQUE USED IN ART AND PHOTOGRAPHY TO PURSUE MORE DYNAMIC AND PLEASING COMPOSITIONS. THE RULE HOLDS THAT IF YOU DIVIDE YOUR PICTURE INTO THREE SECTIONS VERTICALLY AND HORIZONTALLY AND PLACE YOUR POINTS OF INTEREST AT THE INTER-SECTIONS OF THOSE LINES, THE COMPOSITIONS WILL BE IMPROVED. THERE'S NO PROOF FOR SUCH RULES, OF COURSE, BUT YOU MIGHT WANT TO TRY IT YOURSELF AND SEE IF YOU LIKE THE RESULTS. DAVE GIBBONS, OF *WATCHMEN* FAME, HAS MENTIONED USING THE RULE IN SOME PANELS (SEE BIBLIOGRAPHY FOR THE BOOK *ARTISTS ON COMIC ART*).

FOR SOME HEAVIER MATH AND ANOTHER THEORY OF WHAT-LOOKS-GOOD, YOU MIGHT WANT TO LOOK INTO THE EVER-POPULAR "GOLDEN RATIO" AND SEE WHAT KINDS OF RESULTS IT CAN PRODUCE IN YOUR WORK. ALWAYS REMEMBER, THOUGH, IF IT DOESN'T LOOK GOOD TO YOU, IT DOESN'T MATTER HOW MANY THEORIES (INCLUDING MINE) TELL YOU IT'S GOOD. DRAW WITH YOUR EYES, NOT YOUR EARS.

PAGE 166 - FRAGMENTS AND THE SENSES

ON PAGES 88-89 OF *UNDERSTANDING COMICS*, I SUGGEST THAT FRAGMENTED TRANSITIONS LIKE THIS CAN ALSO RECALL OTHER SENSES, SINCE THE MENTAL ACTIVITY THAT STITCHES THEM TOGETHER DOESN'T HAVE TO BE ENTIRELY VISUAL BUT CAN DRAW FROM THE OTHER SENSES AS WELL.

PAGE 168, LAST PANEL - ...BUT DON'T USE THIS AS AN EXCUSE!

EVEN EVERYDAY SETTINGS LIKE OFFICES AND APART-MENTS CAN BE VISUALLY RICH, SO DON'T SKIMP TOO MUCH ON THOSE ENVIRONMENTS. EVEN IN SCENES WHERE THE AUDIENCE IS FAR MORE INTERESTED IN WHAT CHARACTERS ARE SAYING THAN IN WHERE THEY ARE, A LITTLE ATTENTION TO THE DETAILS AROUND THEM CAN HELP EVOKE A MOOD, CONNECT WITH READERS' SENSORY MEMORIES OR REMIND THE READER OF THE BROADER CONTEXT THAT THE CONVERSATION IS TAKING PLACE IN.

YOU DON'T HAVE TO GO AS FAR AS DEREK KIRK KIM:

...BUT AT LEAST CONSIDER THE POSSIBILITIES.

PAGE 169, LAST PANEL - STORIES ABOUT PLACE

EDWARD GOREY'S SILENT STORY "THE WEST WING" IS ANOTHER COMIC (WELL, I CALL IT A COMIC) THAT'S EFFECTIVELY ABOUT A PLACE AND LITTLE ELSE. IT CAN BE FOUND IN HIS COLLECTION, *AMPHIGOREY* (PERIGEE TRADE, 1980).

PAGE 171, PANEL 2 - JOHN PORCELLINO

PORCELLINO'S COMICS CONVEY A VERY STRONG SENSE OF PLACE WITH ALMOST NO RENDERING, BUT HE HAS A GREAT EYE FOR DETAILS AND FREQUENTLY INCLUDES -- WITH JUST A FEW LINES -- OBJECTS THAT TRIGGER MEMORIES IN THE READER THAT AN ARTIST WITH A MORE LABOR-INTENSIVE STYLE MIGHT HAVE MISSED. SINCE I OPEN WITH SUCH DETAILED IMAGES, IT'S

IMPORTANT TO NOTE THAT SOME ARTISTS GET THE JOB DONE WITH FAR FEWER LINES.

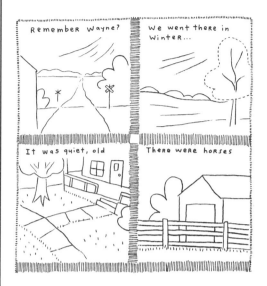

PAGE 174, PANEL ONE - PERSPECTIVE GUIDELINES

NON-REPRO BLUE PENCILS ARE ESPECIALLY USEFUL FOR DRAWING GUIDELINES. THEY DON'T DISTRACT FROM OTHER PENCIL WORK AND DON'T NEED TO BE ERASED BECAUSE TRADITIONAL PRE-PRESS TECHNIQUES DON'T PICK THEM UP WHILE DIGITAL PRE-PRESS CAN EASILY KNOCK THEM OUT. SEE CHAPTER FIVE AND ITS NOTES FOR MORE INFORMATION ON SUCH TOOLS.

PAGE 176-177 - REFERENCE TAKING

WHEN YOU WANT TO GET THE DETAILS RIGHT, YOUR REFERENCE OPTIONS INCLUDE:

- GO TO THE SOURCE AND DRAW IT.
- GO TO THE SOURCE AND MAKE SKETCHES YOU CAN REFER TO WHEN DRAWING IT LATER.
- GO TO THE SOURCE AND TAKE A PHOTO TO USE FOR DETAILED REFERENCE (OR DIRECT COPYING, IF APPROPRIATE).
- FIND A STOCK PHOTO ON THE WEB THAT YOU CAN BUY FOR A FEW BUCKS AND USE FOR DETAILED REFERENCE (OR DIRECT COPYING, IF APPROPRIATE).
- FIND A PHOTO ON THE WEB AND USE IT AS REFER-ENCE FOR AN ORIGINAL DRAWING (BUT NOT COPIED DIRECTLY, SINCE IT'S NOT YOUR PHOTO).

IF YOU HAVE THE TIME AND YOU'RE NEAR YOUR SOURCE (FOR EXAMPLE, A FIRE HYDRANT) IT'S ALWAYS PREFER-ABLE TO START NEAR THE TOP OF THAT LIST. DRAWING FROM LIFE IS STILL THE BEST WAY TO GO IN MOST SITUATIONS. BUT REALISTICALLY, MOST OF US -- MYSELF INCLUDED -- FIND IT HARD THESE DAYS NOT TO JUST GO TO THE WEB AND SAVE THE TIME.

PERSONALLY, I THINK COPYING FROM YOUR OWN PHOTOS, OR FROM STOCK PHOTOS THAT YOU'VE BOUGHT ONLINE, IS LEGITIMATE IF IT REALLY IS THE BEST IMAGE

TOP DOWN: ART BY DEREK KIRK KIM, JOHN PORCELLINO AND EDWARD GOREY (SEE ART CREDITS, PAGE 258).

181

FOR THE JOB. THE PARKING LOT ON PAGE 165 WAS FROM A PHOTO I TOOK, FOR EXAMPLE, AND THE BUILDING ON PAGE 177 IS TAKEN FROM A PICTURE I BOUGHT FOR $3 AT ISTOCKPHOTO.COM. IN BOTH CASES, IT TOOK A LOT OF SEARCHING TO FIND JUST THE RIGHT ONE.

COPYING REALLY ISN'T OKAY IF YOU'RE USING SOMEONE ELSE'S PHOTO WITHOUT PERMISSION, BUT SO LONG AS YOU'RE MAKING SOMETHING NEW AND JUST USING THE PHOTO FOR GENERAL REFERENCE (THE WAY I DID WITH THE TAJ MAHAL ON PAGE 177, FOR EXAMPLE), YOU'RE ON SOLID GROUND, BOTH LEGALLY AND ETHICALLY.

PAGE 178 – CHARACTER AND ENVIRONMENT: A THEORY OF SEPARATION

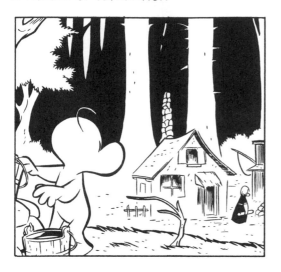

THE LINES YOU USE TO DRAW A CHARACTER ARE DIFFERENT FROM THE LINES YOU USE TO DRAW THE ENVIRONMENTS THEY LIVE IN. THEY SERVE DIFFERENT PURPOSES AND READERS READ THEM IN DIFFERENT WAYS. WHEN READERS SEE THE LINES THAT MAKE UP A CHARACTER'S EYES, FOR EXAMPLE, THEY'RE LOOKING BEYOND THOSE EYES TO THE THOUGHTS AND EMOTIONS REVEALED IN THEM; THEY MIGHT EVEN FEEL A SENSE OF PARTICIPATION IN THAT CHARACTER'S INNER LIFE AND INVESTMENT IN HIS OR HER FATE. WHEN THEY SEE THE LINES THAT MAKE UP A BRICK WALL, ON THE OTHER HAND, THEY'RE MORE LIKELY TO WONDER HOW THE WALL FEELS TO THE TOUCH OR NOTICE HOW SHADOWS FALL ON IT. THE WALL BELONGS TO THE REALM OF SENSES -- SIGHT, SOUND, TOUCH, TASTE, SMELL -- BUT NOT TO THE REALMS OF EMOTION OR IDENTITY.

IN MOST COMICS, DRAWING STYLES DON'T VARY MUCH BETWEEN CHARACTER AND ENVIRONMENT. WHETHER IT'S A MAILMAN OR THE TRUCK HE'S DRIVING, MOST ARTISTS USE ROUGHLY THE SAME STYLE ON BOTH. STILL, IF YOU LOOK CLOSELY, YOU MIGHT NOTICE SOME SUBTLE DIFFERENCES. WITHOUT CONSCIOUSLY INTEND-ING TO, I THINK THAT MANY ARTISTS TEND TO MAKE THEIR CHARACTERS A BIT MORE CONCEPTUALIZED, CARTOONY OR EXAGGERATED, WHILE ENVIRONMENTAL DETAILS LIKE BUILDINGS AND CLOUDS STAY CLOSER TO THE PROPORTIONS, CONTOURS AND SHADING OF THEIR REAL-LIFE COUNTERPARTS.

A FEW ARTISTS HAVE REFLECTED THAT SPLIT MORE VISIBLY, THOUGH, USUALLY DRAWING DELIBERATELY CARTOONY CHARACTERS COMBINED WITH CAREFULLY RENDERED, REALISTIC BACKGROUNDS. IN *UNDERSTAND-ING COMICS*, PAGES 42-44, I TALKED ABOUT THE POTENTIAL BENEFITS OF THIS APPROACH, NOTING HOW SOME MANGA ARTISTS HAD USED IT. THE IDEA BEHIND WHAT I CALLED "THE MASKING EFFECT" WAS THAT THE SIMPLY DRAWN CHARACTERS FACILITATED IDENTIFICA-TION (A PHENOMENON I HAD TALKED ABOUT IN THE PRECEDING 12 PAGES OF *U.C.*) WHILE THE MORE REALISTICALLY-RENDERED DETAILS OF THEIR WORLD EVOKED THE SENSORY EXPERIENCES OF THOSE CHARAC-TERS MORE EFFECTIVELY. "ONE SET OF LINES TO SEE. ANOTHER SET OF LINES TO BE."

SINCE WRITING ABOUT THE MASKING EFFECT IN 1993, I'VE MADE THINGS EVEN MORE CONFUSING WITH FOUR DIFFERENT LEVELS OF IDENTIFICATION:

CHARACTERS:

> THE HUMAN OR HUMAN-LIKE CREATURES THAT WE'RE EXPECTED TO IDENTIFY WITH AND ASSIGN PERSON-ALITIES, MOTIVES AND EMOTIONS TO.

EXTENSIONS:

> CLOTHES, TOOLS, WEAPONS AND OTHER OBJECTS WORN OR HELD BY CHARACTERS WHICH SERVE AS EXTENSIONS OF THEIR IDENTITIES (E.G., WE DON'T SEE OUR UNCLE JACK AND SAY "OH, THERE'S UNCLE JACK AND HIS CLOTHES, GLASSES AND CELL PHONE"; WE PERCEIVE ALL OF THOSE THINGS AS A PART OF UNCLE JACK'S IDENTITY AND JUST SAY "OH, THERE'S UNCLE JACK.")

DISCRETE ENTITIES:

> OBJECTS, ANIMALS OR PLANTS THAT HAVE A DISCRETE IDENTITY AND SHAPE, SEPARATE FROM THE CHARACTERS, BUT NO PERCEIVED MOTIVE OR EMOTION. A CAR, A COUCH, A POTTED CACTUS, A STOP SIGN, A SLEEPING ELEPHANT. THINGS THAT MIGHT BE SAID TO HAVE A "PERSONALITY" BUT ONLY IN THE METAPHORICAL SENSE ("OH, WHAT A SAD LITTLE TROPHY") NOT IN THE SENSE OF AN INNER LIFE.

ENVIRONMENTS:

> SUNSETS, MOUNTAIN RANGES, GRASS, SHADOWS, WALLS, BODIES OF WATER -- SUBSTANCES THE CHARACTER IS LIKELY TO REACT TO ONLY AS SENSORY EXPERIENCES, NOT AS DISCRETE ENTITIES.

SINCE THESE CATEGORIES ARE BASED ON READER PERCEPTION, THE STATUS OF SOMETHING IN ONE CATEGORY CAN CHANGE IF THE PERCEPTION OF IT CHANGES. A CELL PHONE SITTING ON A TABLE UNUSED MIGHT BE SEEN AS A DISCRETE ENTITY; A CAR THAT REARS UP ON ITS HIND WHEELS AND STARTS TALKING MIGHT BE SEEN AS A CHARACTER; A CHARACTER THAT DIES AND BECOMES A SKELETON COULD BE SEEN AS A DISCRETE ENTITY.

ART BY JEFF SMITH (SEE ART CREDITS, PAGE 258).

IF THE MASKING EFFECT WERE APPLIED TO THE FOUR, THEN, THE LEVEL OF REALISM WOULD GO UP AS WE MOVED FROM CHARACTERS TO EXTENSIONS TO DISCRETE ENTITIES TO ENVIRONMENTS, LIKE SO:

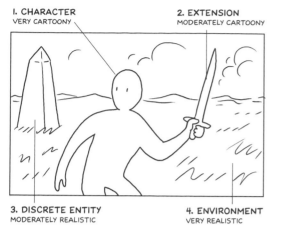

1. CHARACTER
VERY CARTOONY

2. EXTENSION
MODERATELY CARTOONY

3. DISCRETE ENTITY
MODERATELY REALISTIC

4. ENVIRONMENT
VERY REALISTIC

THIS IS ONE OF MY WEIRDER THEORIES, SO THINK TWICE BEFORE EXPERIMENTING WITH IT. IF YOU'RE INTERESTED IN SUCH THINGS, YOU MIGHT WANT TO JUST TRY IT AS AN EXERCISE OR TWO TO SEE IF YOU LIKE THE RESULTS. I THINK IT COULD WORK, BUT I DON'T HAVE ANY PROOF. I'VE TRIED A VARIATION OF THE IDEA AND FAILED, BUT I MIGHT TRY IT AGAIN ONE OF THESE DAYS.

OPTIONAL EXERCISES

#1 - DRAWING THE REAL WORLD

TRY CREATING A SHORT (2-4 PAGE) SKETCHED COMIC IN WHICH EVERYTHING IS DRAWN DIRECTLY FROM LIFE. SCOUT OUT A LOCATION. GET FRIENDS OR FAMILY TO POSE FOR YOU. MAKE SURE YOU HAVE ANY PROPS ON HAND. IN SHORT: PLAN YOUR COMIC AS IF YOU WERE PLANNING A SHORT FILM. BE SURE TO START WITH A BIG WIDE ESTABLISHING SHOT OF YOUR LOCATION (PAGES 160-162) OR WITH AN EFFECTIVE MULTI-PANEL ESTABLISHING SEQUENCE (PAGES 166-167). USE A CAMERA IF YOU NEED TO, BUT TRY DRAWING IT ON THE SPOT AS MUCH AS POSSIBLE, USING JUST YOUR EYES, PENCIL AND PAPER.

#2 - GUESS THE MOOD (PAGES 166-167)

CHOOSE ONE OF THE FOLLOWING THEMES:

- ABANDONED
- SERENE
- FORBIDDING
- WELCOMING
- OFFICIAL
- EXOTIC
- INNOCENT

THEN MAKE A SINGLE PAGE, NINE PANEL COMIC SHOWING FRAGMENTS OF A PLACE BASED ON THAT THEME. NO CHARACTERS AND NO WORDS. JUST IMAGES FROM A SETTING, REAL OR IMAGINARY, THAT YOU THINK EXPRESSES THE THEME.

NOW GIVE THE LIST AND YOUR COMIC TO A FRIEND AND SEE IF HE/SHE CAN GUESS WHICH THEME YOU WERE TRYING FOR.

#3 - YOU ARE HERE (PAGES 166-167)

WHEREVER YOU ARE, RIGHT NOW, NOTICE YOUR SURROUNDINGS. LIST NINE ASPECTS OF IT; SIGHTS, SOUNDS, SMELLS, TEXTURES, ETC... CREATE A SINGLE PAGE, NINE PANEL ESTABLISHING SEQUENCE THAT MANAGES TO EVOKE ALL OF THESE QUALITIES FOR THE READER.

ALTERNATE VERSION: TAKE PHOTOS OF WHAT YOU SEE AROUND YOU, THEN SELECT NINE THAT BEST REPRESENT YOUR SURROUNDINGS AND THE VARIOUS SENSATIONS YOU ASSOCIATE WITH IT.

#4 - PERSPECTIVE EXERCISE (PAGES 170-175)

IF YOU'RE COMFORTABLE WITH PERSPECTIVE ALREADY, OR YOU'VE READ CHELSEA'S BOOK (SEE BIBLIOGRAPHY) TRY THIS:

TAKE A PHOTO OF AN OBJECT WITH A FAIRLY COMPLICATED SHAPE AND A LOT OF PARALLEL EDGES OR RIGHT ANGLES (A CAR, A LAWN MOWER, A COFFEE MAKER, A FIRE HYDRANT). MAKE SURE YOUR VIEWING ANGLE ISN'T STRAIGHT ON, BUT FROM AN ODD ANGLE, SO THAT YOU CAN SEE TWO SIDES OF IT AND ITS TOP OR BOTTOM. THEN TRACE THAT PHOTO INTO A SMALL SECTION OF A LARGE PANEL AND USE IT TO INFER A PERSPECTIVE GRID. USING THE GRID, DRAW AN INVENTED SCENE AROUND IT. THEN IMPROVISE ONE OR TWO NEW PANELS, INCLUDING THE SAME OBJECT, BUT USING A NEW GRID OF YOUR CHOOSING TO SHOW IT FROM DIFFERENT ANGLES.

#5 - REVISIT YOUR PAGES!

IF YOU'VE ALREADY DRAWN SOME COMICS, TAKE A CLOSE LOOK AT YOUR PAGES AND SEE IF YOU WERE SHOWING ENOUGH OF THE WORLD THAT YOUR CHARACTERS INHABIT. IF YOU'RE LIKE MOST ARTISTS, PROFESSIONAL OR AMATEUR, THE ANSWER IS PROBABLY NO. CAN YOU FIND ONE PANEL IN PARTICULAR THAT COULD HAVE BENEFITTED FROM PULLING BACK THE CAMERA AND GIVING YOUR READERS A BETTER VIEW OF YOUR WORLD?

ADDITIONAL NOTES AT:
WWW.SCOTTMCCLOUD.COM/MAKINGCOMICS

Chapter Five
Tools, Techniques and Technology

Making it Real

WHEN MAKING COMICS, THERE ARE ONLY **TWO TOOLS** YOU CAN'T DO WITHOUT.

SO FAR IN THIS BOOK, WE'VE BEEN WORKING ON GETTING TOOL NUMBER **ONE** --

-- YOUR **MIND** --

-- READY FOR THE CHALLENGES COMICS PRESENTS.

THE TECHNIQUES AND TECHNOLOGIES YOU USE TO **PRODUCE** YOUR COMICS ARE UP TO YOU.

SO LONG AS IT FITS IN TOOL NUMBER **TWO** --

-- YOUR **HAND** --

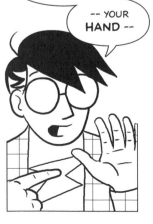

-- AND IT ACCOMPLISHES THE **PURPOSES** YOU'VE SET FOR YOURSELF --

-- THERE'S **NO "WRONG"** TOOL FOR THE JOB.

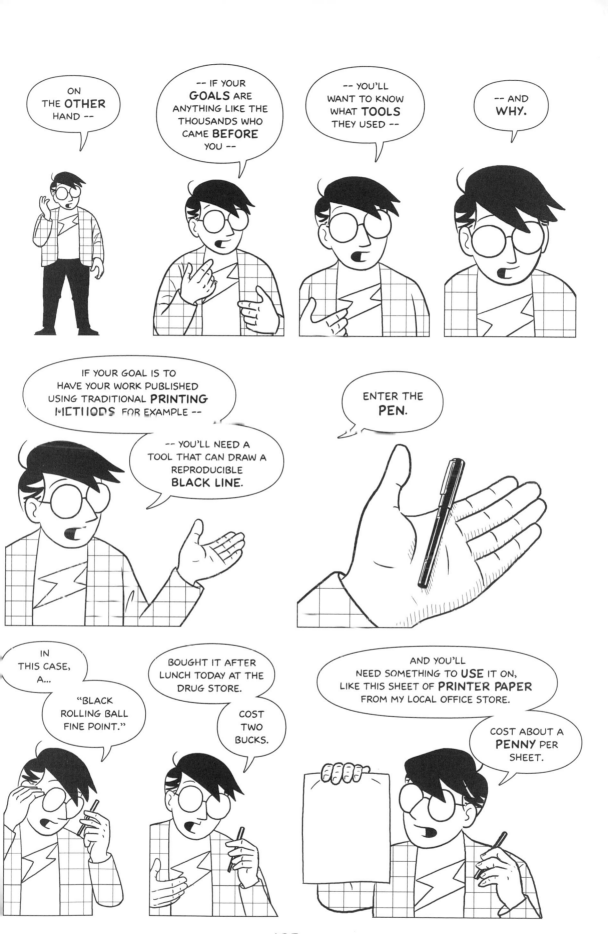

185

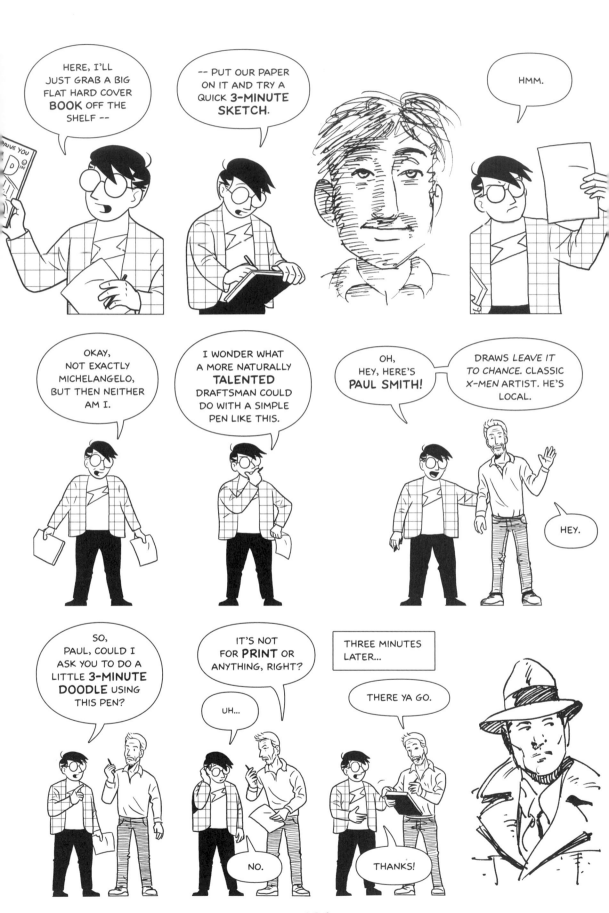

OKAY, EVEN IN A LITTLE DOODLE LIKE THIS, YOU CAN SEE THE CONFIDENT **LINE**, **FORM** AND **COMPOSITION** THAT AN EXPERIENCED ARTIST LIKE PAUL CAN COMMAND, EVEN WHEN USING THE SIMPLEST OF TOOLS.

ACTUALLY, I **LIKE** THAT PEN!

IF PAUL HAD TO DO A **WHOLE BOOK** THIS WAY, HE COULD.

BUT, IS A TWO DOLLAR PEN AND SOME CHEAP PAPER ALL YOU **NEED** TO MAKE COMICS?

FOR A FEW OF YOU, THE ANSWER MIGHT IN FACT, BE **YES!**

SUPPOSE YOU WANTED TO TRAVEL AROUND THE COUNTRY FOR A YEAR, MAKING UP STORIES ABOUT EACH CITY AND THE PEOPLE YOU MEET, JOTTING THEM DOWN AS THEY COME TO YOU.

KEEPING YOUR TOOLS **SIMPLE** MIGHT SUIT SUCH A DIARY-LIKE IMPROVISATIONAL STYLE.

SERIOUS COMICS HAVE BEEN DRAWN USING SIMPLE TOOLS BEFORE.*

SO WHY WOULD YOU INVEST IN **MORE?**

WELL, FOR STARTERS, MAYBE YOU WANT A MORE COMFORTABLE **SURFACE** TO DRAW ON.

OR A STURDIER, LONGER-LASTING **PAPER.**

OR A BIT MORE **VARIATION** IN THE LINEWORK.

OR A WAY TO PLAN FOR AND **ORGANIZE** THE PANELS OF YOUR STORY **BEFORE** THE FIRST LINES ARE EVEN **DRAWN.**

* SPIEGELMAN'S **MAUS** WAS DRAWN WITH A FOUNTAIN PEN, MUCH OF IT ON ORDINARY TYPING PAPER.

187

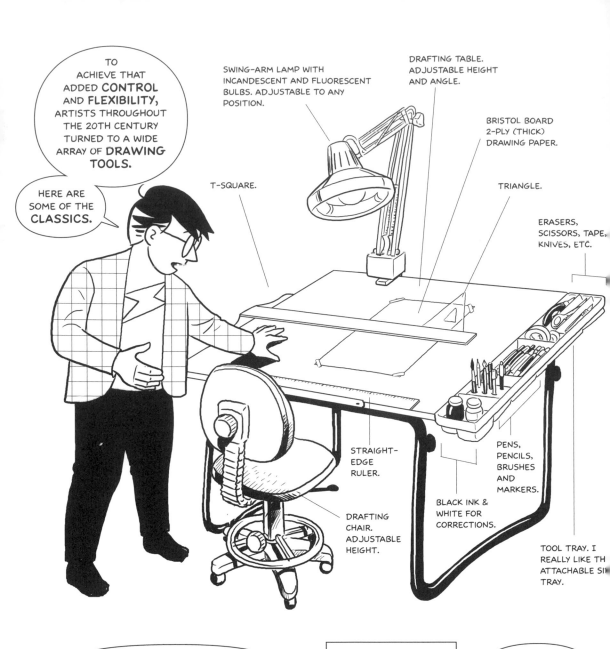

TO ACHIEVE THAT ADDED **CONTROL** AND **FLEXIBILITY,** ARTISTS THROUGHOUT THE 20TH CENTURY TURNED TO A WIDE ARRAY OF **DRAWING TOOLS.**

HERE ARE SOME OF THE **CLASSICS.**

SWING-ARM LAMP WITH INCANDESCENT AND FLUORESCENT BULBS. ADJUSTABLE TO ANY POSITION.

DRAFTING TABLE. ADJUSTABLE HEIGHT AND ANGLE.

BRISTOL BOARD 2-PLY (THICK) DRAWING PAPER.

T-SQUARE.

TRIANGLE.

ERASERS, SCISSORS, TAPE, KNIVES, ETC.

STRAIGHT-EDGE RULER.

PENS, PENCILS, BRUSHES AND MARKERS.

DRAFTING CHAIR. ADJUSTABLE HEIGHT.

BLACK INK & WHITE FOR CORRECTIONS.

TOOL TRAY. I REALLY LIKE TH ATTACHABLE SI TRAY.

YOU'LL NOTICE THAT THE DRAFTING TABLE IS A BIT **HIGH.** THAT MAKES IT ACCESSIBLE WHETHER YOU'RE **SEATED** IN THE SLIGHTLY HIGH DRAFTING CHAIR OR **STANDING.**

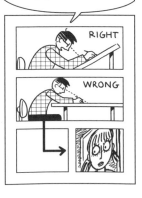

THE **TILT** PREVENTS **BACK STRAIN** AND ALLOWS YOU TO LOOK **STRAIGHT DOWN** AT THE PAGE TO AVOID DISTORTIONS.

RIGHT

WRONG

THOUGH, IF YOU NEED A **LEVEL** SURFACE, IT CAN BE **ADJUSTED.**

WAAH!!

188

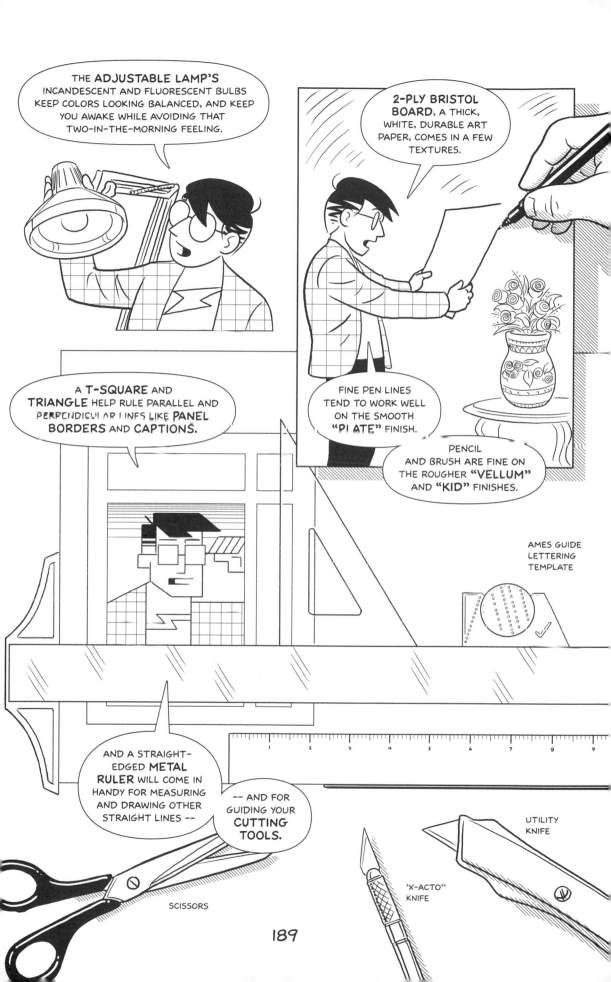

THE **ADJUSTABLE LAMP'S** INCANDESCENT AND FLUORESCENT BULBS KEEP COLORS LOOKING BALANCED, AND KEEP YOU AWAKE WHILE AVOIDING THAT TWO-IN-THE-MORNING FEELING.

2-PLY BRISTOL BOARD, A THICK, WHITE, DURABLE ART PAPER, COMES IN A FEW TEXTURES.

A **T-SQUARE** AND **TRIANGLE** HELP RULE PARALLEL AND PERPENDICULAR LINES LIKE **PANEL BORDERS** AND **CAPTIONS.**

FINE PEN LINES TEND TO WORK WELL ON THE SMOOTH "PLATE" FINISH.

PENCIL AND BRUSH ARE FINE ON THE ROUGHER **"VELLUM"** AND **"KID"** FINISHES.

AMES GUIDE LETTERING TEMPLATE

AND A STRAIGHT-EDGED **METAL RULER** WILL COME IN HANDY FOR MEASURING AND DRAWING OTHER STRAIGHT LINES --

-- AND FOR GUIDING YOUR **CUTTING TOOLS.**

UTILITY KNIFE

'X-ACTO" KNIFE

SCISSORS

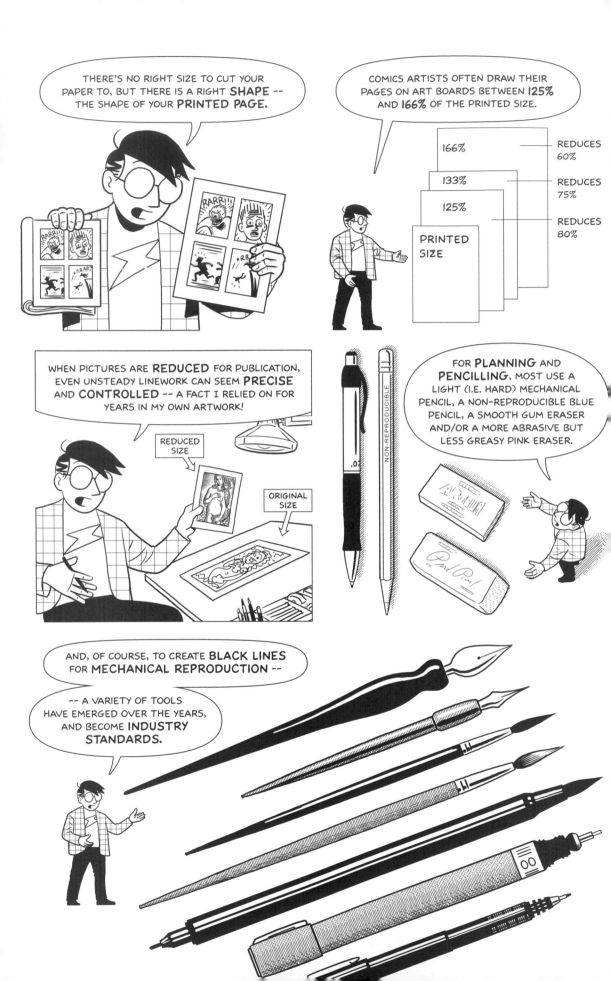

MOST ARTISTS FALL IN **LOVE** WITH ONE OR TWO DRAWING TOOLS EARLY ON, AND STAY HITCHED FOR LIFE.

IF YOU'RE JUST STARTING OUT, YOU MIGHT WANT TO TRY AS **MANY** TOOLS AS POSSIBLE, IN CASE YOUR **PERFECT MATCH** IS OUT THERE SOMEWHERE.

BLACK LINE ART IS A NARROW, SPECIALIZED CRAFT, BUT IT HAS A LOT OF **VARIABLES:**

LINE WIDTH.

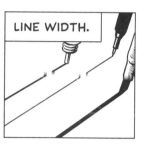

VARIATION.

AND THEN THERE'S **COST, PERMANENCE, EASE** OF USE, HOW A TOOL TAKES TO CERTAIN KINDS OF **PAPER**, ETC.

MOST OF THE CLASSIC DRAWING TOOLS HAVE **EXCELLED** AT ONE OR MORE OF THESE QUALITIES OVER TIME.

PRECISION.

CHARACTER.

SABLE BRUSHES, FOR EXAMPLE, HAVE ALWAYS DELIVERED SMOOTH, CONSISTENT VARIABLE WIDTH LINES, AND ARTISTS FROM SEVERAL GENERATIONS HAVE SWORN BY THEM.

SABLES ARE GREAT AT WHAT THEY DO, BUT THEY COST A **BUNDLE,** DEMAND A LOT OF **LOVE** AND **CARE,** AND CAN ONLY BE USED WITH OPEN BOTTLES OF **INK** AND **WATER** NEARBY --

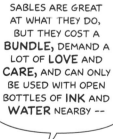

-- LEADING SOME TO SEEK **EASIER TO USE, CHEAPER** AND/OR MORE **PORTABLE** ALTERNATIVES.

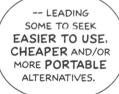

PEN BRUSHES WITH **FELT TIPS** OR THEIR OWN BUILT-IN **INK SUPPLY** HAVE BEEN CATCHING ON FOR THESE REASONS, THOUGH THEY DO HAVE **DETRACTORS.**

SOME FEEL THEIR LINE QUALITY AND VARIATION **PALES** COMPARED TO THE SABLES AND OTHER TRADITIONAL BRUSHES.

BLECH!!

AND OF COURSE, DISPOSABLES CAN COST **MORE** IN THE **LONG RUN.**

BUT LIKE **ANY** TECHNOLOGY, THESE BRUSH ALTERNATIVES CONTINUE TO **EVOLVE,** SO KEEP AN EYE OUT.

NIB PENS -- SOLD WITH A HOLDER AND ASSORTED REMOVABLE NIBS -- PROVIDE **LINE WIDTH VARIATION** LIKE A BRUSH, BUT USUALLY WITHIN A MORE NARROWLY-CONTROLLED RANGE (DEPENDING ON THE NIB). IN EXCHANGE, THEY OFFER **INCREASED AGILITY** WITHIN SMALL AREAS.

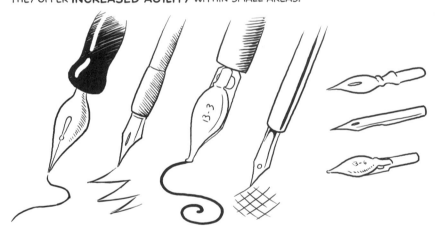

SOME NIB TYPES, LIKE THE VENERABLE **CROW-QUILL*** CAN BE EVEN TRICKIER TO USE AND CARE FOR THAN THE SABLE BRUSHES --

-- BUT FOR MANY, THEIR **PRECISE,** YET UNMISTAKABLY **HAND-DRAWN** LOOK IS INVALUABLE.

FIXED-WIDTH OR **TECHNICAL PENS** PROVIDE THE HIGHEST LEVEL OF **PRECISION** BY ELIMINATING LINE VARIATION ENTIRELY AND GUARANTEEING A SMOOTH CONSISTENT **LINE WIDTH.**

* MADE OF METAL, OF COURSE, BUT DESCENDED FROM ITS NAMESAKE SHOWN HERE.

192

DESCENDED FROM **FOUNTAIN PENS,** THE CLASSIC TECHNICAL PENS COME WITH AN **INK RESERVOIR** INSIDE THEM, ELIMINATING THE NEED FOR DIPPING INK.

LIKE FINE BRUSHES AND NIB PENS, SUCH PENS ARE A CHORE TO CLEAN AND MAINTAIN --

-- BUT THE TECHNICAL PENS' VIRTUES AREN'T PARTICULARLY **SUBTLE,** SO A GREATER NUMBER OF ARTISTS HAVE BEEN WILLING TO SWITCH TO FIXED-WIDTH **MARKERS** WITH (SUPPOSEDLY) PERMANENT INKS AND SAVE THEMSELVES THE HASSLE.

SPEAKING OF INKS, YOU MAY WANT TO **EXPERIMENT.** CERTAIN **TOOLS** WORK BEST WITH CERTAIN **INKS.**

THINNER INKS ARE LESS LIKELY TO CLOG YOUR BRUSH OR PEN, BUT **DENSER** INKS CAN DELIVER A MORE SATISFYINGLY DARK LINE. TRY **MIXING** TO FIND A BALANCE YOU LIKE.

ALSO USEFUL: OPAQUE WHITE PAINT FOR CORRECTIONS.

FOR SOLID BLACK LINES, THESE ARE THE THREE MOST COMMON KINDS OF TOOLS:

BRUSH
BROAD LINE VARIATION

NIB PEN
NARROWER LINE VARIATION

TECHNICAL PEN
FIXED WIDTH

APART FROM THE OCCASIONAL **DRY-BRUSH** OR **TONAL** EFFECT, MOST TWENTIETH CENTURY COMICS WERE BUILT AROUND SOLID BLACK LINES PRODUCED BY TOOLS LIKE THESE --

-- EVEN WHEN THOSE LINES WERE FILLED WITH THE **COLORS** OF MECHANICAL REPRODUCTION --

-- AND IT'S THAT SAME SENSIBILITY THAT INFORMS MANY ARTISTS' STYLES, EVEN **TODAY.**

193

GENERALLY SPEAKING, **BRUSH WORK** TENDS TO NUDGE ONE'S ARTWORK IN A MORE **FLOWING, RHYTHMIC** AND SOMETIMES **"SLICK"** DIRECTION.

NIB PEN WORK CAN BE QUITE SMOOTH, BUT MORE OFTEN TENDS TOWARD A **DRY,** SLIGHTLY **EDGY, BRITTLE** LOOK.

FIXED-WIDTH PEN ART, WHETHER THROUGH TECHNICAL PENS OR MARKERS, TENDS TO BE A BIT **SCHEMATIC** AND **COOL,** THOUGH WHEN USED TO REPRESENT **TONE** THROUGH **STIPPLING** AND **CROSS-HATCHING** IT CAN **WARM UP** A LOT.

BRUSH ART BY CRAIG THOMPSON, MARJANE SATRAPI, JESSICA ABEL, HOPE LARSON, CHARLES BURNS AND SPIKE. NIB PEN ART BY ROBERT CRUMB, JIM RUGG, TOM HART, DAVE COOPER, JUNE KIM AND MEGAN KELSO.

FIXED-WIDTH PEN ART BY RICK GEARY, JOOST SWARTE, JASON SHIGA, HOWARD CRUSE, KRIS DRESEN AND TOC FETCH (SEE ART CREDITS, PAGE 258).

MANY POPULAR COMICS OVER THE YEARS HAVE USED ALL **THREE** FAMILIES OF TOOLS, PLAYING TO EACH ONE'S **STRENGTHS.**

WITH **BRUSH** HANDLING MOST **OUTLINES** --

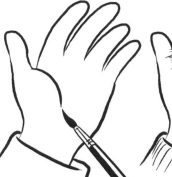

-- **NIB PEN** HITTING MANY OF THE **DETAILS** --

-- AND SOME **TECHNICAL PEN** ON **BORDERS, WORD BALLOONS** OR ADDITIONAL DETAIL WORK.

THE **TRADITIONAL** METHOD FOR LETTERING WAS TO MAKE A SERIES OF LIGHT GUIDELINES AND HAND LETTERING IN **ALL CAPS** WITHIN THEM

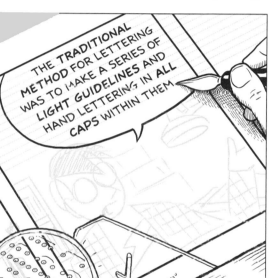

A **T-SQUARE** WAS USED TO KEEP THE GUIDELINES PARALLEL --

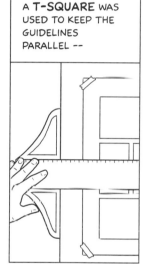

-- AND A LITTLE TEMPLATE CALLED AN **"AMES GUIDE"** SLID BACK AND FORTH AS A PENCIL WAS PLACED IN A SUCCESSION OF HOLES TO PRODUCE AS MANY GUIDELINES AS NEEDED.

THE IDEA WAS THAT EACH ROW OF LETTERS NEEDED TO BE THE SAME HEIGHT WHILE THE SPACE BETWEEN THOSE LINES COULD BE A BIT NARROWER.

LIKE SO:

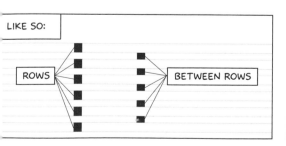

ROWS

BETWEEN ROWS

MANY CARTOONISTS TODAY USE A **FONT** OR JUST LETTER **FREEHAND,** BUT YOU CAN STILL FIND LOYAL USERS OF THE AMES GUIDE SYSTEM AND THEIR WORK CAN BE BOTH **CONSISTENT** AND **ATTRACTIVE.**

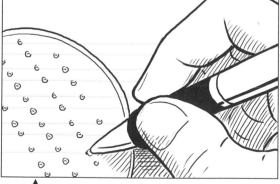

└─ BY ROTATING THE WHEEL, THE SPACES BETWEEN LINES COULD BE INCREASED OR DECREASED PROPORTIONATELY.

A FULLY-STOCKED SET-UP LIKE THIS CAN COST **HUNDREDS OF DOLLARS**, BUT IF YOU WANT TO GO THE TRADITIONAL ROUTE, IT COULD BE **WORTH IT.**

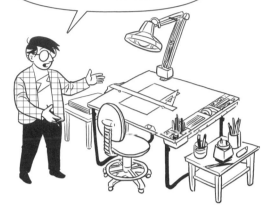

ARTISTS HAVE BEEN MASTERING THESE TOOLS FOR **CENTURIES** --

-- AND THERE'S A RICH **TRADITION** TO DRAW FROM.

A GOOD PAGE OF **ORIGINAL ART** CAN BE AN OBJECT OF TANGIBLE **BEAUTY** AND LASTING **VALUE.**

AND THERE'S NOTHING QUITE LIKE THE RIGHT **PEN** OR **BRUSH** GLIDING ACROSS A NEWLY CUT PIECE OF **BRISTOL BOARD.**

...

AS FOR ME, I HAVEN'T USED ONE IN OVER **TEN YEARS.**

THIS BOOK WAS DRAWN AND LETTERED **DIGITALLY.**

I SKETCHED THE **LAYOUTS** HERE ON MY OLD **DRAWING DESK**, BUT THAT'S IT.

ALL OF THIS FINISHED ART WAS DONE ON THAT **MAC** OVER THERE.

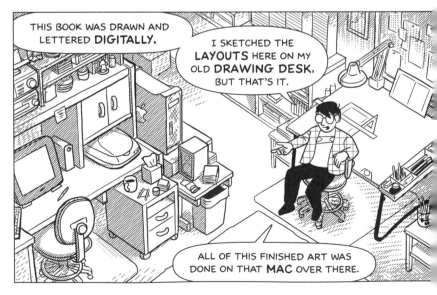

PANEL THREE: ART BY CHARLES DANA GIBSON (1899) (SEE ART CREDITS, PAGE 258).

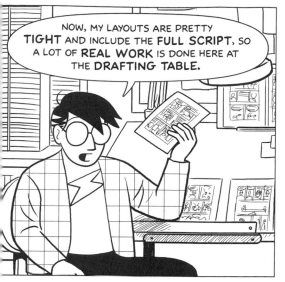

NOW, MY LAYOUTS ARE PRETTY **TIGHT** AND INCLUDE THE **FULL SCRIPT**, SO A LOT OF **REAL WORK** IS DONE HERE AT THE **DRAFTING TABLE.**

BUT THEN, THOSE LAYOUTS ARE **SCANNED IN**, AND USED AS A GUIDE FOR **LETTERING** EACH PAGE IN ADOBE ILLUSTRATOR, AN OBJECT-ORIENTED DRAWING PROGRAM.

...AND INCLUDE THE FULL SCRIPT SO OF **REAL WORK** IS DONE HERE AT THE **DRAFTING TABLE.**

I **EXPORT** THE LETTERING TO PHOTOSHOP AS A SOLID WHITE GRID WITH THE PANELS **PUNCHED OUT** TO FORM **WINDOWS** FOR THE ART TO SHOW THROUGH.*

LIKE THIS!

THEN, WITH THE LETTERING ON **TOP** AND MY SKETCHED LAYOUTS ON THE **BOTTOM**, I CREATE FIVE TO FIFTY LAYERS OF **FINISHED ART** BETWEEN THEM; ALL IN PHOTOSHOP AT **1200 DOTS PER INCH** --

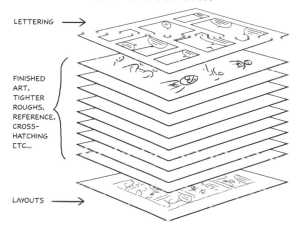

LETTERING →

FINISHED ART, TIGHTER ROUGHS, REFERENCE, CROSS-HATCHING ETC...

LAYOUTS →

-- AND ALL DRAWN WITH A STYLUS DIRECTLY ON THE SCREEN OF AN **18"** TABLET/MONITOR.

AFTER CORRECTIONS, EACH PAGE IS THEN **FLATTENED** TO A SINGLE BLACK AND WHITE **BITMAP**, PLUS A **GRAYSCALE** PAGE IF NEEDED.**

ALL IN ALL, A RADICALLY DIFFERENT WORKING METHOD FROM MY **PEN** AND **BRUSH** DAYS.

BUT BECAUSE THE END RESULT IS A **PRINTED BOOK** FILLED WITH **LINE ART**, MANY OF THE **BASIC PRINCIPLES** OF DRAWING THIS WAY ARE THE SAME.

*THAT PUNCHED OUT PAGE ISN'T REAL, MIND YOU. I'M JUST SHOWING HOW IT WORKS IN SOFTWARE. THERE'S NO ACTUAL, PHYSICAL PAGE AT THIS POINT.

** I'LL POST A MORE DETAILED STEP-BY-STEP AT WWW.SCOTTMCCLOUD.COM/MAKINGCOMICS.

ONE OF THE **BASIC GOALS** OF LINE ART IS TO MAKE ALL THE DETAILS OF A SCENE **CLEAR AT A GLANCE** WITHOUT OVERWHELMING THE EYE.

WHATEVER TOOLS YOU USE, A GOOD WAY TO **ACHIEVE** THAT CLARITY IS TO DRAW **THICKER LINES** AROUND THE **EDGES** OF YOUR SUBJECTS --

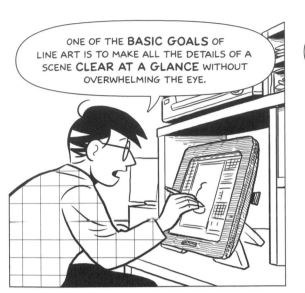

-- AND TO USE **FINER LINES** FOR **INTERIOR** DETAILS AND FOR **OVERLAPPED** OR MORE **DISTANT** SUBJECTS.

IT'S A SIMPLE TECHNIQUE, BUT ONE WHICH CAN TRANSFORM AN UNINTELLIGIBLE JUMBLE OF LINES INTO A SCENE WITH **FORM** AND **DEPTH**.

PEN AND BRUSH ARTISTS GET THAT EFFECT BY **SWITCHING** FROM ONE TOOL TO ANOTHER, OR BY USING A SINGLE TOOL'S ABILITY TO **VARY** LINE THICKNESS.

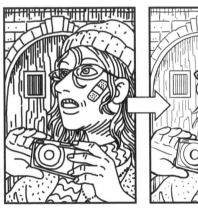

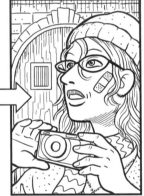

DIGITAL ARTISTS GOING FOR THE SAME EFFECT CAN SWITCH BETWEEN "PENS," "BRUSHES" AND OTHER **VIRTUAL TOOLS** WITH SPECIFIC VARIATIONS AND LINE CHARACTERS BUILT-IN, USING VARIOUS DRAWING AND PAINTING PROGRAMS.

WHEN DRAWING A **CLOSE-UP** LIKE THIS, FOR EXAMPLE, I USED A **28-PIXEL,** VARIABLE WIDTH BRUSH IN PHOTOSHOP.*

WHILE, FOR **DISTANT** FIGURES LIKE THIS, I SWITCHED TO A **14-PIXEL** WIDTH.

* WORKING AT 1200 DOTS PER INCH.

198

I USED A THIN **FIXED-WIDTH** LINE TOOL FOR THE CHECKS --

-- AND A MORE NARROWLY VARIABLE, PEN-LIKE **6-PIXEL** BRUSH FOR SOME DETAIL WORK.

THE TOOL IN MY **DRAWING HAND** NEVER CHANGED --

-- BUT MY **OTHER** HAND SWITCHED FROM TOOL TO TOOL WITH A SERIES OF PRE-PROGRAMMED **FUNCTION KEYS**.

MOST OF WHAT YOU SEE HERE IS DRAWN **FREE-HAND**, NOTHING FANCY, BUT DOING IT DIGITALLY HAS HELPED ME A LOT.

NO MATTER HOW SMALL A GIVEN DETAIL IS, FOR EXAMPLE, I CAN ALWAYS FILL THE SCREEN WITH IT, INCREASING **PRECISION** WITHOUT LEADING TO **HAND-STRAIN.**

ALSO, CREATING **PATTERN-BASED STAMPS** AND **BRUSHES** CAN SPEED UP SOME OF TRADITIONAL DRAWING'S MORE TEDIOUS AND REPETITIVE TASKS.

AND THE **RESIZING** AND **REPOSITIONING** OF DIFFERENT ELEMENTS ON DOZENS OF SEPARATE LAYERS HAS ALLOWED ME TO **FINE-TUNE** MY ART LIKE CRAZY.

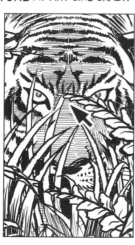

IF YOU WANT TO DIGITALLY CREATE **LINE-ART** FOR **PRINT**, THESE ARE A FEW OF YOUR **OPTIONS.**

IF YOU WANT TO CREATE **TONAL** OR **COLOR** ARTWORK -- ESPECIALLY FOR THE **SCREEN**, AS WITH WEBCOMICS -- YOU'LL HAVE ABOUT **A THOUSAND MORE.**

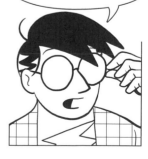

FROM AN ART-CREATION STANDPOINT, THE MOST BASIC DIFFERENCE BETWEEN **PAGE** AND **SCREEN** IS THAT ONE REPRESENTS TONE THROUGH **LINES AND DOTS**, WHILE THE OTHER CAN DISPLAY A **FULL RANGE** OF **TONES** IN EACH **PIXEL**.

AND FOR **WEBCOMICS** ARTISTS, THERE'S NO EXTRA EXPENSE TO USING A FULL RANGE OF **COLORS** (OTHER THAN BIGGER FILE SIZES*)

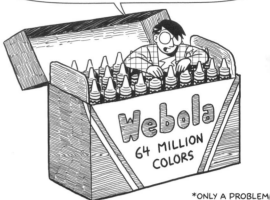

*ONLY A PROBLEM IF YOU GET POPULAR ENOUGH TO WORRY ABOUT BANDWIDTH CHARGES.

THE WEB HAS BECOME A MASSIVE **LABORATORY** FOR **NEW TECHNIQUES**, THANKS TO THE THOUSANDS OF CARTOONISTS MAKING WEBCOMICS EVERY DAY IN DOZENS OF GENRES.

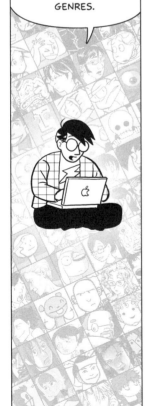

THE COLOR-FILLED, ALL-BLACK, FINE-FEATHERED LINE WORK OF TRADITIONAL **PRINTED COMIC BOOKS** CAN STILL BE SEEN IN PLACES --

NEAR BORDERLESS **COLOR SHAPES** --

-- BUT JOINING IT ARE **COLORED OUTLINES** --

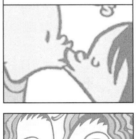

-- ALL OUT **3-D** --

-- **BOLDER, STREAMLINED LINEWORK** --

-- AND EVEN DELIBERATELY **PIXELATED CONTOURS.**

PANEL THREE: SEE ART CREDITS, PAGE 258.

200

PANEL FOUR ONWARD: ART BY STEVE BRYANT, JAMES KOCHALKA, CAT GARZA, SCOTT KURTZ, MIKE KRAHULIK, JOHN ALLISON, DOROTHY GAMBRELL, JOE ZABEL, PATRICK FARLEY, BRIAN CLEVINGER AND R. STEVENS (SEE PAGE 258 FOR MORE INFO).

WEB CARTOONISTS HAVE ALSO TINKERED WITH VARIOUS **DEPTH CUES** NOT OFTEN FOUND IN PRINTED COMICS --

-- SUCH AS **BLURRED** OR **BORDERLESS** BACKGROUNDS --

-- **FADING CONTOURS** --

-- OR **ATMOSPHERIC EFFECTS.**

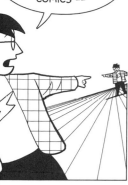

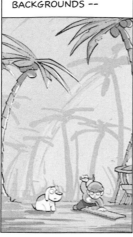

ARTISTS USED TO WORKING WITH **TRADITIONAL MEDIA** HAVE EXPERIMENTED WITH SCANNING STRAIGHT FROM **PENCILS** TO **COLOR,** OR USING ANY NUMBER OF **COLOR TOOLS** --

-- WHILE NATIVE **DIGITAL** ARTISTS HAVE PUSHED THE LIMITS OF **VECTOR STYLIZATION** AND OTHER FORMS OF DIGITAL ART.

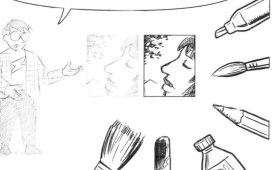

THE CHANGE FROM **PRINT** TO **SCREEN** HAS ALSO RAISED FUNDAMENTAL QUESTIONS ABOUT HOW COMICS ARE **READ.**

THIS IS WHERE WEBCOMICS RUN INTO SOME OF THE **NAVIGATIONAL** ISSUES I TALKED ABOUT IN *REINVENTING COMICS,* AND WHICH I CAN PROBABLY BETTER DESCRIBE **ONLINE** --

-- SO, FOR SOME IDEAS ON THIS AND OTHER TOPICS RELATED TO TECHNOLOGY, GO TO SCOTTMCCLOUD.COM/MAKINGCOMICS AND LOOK FOR THIS BUTTON:

CHAPTER
5 ½

PANEL TWO-FOUR AND SIX: ART BY KAZU KIBUISHI, DREW WEING, JUSTINE SHAW AND DEMIAN 5 (SEE ART CREDITS, PAGE 258).

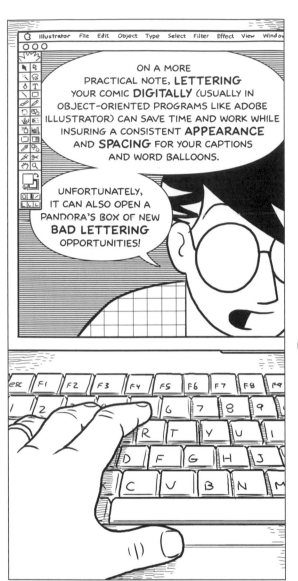

ON A MORE PRACTICAL NOTE, **LETTERING** YOUR COMIC **DIGITALLY** (USUALLY IN OBJECT-ORIENTED PROGRAMS LIKE ADOBE ILLUSTRATOR) CAN SAVE TIME AND WORK WHILE INSURING A CONSISTENT **APPEARANCE** AND **SPACING** FOR YOUR CAPTIONS AND WORD BALLOONS.

UNFORTUNATELY, IT CAN ALSO OPEN A PANDORA'S BOX OF NEW **BAD LETTERING** OPPORTUNITIES!

Including difficult to read --

-- AND SIZES --

-- **FONT CHOICES** --

-- AND VARIOUS BALLOON SHAPE OR WORD PLACEMENT PROBLEMS.

NOW, E x P e R I M E n T, BY ALL MEANS! HAVE **FUN!** TRY EVERY FONT IN THE UNIVERSE!

BUT ALSO BE AWARE OF THE **REASONS** THAT TRADITIONAL HAND LETTERING EVOLVED THE WAY IT DID, AND HOW THOSE PRINCIPLES MAY APPLY TO **YOU.**

FIRST, THERE'S A TRADITION AMONG CARTOONISTS TO USE **SANS SERIF** FONTS FOR BALLOON LETTERING. THIS MIGHT JUST BE A **HABIT** INHERITED FROM EFFICIENCY-MINDED **HAND LETTERERS** --

-- BUT IT MIGHT ALSO BE BECAUSE SIMPLER STROKES IN LETTERING MORE CLOSELY RESEMBLE THE LINE WORK OF THE DRAWINGS THAT **SURROUND** THEM.

SERIF: A SANS SERIF: A

("SANS" = "WITHOUT" IN FRENCH)

It's harder to imagine letters like **these** drawn by the same hand that drew the hand below, for example:

MANY CARTOONISTS, INCLUDING YOURS TRULY, HAVE HAD FONTS MADE OF THEIR OWN HAND-WRITING FOR THIS REASON.*

* THIS FONT WAS ADAPTED FROM MINE BY JOHN ROSHELL OF COMICRAFT AND IS AVAILABLE AT WWW.COMICBOOKFONTS.COM.

HAND-DRAWN FONTS ALSO INSURE THAT THE OCCASIONAL, HAND-LETTERED *EFFECT* WON'T LOOK TOO OUT OF PLACE.

SOME CARTOONISTS CHOOSE THEIR FONTS FROM VARIOUS COMICS-STYLE **FONT PACKAGES** AVAILABLE ONLINE.

AS FOR **BALLOONS**, THERE ARE PLENTY OF **STYLES** AND **SHAPES** TO CHOOSE FROM. ONCE AGAIN, THERE'S NO "RIGHT" WAY TO DO IT, BUT I DO HAVE A COUPLE OF **GENERAL** SUGGESTIONS:

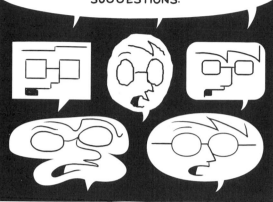

[F]IRST, ALWAYS GIVE A [L]ITTLE **WHITE** [S]PACE BETWEEN [Y]OUR WORDS AND THE [B]ALLOON BORDERS, TO [L]ET BALLOONS AND [A]RT BREATHE A BIT.

ALSO, IF YOU'RE GOING FOR THE CLASSIC **OVAL** BALLOON SHAPE, MAKE SURE THE WORDS FILL THE SPACE COMFORTABLY AND TRY **SQUASHING** THE OVAL A BIT ON ALL FOUR SIDES TO "SQUARE" IT.

UN-SQUASHED OVALS LIKE THIS LEAVE A LOT OF **WASTED SPACE** ON EITHER END, ESPECIALLY WHEN COMBINED WITH A RECTANGULAR **TEXT BOX** LIKE THIS ONE.

THIS IS A BIG SUBJECT OF COURSE. CHECK THIS CHAPTER'S **NOTES PAGE** FOR POINTERS TO AN ONLINE TUTORIAL AND OTHER RESOURCES.

THE LINE **BETWEEN** TRADITIONAL AND DIGITAL METHODS ISN'T ALWAYS CLEAR.

TODAY, PLENTY OF **WEBCOMICS** FEATURE INK AND PAPER DRAWINGS, WHILE PLENTY OF **PRINTED** COMICS ARE DRAWN **DIGITALLY!**

BUT WHEN IT COMES TO GETTING **STARTED** IN COMICS, ONE DIFFERENCE BETWEEN **DIGITAL** AND **ANALOG** STILL LOOMS LARGE:

PRICE.

GETTING A FULL SUITE OF HARDWARE AND SOFTWARE CAN COST THOUSANDS, BUT DEPENDING ON WHAT YOU WANT OUT OF IT, YOU MIGHT GET AWAY WITH SPENDING A LOT **LESS.**

FOR EXAMPLE, IF ALL YOU NEED TO DO IS **SCAN** AND **UPLOAD** SOME HAND-DRAWN COMIC STRIPS TO A FRIEND'S WEBSITE, AN 8-YEAR-OLD **USED LAPTOP** AND **CHEAP SCANNER** MIGHT BE ALL YOU'LL NEED.

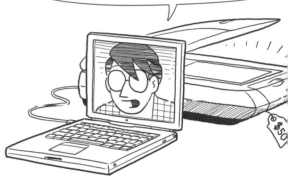

STILL, IF YOU WANT TO CREATE MORE AMBITIOUS **ORIGINAL DIGITAL ART,** EITHER FOR PRINT OR THE WEB, YOU MIGHT NEED TO SPEND A BIT **MORE.**

COMPUTERS THAT PLAY NICE WITH **GRAPHICS PROGRAMS** TEND TO HAVE EXTRA **MEMORY** INSTALLED AND RUN **FAST.**

THOSE OF US WHO PREFER **MACS** -- COMMON AMONG GRAPHIC ARTISTS -- ARE ESPECIALLY VULNERABLE, SINCE THESE BABIES AIN'T CHEAP!

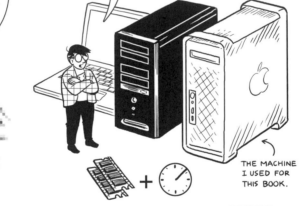

THE MACHINE I USED FOR THIS BOOK.

YOU'LL WANT A **BIG, SHARP MONITOR** IF YOU REALLY PLAN TO STARE AT IT ALL DAY -- OR JUDGE YOUR COLORS BY IT.

HARDLY ANY OF US DRAW WITH A MOUSE, BUT INSTEAD USE SOME FORM OF **GRAPHICS TABLET.**

A **TABLET/MONITOR** THAT ALLOWS YOU TO DRAW DIRECTLY ON THE SCREEN IS ESPECIALLY GOOD -- BUT THEY'RE ALSO ESPECIALLY **EXPENSIVE.** SEE THE CHAPTER NOTES FOR MORE INFO.

GETTING THE PREMIERE **PAINTING, DRAWING** AND **WEB AUTHORING** PROGRAMS CAN ADD A LOT TO YOUR SHOPPING LIST'S **BOTTOM LINE.**

ADD IN A DECENT **DESK** AND **CHAIR, WEB ACCESS,** VARIOUS **PERIPHERALS,** A **PRINTER, INK, SCANNER** AND A **BACK-UP DRIVE** OR **DVD BURNER,** AND YOU CAN IMAGINE HOW IT ADDS UP.

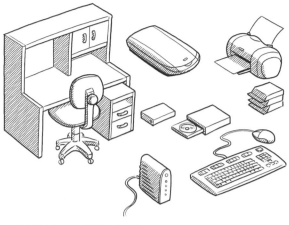

THAT SAID, YOU MAY ALREADY HAVE A COMPUTER IN THE HOUSE AND THERE ARE LOW COST **SOFTWARE ALTERNATIVES** OUT THERE.

ALSO, **PUBLISHING** YOUR WORK ONLINE CAN BE A LOT CHEAPER THAN TRADITIONAL PRINTING AND DISTRIBUTING --

CLICK!

-- AND THE CHANCES OF TECHNOLOGY CLOSING THE PRICE GAP IN THE NEAR FUTURE WITH **AFFORDABLE ALL-IN-ONE WIRELESS GADGETS** LOOKS MORE LIKELY THAN EVER.

FOR NOW, THOUGH, THESE ARE THE **TWO ALTERNATIVES** MOST COMICS ARTISTS CHOOSE FROM, WITH STRONG ADVOCATES FOR EACH, AND A GROWING NUMBER OF ARTISTS COMFORTABLE WITH **BOTH.**

ONE OF THEM BOASTS TOOLS AND TECHNIQUES THAT HAVE BEEN **MASTERED** AND **REFINED** FOR **CENTURIES.** ONE IS **CHANGING** AND **GROWING** BY THE **DAY.**

FOR ARTISTS WORKING IN **PRINT** COMICS, THE SUBJECT OF TOOLS AND TECHNIQUES USUALLY ENDS WHEN THE FINISHED ARTWORK IS SENT OFF TO A **PUBLISHER.**

IN THE **SMALL PRESS** AND **MINI-COMICS** SCENE, PUBLISHING IS A BIT MORE **HANDS-ON,** BUT FOR MOST INK AND PAPER CARTOONISTS --

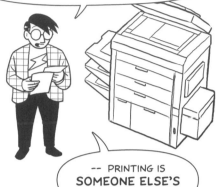

-- PRINTING IS **SOMEONE ELSE'S** JOB.

NOT TRUE ON THE **WEB,** WHERE SELF-PUBLISHING ISN'T JUST PRACTICAL -- IT'S **THE NORM.**

CREATING **WEBPAGES** HAS GOTTEN EASIER IN RECENT YEARS, THANKS TO VARIOUS OFF-THE-SHELF PROGRAMS --

TAP TAP

-- AND THERE ARE ANY NUMBER OF HELPFUL **GUIDES** TO WEB PUBLISHING* --

-- BUT THE BASIC CHALLENGE OF PUTTING COMICS ON THE WEB ISN'T REALLY A **TECHNICAL** ONE.

TELL YOUR STORIES **CLEARLY** AND **EFFECTIVELY,** DESIGN YOUR SITES WITH THE **READING EXPERIENCE** IN MIND --

-- AND EVERYTHING ELSE IS JUST **CONNECTING THE DOTS.**

* SEE CHAPTER NOTES.

206

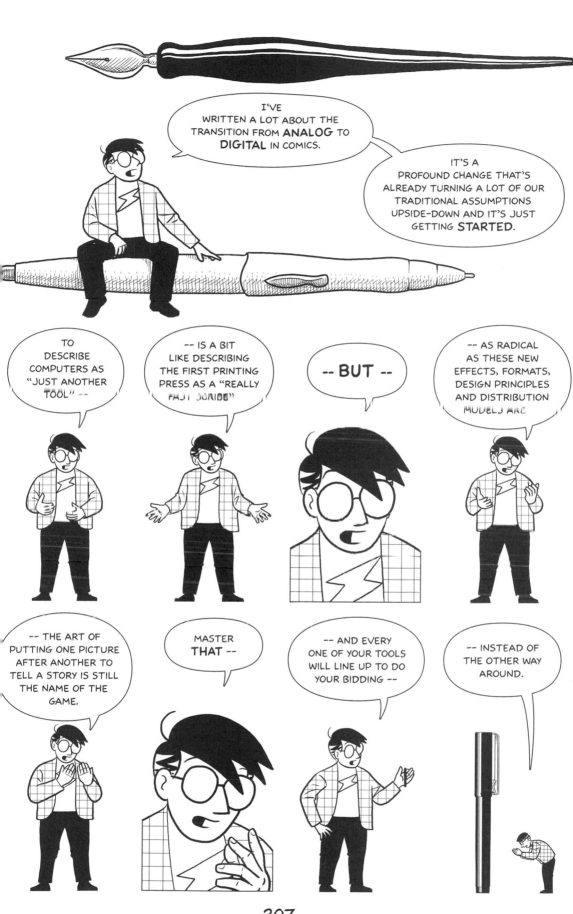

I'VE WRITTEN A LOT ABOUT THE TRANSITION FROM **ANALOG** TO **DIGITAL** IN COMICS.

IT'S A PROFOUND CHANGE THAT'S ALREADY TURNING A LOT OF OUR TRADITIONAL ASSUMPTIONS UPSIDE-DOWN AND IT'S JUST GETTING **STARTED**.

TO DESCRIBE COMPUTERS AS "JUST ANOTHER TOOL" --

-- IS A BIT LIKE DESCRIBING THE FIRST PRINTING PRESS AS A "REALLY FAST SCRIBE" --

-- BUT --

-- AS RADICAL AS THESE NEW EFFECTS, FORMATS, DESIGN PRINCIPLES AND DISTRIBUTION MODELS ARE --

-- THE ART OF PUTTING ONE PICTURE AFTER ANOTHER TO TELL A STORY IS STILL THE NAME OF THE GAME.

MASTER **THAT** --

-- AND EVERY ONE OF YOUR TOOLS WILL LINE UP TO DO YOUR BIDDING --

-- INSTEAD OF THE OTHER WAY AROUND.

NOTES

CHAPTER 5: TOOLS, TECHNIQUES AND TECHNOLOGY

GENERAL NOTES

SINCE I'VE BEEN DRAWING DIGITALLY FOR A WHILE, I PUT OUT THE CALL TO PEOPLE IN MY ADDRESS BOOK WHO STILL GET INK ON THEIR FINGERS TO SEE WHAT THEY WERE USING. SPECIAL THANKS TO THOSE WHO RESPONDED, INCLUDING:

JESSICA ABEL	DEREK KIRK KIM
BRENT ANDERSON	HOPE LARSON
STEVE BISSETTE	DAVID LASKY
LEELA CORMAN	JASON LITTLE
MARK CRILLEY	MATT MADDEN
HOWARD CRUSE	JENN MANLEY LEE
TED DEWAN	CARLA SPEED MCNEIL
KRIS DRESEN	JOSH NEUFELD
TOC FETCH	AL NICKERSON
MARY FLEENER	HENRIK REHR
SHAENON GARRITY	PAULO RIVERA
PIA GUERRA	STEVE RUDE
TOM HART	JUSTINE SHAW
DYLAN HORROCKS	PAUL SMITH
R. KIKUO JOHNSON	SPIKE
MEGAN KELSO	DREW WEING
KAZU KIBUISHI	GENE YANG
JUNE KIM	

IT'S A QUIRKY, SLIGHTLY RANDOM LIST, BUT IT GAVE ME A SENSE OF SOME OF THE TRENDS OUT THERE. THEIR RESPONSES WERE ESPECIALLY HELPFUL IN PUTTING TOGETHER PAGE 194 (MATCHING SPECIFIC TOOLS TO DRAWINGS) BUT I USED THEIR INFORMATION THROUGHOUT THE CHAPTER.

PAGE 185, PANEL SEVEN - THAT TWO DOLLAR PEN

IF ANYONE IS CURIOUS, IT WAS A PILOT PRECISE "V7" ROLLING BALL, AND YES, I LITERALLY BOUGHT IT AT LUNCH, DID MY SKETCH, AND DROVE OVER TO PAUL SMITH'S APARTMENT TO GET A SKETCH WITH THE SAME PEN. I THINK IT WAS ACTUALLY $1.99, SO WITH CALIFORNIA SALES TAX, THAT COMES TO $2.14. THE KIND OF PAPER I BOUGHT FOR THIS IS JUST ABOUT A PENNY A SHEET AFTER TAX, SO THE TOTAL COST WAS $2.15. IF THE PEN MADE IT TO TWENTY-FOUR PAGES, THAT WOULD BE AN ENTIRE COMIC DRAWN FOR $2.38 -- A FAR CRY FROM EVEN THE CHEAPEST OF DIGITAL TOOLS.

PAGE 188-189 - MORE INFORMATION ON THE BASIC SET-UP

DESKS AND CHAIRS:

DRAFTING TABLES AND CHAIRS ARE A BIT ON THE HIGH SIDE, BUT THERE ARE LOWER VERSIONS OF EACH. MAKE SURE THAT WHATEVER TABLE AND CHAIR YOU GET MATCH IN HEIGHT, OR YOU'RE GOING TO BE MISERABLE. ALSO, RESEARCH WHICH CHAIRS SUPPORT YOUR LOWER BACK TO AVOID BACK PAIN (THIS IS TRUE FOR BOTH DRAWING AND COMPUTER SET-UPS). FYI: THE SIDE TRAY SHOULD BE ABOUT $30. I'VE FOUND AT LEAST TWO COMPANIES OFFERING TRAYS SIMILAR TO MINE. DEFINITELY WORTH IT.

LAMPS:

THE SWING-ARMED LUXO-LAMP PICTURED ON PAGE 189 WAS SO COMMON WHEN I STARTED OUT THAT WE CALLED ANY SWING-ARM LAMP A "LUXO." THE INCANDESCENT AND FLUORESCENT BULBS TOGETHER CAN REALLY MAKE A DIFFERENCE. INCANDESCENTS ALONE DON'T KEEP YOU AWAKE AS EFFICIENTLY AND FLUORESCENTS ALONE CAN BE KIND OF BLEAK, BUT THE TWO COMBINED APPROACH THE FREQUENCY OF SUNLIGHT WHICH CAN TRICK YOUR BODY INTO NOT NOTICING THAT YOU'VE BEEN DRAWING FOR 14 HOURS STRAIGHT. HALOGEN LAMPS PRODUCE A SIMILAR EFFECT WHEN NOT SETTING THE CURTAINS ON FIRE.

ART PAPER:

A FEW RESPONDENTS WHO USE STRATHMORE BRISTOL BOARD SAID THEY HAD TO SWITCH TO THE HIGHER QUALITY 400 SERIES RECENTLY WHEN THE PREVIOUSLY RELIABLE 300 SERIES TURNED CRAPPY. WHETHER YOU USE BRISTOL BOARD OR NOT, KEEP AN EYE OUT FOR MINIMAL BLEEDING OR SPREADING OF INK, ABSORPTION WITH MINIMAL FADING, THE ABILITY TO WITHSTAND ERASING, SMOOTHNESS FOR PENS, THICKNESS ENOUGH NOT TO TEAR OR GET DAMAGED EASILY AND THINNESS ENOUGH TO TRACE OVER WITH A LIGHTBOX (SEE BELOW).

T-SQUARE TIP:

A T-SQUARE CAN GET IN THE WAY WHEN YOU'RE NOT USING IT. I SUGGEST STICKING A COUPLE OF SCOTCH MOUNTING SQUARES ABOUT 4 INCHES FROM THE BACK EDGE OF THE DESK (ONE EACH NEAR THE LEFT AND RIGHT SIDES). THEN, WHEN YOU WANT TO STOW THE T-SQUARE WITHIN REACH BUT OUT OF THE WAY, YOU CAN JUST SLIDE IT UP PAST THE SQUARES TO REST.

WORK HABITS:

TAKE BREAKS! IF YOU DO A LOT OF DETAILED WORK (HAND LETTERING OR TYPING ESPECIALLY) YOU CAN GET SERIOUS HAND STRAIN WHICH, IF NOT TREATED, CAN LITERALLY CRIPPLE YOU FOR LIFE! AS SOON AS YOUR HANDS START FEELING SORE, BEGIN TAKING A FEW MINUTES OFF EVERY 20 MINUTES OR SO AND LOOK INTO GETTING A HAND BRACE OR SEEKING OTHER TREATMENTS. REMEMBER, YOUR HANDS ARE TOOL #2 (RIGHT AFTER YOUR BRAIN). TAKE GOOD CARE OF THEM.

OTHER TOOLS TO CONSIDER:

- A LIGHTBOX. A FLAT METAL BOX WITH LIGHTS INSIDE AND A TRANSLUCENT PLASTIC SURFACE. TURNS THICK DRAWING PAPER LIKE BRISTOL BOARD INTO TRACING PAPER THROUGH BACK-LIGHTING.
- AN ULTRASONIC CLEANER. A LITTLE VIBRATING TUB THAT CAN CLEAN TRADITIONAL TECHNICAL PEN PARTS (PAGE 193, PANEL 2), IN CASE YOU PLAN TO GO HARDCORE. THEY'RE PROBABLY AN ENDANGERED SPECIES, ALONG WITH THE PENS THEMSELVES, BUT I FOUND ONE ON THE WEB FOR $110 DOLLARS, SO THEY STILL EXIST AS OF THIS WRITING.
- A CUTTING MAT. A BIG, RUBBERY BOARD YOU CAN SLICE INTO REPEATEDLY WHILE CUTTING BRISTOL BOARD AND OTHER PAPER WITHOUT DAMAGING IT ("SELF-HEALING" AS ONE SITE PUT IT). YOU SHOULD BE ABLE TO FIND ONE FOR UNDER $20, BUT PRICES SEEM TO VARY A LOT. DEFINITELY USEFUL IF YOU PLAN TO USE AN X-ACTO OR UTILITY KNIFE OFTEN.
- A PROPORTION WHEEL. A CIRCULAR SLIDE RULE WITH A SERIES OF NUMBERS ALONG THE EDGES OF TWO CONCENTRIC PLASTIC DISKS INDICATING CORRESPONDING SIZES FOR REDUCTIONS AND ENLARGEMENTS. USEFUL FOR PLACING ON TOP OF GLASSES OR MUGS CONTAINING CARBONATED DRINKS TO KEEP THEM FROM GOING FLAT.

PAGE 190, PANELS ONE-THREE - REDUCING FOR PRINT

BEAR IN MIND, YOUR LINES WILL BE GETTING THINNER WHEN REDUCED FOR PRINT. IF TOO THIN, THEY MAY START BREAKING UP, SO PLAN AHEAD.

PAGE 190, PANEL FOUR - PENCIL PREFERENCES

MY RESPONDENTS SHOWED A LOT OF PASSION FOR SPECIFIC TOOLS, AND DISMAY WHEN ONE OR MORE TOOLS CHANGED OR WERE DISCONTINUED.

"I STRUGGLED FOR YEARS TO FIND THE PERFECT PENCIL," WRITES PIA GUERRA. WHEN PIA'S VENUS VELVET HB YELLOWS RAN OUT SHE COULDN'T FIND REPLACEMENTS ANYWHERE. "GOING ONLINE I LEARNED THERE WERE PEOPLE WHO COLLECTED PENCILS(!) AND THEY WERE FAMILIAR WITH THE VELVETS AND HOW GOOD THEY WERE AND WISHED ME LUCK IN FINDING AN EQUIVALENT SINCE THE COMPANY STOPPED MAKING THEM." EVENTUALLY, AFTER TRYING NEARLY EVERY ART PENCIL ON THE PLANET, PIA SETTLED ON MIRADO F 2.5 SCHOOL PENCILS AND STOCKED UP. "IF YOU FIND SOMETHING THAT WORKS, BUY LOTS OF IT," SHE SUGGESTS, A SENTIMENT THAT WAS ECHOED REPEAT-EDLY IN OTHER RESPONSES.

GETTING JUST THE RIGHT PENCIL IS ESPECIALLY IMPORTANT FOR THOSE WHO DO THEIR FINISHED LINE WORK WITH ONE, AS FOUR OF MY RESPONDENTS NOW

DO, THANKS TO TECHNOLOGICAL ADVANCES.

I JUST USE WHATEVER .7 MM MECHANICAL PENCIL HAS THE BEST GRIP, BUT I'M ONLY DOING LAYOUTS WITH IT BEFORE HEADING INTO DIGITAL FOR EVERYTHING ELSE. I AM LOYAL TO MY PINK PEARL ERASER, THOUGH. OTHER PINK ERASERS SEEM HARD AND GREASY TO ME.

NON-REPRODUCIBLE PENCILS SPARKED SOME LIVELY DISCUSSIONS. THESE ARE LIGHT-COLORED PENCILS THAT DON'T NEED TO BE ERASED AFTER INKING BECAUSE THEIR HUES DON'T SHOW UP IN PRE-PRESS PHOTOGRAPHY, PHOTOCOPYING OR EVEN SCANNING (AT LEAST IN THEORY). I CALL THEM "BLUE PENCILS" BECAUSE I'M FROM ANOTHER CENTURY, BUT THEY ACTUALLY COME IN A FEW COLORS THESE DAYS. THE MOST POPULAR SEEM TO BE THE SANFORD COL-ERASE, AND I'M TOLD THAT WHEN THEY WERE TEMPORARILY DISCONTINUED RECENTLY IT WAS LIKE THE ARAB OIL EMBARGO OF 1973.

SOME, LIKE JASON, HOPE AND JUSTINE, DO A SIGNIFI-CANT AMOUNT OF DETAILED WORK IN NON-REPRO PENCILS. OTHERS USE THEM ONLY FOR PREPARATORY SKETCHES BEFORE PENCILLING WITH GRAPHITE PENCILS. STILL OTHERS WON'T TOUCH 'EM AT ALL.

PAGE 191-192 - BRUSHES WITH GREATNESS

AFTER ALL THESE YEARS, THE KING OF BRUSHES STILL SEEMS TO BE THE VENERABLE WINDSOR-NEWTON SERIES #7 FINEST SABLE, WHICH USES ONLY "KOLINSKY" SABLE HAIRS, MADE EXCLUSIVELY FROM THE WINTER FUR OF THE MALE SABLE'S TAIL -- AND NO, I'M NOT MAKING THAT UP. THE #1-2 SIZES ARE THE MOST COMMON AMONG THOSE I TALKED TO, ALTHOUGH I HEARD FROM ARTISTS USING A #0 (VERY FINE) ALL THE WAY TO A #5 (BIG, BUT STILL CAPABLE OF FINE LINES -- IN FACT PAUL SMITH, WHO USES A #5, REPORTS AN IMPROVED FINE LINE WITH THE BIGGER BRUSH). PRICES VARY, BUT EACH SIZE NUMBER ADDS APPROXIMATELY $10 TO THE PRICE.

NOT ALL WINDSOR-NEWTON SABLES ARE GEMS. PAUL QUOTES ONE BRUSH CONNOISSEUR AS SAYING "WINDSOR-NEWTON MAKES THE FINEST BRUSH IN THE WORLD... EVERY ONCE IN A WHILE." TO FIND A GOOD ONE, PAUL SUGGESTS FLICKING A WET SABLE WITH YOUR WRIST RIGHT IN THE STORE (AFTER ABOUT FOUR MINUTES IN WATER, SOAKED UNTIL IT LOSES ITS SHAPE) TO SEE IF IT NATURALLY SNAPS TO A POINT. IF SO, THAT'S THE SHAPE IT WANTS TO TAKE AND YOU CAN PULL OUT YOUR CREDIT CARD. IF IT SPLITS, IT'S A CURSED EVIL IMPOSTER AND YOU SHOULD PUT IT BACK ON THE SHELF.

OTHER BRUSHES MENTIONED BY MY RESPONDENTS INCLUDE THE CHEAP, YELLOW LOEW-CORNELL #2 (ONCE USED, THOUGH NOT NECESSARILY ENDORSED, BY DREW WEING), THE ORANGE TIP RAPHAEL #4 SABLE BRUSH SERIES 8404 FAVORED BY JESSICA ABEL, AND WINDSOR-NEWTON'S SCEPTRE GOLD, A HALF-SABLE,

HALF-SYNTHETIC MIX WHICH IS CARLA SPEED MCNEIL'S WEAPON OF CHOICE.

ANY NATURAL BRUSH REQUIRES GREAT CARE. WASH OUT THE INK THOROUGHLY WHEN NOT IN USE. IT'S ONLY A MATTER OF TIME UNTIL A BRUSH LOSES ITS SHAPE, BUT WITH FREQUENT CLEANING, YOU CAN EXTEND ITS LIFE CONSIDERABLY. WILL EISNER SUGGESTED WAY BACK IN 1982 THAT I WRAP A PIECE OF PAPER TAPE A FEW MILLIMETERS ABOVE WHERE THE METAL MEETS THE HAIRS TO HELP THE BRUSH KEEP ITS SHAPE, AND THAT DEFINITELY HELPED. IN FACT, WHEN I WAS WORKING IN DC'S PRODUCTION DEPARTMENT THAT YEAR, BRIAN BOLLAND CAME IN TO MAKE SOME CORRECTIONS, BORROWED MY EISNER-IZED SABLE AND MENTIONED WHAT A GOOD LINE IT GAVE.

PAGE 192, PANELS ONE-FOUR - BRUSH ALTERNATIVES

I WAS AN EARLY ADOPTER OF SYNTHETIC BRUSHES STARTING IN 1982. IN FACT MY OLD SERIES ZOT! WAS FILLED WITH FELT BRUSH WORK, BUT I SYMPATHIZE WITH THOSE WHO DON'T TRUST THEM, AND I'D HARDLY POINT TO MY COMICS WORK FROM THAT DAY AS AN EXAMPLE OF GREAT INKING.

CRAIG THOMPSON'S TRUSTY PENTEL POCKET BRUSH PENS (SEE ABOVE) COME WITH REFILLABLE CARTRIDGES OF PIGMENT INKS AS DO THE KURETAKE AND AITOH BRUSH PENS, BUT MANY SYNTHETIC BRUSHES ARE BASICALLY BRUSH-SHAPED FELT-TIPPED PENS. PROB-ABLY THE MOST POPULAR, ESPECIALLY WITH MANGA FANS, ARE COPIC MARKERS, A FAST-DRYING MARKER WITH A CHISEL POINT ON ONE END AND A FLEXIBLE FELT BRUSH ON THE OTHER. THEY COME IN MANY COLORS AND ARE OFTEN USED FOR INKING AND COLORING, BUT DON'T SEEM AS COMMON IN THE PROFESSIONAL COMMUNITY -- YET. RESPONDENTS TO THE SURVEY WHO MENTIONED USING FELT BRUSHES LISTED SAKURA'S PIGMA BRUSH PEN AND THE ZEBRA 303 BRUSH PEN.

MANY SABLE USERS REALLY HATE THE FELT BRUSHES. FELT BRUSH USERS AREN'T EXACTLY JUMPING TO THEIR DEFENSE, BUT SOME SEEM PRETTY SATISFIED. UNIQUE AMONG THE ARTISTS I TALKED TO WAS SPIKE, WHO SAID SHE USES A SABLE BRUSH NOW, BUT THINKS FELT BRUSHES ARE GREAT. "I USED THEM AS TRAINING WHEELS FOR OVER TWO YEARS BEFORE I GRADUATED TO REAL BRUSHES," SHE WRITES. "I WOULD HAVE NEVER HAD THE CONFIDENCE AND PATIENCE TO DEAL WITH A BRUSH STRAIGHTAWAY AFTER I STOPPED USING PLAIN MARKERS TO INK, SO I'VE GOT NO PROBLEM WITH 'EM AT ALL."

PAGE 192, PANELS FIVE-SEVEN - NIB PENS

A NUMBER OF RESPONDENTS STILL USE NIB PENS, BUT

MANY COMPLAIN ABOUT THE QUALITY OF PRODUCTS AVAILABLE IN THE U.S. THE ONCE RESPECTED NIBS FROM HUNT AND SPEEDBALL (NOW THE SAME COMPANY) HAVE REPORTEDLY SUFFERED IN BOTH SELECTION AND QUALITY OVER THE YEARS, THOUGH THE HUNT #102 AND #108 CROWQUILLS AND #B-6 AND #22 NIBS ARE STILL BEING USED, AND SOME STILL SWEAR BY THEM (INCLUDING DREW WEING, BUT HE COULD GET GOOD LINES OUT OF A SNICKERS BAR). CARTOONISTS IN NEW YORK REPORT THE GROWING POPULARITY OF THE JAPANESE G PENS (BRANDS MAY INCLUDE ZEBRA, TACHIKAWA AND NIKKO). THE G PENS ARE BASICALLY THE SAME THING AS TRADITIONAL NIB PENS BUT STRONGER AND WELL-MADE. DAVID LASKY SAID HE'S USING THE ROTRING ART PEN, A NIB PEN WITH ITS OWN BARREL OF INK, MUCH LIKE THE PENTEL POCKET BRUSH AND ITS COUSINS. DAVID DESCRIBES THE ROTRING AS "HIGH MAINTENANCE" THOUGH, AND COMPARED IT TO "OWNING A VESPA."

PAGE 192-193 - FIXED WIDTH AND TECHNICAL PENS

TRADITIONAL TECHNICAL PENS LIKE THE KOH-I-NOOR RAPIDOGRAPH WHICH NEED TO BE DISASSEMBLED TO BE REFILLED AND CLEANED MAY BE A DYING BREED, BUT SOME CARTOONISTS STILL SWEAR BY THEM. HOWARD CRUSE DOES 90% OF HIS INKING WITH TECHNICAL PENS, AND KRIS DRESEN USES THEM FOR EVERYTHING. ROTRING AND STAEDTLER SEEM TO BE OFFERING NEWER VERSIONS OF THE TRADITIONAL DESIGN, WITH CARTRIDGES, WHICH MIGHT BE EASIER TO MAINTAIN, IF MORE EXPENSIVE IN THE LONG RUN.

NEW YORK STATE ARTIST TOC FETCH, AFTER SOME DAZZLINGLY INTRICATE TECHNICAL PEN WORK (AT LEFT) RECENTLY RETURNED TO HIS FIRST LOVE, THE PENCIL.

PLENTY OF ARTISTS FIND FIXED-WIDTH PIGMA MICRONS, ALVIN PENSTIX AND OTHER PRECISION FELT-TIPS AN ADEQUATE, HASSLE-FREE ALTERNATIVE TO TECHNICAL PENS. THEIR MAKERS CLAIM AN "ARCHIVAL QUALITY" INK (OLD-STYLE FELT-TIPS WERE NOTORIOUS FOR FADING), AND COME IN THE SAME PRECISION SIZES AS OLD SCHOOL TECHNICAL PENS. IF THE INK IS GOOD AND THE LINE IS SMOOTH AND CONSISTENT, I SAY GO FOR IT, BUT BEAR IN MIND THAT YOU'LL GO THROUGH DOZENS OF THOSE SUCKERS DURING THE LIFETIME OF ONE RAPIDO-GRAPH, SO LONG-TERM COST MIGHT BE WORTH CONSIDERING.

SOME CARTOONISTS, LIKE JASON LITTLE, REPORT LIKING

THE "DEAD" LINE THAT ALL FIXED-WIDTH PENS PRODUCE. OTHER USERS SEEM A BIT RESTLESS THOUGH. DEREK KIRK KIM USED COPIC'S FIXED-WIDTH MULTILINERS IN THE LAST FEW YEARS, BUT HE'S CONSIDERING GOING BACK TO CROWQUILL. WEBCOMICS CREATOR SHAENON GARRITY REFERS TO HER OWN USE OF MICRONS AS "LAME."

STILL, I NOTICED A CHEAP TOOL BRAVADO EMANATING FROM THE WEB-SAVVY BAY AREA INDY SCENE. "BRUSHES, SHARPIES, PIGMAS AND EVEN BALLPOINT PENS ARE USED," WRITES GENE YANG, "[JESSE HAMM] WALKED UP TO ME AND DEREK DURING A SAN DIEGO CON YEARS AGO AND SAID, 'MIGNOLA DOES EVERYTHING WITH A PIGMA AND A SHARPIE!' I DON'T THINK JESSE'S PICKED UP A BRUSH SINCE."

PAGE 193, PANELS FOUR AND FIVE - INKS AND WHITE PAINT

THREE RESPONDENTS CRITICIZED THE ALLEGED WATERING DOWN OF THE ONCE-STANDARD HIGGINS BLACK MAGIC INK (STEVE BISSETTE CALLED IT "GREY SWILL") BUT TWO OTHERS REPORTED STILL USING IT. R. KIKUO JOHNSON USES SPEEDBALL SUPER BLACK FOR HIS RICH, COMPELLING BRUSH WORK. MEANWHILE, JAPAN'S DELETER BRAND INK AND WHITE CORRECTION POINT ARE CATCHING ON FAST IN NEW YORK

PAGE 195 - A LETTERING ALTERNATIVE

HOWARD CRUSE HAS A SMART SYSTEM FOR THOSE WHO WANT TO GET THE BENEFITS OF GUIDELINES LIKE THOSE MADE BY AN AMES GUIDE, WITHOUT DRAWING THEM OVER AND OVER. HE MADE A SET OF GUIDELINES IN ADOBE ILLUSTRATOR, PRINTED THEM ONTO CLEAR SHEETS AND JUST PLACES THEM AND HIS DRAWING PAPER OVER A LIGHTBOX.

PAGE 197 - DRAWING THIS BOOK DIGITALLY

JUST TO BE CLEAR, THE LAYERS I'M TALKING ABOUT ARE VIRTUAL. I DON'T ACTUALLY PRINT AND STACK THEM LIKE THAT! IT ALL HAPPENS IN PHOTOSHOP. I'LL POST MORE DETAILED STEP-BY-STEPS ONLINE (SEE WEB ADDRESS AT BOTTOM).

PAGE 199, PANEL SEVEN - BRUSHES AND BUSHES!

PHOTOSHOP ALLOWS YOU TO SET SEVERAL PARAMETERS WHEN YOU TURN A SHAPE INTO A BRUSH, BUT THE PROGRAM DOESN'T MAKE IT EASY. I'LL POST A QUICK TUTORIAL ON THE SITE.

PAGE 203 - LETTERING IN ILLUSTRATOR

CHECK CHAPTER FIVE AND A HALF (RIGHT) FOR MORE ON DIGITAL LETTERING METHODS, INCLUDING A COOL LAYER TRICK THAT ALLOWS ENDLESS REPOSITIONING OF TAILS AND LIGHTNING-FAST PANEL BORDERS.

PAGE 204, PANEL EIGHT - THE TABLET MONITOR

AS I WRITE THIS, THE ONLY WAYS FOR GRAPHIC ARTISTS TO DRAW DIRECTLY ON THE SCREEN ARE TO GET A TABLET PC OR WACOM'S CINTIQ MONITOR -- AND FOR MAC USERS LIKE ME, THE CINTIQ IS OUR ONLY OPTION.

I LIKE THE CINTIQ A LOT. I PROBABLY COULDN'T HAVE DONE THIS BOOK HALF AS FAST OR HALF AS WELL WITHOUT IT. BUT THE ONLY GRAPHICS-FRIENDLY MODEL THE MANUFACTURER IS SELLING AS I WRITE THIS COSTS MORE THAN A WHOLE NEW COMPUTER ($2499! THOUGH THINGS MAY HAVE IMPROVED BY THE TIME YOU READ THIS).

IT'S A PRETTY MAMMOTH INVESTMENT, BUT IF YOU HAVE SERIOUS HAND STRAIN PROBLEMS LIKE I DID IN 2003-2004, OR YOU'RE BEING PAID ENOUGH FOR YOUR ART THAT YOU CAN LOG GAINS IN PRODUCTIVITY AS PROFIT, THEN GETTING A TABLET/MONITOR MIGHT MAKE SENSE.

PAGE 204-205 - INDUSTRY STANDARDS

THE MAJORITY OF COMICS PROS I KNOW WHO ARE MAKING COMICS DIGITALLY DO SO ON A MACINTOSH COMPUTER RUNNING ADOBE'S GRAPHICS PROGRAMS. ADOBE PHOTOSHOP IS THE PROGRAM NEARLY ALL OF US OWN, FOLLOWED BY ILLUSTRATOR, ADOBE'S PRECISE "OBJECT-ORIENTED" DRAWING PROGRAM, AND DREAMWEAVER FOR WEB AUTHORING. (DREAMWEAVER USED TO BE IN COMPETITION WITH ADOBE'S LESS-POPULAR GOLIVE, BUT ADOBE BOUGHT THE COMPANY IN 2005).

GETTING ALL THREE PROGRAMS OFF THE SHELF ADDS UP TO AROUND $1,000, BUT DEPENDING ON WHAT YOU WANT TO ACCOMPLISH, THERE MAY BE CHEAPER OR EVEN FREE ALTERNATIVES OUT THERE. CHECK THE SITE FOR MORE DETAILS.

CHAPTER 206 - GUIDES TO WEB PUBLISHING

ALSO SEE THE ADDRESS BELOW FOR SOME POINTERS TO WEB PUBLISHING. (I'M RUNNING OUT OF ROOM!)

CHAPTER FIVE AND A HALF!

I FOUND OUT IN *REINVENTING COMICS* HOW DIFFICULT IT IS TO DESCRIBE WEB-NATIVE TECHNIQUES IN A BLACK-AND-WHITE BOOK, SO I'VE PUT MOST OF MY DIGITAL NOTES ONLINE. I'M ALSO GOING TO SEE IF I CAN PROVIDE UP-TO-DATE INFORMATION ON EQUIPMENT AND SOFTWARE, SINCE THAT TOPIC IS A MOVING TARGET.

GO TO:
WWW.SCOTTMCCLOUD.COM/MAKINGCOMICS

AND LOOK FOR THIS BUTTON:

CHAPTER
5 1/2

Chapter Six

Your Place in Comics

Three Essays about Style

IF I HAD THE GOOD SENSE TO WRITE AN **ORDINARY** HOW-TO BOOK, THIS WOULD BE THE CHAPTER WHERE I EXPLAIN HOW TO "CHOOSE A STYLE THAT'S RIGHT FOR YOU."

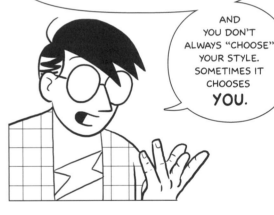

BUT STYLE ISN'T REALLY SOMETHING YOU CAN CHOOSE OFF-THE-SHELF LIKE A SCARF OR A PAIR OF SOCKS. ITS ROOTS GO **DEEPER** THAN THAT.

AND YOU DON'T ALWAYS "CHOOSE" YOUR STYLE. SOMETIMES IT CHOOSES **YOU.**

"STYLE" USUALLY DESCRIBES SURFACE DETAILS LIKE **LINE QUALITY,** A WAY OF DRAWING **FACES** OR ONE'S USE OF **DIALOGUE.**

BUT MANNERISMS LIKE THAT ARE JUST **BYPRODUCTS** OF ARTISTS' ATTEMPTS TO PRESENT THE **WORLD** AS THEY **SEE** IT --

LAST ROW: ART BY JIM WOODRING, KYLE BAKER, JOE SACCO AND CHRIS WARE (SEE ART CREDITS, PAGE 258).

212

-- AND TO CAPTURE THE **ASPECTS** OF **COMICS** THAT MAY HAVE CAPTIVATED THEM AS **READERS.**

BEHIND THAT STRUGGLE LIES THEIR FUNDAMENTAL OUTLOOK ON **LIFE** AND **ART** --

-- A STATEMENT OF THEIR **PASSIONS** AND **PRIORITIES** --

-- AN ECHO OF THE **TIMES** AND **PLACES** THEY'VE COME FROM --

-- AND A SIGNPOST TO **WHERE** THEY WANT THEIR CHOSEN ART TO **TAKE THEM.**

IN SHORT: DISCOVERING YOUR OWN **"STYLE"** IS A DEEPLY **PERSONAL** PROCESS WHICH CAN TAKE **YEARS** --

-- AND IT **CAN'T** BE TAUGHT IN A **BOOK.**

BUT, EVEN THOUGH THE PATH TO FINDING YOUR PLACE IN COMICS IS ONE THAT YOU'LL HAVE TO WALK **ALONE** --

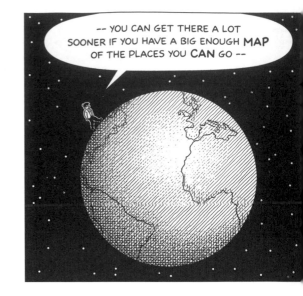

-- YOU CAN GET THERE A LOT SOONER IF YOU HAVE A BIG ENOUGH **MAP** OF THE PLACES YOU **CAN** GO --

-- THE BENEFIT OF THE **EXPERIENCES** OF THOSE WHO HAVE GONE BEFORE --

-- AND THE SKILLS TO DRAW **YOUR OWN** MAP WHEN THAT LANDSCAPE **CHANGES**.

TO GET STARTED THEN, HERE ARE **THREE SNAPSHOTS** OF THAT WORLD OF COMICS STYLES, STARTING WITH MY OWN PERSONAL TAKE ON THE **MANGA** PHENOMENON --

-- FOLLOWED BY A FEW IDEAS ON THE EVOLUTION AND USES OF THE MASS STYLES WE CALL **"GENRES"** --

-- AND AN UNUSUAL, BUT I HOPE USEFUL, NEW WAY OF LOOKING AT **COMICS CULTURE** AND THE IDEALS THAT CAN BOTH **SEPARATE** US AND BIND US **TOGETHER**.

PANEL FIVE: ART BY RUMIKO TAKAHASHI
(SEE ART CREDITS, PAGE 258).

1

UNDERSTANDING
MANGA

IN **1982**, JUST OUT OF COLLEGE AND LIVING IN MANHATTAN, I BECAME OBSESSED WITH READING **JAPANESE COMICS**, OR **"MANGA."**

FUNNY THING IS, ALMOST NONE OF WHAT I WAS READING HAD BEEN **TRANSLATED** AND I DIDN'T KNOW A WORD OF **JAPANESE!**

MY DAY JOB WAS AT **DC COMICS** IN ROCKEFELLER CENTER, JUST A COUPLE OF BLOCKS FROM BOOKS KINOKUNIYA, ONE OF THE BIGGEST JAPANESE BOOKSTORES IN AMERICA.

ALMOST EVERY DAY, ON MY LUNCH HOUR, I'D RIFLE THROUGH THEIR SHELVES **"READING"** THE PICTURES PANEL-BY-PANEL, RIGHT TO LEFT, COVER TO COVER.

IN THOSE PAGES, I FOUND A LOT OF **VISUAL STORYTELLING** TECHNIQUES RARELY SEEN IN AMERICAN COMICS THAT I WAS EAGER TO PUT IN MY OWN COMICS AS SOON AS I GOT THE CHANCE.*

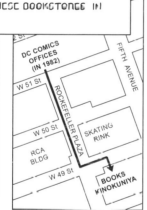

I'VE SEEN BOOKS ABOUT THE **HISTORY, BUSINESS** AND **CULTURE** OF MANGA AND PLENTY OF MANGA STYLE **HOW-TO-DRAW** BOOKS --

-- BUT IN 24 YEARS, I'VE RARELY SEEN ANYONE FOCUS ON THESE **BASIC STORYTELLING TECHNIQUES**, SO LET'S TAKE A **CLOSER LOOK** NOW.

TWO YEARS LATER, AS IT HAPPENED.

IN 1982, **SUPERHERO COMICS** WERE EVEN MORE DOMINANT IN AMERICAN COMIC BOOKS THAN THEY ARE NOW, AND DC COMICS' OFFICES WERE RIGHT IN THE **CENTER** OF THAT INDUSTRY.

MY TWO-AND-A-HALF BLOCK WALK FROM **DC** TO **KINOKUNIYA** SPANNED AN OCEAN OF **DIFFERENCES** BETWEEN THE TWO COMICS CULTURES.

D.C.

Fifth

Rockefeller Plaza

53rd St.

52nd St.

51st St.

50th St.

Avenue of the Americas

KINO

AT LEAST **EIGHT** OF THE MANGA STORYTELLING TECHNIQUES I FOUND ON KINO'S SHELVES WERE ALMOST COMPLETELY **ABSENT** FROM MAINSTREAM SUPERHERO COMICS AT THE TIME, INCLUDING:

ICONIC CHARACTERS. THE SIMPLE, EMOTIVE FACES AND FIGURES WHICH LED TO THE KIND OF READER IDENTIFICATION I TALKED ABOUT IN *UNDERSTANDING COMICS*, PAGES 29-45.

GENRE MATURITY. AN UNDERSTANDING OF THE UNIQUE STORYTELLING CHALLENGES OF LITERALLY HUNDREDS OF DIFFERENT GENRES INCLUDING SPORTS, ROMANCE, S.F., FANTASY, BUSINESS, HORROR, SEXUAL COMEDY, ETC...

A STRONG **SENSE OF PLACE.** ENVIRONMENTAL DETAILS THAT TRIGGERED SENSORY MEMORIES AND, WHEN CONTRASTED WITH ICONIC CHARACTERS, LEAD TO THE "MASKING EFFECT" DISCUSSED IN *UNDERSTANDING COMICS* PAGES 42-45).

A BROAD VARIETY OF **CHARACTER DESIGNS,** FEATURING WILDLY DIFFERENT FACE AND BODY TYPES AND THE FREQUENT USE OF RECURRING ARCHETYPES.

FREQUENT USES OF **WORDLESS PANELS,** COMBINED WITH **ASPECT TO ASPECT** TRANSITIONS BETWEEN PANELS; PROMPTING READERS TO ASSEMBLE SCENES FROM FRAGMENTARY VISUAL INFORMATION.

SMALL REAL WORLD DETAILS. AN APPRECIATION FOR THE BEAUTY OF THE MUNDANE, AND ITS VALUE FOR CONNECTING WITH READERS' EVERYDAY EXPERIENCES -- EVEN IN FANTASTIC OR MELODRAMATIC STORIES.

SUBJECTIVE MOTION. USING STREAKED BACKGROUNDS TO MAKE READERS FEEL LIKE THEY WERE MOVING **WITH** A CHARACTER, INSTEAD OF JUST WATCHING MOTION FROM THE SIDELINES.

VARIOUS **EMOTIONALLY EXPRESSIVE EFFECTS** SUCH AS EXPRESSIONISTIC BACKGROUNDS, MONTAGES AND SUBJECTIVE CARICATURES -- ALL AIMED AT GIVING READERS A WINDOW INTO WHAT CHARACTERS WERE FEELING.

216

EACH OF THESE CONTRIBUTED TO THE MANGA EXPERIENCE IN **DIFFERENT WAYS**, BUT AS I STUDIED MY OWN REACTIONS AS A **READER** AND LOOKED INTO MANGA'S **ROLE** IN JAPANESE SOCIETY --

-- I NOTICED A COMMON **THEME** EMERGING, AS IF ALL OF THESE TECHNIQUES WERE BEING DEPLOYED TOWARD A SINGLE **PURPOSE**...

WHETHER THROUGH THE **ICONIC FACES** AND VARIED VISUAL **ARCHETYPES** THAT NEEDED TO BE FILLED IN BY THE READER TO BRING THEM TO LIFE --

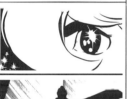

-- OR THE SILENT, WANDERING ENCOUNTERS WITH **ENVIRONMENTS** CAPABLE OF PLACING READERS WITHIN A SCENE --

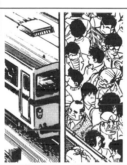

-- OR THE DIRECT CONNECTION TO THE **REAL-LIFE EXPERIENCES** AND **INTERESTS** OF THE AVERAGE READER --

-- OR THE GRAPHIC DEVICES MEANT TO MOVE READERS **EMOTIONALLY**, AS WELL AS **LITERALLY** MOVING WITH THE ACTION --

-- **ALL** OF THESE TECHNIQUES AMPLIFIED THE SENSE OF **READER PARTICIPATION** IN MANGA, A FEELING OF BEING **PART OF THE STORY**, RATHER THAN SIMPLY **OBSERVING** THE STORY FROM AFAR.

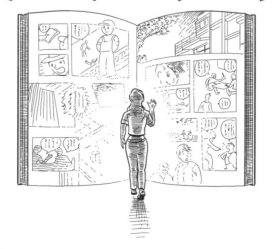

AND FOR ALL THE TALK OF FORMATS, MARKETING AND "CULTURAL DIFFERENCES" IN 1982, I BECAME CONVINCED THAT IT WAS **THIS** QUALITY OF MANGA THAT HAD FUELED ITS MASSIVE SUCCESS AT HOME -- AND, POTENTIALLY, IN NORTH AMERICA.

NOW, THE MANGA INDUSTRY WAS **HUGE** AND **VARIED** IN 1982. I'M NOT SUGGESTING THERE WAS ANY KIND OF DELIBERATE **"NATIONAL STYLE"** FOCUSING ON READER INVOLVEMENT.

IN FACT, THE DIFFERENCES I WAS SEEING BETWEEN MANGA AND MAINSTREAM AMERICAN COMICS MAY, IN PART, HAVE JUST BEEN AN ACCIDENT OF **HISTORY.**

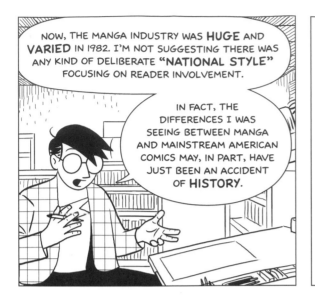

MANY OF MANGA'S READER PARTICIPATION TECHNIQUES CAN BE TRACED TO JAPAN'S "GOD OF MANGA," **OSAMU TEZUKA,** WHO HAD BEEN INSPIRING MANGA ARTISTS SINCE THE LATE '40S.

SUBJECTIVE MOTION FROM TEZUKA'S FIRST HIT *NEW TREASURE ISLAND*, 1947.

USUALLY, A POWERFUL AND POPULAR ARTIST WILL JUST SPAWN A GENERATION OF **CARBON COPIES** --

-- BUT TEZUKA'S OUTPUT ENCOMPASSED SUCH A DIVERSITY OF STYLES AND GENRES THAT EVEN HIS MOST SLAVISH IMITATORS HAD TO PICK **WHICH** TEZUKA TO IMITATE, WHILE THOSE FOLLOWING THE **SPIRIT** OF HIS WORK SOUGHT DIVERSITY IN THEIR OWN STORIES.

JUST AS IN NATURE, A WIDE DIVERSITY OF **ARTISTIC SPECIES** HELPED SPEED MANGA'S EVOLUTION.

BY 1982, WITH STRONG, CONSISTENT INPUT FROM READERS, EACH GENRE HAD TAKEN A **UNIQUE SHAPE** THAT STROVE TO MATCH THE LEVEL OF IMMERSION FELT BY ITS READERS -- AND **AUDIENCE INVOLVEMENT** TECHNIQUES DID THE TRICK NICELY.

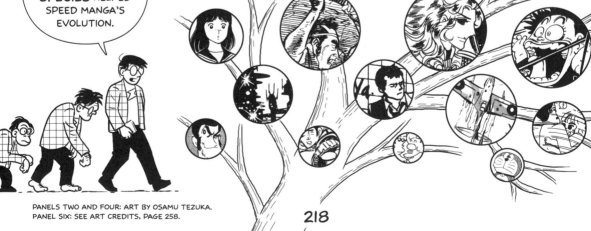

PANELS TWO AND FOUR: ART BY OSAMU TEZUKA.
PANEL SIX: SEE ART CREDITS, PAGE 258.

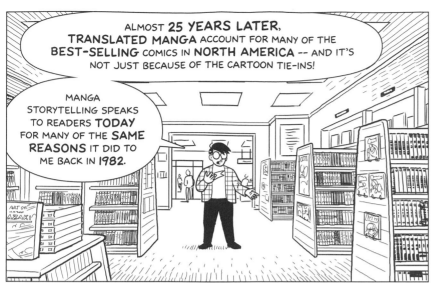

ALMOST **25 YEARS LATER,** **TRANSLATED MANGA** ACCOUNT FOR MANY OF THE **BEST-SELLING** COMICS IN **NORTH AMERICA** -- AND IT'S NOT JUST BECAUSE OF THE CARTOON TIE-INS!

MANGA STORYTELLING SPEAKS TO READERS **TODAY** FOR MANY OF THE **SAME REASONS** IT DID TO ME BACK IN **1982.**

BUT **UNLIKE** 1982, THE DIFFERENCES BETWEEN NORTH AMERICAN COMICS AND MANGA AREN'T AS PRONOUNCED AS THEY ONCE WERE.

THE GROWING **ALTERNATIVE** AND **GRAPHIC NOVEL** MARKETS HAVE PROVED HOSPITABLE TO MANY OF THE SAME QUALITIES LISTED ON PAGE 216.

SOME ARTISTS IN **MAINSTREAM COMICS** GENRES HAVE EMBRACED MANGA STYLES.

AND PLENTY OF **WEBCOMICS** ARTISTS WHO'VE GROWN UP WITH ANIME AND MANGA HAVE INCORPORATED ITS SENSIBILITIES INTO THEIR OWN WORK.

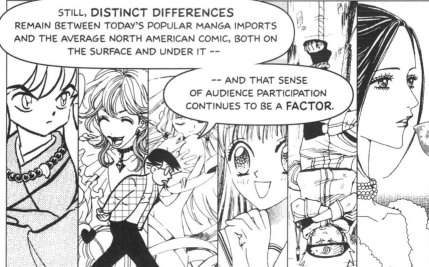

STILL, **DISTINCT DIFFERENCES** REMAIN BETWEEN TODAY'S POPULAR MANGA IMPORTS AND THE AVERAGE NORTH AMERICAN COMIC, BOTH ON THE SURFACE AND UNDER IT --

-- AND THAT SENSE OF AUDIENCE PARTICIPATION CONTINUES TO BE A **FACTOR.**

THE STORYTELLING IN JAPAN'S **SHOJO*** TITLES IS PARTICULARLY COMPELLING, AND DISTINCT FROM WESTERN MAINSTREAM COMICS.

IN THE NORTH AMERICAN TRADITION, THE **PHYSICAL POSITIONS** OF CHARACTERS IN RELATION TO ONE ANOTHER TEND TO BE CAREFULLY SHOWN, AS IF THEY WERE PIECES ON A CHESSBOARD -- EVEN IN **NON-ACTION** GENRES LIKE ROMANCE.

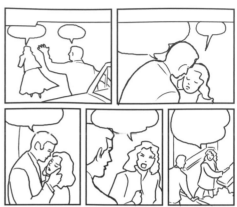

BUT STRUGGLES OF THE HEART ARE **EMOTIONAL** NOT PHYSICAL; THEY HAPPEN **INTERNALLY** --

-- SO WHEN EMOTIONS RUN **HIGH** IN SHOJO MANGA -- AS THEY OFTEN DO -- THE **"ACTION"** MAY BE LITTLE MORE THAN A MONTAGE OF FLOATING, EXPRESSIVE FACES, CASCADING DOWN THE PAGE.

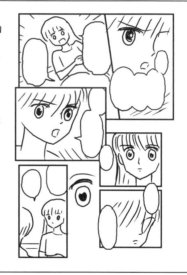

WHETHER IT'S THROUGH THE USE OF **EXPRESSIONISTIC EFFECTS** TO SUGGEST **EMOTION** --

-- OR THE EXAGGERATED TRANSFORMATIONS OF ENTIRE **BODIES** --

NOT SO KAWAII ...

-- THE SHOJO APPROACH INVITES READERS TO **PARTICIPATE** IN THE EMOTIONAL LIVES OF ITS CHARACTERS, NOT JUST **OBSERVE** THEM.

MEANWHILE, IN **SHONEN** TITLES (THOSE AIMED AT BOYS), EMOTIONS CAN RUN EQUALLY HIGH, AS THE **FACES** OF ITS PROTAGONISTS CONSTANTLY REMIND US --

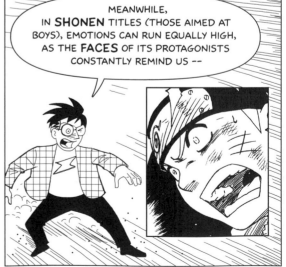

* "SHOJO" = COMICS AIMED AT GIRLS. PANEL ONE: ART BY NATSUKI TAKAYA.

220

PANELS TWO AND FOUR: LAYOUT FROM ART BY JACK KIRBY AND MIHO OBANA. PANEL FIVE: ART BY MIWA UEDA. PANEL EIGHT: ART BY MASASHI KISHIMOTO (SEE ART CREDITS, PAGE 258).

-- BUT THE SENSE OF PARTICIPATION IS A **PHYSICAL** ONE, BROUGHT ON BY **SUBJECTIVE MOTION** AND DIZZY **P.O.V.** FRAMING.

SHUT UP!

TAK TAK

TAK

AW, MAN...!

DON'T DO IT NARUTO

THE SHONEN READER IS **INSIDE THE ACTION** IN THE SAME WAY THAT THE SHOJO READER IS INSIDE CHARACTERS' **HEADS.**

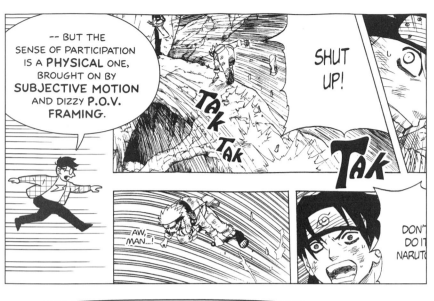
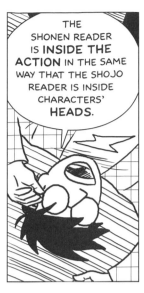

THE **PAGE COMPOSITIONS** AND **BODY LANGUAGE** AREN'T FAR FROM WESTERN ACTION GENRES AND THEY SHARE THE **COMMON GOAL** OF GENERATING **EXCITEMENT** --

KLANG

KLANG

-- BUT MANGA READERS ARE FINDING A **VISCERAL THRILL** IN SUCH PARTICIPATION TECHNIQUES THAT THEY APPARENTLY AREN'T FINDING IN NORTH AMERICAN COMICS --

-- AND SOME ARTISTS IN THE WEST HAVE LOOKED TO MANGA FOR INSPIRATION IN **BRIDGING** THAT **GAP.**

WELL, YOU SHOULD ABOUT THAT BEFORE YOU --

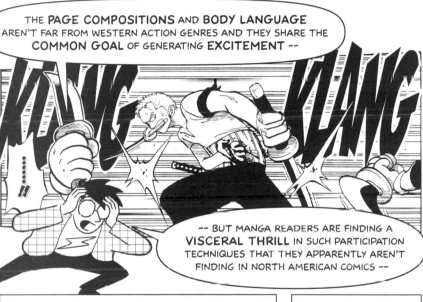

OF COURSE, SOMETIMES A STYLE IS JUST A STYLE, LIKE WHEN SUBJECTIVE MOTION LINES ARE USED TO MAKE A MOMENT LOOK "DYNAMIC" --

-- OR WHEN EXCESSIVE MONTAGES ARE USED JUST TO PRETTY UP A SPREAD --

-- BUT PUTTING THE READER **INSIDE** THE STORY IS STILL THE PRIMARY EFFECT OF MANY OF THE TECHNIQUES THAT MANGA HAS PLAYED HOST TO OVER THE YEARS --

-- AND **UNDERSTANDING** THAT **EFFECT** IS A GOOD FIRST STEP TOWARD TAPPING INTO THAT **POWER.**

PANEL ONE: ART BY MASASHI KISHIMOTO. PANEL THREE: ART BY EIICHIRO ODA. PANEL FOUR: PENCILS BY MARK BAGLEY, INKS BY ART THIBERT & DAN PANOSIAN (SEE ART CREDITS, PAGE 258).

IF YOU'RE A MANGA FAN WHO WANTS TO DRAW COMICS, THEN YOU MIGHT START OUT BY LEARNING HOW TO DRAW IN THAT **STYLE,** AND THERE ARE HUNDREDS OF BOOKS IN PRINT OFFERING TO TEACH YOU **HOW.**

LITERALLY. *HUNDREDS.* I COUNTED.

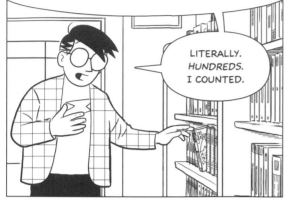

IT'S A NATURAL **FIRST STEP** TO IMITATE YOUR FAVORITE ARTISTS AND I'M NOT GOING TO TRY TO TALK ANYONE OUT OF IT.

BUT IN THE LONG RUN, I HOPE YOU'LL CONSIDER LOOKING **BEYOND** THOSE SURFACE STYLES TO THE FUNDAMENTAL **IDEAS** AND **EFFECTS** THAT THOSE STYLES HAVE GROWN TO CONVEY --

-- AND HOW THEY COMPARE WITH A WORLD OF **OTHER** STYLES.

AND IN **MANGA'S** CASE THAT MEANS FINDING NEW WAYS TO PERSONALLY **CONNECT** WITH READERS --

-- NOT JUST ECHOING THE WAYS OTHER ARTISTS IN OTHER LANDS CONNECTED WITH **THEIRS.**

THAT TRANSITION IS ALREADY STARTING AS I WRITE THIS.

IN NORTH AMERICA, MANGA AND ANIME FANS FROM THE **MID-'90S** HAVE JOINED THE RANKS OF THIS DECADE'S **PROMISING YOUNG ARTISTS.**

BUT DESPITE THEIR INFLUENCES, THEY HAVEN'T JUST BEEN TELLING STORIES ABOUT JAPANESE SCHOOLGIRLS AND SAMURAI.

PANEL TWO: BASED ON ART BY HIROMU ARAKAWA. PANEL SEVEN: ART BY AMY KIM GANTER (SEE ART CREDITS, PAGE 258).

222

INSTEAD, THESE NEW JAPANESE-INFLUENCED COMICS ARTISTS ARE VEERING CLOSER TO **THEIR OWN LIVES** FOR INSPIRATION, AND CLOSER TO THEIR **READERS'** LIVES IN THE PROCESS.

IN THE **MID-'90S**, MANGA (AND ITS BIG BROTHER ANIME) HAD MANY LOYAL FANS IN NORTH AMERICA, AND AMONG THEM WERE ARTISTS THAT ARE NOW BEGINNING TO SIGNIFICANTLY CHANGE COMICS ON THE **WEB** AND, INCREASINGLY, IN **PRINT**.

BUT THAT GENERATION OF YOUNG MANGA READERS WAS **TINY** COMPARED TO THE ONE WE HAVE NOW, AND WHEN **THAT** WAVE HITS MATURITY, THEY'LL TELL STORIES THAT WILL INSPIRE A WHOLE NEW GENERATION.

AND THEY'LL DO IT USING THE **PEOPLE** THEY KNOW AND UNDERSTAND --

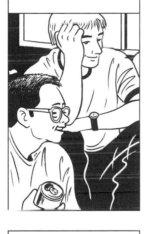

-- THE **PLACES** THEY CAN BRING TO VIVID LIFE --

-- THE EVERYDAY **INTERESTS** AND **DETAILS** THEY CAN MAKE REAL FOR READERS --

-- AND THE **EMOTIONS** AND **SENSATIONS** THEY'VE KNOW FIRST-HAND.

AND AS STYLES AND STORIES ON **BOTH** SIDES OF THE PACIFIC OCEAN CONTINUE TO EVOLVE, **MANGA** CAN BE SEEN FOR WHAT IT ALWAYS HAS BEEN:

ANOTHER WORD FOR **COMICS**.

2

UNDERSTANDING
GENRES

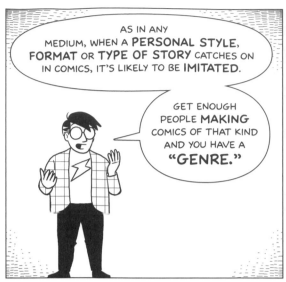

AS IN ANY MEDIUM, WHEN A **PERSONAL STYLE**, **FORMAT** OR **TYPE OF STORY** CATCHES ON IN COMICS, IT'S LIKELY TO BE **IMITATED**.

GET ENOUGH PEOPLE **MAKING** COMICS OF THAT KIND AND YOU HAVE A **"GENRE."**

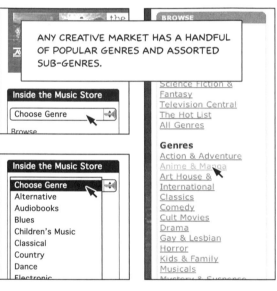

ANY CREATIVE MARKET HAS A HANDFUL OF POPULAR GENRES AND ASSORTED SUB-GENRES.

Inside the Music Store

Choose Genre

Browse

Inside the Music Store

Choose Genre
Alternative
Audiobooks
Blues
Children's Music
Classical
Country
Dance
Electronic

BROWSE

Science Fiction & Fantasy
Television Central
The Hot List
All Genres

Genres
Action & Adventure
Anime & Manga
Art House & International
Classics
Comedy
Cult Movies
Drama
Gay & Lesbian
Horror
Kids & Family
Musicals
Mystery & Suspense

SOME, LIKE THE BROAD GENRES OF **COMEDY** AND **TRAGEDY**, HAVE BEEN WITH US FOR THOUSANDS OF YEARS --

-- WHILE OTHER, FAR MORE **SPECIFIC** SUB-GENRES MAY COME AND GO IN THE WINK OF AN EYE.

← LATE '70S TRUCKER FILMS

GENRES ARE BUILT AROUND **AUDIENCE EXPECTATIONS**. WHEN THE GENRE IS **BROAD**, THE LIST OF EXPECTATIONS IS **SHORT**.

COMEDIES MAKE US **LAUGH**. TRAGEDIES MAKE US **CRY**.*

← (Okay, that's just creepy-looking, sorry.)

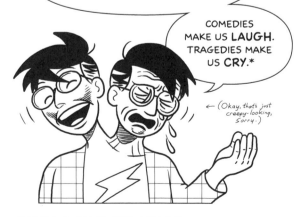

WHEN THE GENRE IS MORE **SPECIFIC** THE LIST OF EXPECTATIONS CAN GET A LOT **LONGER**.

'90S STYLE ROMANTIC COMEDY

Tom Hanks Meg Ryan

You've Got Mail

DVD

☑ CUTE, CHANCE MEETING.

☑ INITIAL DISLIKE.

☑ FALL IN LOVE ANYWAY.

☑ MID-20TH CENTURY AMERICAN POPULAR SONG (OPTIONAL: MAY USE AS TITLE OF FILM).

☑ WACKY BEST FRIENDS.

☑ PRECOCIOUS CHILD/ANIMAL.

☑ FIGHT, BREAK-UP.

☑ YEARNING LONELY MONTAGE.

☑ ROMANTIC REUNION (OPTIONAL: MAY INCLUDE RUNNING FOR CAB OR AIRPLANE).

*IN OUR TIME, AT LEAST. IN SHAKESPEARE'S DAY THE LIST WASN'T NEARLY SO SHORT.

GENRES HAVE **LIFE CYCLES**. AS THEY **AGE**, SUCH LISTS CAN GROW SO **LONG** THAT THE GENRE STARTS TO SAG UNDER THE WEIGHT OF TOO MANY FORMULA-DRIVEN **EXPECTATIONS**.

AT THAT POINT, ITS AUDIENCE MIGHT START TO DWINDLE --

-- **OR** A NEW BREED OF CREATORS MIGHT **THROW AWAY** THAT LIST AND GIVE **NEW LIFE** TO THE GENRE BY REDISCOVERING ITS **BASIC APPEAL**.

WHEN ARTIST **JACK KIRBY** HELPED DEFINE THE MODERN **SUPERHERO** GENRE IN THE SIXTIES,* SUPERHERO COMICS HAD ALREADY BEEN AROUND FOR MORE THAN **20 YEARS**.

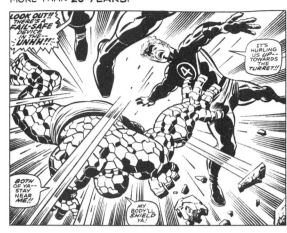

LOOK OUT!! THERE'S A FAIL-SAFE DEVICE IN THE UNHH!!?

IT'S HURLING US *UP* -- TOWARDS THE *TURRET!!*

BOTH OF YA -- STAY *NEAR ME!!*

MY *BODY'LL SHIELD* YA!

ZZZZ

THE SUPERHERO GENRE HAD ITS **RULES**, LEARNED FROM YEARS OF TRIAL AND ERROR: CLEAR, DIAGRAMMATIC LAYOUTS, FULL FIGURES IN ACTION, SMOOTH FLUID LINEWORK...

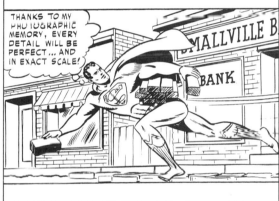

THANKS TO MY PHOTOGRAPHIC MEMORY, EVERY DETAIL WILL BE PERFECT... AND IN EXACT SCALE!

SMALLVILLE B BANK

BUT KIRBY **BROKE** EVERY ONE OF THOSE RULES, AND IN DOING SO, HE SAVED THE GENRE FROM ITSELF (FOR A TIME, AT LEAST).

IF YOU DECIDE TO MAKE COMICS WITHIN A SPECIFIC GENRE, YOU CAN EITHER **PERFECT** A FORMULA CREATED BY **OTHERS** OR CREATE YOUR **OWN**.

EITHER WAY, IT HELPS TO **UNDERSTAND** WHAT THAT FORMULA **IS**.

AND THAT MEANS LOOKING AT A WIDE **VARIETY** OF GENRES TO FIGURE OUT HOW YOURS IS UNIQUE --

-- AND WHETHER OR NOT IT'S **SUCCEEDING** AT ITS MOST BASIC **PURPOSES**.

* ESPECIALLY IN COLLABORATION WITH WRITER STAN LEE.

PANEL THREE: ART BY JACK KIRBY. PANEL FOUR: ART BY CURT SWAN (I THINK! -- SEE ART CREDITS, PAGE 258).

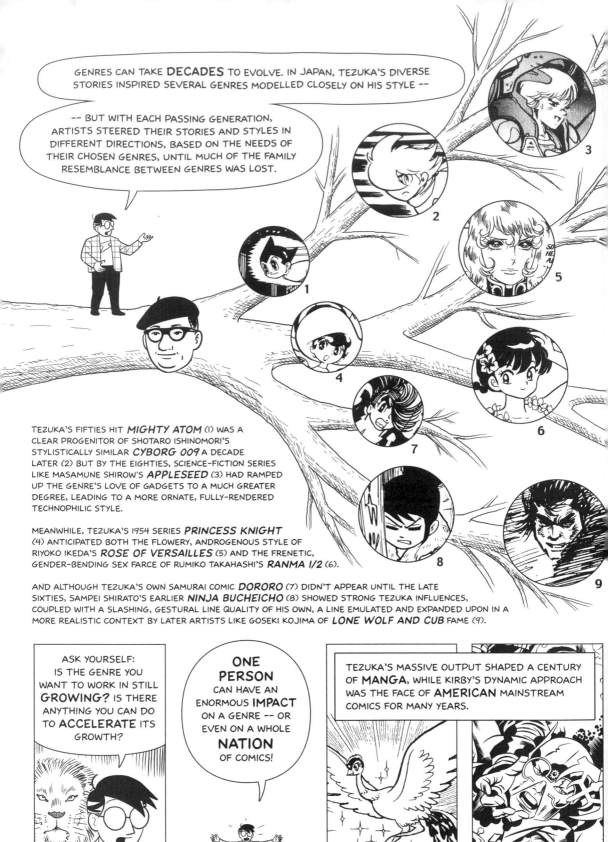

GENRES CAN TAKE **DECADES** TO EVOLVE. IN JAPAN, TEZUKA'S DIVERSE STORIES INSPIRED SEVERAL GENRES MODELLED CLOSELY ON HIS STYLE --

-- BUT WITH EACH PASSING GENERATION, ARTISTS STEERED THEIR STORIES AND STYLES IN DIFFERENT DIRECTIONS, BASED ON THE NEEDS OF THEIR CHOSEN GENRES, UNTIL MUCH OF THE FAMILY RESEMBLANCE BETWEEN GENRES WAS LOST.

TEZUKA'S FIFTIES HIT *MIGHTY ATOM* (1) WAS A CLEAR PROGENITOR OF SHOTARO ISHINOMORI'S STYLISTICALLY SIMILAR *CYBORG 009* A DECADE LATER (2) BUT BY THE EIGHTIES, SCIENCE-FICTION SERIES LIKE MASAMUNE SHIROW'S *APPLESEED* (3) HAD RAMPED UP THE GENRE'S LOVE OF GADGETS TO A MUCH GREATER DEGREE, LEADING TO A MORE ORNATE, FULLY-RENDERED TECHNOPHILIC STYLE.

MEANWHILE, TEZUKA'S 1954 SERIES *PRINCESS KNIGHT* (4) ANTICIPATED BOTH THE FLOWERY, ANDROGENOUS STYLE OF RIYOKO IKEDA'S *ROSE OF VERSAILLES* (5) AND THE FRENETIC, GENDER-BENDING SEX FARCE OF RUMIKO TAKAHASHI'S *RANMA 1/2* (6).

AND ALTHOUGH TEZUKA'S OWN SAMURAI COMIC *DORORO* (7) DIDN'T APPEAR UNTIL THE LATE SIXTIES, SAMPEI SHIRATO'S EARLIER *NINJA BUCHEICHO* (8) SHOWED STRONG TEZUKA INFLUENCES, COUPLED WITH A SLASHING, GESTURAL LINE QUALITY OF HIS OWN, A LINE EMULATED AND EXPANDED UPON IN A MORE REALISTIC CONTEXT BY LATER ARTISTS LIKE GOSEKI KOJIMA OF *LONE WOLF AND CUB* FAME (9).

ASK YOURSELF: IS THE GENRE YOU WANT TO WORK IN STILL **GROWING?** IS THERE ANYTHING YOU CAN DO TO **ACCELERATE** ITS GROWTH?

ONE PERSON CAN HAVE AN ENORMOUS **IMPACT** ON A GENRE -- OR EVEN ON A WHOLE **NATION** OF COMICS!

TEZUKA'S MASSIVE OUTPUT SHAPED A CENTURY OF **MANGA**, WHILE KIRBY'S DYNAMIC APPROACH WAS THE FACE OF **AMERICAN** MAINSTREAM COMICS FOR MANY YEARS.

SIMILARLY, THE 20TH CENTURY BELGIAN MASTER **HERGE** CONSTRUCTED SUCH DETAILED AND RICH ENVIRONMENTS IN HIS FAMOUS *TINTIN* SERIES --

-- THAT THE LION'S SHARE OF ARTISTS THAT FOLLOWED IN HIS FOOTSTEPS GAVE **WORLD-BUILDING** A PROMINENT ROLE IN THEIR WORK AND HELPED DISTINGUISH EUROPEAN COMICS FROM BOTH THE NORTH AMERICAN AND JAPANESE VARIETIES FOR MANY YEARS.

IN RECENT YEARS, WORLD-CLASS CARTOONISTS LIKE **HAYAO MIYAZAKI** HAVE BEEN MORE INCLINED TO BORROW IDEAS FROM ACROSS THE WORLD, LEADING TO A BLURRING OF THE BOUNDARIES BETWEEN REGIONAL STYLES --

-- WHILE A WORLD-WIDE CULTURE OF ARTISTS ON THE **WEB** HAVE BEEN BLURRING THE BOUNDARIES EVEN MORE WITH AN EXPLOSION OF DIVERSE **GENRES** AND **STYLES** NOT CONSTRAINED BY REGIONAL MARKETS --

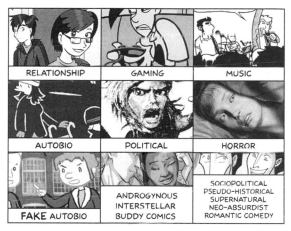

RELATIONSHIP	GAMING	MUSIC
AUTOBIO	POLITICAL	HORROR
FAKE AUTOBIO	ANDROGYNOUS INTERSTELLAR BUDDY COMICS	SOCIOPOLITICAL PSEUDO-HISTORICAL SUPERNATURAL NEO-ABSURDIST ROMANTIC COMEDY

-- OR THE NEED TO BATTLE FOR **SHELF SPACE.**

IF THESE TRENDS CONTINUE, WE MIGHT ASK IF THE WHOLE **IDEA** OF GENRES MIGHT BECOME **MARGINALIZED.**

IS SUCH A THING **POSSIBLE** THOUGH? AND **IF** POSSIBLE, WOULD IT **HELP** OR **HURT** COMICS?

THE **ANSWER,** AS USUAL, DEPENDS ON WHO YOU **ASK.**

ANEL ONE: ART BY HERGE. PANEL TWO: ART BY MOEBIUS, EAN-CLAUDE MEZIERES AND LEWIS TRONDHEIM. PANEL THREE: RT BY HAYAO MIYAZAKI (SEE ART CREDITS, PAGE 258).

227

PANEL FOUR: ART BY JEFF JACQUES, MIKE KRAHULIK, MITCH CLEM, JAMES KOCHALKA, ERIC MILLIKIN, JOE ZABEL, JEFFREY ROWLAND, JENN MANLEY LEE AND DYLAN MECONIS (SEE ART CREDITS, PAGE 258).

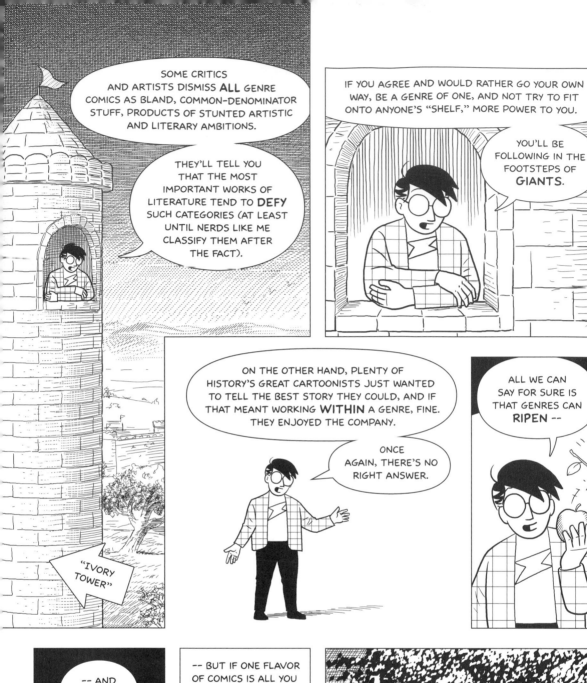

SOME CRITICS AND ARTISTS DISMISS **ALL** GENRE COMICS AS BLAND, COMMON-DENOMINATOR STUFF, PRODUCTS OF STUNTED ARTISTIC AND LITERARY AMBITIONS.

THEY'LL TELL YOU THAT THE MOST IMPORTANT WORKS OF LITERATURE TEND TO **DEFY** SUCH CATEGORIES (AT LEAST UNTIL NERDS LIKE ME CLASSIFY THEM AFTER THE FACT).

IF YOU AGREE AND WOULD RATHER GO YOUR OWN WAY, BE A GENRE OF ONE, AND NOT TRY TO FIT ONTO ANYONE'S "SHELF," MORE POWER TO YOU.

YOU'LL BE FOLLOWING IN THE FOOTSTEPS OF **GIANTS**.

ON THE OTHER HAND, PLENTY OF HISTORY'S GREAT CARTOONISTS JUST WANTED TO TELL THE BEST STORY THEY COULD, AND IF THAT MEANT WORKING **WITHIN** A GENRE, FINE. THEY ENJOYED THE COMPANY.

ONCE AGAIN, THERE'S NO RIGHT ANSWER.

"IVORY TOWER"

ALL WE CAN SAY FOR SURE IS THAT GENRES CAN **RIPEN** --

-- AND THEY CAN **ROT** --

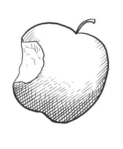

-- BUT IF ONE FLAVOR OF COMICS IS ALL YOU EVER TRY --

-- YOU MIGHT NEVER TASTE THE **DIFFERENCE**.

3

UNDERSTANDING
COMICS
CULTURE

EVERY YEAR, AT **CONVENTIONS** AND **FESTIVALS** AROUND THE WORLD, COMICS ARTISTS MEET FACE TO FACE TO TALK ABOUT LIFE, WORK AND EVERYTHING IN BETWEEN.

ASK A THOUSAND OF THEM WHAT THEY **WANT** OUT OF COMICS, WHAT MAKES IT ALL **WORTHWHILE**, OR WHAT IT TAKES TO **SUCCEED** --

-- AND YOU'LL GET A THOUSAND DIFFERENT **ANSWERS**.

BUT LISTEN CLOSELY AND YOU MAY NOTICE SOME **COMMON** THEMES.

SHARED **IDEALS**, SHARED **VALUES**, SHARED **GOALS**...

LIKE **CAMPFIRES**, THESE ARE THE UNDERLYING PHILOSOPHIES THAT CREATORS HAVE GATHERED AROUND THROUGH THE YEARS, THE BELIEFS THAT BIND LIKE-MINDED ARTISTS TOGETHER WITH A SENSE OF **COMMON PURPOSE**.

THESE "CAMPFIRES" DON'T NUMBER IN THE THOUSANDS, THOUGH.

IN FACT, I THINK THAT MANY ARTISTS ARE DRAWN TO JUST **FOUR**.

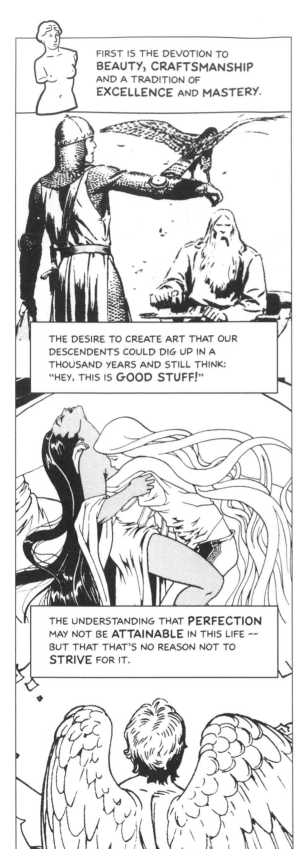

FIRST IS THE DEVOTION TO **BEAUTY, CRAFTSMANSHIP** AND A TRADITION OF **EXCELLENCE** AND **MASTERY.**

THE DESIRE TO CREATE ART THAT OUR DESCENDENTS COULD DIG UP IN A THOUSAND YEARS AND STILL THINK: "HEY, THIS IS **GOOD STUFF!**"

THE UNDERSTANDING THAT **PERFECTION** MAY NOT BE **ATTAINABLE** IN THIS LIFE -- BUT THAT THAT'S NO REASON NOT TO **STRIVE** FOR IT.

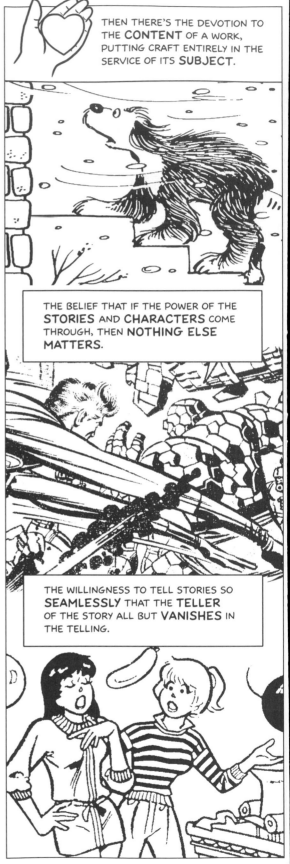

THEN THERE'S THE DEVOTION TO THE **CONTENT** OF A WORK, PUTTING CRAFT ENTIRELY IN THE SERVICE OF ITS **SUBJECT.**

THE BELIEF THAT IF THE POWER OF THE **STORIES** AND **CHARACTERS** COME THROUGH, THEN **NOTHING ELSE MATTERS.**

THE WILLINGNESS TO TELL STORIES SO **SEAMLESSLY** THAT THE **TELLER** OF THE STORY ALL BUT **VANISHES** IN THE TELLING.

THEN THERE'S THE DEVOTION TO **COMICS ITSELF**, TO FIGURING OUT WHAT THE **FORM** OF COMICS IS CAPABLE OF.

AND FINALLY, THE DESIRE FOR **HONESTY, AUTHENTICITY,** AND A CONNECTION TO **REAL LIFE.**

THE EAGERNESS TO TURN COMICS INSIDE-OUT AND UPSIDE-DOWN IN AN EFFORT TO **UNDERSTAND** THE FORM'S POTENTIAL MORE FULLY.

THE DETERMINATION TO HOLD UP A **MIRROR** TO LIFE'S FACE -- WARTS AND ALL -- AND TO RESIST **PANDERING** OR **SELLING OUT.**

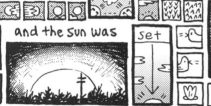

and the sun was

set

THE WILLINGNESS TO LET CRAFT AND STORY TAKE A **BACK SEAT** IF NECESSARY, IN PURSUIT OF **NEW IDEAS** THAT COULD **CHANGE** COMICS FOR THE BETTER.

THE CONVICTION OF ARTISTS TO REMAIN **TRUE TO THEMSELVES** WHILE NEVER TAKING THEMSELVES TOO **SERIOUSLY.** TO FLY NO ONE'S FLAG --

uestion
alc.

What is?

erything.

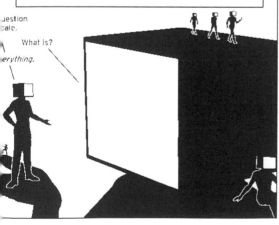

-- NOT EVEN **THEIR OWN.**

WHEN AN ARTIST STARTS TO BUILD HIS OR HER COMICS AROUND ONE OF THESE COLLECTIONS OF VALUES, HE OR SHE MAY DISCOVER A LOOSELY AFFILIATED **TRIBE** OF LIKE-MINDED COMICS ARTISTS THAT SHARE SUCH VALUES. FOR DISCUSSION'S SAKE, LET'S CALL THEM...

THE **CLASSICISTS**	THE **ANIMISTS**	THE **FORMALISTS**	THE **ICONOCLASTS**

EXCELLENCE, HARD WORK, MASTERY OF CRAFT, THE QUEST FOR ENDURING BEAUTY.

PUTTING CONTENT FIRST, CREATING LIFE THROUGH ART, TRUSTING ONE'S INTUITION.

UNDERSTANDING OF, EXPERIMENTATION WITH, AND LOYALTY TO THE COMICS FORM.

HONESTY, VITALITY AUTHENTICITY AND UNPRETENTIOUSNESS. PUTTING LIFE FIRST.

HOW MANY ARTISTS SETTLE FOR JUST **ONE** SET OF VALUES, THOUGH?

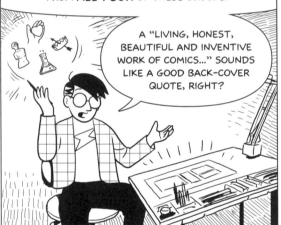

IF YOU'RE LIKE MOST COMICS CREATORS, YOU PROBABLY WOULDN'T MIND ACHIEVING GOALS FROM **ALL FOUR** OF THESE GROUPS.

A "LIVING, HONEST, BEAUTIFUL AND INVENTIVE WORK OF COMICS..." SOUNDS LIKE A GOOD BACK-COVER QUOTE, RIGHT?

AND, IN FACT, MOST CREATORS SPEND TIME AT MORE THAN ONE "CAMPFIRE" DURING THEIR CAREERS.

BUT USUALLY, YOU CAN TELL WHICH ONE BURNS **BRIGHTEST** FOR A GIVEN CREATOR --

-- AND THERE'S ALMOST ALWAYS ONE OF THE FOUR THAT BURNS RARELY OR NOT AT ALL FOR THEM.

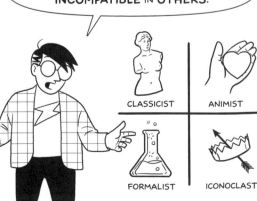

THIS IS PARTIALLY BECAUSE THESE FOUR IDEALS, WHILE **COMPATIBLE** WITH EACH OTHER IN **SOME** WAYS, ARE **INCOMPATIBLE** IN **OTHERS**.

CLASSICIST ANIMIST

FORMALIST ICONOCLAST

FOR EXAMPLE, THE CLASSICIST AND ANIMIST IDEALS BUILD ON TRADITIONS OF **CRAFT** AND **STORYTELLING**, WHICH FORMALISTS AND ICONOCLASTS ENJOY **OVERTURNING**.

TRADITION

—————————————

REVOLUTION

AND CLASSICISTS AND FORMALISTS SHARE A FOCUS ON **ART** FOR **ART'S SAKE**, IN CONTRAST TO THE ANIMIST/ICONOCLAST'S TENDENCY TO SEE ART PRIMARILY THROUGH **LIFE'S** LENS.

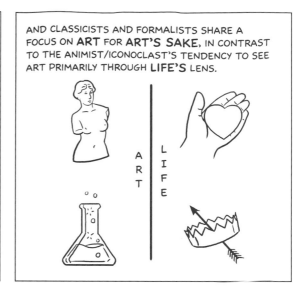

A R T

L I F E

WHEN A COMICS ARTIST SHOWS A STRONG ATTRACTION TO **TWO** OF THESE IDEALS, IT'S USUALLY ONE OF THESE ADJACENT PAIRS.

FOR EXAMPLE, ADVENTURE STRIP MASTER **MILTON CANIFF** PUT STORY FIRST IN THE MOLD OF THE ANIMISTS, BUT HIS IMPECCABLE **COMPOSITIONS** BETRAY A CLASSICIST'S EYE.

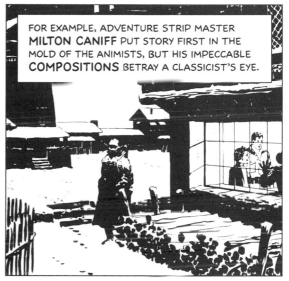

ART SPIEGELMAN, THOUGH PRACTICALLY A PATRON SAINT TO YOUNG **FORMALISTS**, ALSO HAS A STRONG **ICONOCLASTIC** STREAK.

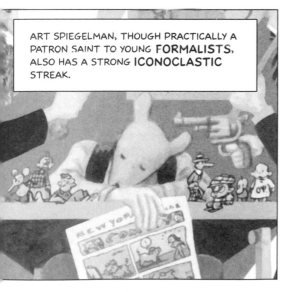

AND DAVE MCKEAN'S ART COMBINES FORMALIST **EXPERIMENTS** WITH A CLASSICIST'S PASSION FOR **MASTERY** AND **BEAUTY**.

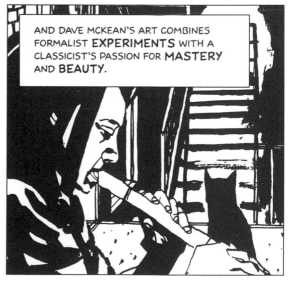

233

MIXING ALONG THE **DIAGONALS** IS LESS COMMON BECAUSE OPPOSITE CORNERS OFTEN REPRESENT OPPOSITE **VALUES**.

A **FORMALIST** APPROACH MAKES THE COMICS FORM **VISIBLE** THROUGH EXPERIMENTATION -- EXACTLY WHAT THE CONTENT-DRIVEN **ANIMIST** TRIES TO **AVOID** BY PUTTING STORY FIRST.

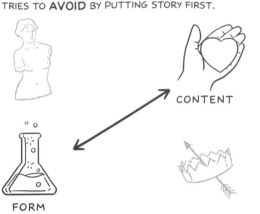

CONTENT

FORM

AND **CLASSICISTS** WHO PURSUE WORKS OF **BEAUTY** MAY FIND LITTLE COMMON GROUND WITH **ICONOCLASTS** WHO FEEL DRIVEN TO CONFRONT THE **"UGLY TRUTHS"** OF LIFE.

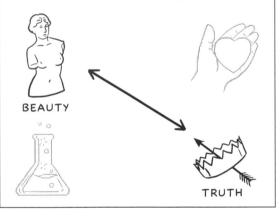

BEAUTY

TRUTH

THERE ARE THOSE WHO EMBODY THESE CONFLICTING IDEALS IN THEIR ART, BUT THEY TEND TO COMBINE THEM LIKE **OIL** AND **WATER** --

-- EACH IDEAL GOVERNING A **DIFFERENT ASPECT** OF THE WORK.

A BEAUTIFULLY CRAFTED, MASTERFUL RENDITION OF JUNK CULTURE'S GROTESQUE UNDERBELLY, FOR EXAMPLE, AS IN THE CASE OF **CHARLES BURNS** --

-- OR A CONSCIOUSLY INVENTIVE, FORMALLY AWARE BODY OF WORK, WITH PURE INTUITIVE MYSTERY AT ITS HEART, AS IN THE ART OF **JIM WOODRING**.

IT'S TEMPTING TO SEE THESE CATEGORIES AS AN OUTGROWTH OF EACH ARTIST'S **PERSONALITY.**

THE FOUR TRIBES CORRESPOND ROUGHLY TO CARL JUNG'S FOUR PROPOSED FUNCTIONS OF **HUMAN THOUGHT*** --

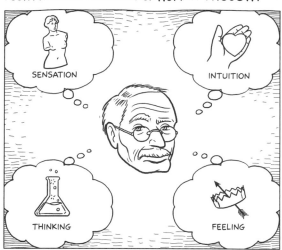

SENSATION

INTUITION

THINKING

FEELING

-- AND I KNOW, IN MY OWN CASE, THAT AS A NERDY, ANALYTICAL SON OF AN ENGINEER, I WAS BOUND TO HEAD FOR THE **FORMALIST** CAMPFIRE.

STILL, ALL WE'RE REALLY TALKING ABOUT HERE IS A COLLECTION OF OBSERVABLE **CLUSTERS,** VALUES THAT DIFFERENT GROUPS OF PEOPLE SEEM TO **SHARE.**

IT'D BE A MISTAKE, NOT TO MENTION **OBNOXIOUS,** TO ASSUME THAT ANYONE'S ARTISTIC PERSONALITY OR POTENTIAL WAS **FIXED FOR LIFE** BY SUCH CHOICES.

OH, YOU WOULDN'T **UNDERSTAND,** MARTIN. YOU'RE AN "ANIMIST."

A **WHAT??**

⇥HMPH⇤

WHATEVER YOUR PERSONALITY, THERE'S NOTHING TO STOP YOU FROM MOVING FROM **ONE CLUSTER** TO **ANOTHER** AS OFTEN AS YOU WANT.

THAT SAID, HEADING TOWARD ONE OR TWO OF THESE ARTISTIC PHILOSOPHIES MIGHT TURN OUT TO BE A **GOOD DIRECTION** FOR YOU IN THE LONG RUN --

-- EVEN IF IT ISN'T THE DIRECTION YOU'RE HEADING IN **NOW.**

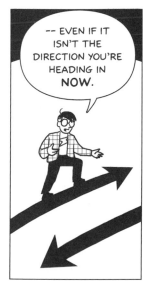

* MORE ON JUNG'S CATEGORIES IN CHAPTER NOTES.

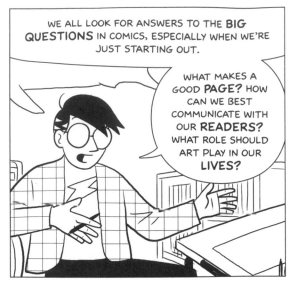

WE ALL LOOK FOR ANSWERS TO THE **BIG QUESTIONS** IN COMICS, ESPECIALLY WHEN WE'RE JUST STARTING OUT.

WHAT MAKES A GOOD **PAGE?** HOW CAN WE BEST COMMUNICATE WITH OUR **READERS?** WHAT ROLE SHOULD ART PLAY IN OUR **LIVES?**

BUT DEPENDING ON WHICH **TRIBE** YOU ASK, EACH QUESTION MIGHT HAVE UP TO **FOUR DIFFERENT ANSWERS!**

AND EVEN IF YOU'RE **LUCKY** AND FIND THE ANSWERS THAT ARE RIGHT FOR YOU FROM THE **START**, IT HELPS TO UNDERSTAND THE **ALTERNATIVES.**

BECAUSE FOR ALL THEIR **STRENGTHS**, EACH OF THESE FOUR APPROACHES TO MAKING COMICS HAS ITS OWN **DOWNSIDE.**

THE CLASSICIST'S LOVE OF **HARMONY** AND **BALANCE**, FOR EXAMPLE, CAN LEAD TO AN UNINTENTIONALLY **STATIC** UNIVERSE WITHOUT REAL DRAMA.

THE **INTUITIVE** APPROACH OF THE ANIMISTS CAN PRODUCE POWERFUL WORK FOR A **TIME**, BUT DOESN'T ALWAYS AGE WELL WITHOUT A **BROADER** PERSPECTIVE.

THE FORMALIST MAY PRODUCE **DRY, ACADEMIC** OR EVEN **UNREADABLE** COMICS BY OBSESSING OVER FORM TO THE **DETRIMENT** OF CONTENT.

AND THE **ICONOCLAST'S** DETERMINATION TO NEVER "SELL-OUT" CAN LEAD TO SOME KNEE-JERK REACTIONS **AGAINST** ANYTHING EVEN REMOTELY **POPULAR** OR **SLICK**.

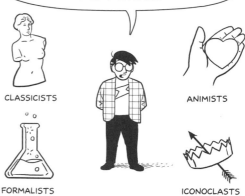

STILL, WHATEVER THEIR DRAWBACKS, ALL **FOUR** TRIBES HAVE BEEN INVALUABLE IN KEEPING COMICS **ALIVE** AND **KICKING** OVER THE YEARS.

CLASSICISTS

ANIMISTS

FORMALISTS

ICONOCLASTS

THE **CLASSICISTS** HAVE BEEN THE **BACKBONE** OF COMICS, DEVELOPING AND REFINING A CENTURY OF TECHNIQUES.

THE **ANIMISTS** HAVE CREATED MORE **READERS** THAN THE OTHER THREE TRIBES PUT TOGETHER, AND ARE OUR MOST VALUABLE ASSETS.

THE **FORMALISTS** KEEP MOVING COMICS FORWARD, STAYING ON THE FOREFRONT OF EACH GENERATION OF NEW **IDEAS**.

AND THE **ICONOCLASTS** ARE COMICS' **CONSCIENCE**, AND THE SOURCE OF MANY OF ITS MOST PROFOUND WORKS.

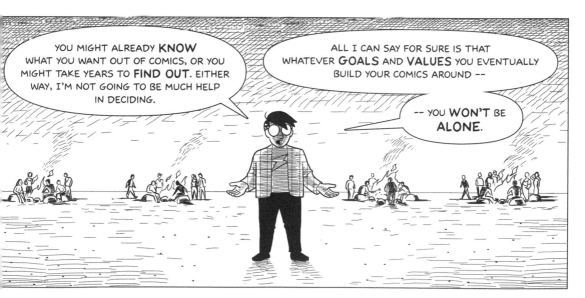

YOU MIGHT ALREADY **KNOW** WHAT YOU WANT OUT OF COMICS, OR YOU MIGHT TAKE YEARS TO **FIND OUT**. EITHER WAY, I'M NOT GOING TO BE MUCH HELP IN DECIDING.

ALL I CAN SAY FOR SURE IS THAT WHATEVER **GOALS** AND **VALUES** YOU EVENTUALLY BUILD YOUR COMICS AROUND --

-- YOU **WON'T** BE **ALONE**.

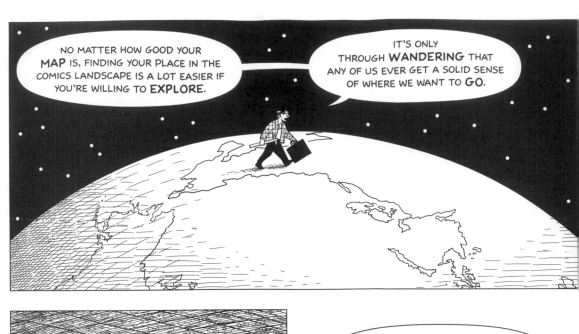

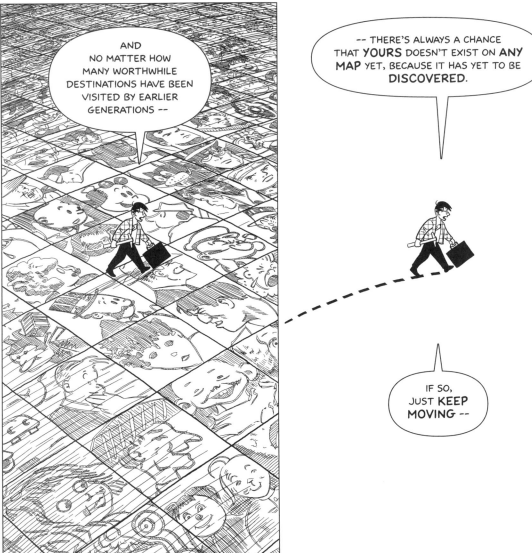

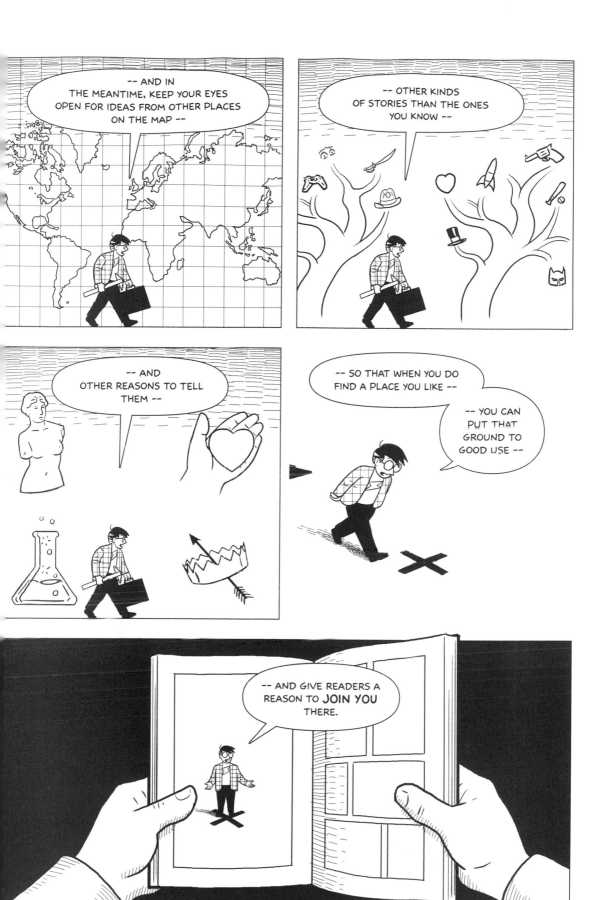

239

NOTES

CHAPTER 6: YOUR PLACE IN COMICS

GENERAL COMMENTS ON MANGA

I'M USING THE WORD "MANGA" TO REFER TO COMICS MADE IN JAPAN AND PUBLISHED FIRST IN JAPANESE. I MIGHT USE THE TERM "MANGA-FORMAT" OR "MANGA-STYLE" TO DESCRIBE COMICS FROM ELSEWHERE THAT ARE INFLUENCED BY JAPAN, BUT IT'S ALL STILL COMICS AS FAR AS I'M CONCERNED. THAT SAID, IF A GUY IN NEWARK WANTS TO CALL HIS COMIC "NEW JERSEY'S BEST MANGA," I'M NOT GOING TO ARGUE WITH HIM.

THIS SECTION STICKS MOSTLY TO THE DYNAMICS BETWEEN THE JAPANESE AND NORTH AMERICAN STYLES BECAUSE THAT'S BEEN THE MOST VISIBLE CULTURE CLASH HERE IN RECENT YEARS, BUT KOREAN, CHINESE AND OTHER TRANSLATED ASIAN COMICS ARE STARTING TO APPEAR ON THE SHELVES. THEIR APPROACH TO STORYTELLING SHOWS SOME DISTINCT DIFFERENCES FROM JAPAN, BUT THEY CLEARLY COME FROM THE SAME PART OF THE WORLD, JUST AS BRITISH COMICS FOLLOWED A DIFFERENT PATH FROM THEIR AMERICAN COUNTERPARTS, WHILE STILL RECOGNIZABLY PART OF THE ENGLISH LANGUAGE COMICS TRADITION.

OTHER FACTORS CAN COMPLICATE THE EAST-WEST DIVIDE. SOME OF THE COLOR WORK IN RECENT AMERICAN MAINSTREAM COMICS IS INFLUENCED BY CLASSIC EUROPEAN ALBUMS, TAKING IT IN A DIFFERENT DIRECTION ENTIRELY, AND COLOR ITSELF IS A BIG DIVIDING LINE, OF COURSE, SINCE ALMOST ALL MANGA IS IN BLACK AND WHITE (SEE UNDERSTANDING COMICS, CHAPTER 8 FOR SOME IDEAS ON HOW COLOR AFFECTS THE READING EXPERIENCE).

IN THIS CHAPTER, MOST OF MY EXAMPLES ARE FROM MAINSTREAM TYPES OF MANGA INCLUDING SOME POPULAR SHOJO AND SHONEN TITLES BECAUSE THOSE ARE THE KINDS THAT ARE AVAILABLE HERE, BUT NORTH AMERICAN BOOKSTORES ONLY SHOW A FRACTION OF WHAT'S AVAILABLE IN JAPAN. SOME GENRES BARELY GET SHELVED AT ALL, ESPECIALLY THOSE DEALING WITH SPECIFIC OCCUPATIONS AND ACTIVITIES. THERE'S ALSO A COUNTERPART TO THE NORTH AMERICAN UNDERGROUND AND ALTERNATIVE SCENE IN JAPAN THAT DOESN'T CROSS THE OCEAN MUCH. CHECK OUT THE

BIBLIOGRAPHY FOR SOME BOOKS ON THE SUBJECT.

NO COUNTRY HAS ALL THE ANSWERS. CARTOONISTS EVERYWHERE TAKE SHORTCUTS. PUBLISHERS EVERYWHERE TRY TO CLONE WHATEVER WORKED LAST TIME. STORE SHELVES EVERYWHERE ARE FAR TOO SHORT. BUT MANGA ARTISTS IN THE LATE 20TH CENTURY MADE EXCEPTIONAL GAINS IN UNLOCKING COMICS' POTENTIAL AND I THINK THAT STUDYING THEIR RESULTS CAN BENEFIT ANYONE SERIOUS ABOUT MAKING COMICS.

PAGE 216 - MORE ON MANGA TECHNIQUES

ICONIC FACES:

SEE UNDERSTANDING COMICS, PAGES 30-45, FOR A DISCUSSION OF HOW CARTOON IMAGERY AFFECTS THE READING EXPERIENCE. ON THIS POINT, THE EAST/WEST CONTRAST I NOTICED IN 1982 WAS SPECIFICALLY BETWEEN MANGA AND THE SUPERHERO "MAINSTREAM" COMICS. THERE WERE PLENTY OF CARTOONY CHARACTERS IN NEWSPAPER STRIPS AND THE KIDS COMICS FROM GOLD KEY, DISNEY, ETC.

SENSE OF PLACE:

THIS WAS A BIT STRONGER IN 1982 THAN IT IS NOW. MANGA NEVER WENT AS FAR AS THE EUROPEANS IN THE WORLD-BUILDING DEPARTMENT (EXCEPT FOR EUROPEAN-INFLUENCED ARTISTS LIKE MIYAZAKI) BUT CONVEYING THE EXPERIENCE OF A PLACE WAS VERY IMPORTANT, AND FREQUENTLY GIVEN A LOT OF ROOM AT THE BEGINNINGS OF SCENES.

WORDLESS PANELS/ASPECT TO ASPECT TRANSITIONS:

NORTH AMERICAN COMICS HAVE DEFINITELY PICKED UP ON THIS OVER THE LAST 25 YEARS WITH THE GROWTH OF GRAPHIC NOVELS AND THE REDUCED NEED TO HURRY STORIES ALONG AND KEEP EVERYBODY TALKING. SEE UNDERSTANDING COMICS, PAGES 74-89, FOR MORE ON HOW SILENCE AND TRANSITION TYPES VARY FROM EAST TO WEST.

SUBJECTIVE MOTION:

SEE UNDERSTANDING COMICS, PAGES 108-114, FOR MORE ON HOW SUBJECTIVE MOTION WORKS.

GENRE MATURITY:

SUSHI CHEFS, BASEBALL PLAYERS, FISHERMEN, STUDENTS, "SALARYMEN"... NO MATTER WHO YOU WERE

LEFT: ART BY KOREAN ARTISTS KIM JEA EUN AND DOHA KANG. RIGHT: ART BY HIRONORI KIKUCHI AND YUKO TSUNO (SEE ART CREDITS, PAGE 258).

240

IN JAPAN, THERE WAS PROBABLY A GENRE OF COMICS DEVOTED TO YOU IN 1982 -- AND AS FAR AS I KNOW, THERE STILL IS. WHAT FASCINATED ME, THOUGH, WAS THAT FROM AN ARTISTIC STANDPOINT, EACH GENRE WAS WILDLY DIFFERENT. EACH HAD ITS OWN APPROACH TO PACING, FRAMING, EXPRESSIONS AND BODY LANGUAGE. IF A BIG MAINSTREAM COMICS PUBLISHER IN THE U.S. DECIDED TOMORROW TO PUBLISH FIVE COMICS DEALING WITH SKATEBOARDING, HIGH SCHOOL ROMANCE, NASCAR, MODELING AND POLITICS RESPECTIVELY, THEY MIGHT FEATURE VERY DIFFERENT TYPES OF STORIES, BUT THE BASIC STORYTELLING ENGINE WOULD PROBABLY BE THE SAME. BY "MATURITY," I MEAN JUST THAT -- THE KIND OF DIFFERENTIATION THAT ONLY COMES WITH YEARS OF GROWTH (AS DISCUSSED ON PAGE 226).

CHARACTER DESIGNS:

VARIETY OF CHARACTER DESIGN IN MANGA HAS SOFTENED OVER THE YEARS AS THE CARTOONY TRADITIONS BEGUN BY TEZUKA HAVE GIVEN WAY TO MORE IDEALIZED CHARACTER DESIGNS. GENERALLY SPEAKING, THE BOY'S ACTION GENRES SHOW A BIT MORE VARIATION THAN GIRL'S ROMANCE. SOME SHOJO ARTISTS TRY A LITTLE TOO HARD TO MAKE EVERYBODY BEAUTI-FUL IN SIMILAR WAYS. THEN AGAIN, I'M A GUY, SO TAKE THAT WITH A GRAIN OF SALT.

SMALL, REAL WORLD DETAILS:

THIS IS ANOTHER AREA WHERE JAPAN AND THE U.S. MIGHT BE MEETING IN THE MIDDLE, AS MANGA VEERS A BIT TOWARD THE FANTASTIC AND NORTH AMERICAN COMICS ARTISTS PAY MORE ATTENTION TO THE REAL WORLD. FOR A GREAT EXAMPLE OF A LATE 20TH CENTURY MANGA MASTER WHO UNDERSTOOD THE POWER OF SMALL MUNDANE DETAILS, CHECK OUT *THE PUSH MAN*, A TRANSLATED COLLECTION OF MATURE, SOMEWHAT DARK STORIES BY YOSHIHIRO TATSUMI AVAILABLE FROM DRAWN AND QUARTERLY.

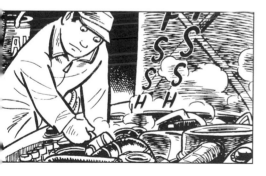

EMOTIONALLY EXPRESSIVE EFFECTS:

SOME STYLES ARE BLATANTLY EXPRESSIONISTIC IN PORTRAYING EMOTIONS THROUGH PEN AND INK. RIYOKO IKEDA HELPED PERFECT SUCH EFFECTS IN CLASSIC STORIES LIKE THE *ROSE OF VERSAILLES*. I DEVOTE CHAPTER FIVE OF *UNDERSTANDING COMICS* TO THE IDEA THAT SQUIGGLES OF INK ON PAPER CAN LOOK HAPPY, SAD, AFRAID OR ANGRY, BUT THESE ARTISTS HAVE MADE THE CASE, FAR MORE ELOQUENTLY THAN I CAN, OVER THE COURSE OF MORE THAN 100,000 PAGES.

PAGE 217 - OTHER EXPLANATIONS

JUST TO BE CLEAR, I DON'T WANT TO COMPLETELY DISCOUNT "FORMATS, MARKETING AND CULTURAL DIFFERENCES" AS FACTORS IN MANGA'S SUCCESS. THE ABSENCE OF COLOR PRINTING ALONE WOULD HAVE STEERED MANGA IN A DIFFERENT DIRECTION FROM EUROPE, AND I'VE SPECULATED MYSELF ABOUT DIFFERING TRADITIONS IN WESTERN AND EASTERN ART. BUT HAVING EXPERIENCED MANGA STORYTELLING MYSELF, I BECAME CONVINCED THAT THE FEELINGS IT PRODUCED IN ME AS A READER WERE THE "ACTIVE INGREDIENT" THAT HAD DRIVEN MANGA'S WILDLY SUCCESSFUL COMICS INDUSTRY.

PAGE 218, PANEL SIX - THE MADAGASCAR EFFECT

ONE OF THE MOST INTERESTING THINGS ABOUT MANGA IN THE DECADES LEADING UP TO THE EIGHTIES IS HOW LITTLE EUROPEAN AND AMERICAN STYLES HAD PENETRATED IT. OSAMU TEZUKA MAY HAVE TAKEN SOME CUES FROM AMERICAN ANIMATION AT THE OUTSET, BUT HE WENT ON TO CREATE SOMETHING UNIQUELY HIS OWN AND IN RETROSPECT -- AS A NATION FOLLOWED HIS LEAD -- UNIQUELY JAPANESE. ARTISTS LIKE OTOMO AND MIYAZAKI WERE JUST BEGINNING TO BRING A MORE EUROPEAN FLAVOR TO MANGA AROUND THE TIME I WANDERED INTO BOOKS KINOKUNIYA ON MY LUNCH HOUR IN 1982, BUT COMPARED TO THE PROMISCUOUS TRADING OF IDEAS BETWEEN EUROPE AND AMERICA DURING THIS PERIOD, JAPAN WAS TRULY AN ISLAND.

JAPAN'S COMICS CULTURE IS LIKE ANOTHER ISLAND NATION, MADAGASCAR, IN THE WAY THAT ITS ARTISTIC FLORA AND FAUNA GREW TO LOOK LIKE NOTHING ELSE ON EARTH DUE TO ITS RELATIVE ISOLATION. ISOLATION CAN SOMETIMES LEAD TO STAGNATION AND INBREED-ING, BUT TEZUKA'S CAREER SEEMS TO HAVE PROMPTED SUCH A BIODIVERSITY OF GENRES AND STYLES RIGHT FROM THE START THAT NATURAL COMPETITION WAS PRESERVED OVER THE COURSE OF FOUR DECADES, LEADING TO A HEALTHY, THRIVING COMICS CULTURE.

PAGE 219, PANEL THREE -- ALTERNATIVE COMICS AND GRAPHIC NOVELS

I INCLUDE A FACE FROM CHYNNA CLUGSTON'S SCHOLAS-TIC COMIC *QUEEN BEE* IN THIS PANEL, WHICH ISN'T EXACTLY PART OF WHAT WE CALL THE "ALTERNATIVE" OR "GRAPHIC NOVEL" SCENE, BUT IT BELONGS IN THIS PANEL MORE THAN IN THE NEXT TWO, SINCE IT'S NOT A WEBCOMIC AND ISN'T "MAINSTREAM" -- AT LEAST NOT IN THE TORTURED SENSE THAT WE USE THE TERM IN AMERICA (I.E., IT DOESN'T LOOK LIKE A SUPERHERO COMIC). CLUGSTON IS CLEARLY INFLUENCED BY AND ASPIRING TOWARD A MANGA STYLE. THOMPSON AND KIM HAVE ABSORBED A LOT OF MANGA INFLUENCES, THOUGH THEY DON'T PURSUE IT AS THEIR DOMINANT STYLE, AND CHRIS WARE JUST HAPPENS TO BE TREADING SOME OF THE SAME GROUND WITH HIS USE OF SILENT MULTI-PANEL ESTABLISHING SHOTS AND OTHER TECHNIQUES.

PAGES 220-221 - SHOJO VERSUS SHONEN

THESE TERMS MOSTLY REFER TO TARGET AUDIENCES (GIRLS VERSUS BOYS) RATHER THAN ANY SPECIFIC GENRE. THERE'S OBVIOUSLY A LOT OF ROMANCE IN SHOJO TITLES AND A LOT OF ACTION IN SHONEN TITLES, BUT THEY'RE NOT IRON-CLAD DISTINCTIONS. RUMIKO TAKAHASHI'S *RANMA 1/2* IS CONSIDERED SHONEN, FOR EXAMPLE, BUT IT'S READ BY PLENTY OF GIRLS, INCLUDING MY OWN DAUGHTERS.

MANGA TARGETED AT ADULT MEN AND WOMEN (SEINEN AND JOSEI, RESPECTIVELY) OR SMALL CHILDREN (KODOMO) AREN'T TRANSLATED AS OFTEN IN THE STATES, BUT YOU CAN FIND SOME ON THE SHELVES.

PAGE 221 - SUPERHEROES AND MANGA

PANEL FOUR IS FROM *ULTIMATE SPIDER-MAN VOLUME ONE* WITH PENCILS BY MARK BAGLEY AND INKS BY ART THIBERT AND DAN PANOSIAN. MANGA-STYLE MOTION LINES LIKE THESE APPEAR IN SEVERAL PLACES, AND THE BOOK HAS A SLIGHT POST-MANGA FLAVOR OVERALL.

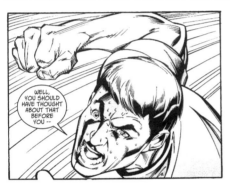

WITH THAT IN MIND, IT'S INTERESTING TO COMPARE IT TO SOMETHING LIKE MASASHI KISHIMOTO'S SUPERHERO-LIKE *NARUTO*, (SEEN AT THE TOP OF PAGE 221) TO SEE HOW MANY DIFFERENCES STILL REMAIN BETWEEN THE TWO COMICS CULTURES. FIGURES IN THE *ULTIMATE SPIDER-MAN* PANELS SEEM TO FACE OUT MORE OFTEN, FOR EXAMPLE. THE FIGURES IN NARUTO OFTEN FACE AWAY FROM THE READER, AS IF WE'RE RUNNING INTO ACTION BEHIND THEM OR CONTROLLING THEIR MOVEMENTS IN A GAME. FIGURES IN *US-M* ALSO TEND TO FILL THE PANEL MORE. KISHIMOTO SEEMS LESS RELUCTANT TO PULL BACK FOR LONG-SHOTS OF HIS HEROES (THOUGH HE GOES TOE-TO-TOE WITH HIS AMERICAN COUNTERPARTS IN THE EXTREME CLOSE-UPS DEPARTMENT).

PAGES 222-223 - MANGA'S SCATTERED SEEDS

WHEN I BEGAN MAKING COMICS IN THE EARLY '80S, THERE WERE ONLY A FEW PUBLISHED ARTISTS WHO OPENLY ACKNOWLEDGED A MANGA INFLUENCE. THE THREE MOST PROMINENT AT THE TIME WERE WENDY PINI, FRANK MILLER (WHOSE SERIES RONIN HAD DIRECT NODS TO LONE WOLF AND CUB) AND COLLEEN DORAN. ALL INCORPORATED MANGA IDEAS INTO THEIR WORK,

THOUGH NONE WOULD BE DESCRIBED AS "AMERICAN MANGA" AS SOME LATER TITLES WOULD BE. ARTISTS LIKE LEA HERNANDEZ PURSUED MANGA STYLES MORE FULLY AND WERE PRECURSORS TO THE MORE RECENT OEL (ORIGINAL ENGLISH LANGUAGE) MANGA VOLUMES WHICH SIT ALONGSIDE JAPANESE IMPORTS IN THE SAME FORMAT.

LIKE ANY STYLE WITH A DEVOTED FAN FOLLOWING, THERE'S SOME CONTROVERSY OVER TERMINOLOGY AND AUTHENTICITY (ASK A 20-SOMETHING NIRVANA FAN WHAT "GRUNGE" MEANS FOR A DEMONSTRATION OF THIS PRINCIPLE). THE EARLY TERM "AMERI-MANGA" BECAME AN INSULT IN SOME CIRCLES, AND EVEN "OEL" HAS ITS DETRACTORS, THOUGH IT'S HARD TO IMAGINE A MORE NEUTRAL WAY OF DESCRIBING SUCH BOOKS. SOME OEL MANGA LIKE SVETLANA CHMAKOVA'S *DRAMACON* STAY VERY CLOSE TO MAINSTREAM MANGA STYLES AND CELEBRATE MANGA'S MORE IDIOSYNCRATIC TOUCHES LIKE "CHIBIS" (PAGE 220, PANEL SIX IS A CHIBI VERSION OF ME). OTHER OELS LIKE AMY KIM GANTER'S *SORCERERS AND SECRETARIES* (PAGE 222) STILL RETAIN SOME WESTERN FLAVOR BUT ARE TARGETED TO MANGA READERS THROUGH FORMAT, PUBLISHER AND OVERALL TONE.

GANTER AND BRYAN LEE O'MALLEY (WHOSE *SCOTT PILGRIM* CAN BE SEEN AT THE TOP OF PAGE 223) ARE PART OF A NEW WAVE OF YOUNG CARTOONISTS WHO'VE READ PLENTY OF COMICS FROM JAPAN AND AMERICA OVER THE YEARS, AND WHOSE INFLUENCES HAVE BLENDED TO THE POINT WHERE IT'S HARD TO TELL WHERE ONE STYLE BEGINS AND THE OTHER ENDS. THIS TREND IS ESPECIALLY NOTABLE IN THE GROUND-BREAKING *FLIGHT* ANTHOLOGY, WHICH ALSO BECAME A MEETING PLACE FOR WEBCOMICS ARTISTS HEADING FOR PRINT AND ANIMATION ARTISTS HEADING FOR COMICS. *PUBLISHER'S WEEKLY* EVEN REFERRED TO GANTER AS PART OF THE "FLIGHT GENERATION," WHICH MAY NOT BE FAR OFF WHEN WE LOOK BACK AT THIS PERIOD.

PAGES 227 - UNDERSTANDING BANDE DESSINEE?

LIKE MANGA, THE EUROPEAN TRADITION IS INCREDIBLY RICH AND DIVERSE. OBVIOUSLY, I DON'T THINK THAT EVERYBODY IN EUROPEAN COMICS IS CONSCIOUSLY GOING AFTER WORLD-BUILDING AS THEIR TOP ASSIGNMENT. LIKE ARTISTS IN ANY CULTURE, THEY HAVE A THOUSAND DIFFERENT GOALS IN MIND WHEN THEY SIT DOWN TO THE DRAWING BOARD.

BUT COMPARED TO JAPAN AND NORTH AMERICA, WORLD-BUILDING WAS A CONSTANT FEATURE IN THE COMICS OF ARTISTS FROM HERGE TO UDERZO TO MOEBIUS TO TARDI TO SCHUITEN TO JANSSON. NO MATTER WHAT THE GENRE, EUROPEAN ARTISTS RARELY SKIMPED ON THE CREATION OF RICH ENVIRONMENTS AND THE CONSTANT REITERATION OF THOSE ENVIRONMENTS ON EVERY PAGE. FOR MUCH OF THE 20TH CENTURY, WORLD-BUILDING WAS A BEDROCK ASSUMPTION, FAR ABOVE WHICH, DIVERSE CAREERS TOOK ROOT.

LIVING IN AMERICA, I MAY BE TOO CLOSE TO SPOT OUR OWN COMMON DENOMINATORS, BUT I DON'T DOUBT

SEE ART CREDITS, PAGE 258.

THAT THEY EXIST. SUMMING UP POST-KIRBY SUPER-HERO COMICS WOULD BE LIKE SHOOTING FISH IN A BARREL, BUT IS THERE A SINGLE THEME THAT ROPES IN EVERYTHING FROM KIRBY TO EISNER TO CRUMB TO SCHULZ? IS IT THE PRIMACY OF THE FIGURE? OUR APPROACH TO BACKGROUNDS? THE PROTAGONIST AS LONER? THE WAY CHARACTERS PLAY TO THE READER? OUR FREQUENT USE OF THE WORD "INVULNER-ABLE?"

WHATEVER MAKES NORTH AMERICAN COMICS UNIQUE, IT'S PROBABLY BLURRED IN THE LAST 20 YEARS AS EUROPEAN AND JAPANESE INFLUENCES HAVE ENTERED THE MIX -- AND AS JAPAN AND EUROPE'S UNIQUE QUALITIES HAVE ALSO SOFTENED.

EUROPE, NORTH AMERICA AND JAPAN MAY NEVER AGAIN BE AS DIFFERENT FROM ONE ANOTHER AS THEY WERE WHEN I WAS STARTING OUT. THE WORLD IS SHRINKING, INTERNATIONAL STYLES ARE EMERGING, AND SOON, THE WEB MAY SCRAMBLE THINGS BEYOND RECOGNITION. BUT BACK IN 1982, THE OCEANS SEEMED ESPECIALLY WIDE FOR A YOUNG COMICS FAN.

PAGES 229-237 - THE FOUR TRIBES

I ACTUALLY SAT ON THIS IDEA FOR OVER TEN YEARS WITHOUT PUBLISHING IT, CONCERNED THAT IT MIGHT DO MORE HARM THAN GOOD. I'M SYMPATHETIC TO THOSE WHO SEE ANY SUCH EFFORTS TO CATEGORIZE ART AS REDUCTIVE AND FUTILE. BUT THEN I'D SEE THESE RANTS LIKE:

- "CRAFT IS THE ENEMY OF ART!"
- "ALTERNATIVE COMICS ARE FOR PEOPLE WHO CAN'T DRAW."
- "EVERYONE MAKING MAINSTREAM COMICS IS A SELL-OUT."
- "EXPLAINING ART RUINS IT."
- "IF IT HAS NO NEW IDEAS, WHAT GOOD IS IT?"

AND I REALIZED THAT IN A WORLD WHERE SO MANY PEOPLE REDUCE ART TO TWO SIDES, MAYBE REDUCING IT TO **FOUR** WOULD BE AN IMPROVEMENT.

COMICS IS AN ECOSYSTEM, AND EACH OF THE FOUR TRIBES HAS A ROLE TO PLAY IN KEEPING IT HEALTHY AND GROWING. DECLARING WAR ON ANOTHER'S ARTISTIC PHILOSOPHY IS AS POINTLESS AS A TREE SCOLDING THE GRASS FOR BEING SHORT. WE MAY BE COMPETING FOR THE SUNLIGHT OF OUR READERS' ATTENTION, BUT THAT DOESN'T MEAN WE'D BE BETTER OFF WITHOUT EACH OTHER.

PAGE 235 - CLUSTERS

THIS IS AN IMPORTANT POINT THAT I HOPE KEEPS THE FOUR TRIBES IDEA FROM DESCENDING INTO SOME-THING MORE TOXIC. THERE ARE NO HARD DIVIDING LINES BETWEEN THESE FOUR IDEALS, AND NO ONE LABEL CAN EVER SUM UP A HUMAN BEING. BUT EACH PHILOSOPHY HAS A CERTAIN GRAVITY TO IT THAT MAKES THOSE CLUSTERS OF ARTISTS VISIBLE ON THE PAGE, ON THE WEB AND ON THE CONVENTION FLOOR.

NEW ARTISTS WALK INTO THE CROWD, MEET OTHERS LIKE THEMSELVES AND GRADUALLY START HANGING OUT WITH THE ARTISTS THAT SHARE THEIR VALUES, THE ONES WHO "GET IT" WHEN THEY START TALKING ABOUT THE THINGS THAT ARE THE MOST IMPORTANT TO THEM. THINK OF HOGWARTS' SORTING HAT IN THE *HARRY POTTER* BOOKS, PICKING OUT THE GRYFFINDORS, HUFFLEPUFFS, RAVENCLAWS AND SLYTHERINS... ONLY THERE'S MORE TABLE-HOPPING, AND HARDLY ANYONE IS TRYING TO KILL YOU.

PAGE 236-237 - DRAWBACKS OF THE TRIBES

I'LL CONFESS TO THE SINS OF THE FORMALIST. I CAN POINT TO ANY NUMBER OF COMICS THAT I'VE DRAWN IN WHICH EXPERIMENTAL IDEAS WERE PRETTY MUCH THEIR ONLY VIRTUE. ANYBODY CALLING SUCH COMICS "DRY," "ACADEMIC" OR "UNREADABLE" WON'T GET MUCH RESISTANCE FROM ME. AS LONG AS SOMETHING IS JUST AN EXPERIMENT, ARTISTS LIKE ME ARE CONTENT WITH SOME FAILURES ALONG THE WAY. "IF YOU CAN GUARAN-TEE THE RESULTS IN ADVANCE, IT'S NOT AN EXPERI-MENT" SUMS UP THE ATTITUDE.

BUT FORMALISTS LIKE ME CAN SCREW UP BADLY WHEN WE TRY TO TELL A STORY STRAIGHT. WE KEEP GETTING DISTRACTED BY ALL THE FORMAL POSSIBILITIES ALONG THE WAY, AND WIND UP WITH A STIFF, FILL-IN-THE-BLANKS COMIC WHERE INDIVIDUAL PANELS ARE JUST BORED EXCUSES TO GET TO THE NEXT BIG IDEA. YOU MIGHT CALL IT THE "NOT SEEING THE TREES FOR THE FOREST" PROBLEM, AND IT'S A COMMON ONE WITH ART-NERDS LIKE ME. IT'S HARD TO JUST TELL A STORY STRAIGHT WHEN THERE ARE SO MANY POSSIBILITIES IN THE AIR.

I'M NOTORIOUS FOR ENCOURAGING A LOT OF CRAZY EXPERIMENTS IN PRINT AND ON THE WEB, EVER SINCE *UNDERSTANDING COMICS* CAME OUT IN 1993. YET IN MOST OF THIS BOOK, I'M ESSENTIALLY TEACHING MY READERS TO BURY THEIR EXPERIMENTS AND IMPERSON-ATE ANIMISTS! GO BACK TO PAGE ONE. SEE THE BALLOON IN THAT MIDDLE PANEL?:

> A READING EXPERIENCE SO SEAMLESS THAT IT DOESN'T FEEL LIKE READING AT ALL BUT LIKE **BEING** THERE?

THAT'S THE LAST THING ON A FORMALIST'S MIND, AND IT'S NOT EXACTLY WHAT THE ICONOCLASTS OR CLASSI-CISTS ARE AFTER EITHER. BUT JUST AS I MENTION IN THE NOTES TO CHAPTER ONE, THIS IS WHERE MAKING COMICS STARTS. IT'S WHY COMICS EXIST. AND PURSUING THAT GOAL HELPS TO ILLUMINATE THE PATH TO ANY NUMBER OF OTHER GOALS.

ADDITIONAL NOTES AT:
WWW.SCOTTMCCLOUD.COM/MAKINGCOMICS

Chapter Seven

Making Comics

The Comics Professional

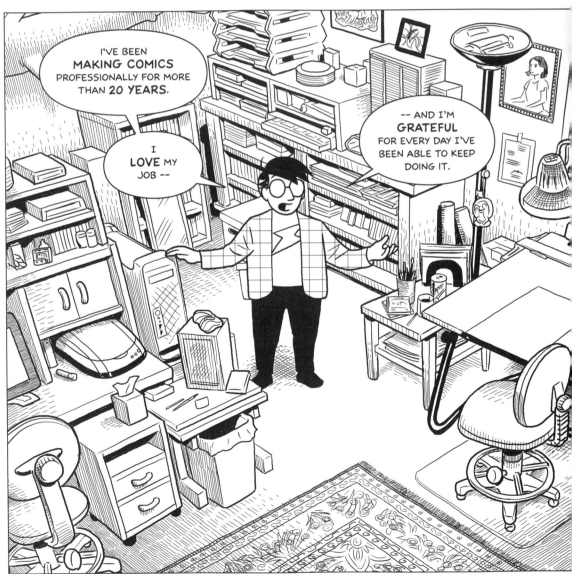

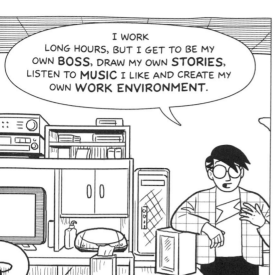

I WORK LONG HOURS, BUT I GET TO BE MY OWN **BOSS**, DRAW MY OWN **STORIES**, LISTEN TO **MUSIC** I LIKE AND CREATE MY OWN **WORK ENVIRONMENT**.

EXCEPT FOR THE SHARK.

THAT WAS ALREADY HERE WHEN I RENTED THIS PLACE.

IN SHORT, FOR A **CONTROL FREAK** LIKE ME, IT'S THE **PERFECT JOB**!

IF MAKING COMICS SOUNDS LIKE A GOOD JOB TO **YOU**, YOU MIGHT BE WONDERING HOW TO BREAK INTO **"THE BUSINESS."**

BUT BEFORE CONSIDERING THAT, YOU'LL NEED TO ASK YOURSELF: **"WHICH BUSINESS?"**

IN NORTH AMERICA ALONE, THERE ARE **TWICE** AS MANY MARKETS TO CONSIDER AS WHEN I STARTED.

NONE OFFER AN EASY ROAD TO FAME OR FORTUNE, AND SOME ARE MORE CREATIVELY RESTRICTED THAN OTHERS, BUT MOST OFFER AT LEAST A FEW **SUCCESS STORIES**.

NEWSPAPER COMIC STRIPS

PERIODICAL COMIC BOOKS

GRAPHIC NOVELS

ALTERNATIVE / SMALL PRESS

MISCELLANEOUS PRINT

MANGA FORMAT

WEBCOMICS

OTHER NEW MEDIA

SOME OF COMICS' BIGGEST SUCCESS STORIES OVER THE YEARS HAVE BEEN IN **NEWSPAPER STRIPS** AND PERIODICAL **COMIC BOOKS.**

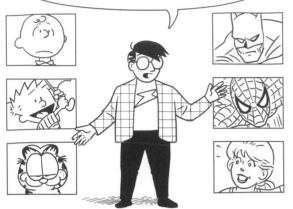

THE SYNDICATES AND PUBLISHERS THAT SERVICE THE BIGGEST SHARES OF THESE MARKETS ARE VERY SELECTIVE ABOUT THE **STYLE** AND **CONTENT** OF WHAT THEY ACCEPT, THOUGH.

AND THE **COMPETITION** IS FIERCE!

ENTER

ME! NO, ME!!

IF THE KINDS OF COMICS YOU WANT TO MAKE DON'T FIT EASILY INTO A POPULAR NICHE, YOU MIGHT FIND MORE CREATIVE LATITUDE IN **"ALTERNATIVE" COMICS** PUBLISHERS AND **ARTS WEEKLIES** --

LA WEEKLY
EIGHTBALL
SHARK HUNTERS

-- OR **SELF-PUBLISHING** VIA OFFSET PRESS, PRINT-ON-DEMAND OR EVEN PHOTOCOPYING.

WHRRRRR... SHLK SHLK

WITH LIMITED **DISTRIBUTION,** SUCH OPTIONS MEAN LITTLE OR NO CASH UP FRONT --

KRAFT Macaroni & Cheese

YOUR NEW DINNER MENU

TOP Ramen

-- BUT ALTERNATIVE AND SMALL PRESS WORK CAN ALSO FEED INTO THE **GRAPHIC NOVEL** MARKET. IN FACT, MANY HITS OF THE GRAPHIC NOVEL MOVEMENT **ORIGINATED** IN THE SMALL PRESS AND ALTERNATIVE SCENES.

THE COMPLETE MAUS
art Spiegel
GHOST WORLD
Blankets
David Cl
A WINNI ORRIGAN
CRAIG THOMPSON

OF COURSE, THE MOST SUCCESSFUL COMICS MARKET IN NORTH AMERICA DOESN'T ACTUALLY **COME** FROM NORTH AMERICA --

-- BUT SOME ARTISTS IN NORTH AMERICA HAVE HAD LUCK CREATING **MANGA-FORMATTED** COMICS OF THEIR OWN.*

* EITHER THROUGH DOMESTIC OR JAPANESE PUBLISHERS

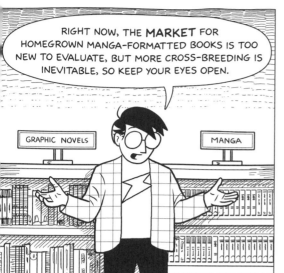

RIGHT NOW, THE **MARKET** FOR HOMEGROWN MANGA-FORMATTED BOOKS IS TOO NEW TO EVALUATE, BUT MORE CROSS-BREEDING IS INEVITABLE, SO KEEP YOUR EYES OPEN.

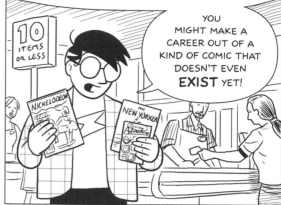

ALSO KEEP YOUR EYES OPEN FOR OPPORTUNITIES IN **OTHER PRINT PUBLICATIONS** THAT RUN COMICS. THESE POP-UP ALL THE TIME AND CAN RESULT IN GREAT **VISIBILITY**.

YOU MIGHT MAKE A CAREER OUT OF A KIND OF COMIC THAT DOESN'T EVEN **EXIST** YET!

ON THE **WEB**, PUBLISHING AND DISTRIBUTION ARE ONE AND THE SAME AND -- AT LEAST AT THE ENTRY POINT -- FAIRLY **CHEAP**.

IF YOU HAVE THE **EQUIPMENT** FOR IT, OF COURSE.

RIGHT NOW, THE BIGGEST **WEBCOMICS HITS** ARE ABLE TO TURN A PROFIT FROM ADVERTISING, MERCHANDISE, DONATIONS, ETC. MOST STILL STRUGGLE TO MAKE A LIVING, BUT THE SCENE IS CHANGING CONSTANTLY.

SEE THE **NOTES PAGE** FOR MORE INFO.

EVEN THE WEB MAY NOT BE THE COMICS BUSINESS' **CUTTING EDGE** IN A FEW YEARS, AS THE PROSPECT OF NEW **INFORMATION APPLIANCES** AND OTHER APPLICATIONS OF NEW MEDIA LOOMS.

THERE HAVE BEEN SOME INITIATIVES IN THIS DIRECTION BUT THE FIELD IS STILL IN ITS **INFANCY**, AND ITS FATE IS ANYONE'S GUESS.

IF YOU'RE LIKE MOST PEOPLE, YOU WANT TO **DO YOUR OWN THING** AND GET **PAID** FOR IT, AND WHILE REALIZING THAT DREAM MIGHT NEVER BE **EASY**, THE GROWTH OF NEW MARKETS HAS DEFINITELY **HELPED**.

THE WHOLE IDEA OF **"BREAKING INTO"** COMICS IMPLIES THAT THERE'S SOME SORT OF **INSTITUTION** WITH A **FIXED LOCATION** THAT YOU CAN **FIND** AND **PENETRATE** --

≈GASP!≈ HE'S **FOUND** US!!

WE **HAVE** TO GIVE HIM A JOB NOW!!

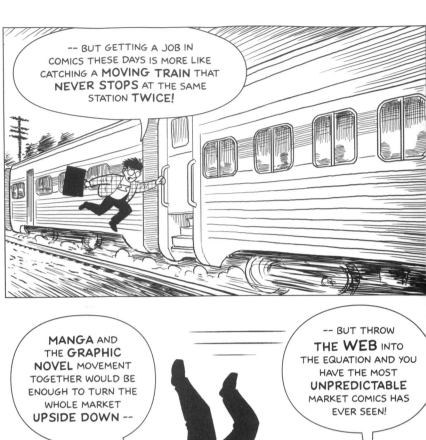

-- BUT GETTING A JOB IN COMICS THESE DAYS IS MORE LIKE CATCHING A **MOVING TRAIN** THAT **NEVER STOPS** AT THE SAME STATION **TWICE!**

MANGA AND THE **GRAPHIC NOVEL** MOVEMENT TOGETHER WOULD BE ENOUGH TO TURN THE WHOLE MARKET **UPSIDE DOWN** --

-- BUT THROW **THE WEB** INTO THE EQUATION AND YOU HAVE THE MOST **UNPREDICTABLE** MARKET COMICS HAS EVER SEEN!

BE PREPARED TO TAKE SOME **TUMBLES** BEFORE YOU GET IT RIGHT!

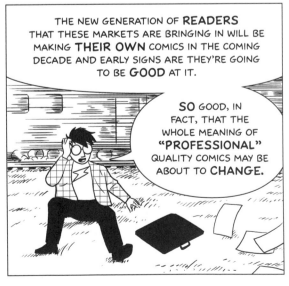

THE NEW GENERATION OF **READERS** THAT THESE MARKETS ARE BRINGING IN WILL BE MAKING **THEIR OWN** COMICS IN THE COMING DECADE AND EARLY SIGNS ARE THEY'RE GOING TO BE **GOOD** AT IT.

SO GOOD, IN FACT, THAT THE WHOLE MEANING OF **"PROFESSIONAL"** QUALITY COMICS MAY BE ABOUT TO **CHANGE.**

THAT'S WHY I HOPE THAT YOU'LL DO MORE THAN JUST **CATCH-UP** TO MY GENERATION OF PROS --

-- BUT WILL TRY TO GO **BEYOND** WHAT **ANY** OF US HAVE EVER DONE.

LOOK BACK THROUGH THIS BOOK AND YOU'LL FIND A DOZEN OPPORTUNITIES TO **GO BEYOND** WHAT **ANY** COMICS ARTIST WORKING TODAY IS ACHIEVING!

THESE AREN'T THE GOALS EVERY SUCCESSFUL ARTIST MEETS --

-- THEY'RE THE GOALS PROFESSIONALS USUALLY **FAIL** TO MEET -- INCLUDING **ME!**

NOW'S YOUR CHANCE TO EXPLORE THE CUTTING EDGE **STORYTELLING TECHNIQUES** MY GENERATION HAS ONLY BEGUN TO **UNDERSTAND** --

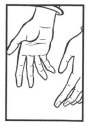

-- TO FIND SOMETHING NEW TO **SAY**, AND SAY IT WITH A CLEAR, STRONG **VOICE** --

 CHOICE OF **MOMENT**

 CHOICE OF **FRAME**

CHOICE OF **IMAGE**

 CHOICE OF **WORD**

 CHOICE OF **FLOW**

-- TO CREATE **CHARACTERS** WITH INNER LIVES SO **DEEP** AND OUTER APPEARANCES SO **VARIED** AND **COMPELLING**, THEY TAKE ON **LIVES OF THEIR OWN.**

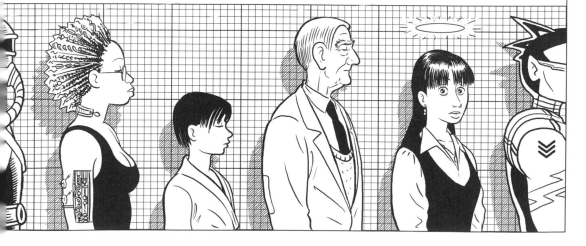

NOW'S YOUR CHANCE TO TAP INTO THE EMOTIONAL POWER OF **FACIAL EXPRESSIONS** --

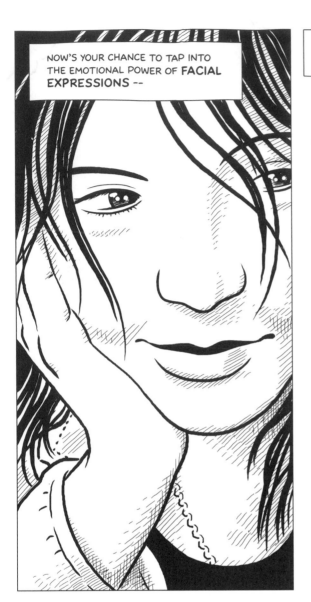

-- AND THE **SIGNS** AND **SYMBOLS** OF THE **HUMAN BODY** --

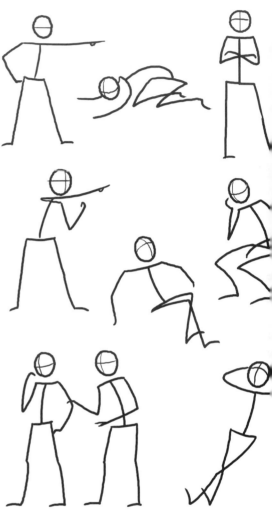

-- BRING **WORDS AND PICTURES** TOGETHER TO CREATE **IDEAS** AND **SENSATIONS** NONE OF US EVEN DREAMED COMICS COULD PRODUCE --

-- AND TRANSPORT US TO **PLACES** WE NEVER DREAMED COMICS COULD GO.

WHATEVER **TOOLS** YOU USE --

-- WHATEVER **PASSIONS** DRIVE YOU TO **CREATE** --

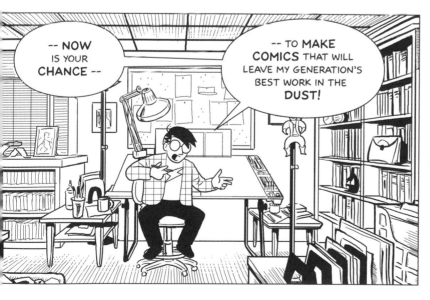

-- **NOW** IS YOUR **CHANCE** --

-- TO **MAKE COMICS** THAT WILL LEAVE MY GENERATION'S BEST WORK IN THE **DUST!**

IF YOU THINK YOU HAVE WHAT IT TAKES.

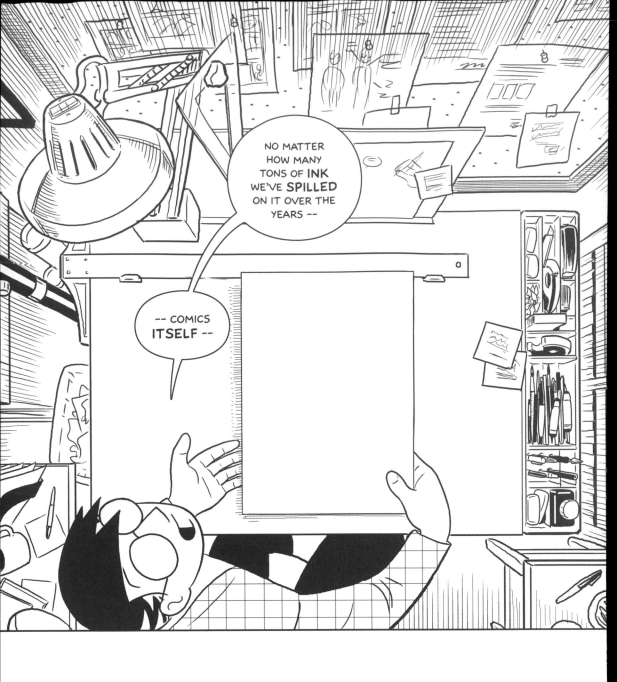

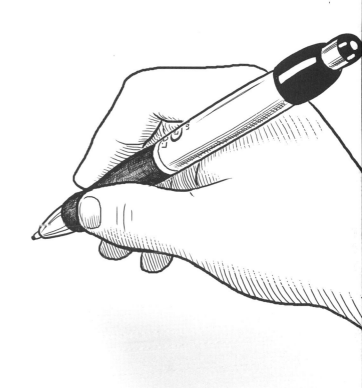

NOTES

CHAPTER 7: MAKING COMICS

PAGE 244 - A GOOD JOB TO HAVE?

I REALLY DO LOVE MY JOB, BUT NOT EVERYONE WHO MAKES COMICS FEELS THE SAME WAY, AND I DON'T KNOW ANY CARTOONISTS WHO WOULD CALL IT "EASY."

CHRIS WARE WARNED AN AUDIENCE OF WOULD-BE CARTOONISTS: "YOU REALLY, REALLY HAVE TO WORK HARD. DRAWING COMICS REQUIRES PRETTY MUCH ALL OF YOUR FREE TIME... TWO OR MORE DECADES WILL PASS WITHOUT YOUR NOTICING IT AT ALL. FRIENDS WILL BE MARRIED, HAVE CHILDREN, GET DIVORCED AND DIE, ALL WHILE YOU'RE WORKING ON YOUR SLOW MOTION PICTURE STORY. AVERAGE RATIO OF WORK TIME TO ACTUAL NARRATIVE STORY TIME, FOUR THOUSAND TO ONE." WARE'S OWN COMICS ARE UNUSUALLY LABOR-INTENSIVE, BUT OTHERS ECHO HIS DIRE PROGNOSIS, MOST FAMOUSLY CHARLES SCHULZ WHO FLATLY STATED: "CARTOONING WILL DESTROY YOU; IT WILL BREAK YOUR HEART."

I'LL STICK BY MY "NICE WORK IF YOU CAN GET IT" ATTITUDE -- AND I'M NOT ALONE -- BUT IT'S ALSO IMPORTANT TO STRESS THE "IF" IN THAT CHEERY PHRASE. THE NUMBER OF COMICS ARTISTS MAKING ENOUGH MONEY TO SUPPORT A FAMILY IS VERY SMALL COMPARED TO THE NUMBER OF THOSE WHO WANT TO, AND THE TALENT AMONG THE WANNABES HAS SKYROCKETED LATELY. BEING GOOD ENOUGH ISN'T GOOD ENOUGH. YOU HAVE TO BE GREAT.

PAGE 247, PANELS THREE-FOUR - THE WEBCOMICS MARKET

NO MARKET IS AS UNPREDICTABLE AND RAPIDLY EVOLVING AS WEBCOMICS. I'M WRITING THIS IN SPRING, AND BY THE TIME THIS BOOK COMES OUT IN AUTUMN, EVERYTHING MIGHT HAVE CHANGED AGAIN. SOME THINGS ARE CONSTANT THOUGH. YOUR BEST BET FOR GETTING NOTICED IS STILL DOING GOOD WORK THAT CONNECTS WITH YOUR AUDIENCE, FOLLOWED BY GETTING THE WORD OUT TO THOSE ARTISTS AND BLOGGERS THAT FREQUENTLY LINK TO THINGS THEY LIKE. GET TO KNOW THE SCENE AS A READER AND YOU'LL FIND IT EASIER TO JOIN THE SCENE AS AN ARTIST AND WRITER.

RIGHT NOW, THE MOST SUCCESSFUL COMICS ON THE WEB ARE THE WEB-NATIVE HUMOR STRIPS WITH AUDIENCES BIG ENOUGH TO ATTRACT ADVERTISERS AND SPONSORSHIPS, PROMOTE ASSOCIATED PRINT TITLES AND SELL MERCHANDISE. LONG FORM WEBCOM-ICS, THE EQUIVALENTS OF COMIC BOOKS AND GRAPHIC NOVELS ONLINE, HAVE HAD FEWER BREAK-OUT HITS BUT CONTINUE TO PROLIFERATE.

PAID DOWNLOADS, DESPITE AN EXPLOSION IN THE MUSIC INDUSTRY, ARE LESS COMMON IN ENGLISH LANGUAGE WEBCOMICS AT THIS POINT, THOUGH BUSINESSMEN AND CARTOONISTS (INCLUDING ME) CONTINUE TO TRY OUT VARIOUS MODELS, AND THERE ARE SOME SIGNIFICANT RUMBLINGS IN THE ASIAN ONLINE COMICS MARKET.

I'LL TRY TO SUM UP THE CURRENT SCENE IN MY ONLINE NOTES (AND IN MY ONLINE EXTENSION TO THE TECHNOLOGY SECTION, "CHAPTER 5 1/2"). FOR NOW, JUST REMEMBER THAT NO COMICS MARKET BETTER FITS THAT RUNAWAY TRAIN METAPHOR FROM PAGE 248 THAN WEBCOMICS.

FINAL THOUGHTS

I SAID AT THE BEGINNING OF THIS BOOK THAT THERE ARE NO RULES YOU NEED TO FOLLOW. IF YOU'RE CURIOUS THOUGH, I DO HAVE SOME RULES I TRY TO FOLLOW MYSELF. HERE ARE FOUR:

1. LEARN FROM EVERYONE
2. FOLLOW NO ONE
3. WATCH FOR PATTERNS
4. WORK LIKE HELL

NOBODY HAS ALL THE ANSWERS, INCLUDING ME, BUT I THINK EVERYONE HAS A PIECE OF THE PUZZLE. I HOPE YOU'LL TREAT THIS BOOK AS A STARTING POINT, A GUIDE TO THE PATTERNS AND POSSIBILITIES AT LEAST ONE ARTIST BELIEVES HE SEES OUT THERE. THERE ARE PLENTY OF MY PEERS WHO DISAGREE WITH ME ABOUT SOME OF THESE TOPICS. LEARN FROM ALL OF US AND DECIDE FOR YOURSELF WHAT WORKS FOR YOU.

YOU COULD IGNORE EVERYTHING I'VE WRITTEN AND STILL PRODUCE A GREAT COMIC. YOU COULD FOLLOW EVERY SUGGESTION I'VE MADE AND STILL TURN OUT A PIECE OF CRAP. THERE'S NO REPLACEMENT FOR INSTINCT AND INSPIRATION. BUT IF THIS BOOK HAS HELPED TO IMPROVE THE FORMER OR BOLSTER THE LATTER, THAT'S ENOUGH FOR ME.

THANKS FOR READING AND GOOD LUCK,

-- SCOTT MCCLOUD
 SOMEWHERE IN AMERICA, 2006

FOR ADDITIONAL NOTES, "CHAPTER 5 1/2," RESOURCES, LINKS, UPDATES, PONTIFICATIONS, RUN-ON SENTENCES, WEASELLY DISCLAIMERS AND DETAILS ON THE MASSIVE *MAKING COMICS TOUR (ALL FIFTY STATES, STARTING IN FALL OF 2006 -- WE HOPE!)* VISIT:

WWW.SCOTTMCCLOUD.COM/MAKINGCOMICS

Bibliography and Suggested Reading

A true bibliography for this book would be thousands of titles long, since most of the ideas in these pages came from reading comics, not books *about* comics. Still, I hope you'll find the following list helpful. Some of these books helped me directly with research. Many are just good books I can recommend.

The Head of the Class

There are a few books which excel at their respective topics to such a degree that they qualify as essential reading. Here they are:

Chelsea, David. *Perspective! For Comics Artists*. New York, NY: Watson-Guptill, 1997.

Eisner, Will. *Comics and Sequential Art*. Tamarac, FL: Poorhouse Press, 1985.

Faigin, Gary. *The Artist's Complete Guide to Facial Expression*. New York, NY: Watson-Guptill, 1990.

Lee, Stan and John Buscema. *How to Draw Comics the Marvel Way*. New York, NY: Simon and Schuster, 1978.

Tufte, Edward. *The Visual Display of Quantitative Information*. Cheshire, CT: Graphics Press, 1987.

Chelsea and Faigin's books are the most practical since you're bound to need their advice on every page you draw. Chelsea's book is in comics form like this one and it's a real eye-opener. If you've ever had trouble drawing in perspective, he'll set you right in record time. Faigin's book on expressions was a great help for me personally. As with my own section on expressions, though, don't get hung up on style. Faigin isn't telling you how to draw expressions in any particular way, just helping you understand how the face works and he does that extremely well.

Eisner's book is a foundation we've all been building on for years. His 1996 book *Graphic Storytelling and Visual Narrative* is also recommended.

Lee and Buscema are much narrower in their focus, but if you want to understand the style of comics they helped refine in the '70s, *Marvel Way* certainly delivers.

Tufte's book is about information design, not comics, but his ideas on clarity and communication are powerful and persuasive. Tufte knows that good design is about more than just choosing the right logo and does a great job of explaining why. *Visual Display* is the classic that started it all, but his later books *Envisioning Information* (1990) and *Visual Explanations* (1997) are just as good.

General Reference / Theory

Blackbeard, Bill and Martin Williams. *The Smithsonian Collection of Newspaper Comics*. Washington, DC: Smithsonian Institution Press, 1977. A classic, oversized collection of many classic early comic strips. Might be at your local library if you can't find (or afford) a used copy.

Dooley, Michael and Steve Heller. *The Education of a Comics Artist: Visual Narrative in Cartoons, Graphic Novels, and Beyond*. New York, NY: Allworth Press, 2005. Interviews with a wide range of comics artists and cartoonists (including me) and odd, but interesting glimpses into the brains of some of the better artists working today.

Gravett, Paul. *Graphic Novels: Stories to Change Your Life*. New York, NY: Collins Design, 2005. Slick coffee table format, but Gravett is a serious observer of the scene and covers a lot of ground (same goes for his Manga book below).

Harvey, R.C. *The Art of the Comic Book*. Jackson, MS: University Press of Mississippi, 1996. Also see Harvey's 1994 book *The Art of the Funnies*.

Schutz and Brownstein editors. *Eisner/Miller*. Milwaukie, OR: Dark Horse Publishing, 2005. Two giants of American comics, Will Eisner and Frank Miller, talk about anything and everything for 347 pages.

More on Manga

Deppey, Dirk editor. *The Comics Journal #269*. Seattle, WA: Fantagraphics, 2005. Several interesting essays about Manga in this oversized edition of the venerable TCJ.

Gravett, Paul. *Manga: Sixty Years of Japanese Comics*. London, UK: Laurence King Publishing, 2004.

Schodt, Frederik L. *Manga! Manga! The World of Japanese Comics*. Tokyo/New York: Kodansha International, 1983. A year after I started scouring the shelves at Books Kinokuniya in New York (see page 215), Schodt's book came out and answered a lot of questions. Also check out his more recent *Dreamland Japan*.

Shiratori, Chikao. *Secret Comics Japan*. San Francisco, CA: Cadence Books, 2000. Nice anthology of some Japanese underground comics, compiled by a former editor of the influential Japanese alternative anthology *Garo*.

And yes, there are literally hundreds of how-to books focusing on Manga styles. I wish I could help sort through the pile, but I've had trouble identifying the standouts. Pick whatever looks good to you. Just keep an eye on what's going on *under* those styles.

Drawing Humans

Bridgman, George. *Constructive Anatomy, Bridgman's Life Drawing, etc.* New York, NY: Dover Publications. Popular figure drawing books from the 1920s, still in use today.

Darwin, Charles. *The Expression of the Emotions in Man and Animals.* Oxford, UK: Oxford University Press, third edition 1998, first published in 1872. With extensive footnotes by Paul Ekman.

Ekman, Paul. *Emotions Revealed.* New York, NY: Henry Holt, 2003. In-depth analysis of facial expressions. Sparse illustrations, but still useful for artists and a key source for Gary Faigin's book.

Hamm, Jack. *Cartooning the Head and Figure.* New York, NY: The Putnam Publishing Group, 1967. I don't know any contemporary cartoonists who actually want to *draw* like Jack Hamm, but we all adore his goofy, obsessively detailed how-to books and you might too.

Morris, Desmond. *Manwatching.* New York, NY: Harry N. Abrams, 1977. (Out of print but don't let that stop you.) If the stuff on page 111 interests you, track down a copy of Morris' mindblowing book from the '70s. I was frustrated in my search for a guide to body language that was as good as the texts I found for facial expressions (most seemed pre-occupied with how to pick up women at the water cooler or convince the regional sales manager that you were a go-getter) but Morris' book, which I've owned since college, continues to be a source of inspiration and delight.

Writing for Comics

Gertler, Nat editor. *Panel One: Comic Book Scripts by Top Writers.* Thousand Oaks, CA: About Comics, 2002. Examples of various comics scripts in the form they were given to the artist; the follow-up volume, *Panel Two* reprints one of my own scripts from the '80s.

O'Neil, Denis. *The DC Comics Guide to Writing Comics.* New York, NY: DC Comics, 2001. From the same series as DC's art instruction guides (below).

Salisbury, Mark. *Writers on Comics Scriptwriting.* London, UK: Titan Books, 2002. Don't have it, but the one on artists (see below) is pretty good and I'm guessing this is too.

Tools and Techniques

Blair, Preston. *Cartoon Animation.* Laguna Hills, CA: Walter Foster Publishing, 1995 (more compact format than the original I got back in the '70s).

Collins, Sean T. editor. *How to Draw: The Best of Wizard Basic Training.* Congers, NY: Wizard Entertainment, 2005. Pretty much the polar opposite of this book, but a decent survey of contemporary mainstream superhero styles, plus some great advice from smart veterans like Joe Kubert and Walt Simonson.

Guptill, Arthur L. *Rendering in Pen and Ink.* New York, NY: Watson-Guptill, 1997. Originally published in 1937. Recommended by several artists I contacted.

Loomis, Andrew. *Various titles.* Paul Smith and other artists I know swear by the figure drawing books of Andrew Loomis. The site SaveLoomis.org has links to online sources for various Loomis titles.

Martin, Gary with Steve Rude. *The Art of Comic-Book Inking.* Milwaukie, OR: Dark Horse Publishing, 1997. A well-respected how-to guide that a few of my correspondents mentioned. May be out of print, but you might still find copies out there.

Norling, Ernest. *Perspective Made Easy.* Mineola, NY: Dover Publications, 1999. First published in 1939, this book solidly delivers the promise of the title. And it's cheap! Another favorite of Paul Smith.

Richardson, John Adkins. *The Complete Book of Cartooning.* Englewood Cliffs, NJ: Prentice-Hall, 1977. Though a bit dated, Drew Weing and I both have fond memories of this smart, eclectic book that caught our eye when we were first learning to make comics.

Salisbury, Mark. *Artists on Comics Art.* London, UK: Titan Books, 2000. Interesting discussions with comics artists about their techniques.

Various. *The DC Comics Guide to... (... Pencilling, ...Inking, ...Coloring and Lettering).* New York, NY: DC Comics, 2002-2004. Slick, well-done and informative guides modern mainstream techniques.

Walker, Mort. *The Lexicon of Comicana.* Port Chester, NY: Comicana Inc., 1980. Not practical, but a lot of fun.

Withrow, Steve and John Barber. *Webcomics: Tools and Techniques for Digital Cartooning.* Hauppauge, NY: Barrons Educational Series, 2005. Big, flashy collection of some of the Web's most creative cartoonists. Definitely skewed to the eccentric artsy cartoonists like me, but it offers a lot of good information on tools and techniques.

For online guides, visit:
www.scottmccloud.com/makingcomics

Art Credits

Unless otherwise noted, the creator is also the copyright holder.

Page 5, panel 1: Lynn Johnston, *For Better or For Worse*. David Mazzucchelli, *Batman: Year One* (with Frank Miller) © DC Comics. Art Spiegelman, *Maus: A Survivor's Tale*. Rumiko Takahashi, *Ranma 1/2* © Rumiko Takahashi/Shogakukan. David B., *Epileptic*. Demian 5, *When I am King* (www.demian5.com).
Page 25, panel 4: Jaime Hernandez, *Love and Rockets*.
Page 27, panel 6: Matt Feazell, from *Disney Adventures/Mickey Mouse* ©/™ Disney.
Page 28, panel 4: Jason Lutes, *Jar of Fools*.
Page 29, panel 3: Craig Thompson, *Blankets*. **Panel 4:** Ho Che Anderson, *King*. Frank Miller, *Sin City*.
Page 30, panel 4: Image of Kelly Donovan used by permission. Thanks, Kelly!
Page 31, panel 31: Derek Kirk Kim, *Same Difference and Other Stories*.
Page 47, panel 3: Eiichiro Oda, *One Piece*. **panel 4:** Francois Schuiten, *Zara* (with Luc) © Les Humanoides.
Page 56: Chester Brown, *Louis Riel*.
Page 68, panel 2-4: Characters from *Zot!* © Scott McCloud. **Panel 5:** Dumbledore from *Harry Potter* by J. K. Rowling, Gandalf from *The Lord of the Rings* by J. R. R. Tolkien, Obi Wan Kenobi from *Star Wars* © Lucasfilm.
Page 66: Steve Ditko, *Amazing Fantasy #15* (with Stan Lee) © Marvel Entertainment Group.
Page 69, panel 4: Walt Kelly, *Pogo* © OGPI.
Page 70, panel 7: Rumiko Takahashi, *Ranma 1/2* © Rumiko Takahashi/Shogakukan.
Page 72, panel 1: Uderzo, *Asterix* (with Goscinny) © Dargaud. **Panel 2:** Yasuiti Osima, *Father and Son* (with Norio Hayasi). **Panel 3:** Jaime Hernandez, *Love and Rockets*. *Zot!* © me. Characters from Neil Gaiman's *Sandman* © DC Comics. Characters from *The Fantastic Four* © Marvel Entertainment Group.
Page 79, panel 2: Craig Thompson, *Blankets*.
Page 100, panel 5: Art Spiegelman, *Maus: A Survivor's Tale*. Chris Ware, *Jimmy Corrigan: The Smartest Kid on Earth*. **Panel 6:** Jason Little, *Jack's Luck Runs Out*.
Page 106, panel 5: Bryan Hitch with Paul Neary/Andrew Currie, *The Ultimates Volume 2* (with Mark Millar) © Marvel Entertainment Group. **Panel 6:** Chris Ware, *Jimmy Corrigan: The Smartest Kid on Earth*; R. Crumb, "Memories are Made of This" from *Weirdo #22*; Seth, *Clyde Fans Book One*; Eric Drooker, "Home" from *Flood*.
Page 115, panel 1: Heinrich Kley, Untitled sketch. **Panel 2:** Jaime Hernandez, *Love and Rockets*. **Panel 4:** Tom Hart, *The Sands*.
Page 124: Preston Blair, *Cartoon Animation*.
Page 125: Jaime Hernandez, *Love and Rockets*. Mort Walker, *The Lexicon of Comicana*. Kyle Baker, *Kyle Baker Cartoonist: Volume 2*.
Page 126: Charles Schulz, *Peanuts* © United Media, Jaime Hernandez, *Love and Rockets*. Will Eisner, *City People Notebook, Contract with God and Family Matters*. Craig Thompson, *Blankets*.
Page 132: Spongebob SquarePants ™ Viacom.
Page 135, panel 7: Renée French, *The Soap Lady*. **Panel 8:** Patrick Atangan, *The Yellow Jar*.
Page 136, Panel 3: (top down) Junji Ito, *Uzumaki* © Junji Ito / Shogakukan; Jeff Smith, *Bone*; Tom Hart *Hutch Owen's Working Hard*, Chris Ware, *Acme Novelty Library*; James Sturm, *The Golem's Mighty Swing*; David B., *Epileptic*; And Vera Brosgol "I Wish..." from *Flight #1*.
Page 137, panel 3: David Mazzucchelli, *City of Glass* (with Paul Karasik) adaptation © Bob Callahan Studios.
Page 138, panel 7: Art Spiegelman, "Don't Get Around Much Anymore" from *Breakdowns*.
Page 139, panel 2: Steve Ditko, *Ditko Public Service Package*. **Panel 3:** Will Eisner, *A Contract with God*. David Choe, *Slow Jams*. Chris Ware, *Jimmy Corrigan: The Smartest Kid on Earth*.
Page 140-141: See credits for 135-139.
Page 142, panel 2: Will Eisner, *Comics and Sequential Art*. Panel 4: Posy Simmonds, *Gemma Bovery*. **Panel 6:** Peter Kuper, "Sex, Drugs, Rock'n'Roll" from *Stripped*. Hope Larson & Lucy Knisley. *Letters from the Bottom of the Sea*.
Page 144, panel 2: Jack Kirby, *Fantastic Four* (with Stan Lee) © Marvel Entertainment Group. **Panel 3:** Patrick McDonnell, *Mutts*. **Panel 4:** Dave Sim, *Cerebus* (with Gerhard). **Panel 6:** Will Eisner, *Comics and Sequential Art*.
Page 145, panel 1: Dan Clowes, *Ghost World*. **Panel 2:** Jason Lutes, *Berlin*.
Page 149, panel 5: Leonardo Da Vinci, Tiny bit o' *The Mona Lisa*; Jane Austen, Tiny bit o' *Pride and Prejudice*.
Page 152, panel 5: Patrick McDonnell, *Mutts*.
Page 153, panel 1: Vincent Van Gogh, Tiny bit o' *Starry Night*; James Joyce, Tiny bit o' *Ulysses*.
Page 154: Will Eisner, *The Spirit*.
Page 155: David Choe, *Slow Jams*. Guy Delisle, *Pyongyang* © Guy Delisle and L'Association; Marjane Satrapi, *Persepolis* © Marjane Satrapi and L'Association.
Page 156, top down: Will Eisner, *The Spirit*; Shawn McManus, *Sandman* (writer Neil Gaiman, lettering Todd Klein) © DC Comics; Jordan Crane, *The Clouds Above*; Masashi Kishimoto, *Naruto*. Bottom right: Craig Thompson, *Blankets*.
Page 167, panel 1: Seth, *Clyde Fans Book One*.
Page 169, panels 1-3: Charles Schulz, *Peanuts* © United Media. Panel 4: Rick Geary, "The Age of Condos" from *At Home with Rick Geary*.
Page 171, panel 2: John Porcellino, *King-Cat Comics and Stories: Special Mini-Supplement to McSweeney's Quarterly Concern #13*. **Panel 3:** Debbie Drechsler, "Sixteen" from *Twisted Sisters 2*. **Panel 4:** Richard Mcguire, "ctrl" from *McSweeney's Quarterly Concern #13*. **Panel 5:** Gary Panter, *Jimbo in Purgatory*. **Panel 6:** Mariscal, "Crash" from *Read Yourself Raw*.
Page 179, panel 2: Hayao Miyazaki, *Nausicaa of The Valley of the Winds* © Nibariki/Tokuma Shoten.
Page 181: Derek Kirk Kim, *Healing Hands*; Edward Gorey, "The West Wing" from *Amphigorey*; John Porcellino, *King-Cat Comics and Stories: Special Mini-Supplement to McSweeney's Quarterly Concern #13*.
Page 182: Jeff Smith, *Bone*.
Page 186: Art by Paul Smith. (Duh).
Page 193: Giorgio Cavazzano, *Walt Disney's World of The DragonLords* (with Byron Erickson) © Disney Enterprises.
Page 194, first row: Craig Thompson, *Blankets*; Marjane Satrapi *Persepolis* © Marjane Satrapi and L'Association; Jessica Abel, *La Perdida*. **Second row:** Hope Larson, *Salamander Dream*; Charles Burns, *Black Hole*; Spike, *Templar, Arizona*. **Third row:** R. Crumb, "The Crumb Family" from *The R. Crumb Handbook*; Jim Rugg, *Street Angel* (with Brian Maruca); Tom Hart, *Hutch Owen*. **Fourth Row:** Dave Cooper, *Dan and Larry*; June Kim, "Sheep, Sheep, Sleep"; Megan Kelso, "The Pickle Fork" from *Scheherazade*. **Fifth Row:** Rick Geary, *At Home with Rick Geary*; Joost Swarte, "The Mirror" from *Raw #5*; Jason Shiga, *Double Happiness*. **Sixth Row:** Howard Cruse, *Stuck Rubber Baby*; Kris Dresen, *Encounter Her*; Toc Fetch, *...of the Most Pope Joey... Volume 5, no.1: The Tenacious Facts of Life of a Noman*.
Page 196: Charles Dana Gibson, "The Education of Mr. Pipp" (1899).
Page 200: Panel 3: Okay, left to right, top down (some were obscured when the collage was pasted in -- apologies to the sliced-up cartoonists) Greg Dean, *Real Life*; Steven Charles Manale, *Superslackers*; Tatsuya Ishida, *Sinfest*; Erika Moen, *DAR: A Super-Girly Top-Secret Comic Diary*; Tracy White, *Traced*; Matt Bayne, *Knights of the Shroud*; Barry Deutsch, *Hereville*; Tintin Pantoja, *Sevenplains*; Roger Langridge, *Hotel Fred*; Spike, *Templar, Arizona*; Neil Babra, *Imitation of Life*; Raina Telgemeier, *Smile*; Walt Holcombe, *Hails at Sea*; Paul Taylor, *Wapsi Square*; R. Stevens, *Diesel Sweeties*; Jason Turner, *Bright Morning Blue*; Scott Kurtz, *PvP*; Bill Mudron, *Pan*; Adrian Ramos, *The Wisdom of Moo*; Kean

Soo, *Jellaby*; Ursula Vernon, *Digger*; Demian 5, *The Truth about Elephants*; Dorothy Gambrell, *The New Adventures of Death*; Um... big rectangle thing... maybe D. Merlin Goodbrey; James Kochalka, *American Elf*; Bryant Paul Johnson, *Teaching Baby Paranoia*; Jason Thompson, *The Stiff*; Mike Krahulik, *Penny Arcade* (with Jerry Holkins); Reinder Dijkhuis, *Courtly Manners* (with Geir Strom); Steven L. Cloud, *Boy on a Stick and Slither*; Kris Dresen, *Manya*; Chris Shadoian, *Streets of Northampton*; Shaenon Garrity, *Narbonic*; Chuck Whelon, *Pewfell* (with Adam Prosser); Derek Kirk Kim, *Half Empty*; Jenn Manley Lee, *Dicebox*; Kazu Kibuishi, *Copper*; Jeff Jacques, *Questionable Content*; Cat Garza, *Cuentos de le Frontera*; Dylan Meconis, *Bite Me*; James Turner, *Beaver and Steve*; Mitch Clem, *Nothing Nice to Say*; Lea Hernandez, *Texas Steampunk*; Christopher Baldwin, *Little Dee*; Faith Erin Hicks, *Ice*; Clio Chiang, *Cascadia*; Natasha Allegri, *Normal Life*; Jeffrey Rowland, *Wigu*; Nicholas Gurewitch, *Perry Bible Fellowship*; Les McClaine, *Jonny Crossbones*; John Allison, *Scary Go Round*; Rachel Hartman, *Return of the Mad Bun*; Steve Bryant, *Athena Voltaire* (with Paul Daly and Chad Fidler; Colin White, *Amicably Subversive*; Jonathan Rosenberg, *Goats*; Fred Gallagher, *Megatokyo*; Svetlana Chmakova, *Chasing Rainbows*. **Panel 4:** Steve Bryant, *Athena Voltaire* (with Paul Daly and Chad Fidler). **Panel 5:** James Kochalka, *American Elf*; Cat Garza, *Cuentos de le Frontera*. **Panel 6:** Scott Kurtz, *PvP*; Mike Krahulik, *Penny Arcade* (with Jerry Holkins). **Panel 7:** John Allison, *Scary Go Round*; Dorothy Gambrell, *The New Adventures of Death*. **Panel 8:** Joe Zabel, *Fear Mongers*; Patrick Farley, *Delta Thrives*. **Panel 9:** Brian Clevinger, *8-Bit Theatre*; R. Stevens, *Diesel Sweeties*.

Page 201, panel 2: Kazu Kibuishi, *Copper*. **Panel 3:** Drew Weing, *Pup*. **Panel 4:** Justine Shaw, *Nowhere Girl*. **Panel 6:** Demian 5, *When I am King*.

Page 210: Toc Fetch, *...of the Most Pope Joey... Volume 3, no.1: The Tendaciously Sane Adventures of a Noman*.

Page 212, bottom row: Jim Woodring, *Frank*; Kyle Baker, *Undercover Genie, Volume One*; Joe Sacco, *The Fixer*; Chris Ware, *Jimmy Corrigan: The Smartest Kid on Earth*.

Page 213, top row: Jeff Smith, *Bone*; Rumiko Takahashi, *InuYasha*; Marjane Satrapi, *Persepolis*; Erik Drooker, *Flood*. **Second row:** Osamu Tezuka, *Astroboy*; Herge, *Tintin* © Casterman; Charles Schulz, *Peanuts* © United Media; Phoebe Gloeckner, *A Child's Life*. **Third row:** David B., *Epileptic*; Demian 5, *When I am King*.

Page 214, panel 5: Rumiko Takahashi, *InuYasha*.

Page 216, panel 1: Batman © DC Comics, Astroboy © Tezuka Productions. **Left column:** Yamasaki & Adachi, *Flower Comics Series* (book title in Japanese, sorry); Ishii Isami, *750 Rider*; Osamu Tezuka, *Vampire*; Yasuiti Osima, *Father and Son* (with Norio Hayasi). **Right column:** Shinji Mizushima, *Dokaben*; Yamasaki & Adachi, *Flower Comics Series*; Osamu Tezuka, *Dororo*; Keiji Nakazawa, *Gen of Hiroshima*; Riyoko Ikeda, *Rose of Versailles*.

Page 217, middle tier: Shotaro Ishinomori, *Cyborg 009* (2 images); Yasuiti Osima, *Father and Son* (with Norio Hayasi) (2 images); Shinji Mizushima, *Dokaben*; Yoshihiro Tatsumi, "Disinfection" from *The Push Man and Other Stories*; H Sato, *Shonen Champion Comics Series* (book title in Japanese); Ishii Isami, *750 Rider*; Riyoko Ikeda, *Rose of Versailles*; Yasuiti Osima, *Father and Son* (with Norio Hayasi).

Page 218, panel 2-4: Osamu Tezuka, *New Treasure Island, Astroboy, Blackjack, Dororo, Princess Knight, Jungle Emperor, Buddha* © Tezuka Productions. **Panel 6, left to right:** Katou Kazuhiko a.k.a. Monkey Punch, *Lupin III*; Yamasaki & Adachi, *Flower Comics Series* (book title in Japanese); Keiko Takemiya, *Toward Terra*; Shinji Mizushima, *Dokaben*; Kazuo Koike and Goseki Kojima, *Lone Wolf and Cub*; Katsuhiro Ohtomo, *Action Comics Series* (book title in Japanese) (with Toshihiko Yahagi); Shunji Sonoyama, *The Chief Clerk in His Prime*; Riyoko Ikeda, *Rose of Versailles*; Reiji Matsumoto, *Ghost Warrior*; Fujiko F. Fujio, *Doraemon*; Akira Toriyama, *Dr. Slump*; Camemaru and Takeshi Yoneda (I think -- credits in Japanese), *Bottom Madonna*.

Page 219, panel 3: Craig Thompson, *Blankets*; Chris Ware, *Jimmy Corrigan, The Smartest Kid on Earth*; Chynna

Clugston, *Queen Bee*; Derek Kirk Kim, *Same Difference*. **Panel 5:** Fred Gallagher, *Megatokyo*. **Panel 6:** Rumiko Takahashi, *InuYasha*; Moyoco Anno, *Sugar Sugar Rune*; Clamp, *Chobits*; Natsuki Takaya, *Fruits Basket*, Masashi Kishimoto, *Naruto*; Ai Yazawa, *Paradise Kiss*.

Page 220, panel 1: Natsuki Takaya, *Fruits Basket*. **Panel 2:** Layout from "Everybody Wants my Girl" by Joe Simon and Jack Kirby, from the collection *Real Love*. **Panel 4:** Layout from *Kodacha* by Miho Obana. **Panel 5:** Miwa Ueda, *Peach Girl*. **Panel 8:** Masashi Kishimoto, *Naruto*.

Page 221, panel 1: Masashi Kishimoto, *Naruto*. **Panel 3:** Eiichiro Oda, *One Piece*. **Panel 4:** Mark Bagley, Art Thibert and/or Dan Panosian, Ultimate *Spider-Man Volume One* (with Bill Jemas and Brian Michael Bendis).
Panel 2: Edward Elric from *Full Metal Alchemist* © Hiromu Arakawa/Square Enix. **Panel 7:** Amy Kim Ganter, Sorcerers and Secretaries © Amy Kim Ganter and Tokyopop.

Page 223, panel 1: Bryan Lee O'Malley, *Scott Pilgrim*.

Page 225, panel 3: Jack Kirby, *The Fantastic Four* (with Stan Lee) © Marvel Entertainment Group. **Panel 4:** Superman © DC Comics; this panel may be drawn by Curt Swan but there were no art credits in the anthology I found this panel in.

Page 226, panel 1, circle #1: Osama Tezuka, Astroboy © Tezuka Productions. **#2:** Shotaro Ishinomori, *Cyborg 009*. **#3:** Masamune Shirow, *Appleseed*. **#4:** Osamu Tezuka, *Princess Knight* © Tezuka Productions. **#5:** Ryoko Ikeda, *Rose of Versailles*. **#6:** Rumiko Takahashi, *Ranma 1/2* © Rumiko Takahashi/Shogakukan. **#7:** Osamu Tezuka, *Dororo* © Tezuka Productions. **#8:** Sampei Shirato, *Ninja Bucheicho*. **#9:** Kazuo Koike and Goseki Kojima, *Lone Wolf and Cub*. **Panel 4:** Osamu Tezuka, *Phoenix*; Jack Kirby, *New Gods* © DC Comics.

Page 227, panel 1: Herge, *Tintin* © Casterman. **Panel 2:** Moebius, *Oeuvres Completes Tome 2*; Jean-Claude Mézières, Ambassador of the Shadows (with Pierre Cristin); Lewis Trondheim, *Mildiou* © Editions du Seuil. **Panel 3:** Hayao Miyazaki, *Nausicaa of The Valley of the Winds* © Nibariki/Tokuma Shoten. **Panel 4:** Jeff Jacques, *Questionable Content*; Mike Krahulik, *Penny Arcade* (with Jerry Holkins); Mitch Clem, *Nothing Nice to Say*; James Kochalka, *American Elf*; Eric Millikin, *Fetus-X*; Joe Zabel, *Fear Mongers*; Jeffrey Rowland, *Overcompensating*; Jenn Manley Lee, *Dicebox*; Dylan Meconis, *Bite Me*. **Panel 5:** The Hulk © Marvel Entertainment Group.

Page 230, left: Hal Foster, Prince Vallant © King Features; Colleen Doran, *A Distant Soil*; P. Craig Russell, *Murder Mysteries* (with Neil Gaiman), text © Neil Gaiman, adaptation and illustrations © P. Craig Russell. **Right:** Lynn Johnston, *For Better or For Worse*; Jack Kirby, *The Fantastic Four* (with Stan Lee) © Marvel Entertainment Group; Dan DeCarlo, *Betty and Veronica* © Archie Comics.

Page 231, left: Art Spiegelman, "Ace Hole; Midget Detective" from *Breakdowns*; Kevin Huizenga, "The Sunset" from *Goriana*; Daniel Merlin Goodbrey, *The Formalist*. **Right:** Julie Doucet, *My New York Diary*; Jacques Tardi, "Manhattan" reprinted in *Read Yourself Raw*; R. Crumb, "I'm Grateful! I'm Grateful!" from *Weirdo #25*.

Page 233, panel 4: Milton Caniff, *Terry and the Pirates* © King Features. **Panel 5:** Art Spiegelman, *In the Shadow of No Towers*. **Panel 6:** Dave McKean, *Cages*.

Page 234, panel 5: Charles Burns, *Black Hole*. **Panel 6:** Jim Woodring, *Frank*.

Page 240, left: Kim Jea Eun, *Soul to Seoul* © Kim Jea Eun/Daiwon C.I.; Doha Kang, *The Great Catsby*. **Right:** Hironori Kikuchi "Gedatsu Man" © Hironori Kikuchi/Seirindo; Yuko Tsuno, "Swing Shell" © Yuko Tsuno/Garo; both reprinted in *Secret Comics Japan*.

Page 241: Yoshihiro Tatsumi, "Traffic Accident" from *The Push Man and Other Stories*.

Page 242: Mark Bagley, Art Thibert and/or Dan Panosian, Ultimate *Spider-Man Volume One* (with Bill Jemas and Brian Michael Bendis).

Page 246, panel 1: Charlie Brown ™ United Media; Calvin and Garfield ™ Universal Press Syndicate; Batman ™ DC Comics; Spider-Man ™ Marvel Entertainment; Betty ™ Archie Comics.

Index

BOOKS BY SCOTT McCLOUD

UNDERSTANDING COMICS
The Invisible Art

ISBN 978-0-06-097625-5 (paperback)

Praised throughout the cartoon industry by such luminaries as Art Spiegelman, Matt Groening, and Will Eisner, this innovative comic book provides a detailed look at the history, meaning, and art of comics and cartooning.

REINVENTING COMICS
How Imagination and Technology Are Revolutionizing an Art Form

ISBN 978-0-06-095350-8 (paperback)

Following in the footsteps of *Understanding Comics*, Scott McCloud explores comics as art and literature; the chaotic comics industry; public perceptions of comics; and the fight for sexual and ethnic diversity. This comprehensive analysis covers comics' digital revolutions, including the challenges of production; the exploding world of online delivery; and finally, comics' startling transformations as it enters the digital landscape for a new century.

MAKING COMICS
Storytelling Secrets of Comics, Manga and Graphic Novels

ISBN 978-0-06-078094-4 (paperback)

With his trademark mix of dry humor and legitimate instruction, Scott McCloud focuses on the art form itself, exploring the creation of comics, from the broadest principles to the sharpest details (like how to accentuate a character's facial muscles in order to form the emotion of disgust rather than the emotion of surprise) to learn how to master the human condition through word and image in a brilliantly minimalistic way. Comic book devotees as well as the most uninitiated will marvel at this journey into a once-underappreciated art form.

ZOT!
The Complete Black and White Collection: 1987-1991

ISBN 978-0-06-153727-1 (paperback)

Zachary T. Paleozogt lives in "the far-flung future of 1965," a utopian Earth of world peace, robot butlers, and flying cars. Jenny Weaver lives in an imperfect world of disappointment and broken promises—the Earth we live in. Stepping across the portals to each other's worlds, Zot and Jenny's lives are changed forever.

For the first time since its original publication more than twenty years ago, Scott McCloud's black and white series has been collected in its entirety in this must-have commemorative edition for aficionados to treasure and new fans to discover.

www.scottmccloud.com/makingcomics